Advertising AND Societies

PETER LANG
New York • Washington, D.C./Baltimore • Bern
Frankfurt am Main • Berlin • Brussels • Vienna • Oxford

KATHERINE TOLAND FRITH
& BARBARA MUELLER

Advertising AND Societies

Global Issues

SECOND EDITION

PETER LANG
New York • Washington, D.C./Baltimore • Bern
Frankfurt am Main • Berlin • Brussels • Vienna • Oxford

Library of Congress Cataloging-in-Publication Data

Frith, Katherine Toland.
Advertising and societies: global issues /
Katherine Toland Frith, Barbara Mueller. — 2nd ed.
p. cm.
Includes bibliographical references and index.
1. Advertising. 2. Advertising—Social aspects.
3. Intercultural communication. I. Mueller, Barbara. II. Title.
HF5823.F9826 659.1'042—dc22 2009036548
ISBN 978-1-4331-0385-8

Bibliographic information published by **Die Deutsche Nationalbibliothek**.
Die Deutsche Nationalbibliothek lists this publication in the "Deutsche
Nationalbibliografie"; detailed bibliographic data is available
on the Internet at http://dnb.d-nb.de/.

The paper in this book meets the guidelines for permanence and durability
of the Committee on Production Guidelines for Book Longevity
of the Council of Library Resources.

For Michael Frith, to whom I owe a world of thanks

For my husband Juergen and my daughter Sophie as they
are the center of my universe

Table of Contents

Figures & Tables

Chapter 4

Chapter 5

Chapter 6

Chapter 7

Chapter 8

Chapter 9

Chapter 10

Preface

Consumers around the globe—in both developed and emerging markets—are increasingly influenced by commercial communications. The goal of *Advertising and Societies: Global Issues* is to provide an international perspective on the practice of advertising while examining some of the ethical and social ramifications of advertising in diverse societies. The text introduces the cultural, economic, political, and regulatory issues surrounding advertising practice in today's global context, using current data and examples from around the world. This book is designed to show readers how issues—such as the commercialization of cultures, distorted representations of women and ethnic groups in advertisements, marketing efforts targeting the youngest of consumers, and the advertising of controversial products, such as cigarettes, alcohol, and prescription drugs—all have relevance to a wider global community.

Our objective in writing this second edition is to reflect the dramatic changes impacting the field of advertising that have taken place since the introduction of the first edition. Without question, the keystone of our global economy continues to be the multinational corporation. The United States was once considered the hub of world trade. Today, American corporations have come to realize that the U.S. is no longer an isolated, self-sufficient national economy but instead simply another player in the global marketplace. *Fortune* magazine's 2008 list of the Global Fortune 500 shows the fewest U.S. businesses in more than a decade and confirms the rising prominence of the emerging markets. Less than 10 years ago, India, Mexico, and Russia posted only one company on the Global Fortune 500. The 2008 list includes seven from the subcontinent and five firms each from Mexico and Russia. But it appears that China is stealing the show. With an unprecedented total of 29 companies on the list, China posted as many companies as Italy, Spain, and Australia combined (Mero, 2008). While the United States continues to both produce

and consume the bulk of the world's advertising, advertising's global presence is evidenced by the location of major advertising markets. In rank order, the top global advertising markets are the United States, Japan, the United Kingdom, Germany, China, France, Italy, Spain, Brazil, and South Korea. Both China and South Korea are new to this list. And today, 8 of the top 10 world advertising organizations are headquartered outside the United States. Global marketers must respond to shifting consumer demographics. Most Western countries are aging and shrinking. Further, the current economic slowdown has caused many consumers in developed nations to tighten their belts. Such trends have caused an ever-growing number of advertisers to look to developing countries for both larger and more youthful markets. Indeed, three-quarters of the world's population live in developing areas. The consumer class (individuals whose purchasing power parity is more than US$7,000) now includes more than 1.7 billion people—with nearly half of them in developing nations. Another four billion people, i.e., two-thirds of the world's population, are still at the bottom of the global economic pyramid—yet even these poorest of the poor represent market potential. Global marketers are looking beyond the traditional media to find new and more effective ways to communicate with their customers in every corner of the world. A flood of emerging technologies is responsible for the evolution of new media forms—forms that were unimaginable as little as 5 or 10 years ago. As a result, consumers are exposed to commercial messages just about everywhere—on the Internet, in an elevator, at the gas station, in classrooms, in the restroom, and even embedded into their favorite movies and TV shows. The global consumer, whether in New York or New Delhi, will find it increasingly difficult to escape the efforts of marketers. These dramatic changes are reflected in the pages of this second edition. Overall, this book provides students, practitioners, and scholars with a comprehensive review of the literature on advertising and society, using up-to-date examples from international media to document how advertising impacts the emerging global consumer and influences global consumer culture.

We are indebted to a number of individuals for the successful completion of this text. We deeply appreciate the skill and dedication of our publishing team at Peter Lang. First and foremost, we would like to acknowledge Chris Myers, managing director, who has been so supportive of our work over the years—and a good friend, as well. Special thanks go to Mary Savigar, senior acquisitions editor, for encouraging this edition and for being so great to work with. Thanks also go to Toni Mortimer, who so diligently edited the manuscript, as well as to Bernadette Shade for once again doing such a bang-up job of managing the production process. And we express gratitude to our research assistants, especially Jing Yi, for her dedication and help. Finally, for their continued understanding and encouragement, we would like to thank our families. Writing is indeed a time-consuming endeavor and we feel compelled to thank our husbands, Michael and Juergen, for taking up the slack on the home front. And, Sophie deserves applause for brilliantly maneuvering her way through her first year of high school—despite a mom who was less than fully attentive over the past nine months.

Katherine Toland Frith
Barbara Mueller

REFERENCE

Mero, Jenny. (2008, July 21). Power shift. *Fortune*, p. 161.

1

International Advertising and Globalization

INTRODUCTION

"Globalization" refers to the increasing internationalization of economic life and its effects on trade, national sovereignty, laws and regulations, the mass media, and cultural identity (Corcoran, 1998). In economic terms, globalization is the process by which a firm attempts to earn additional profit through entry into overseas markets. Although the term "globalization" became popular during the last part of the twentieth century, the forces that shaped globalization can be traced back as far as the fifteenth century. Europe led the move toward globalization through colonization in the eighteenth and nineteenth centuries. The United States led the most recent phase of globalization in the twentieth century, driven by the increasing access to communication technologies and the opening of international markets to multinational corporations and their advertising agencies. And today we live in a world of transnational cultural flows. This chapter explores some of the theories that have driven globalization and traces the growth of multinational corporations and their advertising agencies as they spread the gospel of capitalist development throughout the world.

A SHORT HISTORY OF GLOBALIZATION

Today, the new media available through cell phones, satellites, and computers allow advertising messages to spread globally at a phenomenal rate. Because of the availability of rapid communication and advanced transportation, companies like Amazon have been able to build in a few short years what corporations like Coca-Cola took over a century to establish.

To understand the relationship between international advertising and globalization we must trace the historical factors that have contributed to the current situation. While the term "globalization" has only recently gained popularity, the process of globalization has its antecedents in colonization and mercantilism. Colonialism or colonization mainly took place from the sixteenth century to the early twentieth. Essentially, it was a system of one country's political and economic domination over another—usually achieved through aggressive, often military, action. It began with the Age of Exploration in the fifteenth century when European countries first ventured beyond their borders in search of natural resources and trade products. A colonial power could increase its wealth by conquering another country and taking its riches or exploiting its mineral wealth such as silver, gold, or tin (Cell, 1999).

Exports to the colonies brought in wealth from outside and were considered preferable to both trade within a country and to imports from overseas. Within this mercantilist system, colonies were important assets because the colonizing country could control markets for its exports and deny these markets to its competitors. Because mercantilists assumed that the volume of world wealth and trade was relatively static, it followed that one country's gain was another's loss. This type of thinking led to the period of imperialism or empire building that commenced during the seventeenth and eighteenth centuries. The Portuguese built a commercial empire along the coast of West Africa where they established a trade in gold and slaves. The Spanish conquistadors (conquerors) overwhelmed the Aztec and Inca empires in what are now Mexico, Peru, and other parts of South America. The Portuguese, and later the Dutch, moved into Southeast Asia, while the British and French colonized much of North America and later India and Indochina. During the early colonial period, England granted a charter to the British East India Company to establish overseas commercial and trade interests. Holland established the Dutch East India Company for the same purposes. These two companies were probably the first truly multinational corporations.

INTERNATIONAL ADVERTISING AND GLOBALIZATION

The eighteenth century brought with it a change in economic thinking related to mercantilism. This was when the doctrine of free trade first started to take root. Economists—particularly British economist Adam Smith—argued against government regulation of the economy. Smith asserted that trade with the colonies was no more profitable than trade with independent countries. He argued that while political strategy might justify colonialism, economics could not. By the nineteenth century, free trade policies were prompting European nations to establish informal empires or "spheres of influence" (Cell, 1999).

Europeans were successful in their conquests because their military power afforded them a huge advantage over the rest of the world. Armed force helped them expand their commercial activities. In addition to trade, another justification for colonization was the attitude prevalent in Europe during the nineteenth century that rather than exploiting their colonies, the European countries were controlling them in order to protect what they viewed as "weak" peoples. And, of course, imposing religion and "civilization" was another justification for colonization.

In the twentieth century, colonialism was not exclusively a European undertaking. During the same period, Japan became a major imperial power. In the early 1940s, Japan, claiming that it was uniting Asian nations against Western domination, subjugated much of Asia for its political and

economic purposes. In addition, the United States annexed territories such as Alaska, Hawaii, and Puerto Rico. China took control of Tibet. It was not until the end of World War II (1939–1945) that many colonized nations began to gain a degree of political and economic independence.

THE RISE OF THE MULTINATIONAL CORPORATION

The roots of globalization lie in economic trade and improved methods of communication. Before the twentieth century, economic expansion had been the sole domain of governments and nation-states. Starting in the early twentieth century, private corporations began to take over this role. It is important to differentiate between a corporation and a company. A company, in business terms, is an organization created to pursue profit by providing goods or services. A corporation is usually a large company or organization that has been established under a government charter. Corporations can associate together for a common purpose under a common name. The government charter gives a corporation certain legal privileges, including the right to buy and sell property, to enter into contracts, to sue and be sued, and to borrow and lend money. Today, large corporations generate about 90 percent of all business income (Peterson, 1999).

As noted, the first truly multinational corporations emerged in the seventeenth century when the English and Dutch granted charters to joint-stock corporations: the British and the Dutch East India companies. These companies were given authority to govern in the colonies and to engage in trade. By the twentieth century, the corporation had become the dominant type of business organization throughout the world (Peterson, 1999).

In 1811, New York became the first U.S. state to pass a law outlining the procedure for chartering a corporation; other states soon followed. However, it was not until after World War I (1914–1918) that the United States began to emerge as a major world economic power. At the same time as Europe was recovering economically from the war, the United States was building up its economic strength through its overseas territories, free access to markets, and plentiful raw materials.

In the 1920s, Henry Ford's introduction of assembly-line production methods allowed corporations to cut production costs and increase their output of products that were more affordable for an increasing number of people. By the end of the decade, the main industries in the United States had evolved from small companies into major corporations. AT&T dominated the telephone industry; General Motors, Ford, and Chrysler produced the majority of automobiles; and Westinghouse and GE controlled the electrical equipment sectors (Sivulka, 1998). Bagdikian (1997) has noted that advertising was a vital gear in the machinery of corporate power, as

> it not only helped create and preserve dominance of the giants over consumer industries, it also helped create a picture of a satisfactory world with the corporations as benign stewards. (p. 131)

In 1926 Calvin Coolidge, then president of the United States, attributed the success of mass demand for products "entirely to advertising" and noted that advertising "is a great power . . . part of the greater world of regeneration and redemption of mankind." (Bagdikian, p. 148)

The 1930s Great Depression put a damper on industrial growth, but the postwar boom from 1945 to 1960 allowed more American corporations to enter into the international arena. Corporations like Coca-Cola, Colgate-Palmolive, Westinghouse, and General Motors built plants around the world. Thus, American corporations joined European corporations in spreading capitalist growth across the planet. In the United States, only 7,000 multinational corporations

existed in 1970, but by the mid-1990s, their numbers had grown to 37,000 parent corporations—with over 200,000 affiliates worldwide.

During the first part of the twentieth century, U.S. and European corporations topped the list of Global Fortune 500. However, today the rise of the emerging economies and the financial woes in developed markets are all reflected in a shift. U.S.-based Wal-Mart Stores have held on to the top spot, but now only 153 of the Global Fortune 500 corporations are U.S. based. The country rising fastest on the 2008 list was China with 29 top corporations—as many as Italy, Spain, and Australia combined (Mero, 2008) (see Table 1.1).

Table 1.1: World's Largest Corporations from *Fortune Magazine* 2008

RANK 2007		HEADQUARTERS	REVENUES (MILLIONS)
1	Wal-Mart Stores	U.S.	378,799.0
2	Exxon Mobil	U.S.	372,824.0
3	Royal Dutch Shell	Netherlands	355,782.0
4	BP	Britain	291,438.0
5	Toyota Motors	Japan	230,200.8
6	Chevron	U.S.	210,783.0
7	Ing Group	Netherlands	201,516.0
8	Total	France	187,279.5
9	General Motors	U.S.	182,347.0
10	Conocophillips	U.S.	178,558.0
11	Daimler	Germany	177,167.1
12	General Electric	U.S.	176,656.0
13	Ford Motor	U.S.	172,468.0
14	Fortis	Belgium/Netherlands	164,877.0
15	AXA	France	162,762.3
16	Sinopec	China	159,259.6
17	Citigroup	U.S.	159,229.0
18	Volkswagen	Germany	149,054.1
19	Dexia Group	Belgium	147,648.4
20	SBC Holdings	Britain	146,500.0
21	BNP Paribas	France	140,726.5
22	Allianz	Germany	140,618.4
23	Crédit Agricole	France	138,154.6
24	State Grid	China	132,885.1
25	China National Petroleum	China	129,798.3

Source: Fortune 500 List of Corporations. (2008).

SPREADING IMAGES OF "THE GOOD LIFE"

A corporation seeks markets outside its national borders when there is insufficient opportunity for expansion at home (Mueller, 1996). American corporations first started to seek markets outside the United States in the late nineteenth century. By the early twentieth century, U.S. advertising agencies began to follow their clients into the international marketplace (Mueller, 1996). The J. Walter Thompson (JWT) advertising agency opened its first overseas office in Great Britain in 1899, and by the 1950s had 15 overseas agencies (Sivulka, 1998). The Standard Oil and Coca-Cola accounts took the McCann Erickson advertising agency into Europe in the 1920s. And while the trend toward globalization slowed between 1920 and 1940 due to the two world wars, it picked up again in 1945 and has proceeded unabated since then.

The 1960s were a major decade of international expansion by multinational corporations and their advertising agencies. *Advertising Age* called 1960, "a year of decision—the decision to enter into the international field" (Crichton, 1961). It was during this phase of agency expansion abroad that the international billings of the major U.S. advertising agencies first began to outstrip the growth of domestic billings. In 1960, some 36 American ad agencies had branches outside the United States and operated a total of 281 overseas offices. By the 1970s, international billings reached an annual US$1.8 billion and accounted for more almost 20 percent of total agency U.S. billings (Kim, 1994). By moving abroad, U.S. advertising agencies could both service their multinational clients and compete for the accounts of other U.S. firms operating internationally. Later, because the domestic advertising business began to level off in the United States in the 1960s and 1970s, overseas markets began to look more appealing to the U.S. multinational advertising agencies.

The first phase of U.S. agency overseas expansion was aimed mainly at European markets. During the 1960s, many U.S. multinational corporations opened subsidiaries in Europe—the majority sited their overseas headquarters in England. By the end of the decade, U.S.-based transnational advertising agencies dominated the British scene—operating 6 of the top 10 agencies in London (Kim, 1994). Likewise in Latin America, U.S. agencies began to dominate the market during the decade of the 1970s. For example, in 1977, the total billings of advertising agencies in Latin America were about US$686 million and multinational agencies accounted for 67 percent of this total. Of the 10 largest agencies in Latin America in the 1970s, the 5 largest were all U.S. based: J. Walter Thompson, McCann Erickson, Kenyon and Eckhardt, Leo Burnett, and Grey Advertising (Kim, 1994). As a consequence of this global expansion, the international billings of U.S. agencies with overseas operations more than doubled during the decade. Today, the largest advertising agency chains are still headquartered in the United States, Japan, and Europe (see Table 1.2).

Table 1.2: World's Top Ten Agency Brands in 2007

RANK	ORGANIZATION	HEADQUARTERS
1.	Dentsu	Tokyo
2.	BBDO Worldwide	New York
3.	McCann Erickson Worldwide	New York
4.	DDB Worldwide Communications	New York
5.	TBWA Worldwide	New York
6.	J. Walter Thompson	New York
7.	Publicis Worldwide	Paris
8.	Hakuhodo	Tokyo
9.	Young & Rubicam	New York
10.	Ogilvy & Mather Worldwide	New York

Source: Agency Report. (2008, December 29).

The second major surge of international expansion by advertising agencies occurred during the 1980s—the decade of megamergers. These mergers involved a handful of large, highly profitable ad agencies operating at the global level. For instance, in 1986, BBDO International, Doyle Dane Bernbach, and Needham Harper Worldwide announced a three-way merger to create the world's largest advertising firm, the Omnicom Group. A few weeks later, Saatchi & Saatchi bought out Ted Bates Worldwide and immediately surpassed Omnicom in size and billings—with over 150 offices in 50 countries. Next, J. Walter Thompson, the oldest U.S. advertising agency, was acquired by the British WPP Group. Today the top three holding companies, Omnicom, WPP, and Interpublic, together control 39 percent of the world's ad agencies (see Table 1.3).

Table 1.3: Top Ten Ad Agency Holding Companies in 2007

RANK	AD ORGANIZATION	HEADQUARTERS
1.	Omnicom Group	New York
2.	WPP Group	London
3.	Interpublic Group	New York
4.	Publicis Groupe	Paris
5.	Dentsu	Tokyo
6.	Aegis Group	London
7.	Havas	Suresnes, France
8.	Hakuhodo	Tokyo
9.	MDC partners	Toronto/New York
10.	Alliance Data Systems	Dallas

Source: Agency Report. (2008, December 29).

Another outcome of the decade of megamergers was the integration of public relations into the holding companies' stable or resources. The Interpublic Group acquired the public relations firms of Weber Shandwick and DeVries, while Omnicom acquired Fleishman-Hillard and Porter Novelli and WPP acquired Hill & Knowlton and Burson-Marstellar. This meant that clients could now expect integration with their advertising and PR strategies. In addition, the large holding companies set up sister media strategy firms. This meant that the agencies in the WPP Group, for example, could now buy media in bulk through MindShare or Mediaedge:cia (see Table 1.4). Thus, the era of integrated marketing communication (IMC) became a reality in the 1990s.

The Structure of the WPP Group (A partial list of companies held)

Advertising Agencies
- J. Walter Thompson
- Ogilvy & Mather
- Y & R Advertising
- Batey Ads
- Marsteller

Media Specialists
- MindShare
- Mediaedge:cia
- MAXUS

Public Relations
- Burson-Marstellar
- Hill & Knowlton
- Ogilvy PR

Branding
- Landor Associates
- Fitch
- Designworks

Specialized Communications
- Sudler & Hennessey
- Millward-Brown
- 141 Worldwide
- Wunderman

Table 1.4: Top 10 Media Specialist Companies in 2007

RANK	MEDIA SPECIALIST	HOLDING COMPANY	HEADQUARTERS
1	Media Com	WPP	New York
2	OMD Worldwide	Omnicom	New York
3	Mindshare Worldwide	WPP	New York/London
4	Starcom UK Group	Publicis	London
5	Carat	Aegis	London
6	Zenith Optimedia	Publicis	London
7	Mediaedge:cia	WPP	London
8	Initiative London	Interpublic	London
9	Walker Media	Aegis	London
10	PHD	Omnicom	New York

Source: Top 10 Media Agencies. (2008, February 21).

THE GLOBALIZATION OF ADVERTISING

While mass communication academics became interested in globalization only in the last decade of the twentieth century (Hall, 1991; Hannerz, 1991; Robertson, 1991), it was an important issue for the international advertising industry as early as the 1960s. In that decade, Arthur Fatt (1967), one of the founders of Grey Advertising, published an article in the *Journal of Marketing* stating that

a growing school of thought holds that even different peoples are basically the same, and that an international advertising campaign with a truly universal appeal can be effective in any market. (p. 61)

As the CEO of a very successful multinational advertising agency, his words had a strong impact on the industry as a whole. He went on to promise, perhaps even foretell, that

advertising is not only helping to break down national economic boundaries, but ingrown characteristics and traditions once considered almost changeless. (Fatt, 1967, p. 61)

During the 1960s, most international advertising operations focused on Europe. In response to the expansion of American agencies like Grey, the Europeans voiced concern over the impact of American-style advertising campaigns on their local cultures. While U.S. advertising practitioners saw no harm in spreading American ideals around the world, Europeans felt that advertising should be localized and reflect national values; for example, German advertising should express German culture and French advertising ought to express French culture.

In the *Journal of Marketing*, Arthur Fatt (1967) responded to these criticisms, noting that "most people everywhere, from Argentina to Zanzibar, want a better way of life for themselves and for their families" (p. 61). He contended that there was a set of "universal" human characteristics:

The desire to be beautiful is universal. Such appeals as "mother and child," "freedom from pain," and the "glow of health," know no boundaries. (p. 61)

Figure 1.1: DeBeers ad in Mandarin in a Chinese magazine

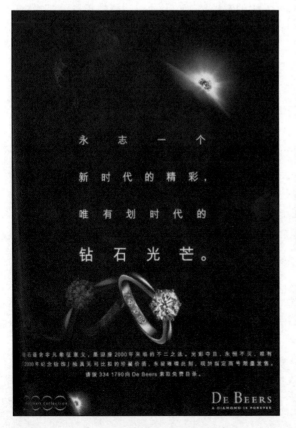

Figure 1.2: DeBeers ad in English in a U.S. magazine

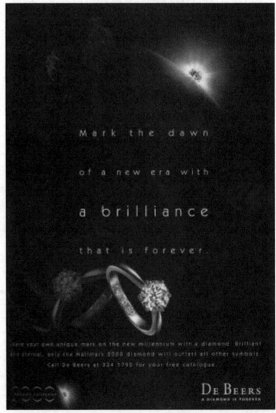

Fatt (1967) advocated that advertisers and their agencies use these universal appeals. He promised that "global campaigns" featuring appeals to beauty, health, and the good life would lead to more effective advertising and would save corporations huge sums of money. He also warned that changing ad appeals to suit localized markets was not only "unnecessary and expensive" but also "suicidal" (p. 62). Thus, the founder of Grey Advertising began a debate that has continued for more than 40 years. Can a single advertising campaign be used worldwide or does a campaign need to be specialized for each market? In reality, there are both types of campaigns being run today.

In the early 1980s, Theodore Levitt (1983) published an article in the *Harvard Business Review* recommending that multinational advertisers downplay cultural differences and treat the world as if it were a single, homogeneous market. He coined the term "standardized" for uniform global advertising. Levitt stated, "Companies must learn to operate as if the world were one large market—ignoring superficial regional and national differences" (p. 92). He admonished corporations doing business abroad to operate with resolute constancy—to sell the "same thing, in the same way, everywhere" (p. 93)—and pointed to the worldwide success of corporations like McDonald's, Coca-Cola, and Levi's jeans. Levitt noted, "Different cultural preferences, national tastes and standards, and business institutions are vestiges of the past" (p. 93).

Thus, today we see standard ad campaigns that run with little change worldwide. The DeBeers ads in Figures 1.1 and 1.2 are examples of standardized ads. Standardizing the visual elements of an advertising campaign means that the campaign uses the same photograph and layout worldwide and requires only minimal translation of copy into the local language. These DeBeers ads ran in China and in the United States with essentially the same layout and same copy only translated from English to Chinese for the China market (see Figures 1.1 and 1.2). The assumption here is that regardless of culture, people everywhere share the belief that "diamonds are a girl's best friend."

This type of standardized campaign offers the advertiser greater control over the content, since only one creative campaign needs to be designed and produced, usually in corporate headquarters in New York, London, or Tokyo. Additionally, using standardized campaigns allows advertisers to maintain a single, unified brand image worldwide (Tansey, Hyman, & Zinkham, 1990). However, as we shall see in Chapter 2, while the words in the ad can be generally translated into different languages without too much controversy, when photographs are used in the ad it can create problems across cultures. Thus, the challenges to globalized advertising can be both visual and verbal in nature. There are many stories of advertisers who have run into trouble when they tried to translate a campaign into another language. For example, when the American Dairy Association introduced the highly successful "Got Milk?" campaign from the USA into Mexico, the Spanish translation was, "Are you lactating?" (Mueller, 2006). The slogan was quickly replaced with "And you, have you given them milk today?"

While the arguments over standardized versus localized campaigns tend to swing back and forth, some marketers/advertisers have created "glocalized" campaigns. McDonald's, for example, used the "I'm lovin' it" campaign all over the world but localized it by using local models in many countries to give the global campaign a local look.

CONCLUSIONS: THE DEBATE OVER INTERNATIONAL ADVERTISING

A two-way relationship exists between a society and advertising in general and international advertising in particular. Advertising agencies do far more than merely provide commercial information as they disseminate advertising messages. Ads transmit values, influence the behavior of both individuals and value-forming institutions, and even sway national development policies. A good deal has been learned about the role advertising agencies play in their home nations. The United States, the United Kingdom, and Japan have economic systems based on plenty and were traditionally organized to produce and distribute goods and services far in excess of people's basic needs. Somewhat less is known, though, about how agencies operate amidst the scarcity and poverty of the Third World, or in particular, how directly or indirectly, intentionally or unintentionally, they affect the lives of people, especially those in the poorest nations.

While advertising has been said to shape society, at the same time it is essential to recognize that it also mirrors it. One's style of living dictates the manner in which one consumes, the priority of one's needs and wants, and the advertising messages one perceives as effective. Cultural values are the core of advertising messages, and Holbrook (1987) has suggested that in order to convince potential customers to purchase a client's product or service, advertisers must comply with a public's value system rather than running counter to it. Empirical research has supported that advertisements reflecting local cultural values are indeed more persuasive than those that ignore them (Gregory & Munch, 1997; Han & Shavitt, 1994; Taylor et al., 1997).

However, according to Pollay (1986, 1987), advertising sometimes acts as a distorted mirror. Advertising tends to favorably portray hedonistic characteristics and to celebrate instant gratification, materialism, and covetousness. In contrast, often lacking or negatively portrayed in commercial messages are altruistic characteristics that advocate postponing gratification and instead show the advantages of calculated purchasing. The result is a distorted mirror that reflects only those values that help sell goods. Pollay's distorted mirror metaphor has been widely disseminated throughout the social sciences and humanities literature (Fowles, 1996).

Thus, it can be said that advertising can both reflect (more or less accurately) and shape a society. In the following chapters, we will explore this interrelationship between advertising and a society's culture and its economic and political systems as well as its legal environment.

REFERENCES

Agency Report. (2008, December 29). *Advertising Age.* Retrieved February 6, 2009, from http://adage.com/datacenter/

Bagdikian, Ben H. (1997). *The media monopoly.* Boston: Beacon.

Cell, John W. (1999). *Colonialism and colonies* (CD-ROM). Microsoft Encarta. Redmond, WA: Microsoft.

Corcoran, F. (1998, July). *Centre-periphery relations in the television industry: Globalisation or imperialism.* Paper presented at the IAMCR Conference, Glasgow, Scotland.

Crichton, John. (1961, February). 6 billion billed by 677 agencies in 1960. *Advertising Age,* p. 1.

Fatt, Arthur. (1967, January). The danger of "local" international advertising. *Journal of Marketing, 31,* 60–62.

Fortune 500 List of Corporations. (2008). *Fortune, 158*(2), 156–174, 179–182.

Fowles, J. (1996) *Advertising and popular culture.* Thousand Oaks, CA: Sage.

Gregory, Gary D., & Munch, James. (1997). Cultural values in international advertising: An examination of familial norms and roles in Mexico. *Psychology and Marketing, 14*(2), 99–119.

Hall, Stuart. (1991). The local and the global: Globalization and ethnicities. In Anthony D. King (Ed.), *Culture, globalization and the world system* (pp. 19–39). Binghamton, NY: SUNY.

Han, Sang Pil, & Shavitt, Sharon. (1994). Persuasion and culture: Advertising appeals in individualistic and collectivistic societies. *Journal of Experimental and Social Psychology, 30*(4), 326–350.

Hannerz, Ulf. (1991). Scenarios for peripheral cultures. In Anthony D. King (Ed.), *Culture, globalization and the world system* (pp. 107–127). Binghamton, NY: SUNY.

Holbrook, Morris B. (1987, July). Mirror, mirror on the wall, what's unfair in the reflections on advertising? *Journal of Marketing, 51,* 95–103.

Kim, Kwangmi Ko. (1994). *The globalization of the Korean advertising industry: History of early penetration of TNAA's and their effects on Korean society.* Unpublished doctoral dissertation, Pennsylvania State University.

Levitt, Theodore. (1983, May–June). The globalization of markets. *Harvard Business Review, 61,* 92–101.

Mattelart, Armand, & Schmucler, Hector. (1985). *Communication and information technologies: Freedom of choice for Latin America.* Norwood, NJ: Ablex.

Mero, Jenny. (2008, July 21). Power shift. *Fortune.* p. 161.

Mueller, Barbara. (1996). *International advertising: Communicating across culture.* Belmont, CA: Wadsworth.

Mueller, Barbara. (2006). *Dynamics of international advertising: Theoretical and practical perspectives.* New York: Peter Lang.

Pollay, R. (1986). The distorted mirror: Reflections on the unintended consequences of advertising. *Journal of Marketing, 50*(2), p.18–36.

Pollay, R. (1987). On the value of reflections on the values of the distorted mirror. *Journal of Marketing, 51*(3), p. 104–109.

Peterson, Wallace. (1999). *Corporations* (CD-ROM). Microsoft Encarta. Redmond, WA: Microsoft.

Robertson, Roland. (1991). Social theory, cultural relativity and the problem of globality. In Anthony D. King (Ed.), *Culture, globalization and the world system* (pp. 70–90). Binghamton, NY: SUNY.

Sivulka, Juliann. (1998). *Soap, sex and cigarettes: A cultural history of American advertising.* Belmont, CA: Wadsworth.

Tansey, R., Hyman, M., & Zinkhan, G. (1990). Cultural themes in Brazilian and U.S. auto ads: A cross-cultural comparison. *Journal of Advertising, 19,* 30–39.

Taylor, Charles R., Miracle G., & Wilson, R. Dale. (1997, Spring). The Impact of information level on the effectiveness of U.S. and Korean television communication. *Journal of Advertising, 20,* 1–15.

Top 10 Media Agencies. (2008, February 21). *Campaign.* Retrieved February 6, 2009, from http://www.brandrepublic.com/Campaign/AgencyRankings/785868/Top-10-Media-Agencies-2008/

World's Top 50 Agency Companies. (2008, December 29). *Advertising Age.* Retrieved February 6, 2009, from http://adage.com/datacenter/datapopup.php?article_id=126706

2

Advertising and Culture

INTRODUCTION

Each country exhibits a set of unique cultural characteristics based on history, geography, and values. As noted in Chapter 1, the debate over whether consumers are the same worldwide or whether they are different has long interested advertisers. While people worldwide generally all hope for health and happiness, culture shapes consumers' needs and wants, their methods of satisfying them, and how they respond to advertising messages. In this chapter we will review some theories on how culture and geography shape the way people see the world and how consumers in different parts of the world view messages in advertisements.

THE CONCEPT OF CULTURE

Over a century ago, Edward Taylor (1871) defined culture as "a complex whole, which includes knowledge, beliefs, art, morals, law, custom, and any other capabilities and habits acquired by individuals as members of a society" (p. 1). Adamson Hoebel (1960) referred to culture as the "integrated sum total of learned behavioral traits that are manifest and shared by members of society" (p. 168). Culture has also been defined as a "learned, shared, compelling, interrelated set of symbols whose meaning provides a set of orientations for members of a society" (Terpstra & David, 1991).

Well over 160 different definitions of culture have been identified in the anthropological literature (Kroeber & Kluckhohn, 1952). Clearly, no shortage of definitions of this concept exists. The three definitions provided here reveal some commonalties. It is generally agreed that cul-

ture is not inherent or innate but rather is learned. Learning typically takes place in institutions such as the family, church, and school. But, more than perhaps anything else, culture is learned informally—for instance, by role modeling—as well as at home or at school. Most definitions also emphasize that culture is shared by members of a group. It is this shared aspect that enables communication between individuals within that culture.

For the most part, we live our lives unaware of the tremendous impact our culture has on us. For example, Americans automatically drive on the right-hand side of the road, try to arrive on time for appointments, and generally shake hands when they first meet someone. Without thought, we react to our environment in a manner that is socially acceptable because that is how we have been socialized. Edward T. Hall (1966) points out: "No matter how hard man tries, it is impossible for him to divest himself of his own culture, for it has penetrated to the roots of his nervous system and determines how he perceives the world . . . people cannot act or interact in any meaningful way except through the medium of culture." When we move into another culture, we carry our cultural map with us, responding to the foreign environment in ways that would be acceptable in our own culture, but that may or may not be acceptable in different surroundings.

WHAT IS LOCAL?

To analyze the debate on globalization, culture, and advertising, first we need to define the terms "local" and "global." "Local" is a concept referring to people's relationship to the larger world. It refers to the sense of ourselves as belonging to a specific place at a specific time in history. As Stuart Hall (1991) says, it is our sense of identity—of the origin of our being or the ground for our actions. It contains the notion of the true self, the one we present to the world. When someone says, "I am an American," "I am Irish," or "I am Malaysian," they are expressing this localness. It is a kind of guarantee of our authenticity.

National identity—a sense of ourselves as belonging to a particular national culture—has several components. First, it incorporates a shared sense of continuity between successive genera-tions based on shared memories of specific events and people. Another component of national identity is "a sense of common destiny on the part of the collectivity sharing those experiences" (Lash & Urry, 1994, p. 310). A local culture is shared by any group of people living in a bounded space and engaging in daily face-to-face relationships (Featherstone, 1995). We express our sense of localness or national identity by incorporating shared sets of rituals, symbols, ceremonies, and ideologies that link us to a certain place and a common sense of the past. Advertisers use these signs and symbols of locality to appeal to the audience's sense of belonging and to bring the message and the audience closer together. For instance, Tommy Hilfiger and Ralph Lauren (Polo) use the colors red, white, and blue to appeal to the primary—American—audience's sense of pride in their country.

"Local" is also a relational notion. It involves drawing a boundary around a particular space, and it includes insiders and excludes outsiders. "We" are American; "they" are Canadian (while, at the same time, we may all be North American). Most people can to some extent relate to the larger global community, but for the most part, people are more acutely aware of their own national identity.

McDonald's, a corporation that has been criticized (Ritzer, 2000) for spreading American-style fast food around the globe, has had to become sensitive to local symbols and tastes. It now

incorporates these into its advertising and marketing plans and attempts to adjust its advertising strategies to fit the local cultural environment. Some call this practice "glocalization." In Israel, McDonald's serves kosher food; in Saudi Arabia, McDonald's serves *halal* (acceptable for Muslims) food and closes five times a day for Muslim prayers. In India, where almost 50 percent of the population is vegetarian, McDonald's opened its first beefless outlet serving vegetable nuggets instead of Big Macs (Friedman, 1999). In parts of London, where a large proportion of the population are immigrants from India, you can get a McChicken Korma served on *naan* bread and have Bombay spices on your fries. The recent McDonald's "I'm lovin' it" campaign used the same slogan globally but incorporated local models in ads in many countries to glocalize the campaign.

In Japan, where there are over 2,000 outlets, McDonald's has adjusted its advertising and marketing to fit into the Japanese culture. They even renamed Ronald McDonald "Donald McDonald" to make it easier for the Japanese to pronounce. In fact, McDonald's has been so successful at integrating "Makadonaldo" into the Japanese culture that the story is told of a little Japanese girl who takes a trip with her parents to Los Angeles. As they are driving around the city, the little girl points out of the car window and says excitedly to her mother, "Look, mom, they have McDonald's in this country too" (Friedman, 1999, p. 238). The little girl just assumed that McDonald's was from Japan.

WHAT IS GLOBAL?

In recent years we have witnessed the emergence of a truly "global" village. The advent of new communication technologies like the fax, cell phone, and Internet has accelerated the pace and scope of trade and the resulting spread of ideas. Previously, new products and ideas took centuries to diffuse around the world, but today it takes only seconds. With digitization and electronic communication, it becomes easier for new companies to spread the word about their products around the globe. Whereas Ford Motors took a century to establish a global presence, Starbucks, the Seattle-based coffee shop franchising firm, started venturing overseas in 1996 by setting up stores in Japan and Singapore. In just over a decade, this chain has grown from 17 locations in the United States to over 4,700 locations worldwide.

Another good example is the online bookseller Amazon.com. Relying on the World Wide Web as its sole advertising medium, it has established markets in 220 countries around the world—in just over a decade after the company was founded. Amazon.com not only operated globally, but it additionally divided its global market for books linguistically and geographically so it had the ability to respond to local tastes. U.S. titles are listed on all their Web sites—the largest selection on the U.S. site—but U.K. titles are additionally available on their site for England; German titles from German-language sites for Germany and Austria; French titles from a French-language site; Japanese titles from a Japanese-language site; and a Spanish-language site specializes in Spanish book titles.

The recent convergence of global communications and global trade has created a growing set of people worldwide who are beginning to identify with the concept of "global citizen." One of the characteristics of the global citizen is the loss of a sense of a common historical past and the emergence of a sense that the world is a single place. This phenomenon has only existed since the latter part of the twentieth century. It is in part the result of higher levels of cooperation between nations (e.g., the European Union, the British Commonwealth, and the North American

Free Trade Association). And, it has been accelerated by the introduction of new forms of communication technology and the Internet that provide for interaction and allow greater dialogue than have ever before been possible.

CULTURE SHAPES HOW WE COMMUNICATE

Sociologists and communication scholars have shown that culture shapes how we communicate. In the late 1970s, Edward T. Hall (1976) stated in his book *Beyond Culture* that it is man's culture that gives each person his or her identity. This culture is a total communication framework including words, actions, postures, gestures, tones of voice, and facial expressions. These factors form complete communication systems with meanings that can be read correctly only if one is familiar with the culture in its historical, social, and cultural context. Hall's culture-context theory suggested that people in different cultures communicate differently and in turn see the world differently. He theorized that the nature of "context" affected the entire communication process and that meaning and context were intertwined.

Hall's (1976) well-known theory of high-context and low-context communication is based on the idea that high-context cultures, like those in Asia, are cultures with extensive information networks among family, friends, and colleagues, and with close relationships. Information is transmitted either in the physical context or internalized in the person, "while very little is in the coded, explicit, part of the message" (E. T. Hall, 1976, p. 91). People in low-context cultures like the United States tend to compartmentalize their personal relationships, work, and many aspects of day-to-day life. Consequently, when they interact with others they need detailed background information (Hall & Hall, 1990). In low-context cultures like the United States, messages must be direct and clear because people spend less time together, value logic and directness, and do not focus on contextual cues. Both Hofstede (2001) and de Mooij (2005) have related Hall's theories on the communication differences between high-context and low-context countries to marketing principles and advertising strategies.

VERBAL COMMUNICATION

The Sapir-Whorf Hypothesis suggests that language is not merely a mechanism for communicating ideas but is itself a shaper of ideas (Sapir, 1921). This view has also been referred to as "linguistic determinism," which simply means that folks speaking different languages are likely to think and to perceive reality differently. For example, Whorf's work with the Hopi Indians revealed they do not conjugate verbs in terms of past, present, and future as English-language speakers do. In Hopi the single word *wari* would be used to convey both that someone is now running and that the individual ran in the past. For the Hopi, a statement of fact is considered more important than whether it is a present or past event (Sapir, 1921).

Languages also differ in their levels of formality. In Indonesia the Javanese language has six levels of formality depending on the gender and status of the speaker and listener as well as on the context of the conversation. This has a number of implications for marketing communications. For example, when television advertisers address their audiences in commercials they always use the word *anda,* meaning "you." Yet in spoken Indonesia and Javanese, this informal use of the word "you" would not be acceptable in most social situations. Some advertising critics

in Asian cultures contend that advertising reshapes social interactions by popularizing the way people communicate. Children, for example, hearing this used on TV commercials might then refer to their elders as *anda* rather than use the more formal terms of address.

Current laws regarding foreign language use in countries such as Holland, France, and Korea are designed essentially to protect the sovereignty of the local language. In Korean advertising, foreign languages must be translated into Korean, if a translation is at all possible. "Unnecessary" use of foreign languages and mixing Korean with foreign languages is prohibited. However, there is no regulatory framework spelling out exactly what is "unnecessary" use (Ambler, 2000). And a recent study (Gerritsen et al., 2000) found that while one-third of the commercials on Dutch television contain English words and phrases, Dutch consumers neither understand nor appreciate them.

While language helps to define a cultural group, the same language can also be spoken in a number of different countries. English is spoken in the United States, England, and much of Canada, Australia, and Ireland, while Spanish is spoken in Spain, Mexico, Argentina, and Peru. Often, however, different words are used for the same thing or the same words have different meanings. For example, a major paper towel producer learned the hard way that the British and American English languages are sufficiently dissimilar when it attempted to use its successful U.S. advertisement in England. The slogan was, "There is no finer paper napkin for the dinner table." The problem? In England, a napkin or "nappy" refers to a diaper.

According to Maletzke (1976), "the extent to which individuals or groups understand one another, fail to understand, or misunderstand, is determined by the degree to which the world views and frames of reference of the partners in communication overlap. The larger the common ground of *Weltanschauung* is, the simpler it is that there will be an adequate meeting-of-minds. The less common ground there is, the fewer frames of reference, then the more likely it is that there will be serious misunderstandings and non-comprehension" (p. 412).

Errors in the translation of brand names, packaging copy, and advertising messages have cost businesses millions of dollars, not to mention the damage to their credibility and reputation. It is not enough for translators merely to be familiar with the native tongue. In order to avoid translation blunders, translators must also be familiar with nuances, idioms, and slang. Consider the following:

- In Latin America, the brand name Chevy Nova (a bright shining star in General Motors's dictionary) translated into "Chevy doesn't run" in Spanish.
- One firm sold shampoo in Brazil under the name "Evitol." Little did they realize that it was claiming to be selling "dandruff."

VISUAL COMMUNICATION

Cultural studies theorists like Stuart Hall (1974) have demonstrated how advertising visuals can be polysemic, that is, an advertising visual can mean different things to different people. By deconstructing advertisements in a critical way Hall showed how readers could expose the social and political power structures in society that combine to produce the visual texts. His work is quite well known for demonstrating how the viewer can choose the "preferred" or surface meaning from a picture or could take an "oppositional" reading to uncover the hidden ideological and cultural meanings.

Barbara Stern (1992) and others have argued that to understand how an advertisement means, the audience must deconstruct the signs and symbols embedded in the advertisement's visual message, based on their cultural knowledge (Barthes, 1972; E. T. Hall, 1976; Fiske, 1989; Frith, 1998). They contend that culture shapes the way we receive messages (Barthes, 1972; E. T. Hall, 1976; Fiske, 1989; S. Hall, 1974; Williamson, 1978). Yet, while academic researchers have tried to explain how audiences deconstruct advertising based on their cultural knowledge, advertisers and marketers have tended to rely on focus groups and "share-of-mind" surveys to determine what consumers like, but seldom are they able to determine what global consumers actually "see" when they look at an ad. It is only recently that cognitive psychologists have begun to scientifically study the way culture shapes how people process visual information and how they actually see the world (Nisbett, 2003).

COGNITIVE PSYCHOLOGY AND ADVERTISING

Researchers have long known that visual messages are polysemous; that is, they can be interpreted in several different ways. Yet it is only very recently that psychologists have been able to demonstrate that culture shapes the cognitive processing of visual messages. This research is valuable for global advertisers. Richard E. Nisbett (2003) of the University of Michigan, Ann Arbor, has been using eye-tracking cameras to study how American students and Chinese students looked at visual images. Nisbett and his colleagues have been able to discern that Westerners pay more attention to the focal object in a photograph, while Asians attend more broadly to the overall surroundings and to the relations between the object and the field. The University of Michigan research team asked 25 Americans of European descent and 27 native Chinese to view a series of pictures, while they recorded what the participants' eyes focused on. The Americans looked more at the foreground object, such as a tiger in the center of the photo, while the Chinese spent more time studying the background and taking in the whole picture. In the split second after each participant first saw the picture, the Americans looked at the focal object in the picture 20 percent longer than the Chinese, and their eyes darted around much less than the Chinese. When asked to describe what they each saw, the Americans noted "the tiger" while the Chinese were more concerned with the relationship between the foreground and the background.

Ji, Schwarz, and Nisbett (2000) found that when asked to describe what they saw in visuals, Asians paid more attention to the social world than did Westerners. Cohen and Gunz (2002) indicated that Asians had a more holistic view of things and were more concerned with other people compared to North Americans. In a study of photographs, Nisbett (2003) asked Japanese students and American students what they recalled after seeing eight underwater vignettes that had one or more "focal" fish in the foreground and contained background objects such as plants, rocks, or bubbles. The result showed that the Japanese made references to background elements and constructed relationships involving the fish with background objects far more than the U.S. students. Nisbett (2003) concluded, "Asians view the world through a wide-angle lens, whereas Westerners have tunnel vision" (p. 89). In sum, he found that Easterners tended to pay more attention to the field (the environment) than did Westerners, who tended to focus on the central object.

In addition, cognitive psychologists have found that people who grew up in the United States tended to focus on solving specific problems, whereas people raised in China tended to be more

holistic—trying to understand the context of the problem. One explanation for these findings was that Easterners live in a more socially complicated world and have to pay more attention to the context of a situation. In the West, people tend to focus on a task and getting the job done. Nisbett (2003) traced the reasons that culture shapes perception back at least 2,000 years. Easterners, he found, appear to think more "holistically," paying greater attention to context and relationship, relying more on experience-based knowledge than on abstract logic and showing more tolerance for contradiction. Westerners are more "analytic" in their thinking, tending to detach objects from their context, to avoid contradictions, and to rely more heavily on formal logic. According to Nisbett (2003), East-West differences are a result of differing social and religious practices, different languages, and even dissimilar geography.

Historically, the ancient Chinese viewed the world in holistic terms: They saw the relationships between events and regarded the world as complex and highly changeable and its components as interrelated. They perceived reality as a series of events moving in cycles between extremes and they felt that control over events required coordination with others. Western thought is based on Greek philosophy. Thus, like the ancient Greeks, Westerners see the world in analytic atomistic terms; they see objects as discrete and separate from their environments; they see events as moving in linear fashion when they move at all; and they feel themselves to be personally in control of events even when they are not. These ideas are not new, but the science used to measure the differences in perception is what sets the work of Nisbett and his colleagues apart from earlier sociologists and cultural anthropologists.

READING ADS

In a globalized world, where a good picture is worth a thousand words, the trend in advertising—worldwide—has been to avoid words (that can carry cultural content) and use visuals to carry the message. As William Ryan notes:

> It's no surprise that art work—usually photography—dominates most communications. The fact is we are visually predisposed, and photography carries the weight and power of most communications—in everything from websites to magazines, identity materials to advertising. (Ryan & Conover, 2004, p. 19)

Since the average magazine reader spends only about four or five seconds on each page and a TV viewer sees 30-second commercials, the trend in advertising has been toward running advertising campaigns that are predominately visual. But research has shown that culture shapes the way consumers view advertising messages.

To demonstrate how this works, researchers in Singapore (Frith & Karan, 2008) used the photo from a global ad to see how students in India, Singapore, and the United States "read" the advertisement (see Figure 2.1). While the original ad had the advertiser's name on the lower right-hand side, the researchers removed the logo so that respondents would describe what they saw in the picture.

The researchers (Frith & Karan, 2008) were interested to see how consumers in different cultures described an ambiguous picture in an ad (see Figure 2.2). The polysemic nature of this photograph allows for much imaginative writing: Why is the girl lying down? Where is she? What is the "story" behind the photo? Would the American students describe the foreground object,

Figure 2.1: Original Furla ad

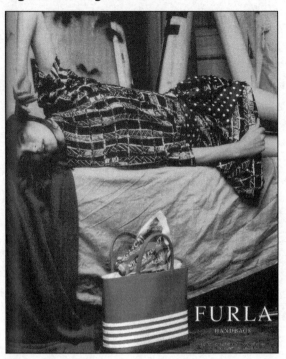

Figure 2.2: Woman and handbag, from the Furla ad

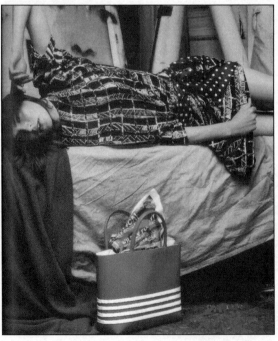

the purse? Would the Asian students attend more broadly to the overall surroundings, the context (the room, the background)?

THREE READINGS

Indians

The majority of Indian students who looked at the picture in Figure 2.2 wrote stories about the woman on the bed. Only a few mentioned the red handbag in the foreground. When analyzing the visual they were most imaginative. They tended to construct narratives about the woman, saying she was "tired" or was "resting," and they wove imaginative stories around her life, such as, "she is tired from shopping for her family," or "she has been doing her duty for her family by going to the store."

Some students constructed stories using contextual details. A few said she might be posing for a painter. One said, "she is dreaming of owning the red bag in the foreground." The Indian students did not mention the background or the colors of the walls, though some mentioned the messy sheets and overall untidy environment.

Singaporeans

The Singaporeans were more interested in the details in the photo in Figure 2.2 than were the Indian students. The Singaporean students noted things like the patterns and prints on the dress worn by the woman ("her skirt has polka dots"). They also described the background such as the colors in the photo. Many noted the contrast between the dull blue-gray background and the bright red bag in the foreground. One said, the "blue color of the background makes her seem depressed."

A surprising number of the Singaporeans mentioned the details of the room, including noting the eyes and faces on the wall behind the model, "behind the girl is a picture with a woman's face" or "I see faces on the wall."

Many noted the context, "the room looks too small," or "it's not her room," or she's in a "dilapidated house." Some described the mood of the woman, "she is a lazy person," or "she seems depressed." While others noted small details like, "she's digging something out her ear," or "she's shutting her ear," "she is in an ugly/weird pose." Some thought she was a model, "the woman is seducing an artist in his studio," or "a woman flirting with a photographer." The Singaporeans were much more apt to see sexual innuendo in the visual than were the Indians. A number noted the model was tugging at her skirt, and they viewed her as sensual, and coquettish, and could see lust and sex appeal in the picture.

Americans

The Americans generally listed exactly what they saw in Figure 2.2: "I see a woman lying on a bed in a trashy house, there is a red shopping bag on the floor in front of her." The Americans almost never described the room, the messy sheets, or the colors on the walls. None of the Americans mentioned the faces on the background walls or the patterns on the model's dress.

There were some creative answers like "she is a stressed-out college student who has just failed a test and is trying to think herself out of this jam." Another student asked, "is her hand motioning and acting like a gun?" Generally the responses from the Americans were direct and straightforward. There were some sexual responses, such as, "she's waiting for more."

CULTURE SHAPES HOW WE READ AN AD

This study (Frith & Karan, 2008) shows that culture shapes how we view the visual messages in an ad. For the most part, the Americans described what they saw precisely and clearly, while the Indians embellished what they saw and used the objects in the photo to create stories or narratives. The Singaporeans looked at the details in the photograph and studied the picture in greater depth than either the Indians or the Americans. It seems that culture shapes what we see, and differing educational systems, history, geography, and culture all help to shape our perceptions.

In terms of standardized global advertisement, we can conclude that a standard globalized ad may elicit different responses in different parts of the world. Thus, the lone cowboy in Marlboro's worldwide campaign may not be as resonant to readers in, say, India, for example, as it is in the United States. Even theories that suggest all audiences like to see the "product as hero" may not hold true worldwide. Featuring the product as the central focus may be successful in some Western cultures, but in some other cultures, photos suggesting romantic themes of love, drama, and human interaction may prove to be the most captivating.

Also, humor is culturally constructed. What is funny in one society may not be funny in another. Apple ran a series of highly successful humorous, "Hi, I'm a Mac. Hi, I'm a PC" commercials in the United States. In the American ads, a nerdy PC guy keeps getting trumped by his hip Mac counterpart who uses witty lines to demonstrate how Macs are better (see Figure 2.3).

Figure 2.3: PC vs. Mac ad in the United States

But when advertisers attempted to use the Apple ads in the rest of the world they ran into problems. In Japan, for example, the commercials were reshot using a local comedy team, the Rahmens. While Apple did adjust the scripts, nevertheless, the Japanese audiences disliked the ads because in Japanese culture

it is rude to brag about one's strengths and to disparage the compe-
tition. In addition, the Japanese viewers thought the Mac guy was
wearing low-end brand clothing, while they felt the PC guy (who
was supposed to look like a nerd) was actually quite well dressed. In
terms of body language, the viewers thought that Mac looked embar-
rassed while PC looked stylish. So all in all even with Apple's efforts
to localize the humor, the commercials were finally withdrawn in
Japan (see Figure 2.4).

Figure 2.4: PC vs. Mac in Japan

A GLOBAL WORLD WITH LOCAL SENSITIVITIES

Increasingly, global advertisers are learning that the global strategies which were common currency
in the 1990s have run their course. There are many stories about companies that have blundered
in China. In 2003, Toyota ran a television commercial that featured a Toyota Prado towing a
broken-down Chinese military vehicle past two bowing stone Chinese lions. Historically, these
stone sculptures have been revered as a symbol of Chinese power. The TV network received so
many complaints about the commercial that they banned it from the air. The Toyota company
had to publicly apologize to the Chinese viewing community. To make things worse, it turns out
that the marketing department of Prado had authorized the Chinese translation to be *Badao,*
using characters that mean "high handed" or "domineering" and could also be used in the word
"hegemony." This was not a very auspicious name for a Japanese company to use in China, where
sensitivities to the Japanese occupation still run quite high.

McDonald's also had to withdraw a TV commercial in China following complaints. The
commercial, which was meant to be humorous, showed a Chinese man on his knees begging
for a discount from a store clerk. The message that the food giant was trying to get across was
that they offered cheap meals year-round, not just on certain holidays. However, the Chinese
consumers felt that the images in the commercial attacked the Chinese people's dignity. In China,
begging is considered to be humiliating.

Understanding cultural values is the key to success in global marketing and advertising.
Today, this involves much more that merely adding a few token changes in a global campaign
or shooting the commercial with local actors or actresses. Today's consumers are able to read
subtleties in tone of voice, body language, as well as cultural symbols in ads. Thus advertisers
have to understand the fine points of each culture in order to be effective and not to offend.

REFERENCES

Ambler, Chris. (2000, July 26). Restrictions on the use of English paradoxical to some firms. *Korea Herald,* p. 1.

Barthes, R. (1972). *Mythologie.* New York: Hill and Wang.

Cohen, D., & Gunz, A. (2002). *As seen by the other . . . : The self from the "outside in" and the "inside out" in the
 memories and emotional perceptions of Easterners and Westerners.* Unpublished manuscript, University
 of Illinois.

de Mooij, M. (2005). *Global marketing and advertising: Understanding cultural paradoxes* (2nd ed.). London: Sage.

Featherstone, Mike. (1995). *Undoing culture: Globalization, postmodernism and identity.* Thousand Oaks, CA: Sage.

Fiske, J. (1989). *Reading the popular.* Boston: Unwin Hyman.

Friedman, Thomas. (1999). *The Lexus and the olive tree.* New York: HarperCollins.

Frith, K. T. (1998). *Undressing the ad: Reading culture in advertising.* New York: Peter Lang.

Frith, Katherine T., & Karan, Kavita. (2008). *Commercializing Women: Images of Asian Women in the Media.* Cresskill, NJ: Hampton Press.

Gerritsen, M., Korzilius, H., can Meurs, F., & Gijsbers, I. (2000). English in Dutch commercials: Not understood and not appreciated. *Journal of Advertising Research, 40*(4), 17–29.

Hall, Edward T. (1966). *The hidden dimension.* Garden City, NY: Anchor Press/Doubleday.

Hall, Edward T. (1976). *Beyond culture.* New York: Anchor Books.

Hall, Edward T., & Hall, Mildred Reed. (1990). *Understanding cultural differences.* Yarmouth, ME: Intercultural Press.

Hall, Stuart. (1974). *Encoding and decoding: Education and culture.* Birmingham, England: Centre for Cultural Studies.

Hall, Stuart. (1991). The local and the global: Globalization and ethnicity. In A. D. King (Ed.), *Culture, globalization and the world-system: Contemporary conditions for the representation of identity* (pp. 19–39). Binghamton, NY: SUNY.

Hoebel, Adamson. (1960). *Man, culture and society.* New York: Oxford University Press.

Hofstede, G. H. (2001). *Culture's consequences* (2nd ed.). London: Sage.

Ji, L., Schwarz, N., & Nisbett, R. E. (2000). Culture, autobiographic memory, and social comparison: Measurement issues in cross-cultural studies. *Personality and Social Psychology Bulletin, 26,* 585–593.

Kroeber A. L., & Kluckhohn, C. (1952). Culture: A critical review of concepts and definitions. *Papers of the Peabody Museum of American Archeology and Ethnology, 41*(1).

Lash, Scott, & Urry, John. (1994). *Economies of signs and space.* London: Sage.

Maletzke, G. (1976). Intercultural and international communication. In H. Fischer & J. Merritt (Eds.), *International and intercultural communication.* New York: Hastings House.

Nisbett, Richard E. (2003). *The geography of thought: How Asians and Westerners think differently . . . and why.* New York: Free Press.

Ritzer, George. (2000). *The McDonaldization of society: An investigation into the changing character of contemporary society* (3rd ed.). Thousand Oaks, CA: Pine Forge.

Ryan, William, & Conover, Theodore. (2004). *Graphic communication today.* Singapore: Thompson/Delmar Learning.

Sapir, E. (1921). *An introduction to the study of speech.* New York: Harcourt, Brace and World.

Stern, Barbara. (1992). Feminist literary theory and advertising research: A new "reading" of the text and the consumer. *Journal of Current Issues and Research in Advertising, 14*(1), 9–21.

Taylor, Edward. (1871). *Primitive cultures.* London: John Murray.

Terpstra, Vern, & David, Kenneth. (1991). *The cultural environment of international business* (2nd ed.). Cincinnati, OH: Southwestern.

Williamson, J. (1978). *Decoding advertisements: Ideology and meaning in advertising.* London: Marion Boyers.

Advertising and Economic Issues

Having devoted a good deal of attention to culture and the relationship between advertising and culture, we now turn our attention to how advertising influences, and is influenced by, the economic environment of a country.

ADVERTISING'S INFLUENCE ON THE ECONOMIC ENVIRONMENT

A market's economy and its advertising are inextricably linked. First, we will address the impact that advertising has on economic systems. Many have argued that advertising drives the economy. By helping to stimulate and maintain consumer demand, advertising helps to sustain employment and income. William Arens and David Schaefer (2007) note that when business cycles move upward, advertising contributes to the increase. When business cycles are down, advertising may act as a stabilizing force by encouraging more buying. In developed markets, advertising expenditures usually account for between 2 and 3 percent of the gross domestic product (GDP), whereas in less developed countries, they generally account for about 1 percent or even less. Similarly, per capita advertising expenditures are lower in less developed markets than in more economically advanced countries. In the United States, advertising expenditures amount to US$876.59 for every man, woman, and child—the highest per capita ad spending in the world. Per capita ad expenditures in Japan are US$397.91, and in the United Kingdom they are US$329.21. For purposes of comparison, expenditures in Spain are US$154.40, while in China they are just US$14.00 (Arens & Schaefer, 2007, p. 28). Indeed, it has been argued that the level of advertising investment in a country is directly proportional to its standard of living.

THE INFLUENCE OF THE ECONOMIC ENVIRONMENT
ON THE BUSINESS OF ADVERTISING

While advertising influences the economy, the economy has a direct impact on the business of advertising. Marketing activity in general, and advertising in particular, is heavily influenced by the state of the economy. Michael Belch and George Belch (1990) note that "attention must be given to macroeconomic conditions that influence the state of the economy such as changes in gross national product, whether the economy is in a period of inflation or recession, interest rates and unemployment levels. Micro economic trends, such as consumer income, savings, debt, and expenditure patterns are also important, as a consumer's ability to buy is a function of many factors including changes in real income, disposable and discretionary income, savings and debt levels" (p. 68). Changes in economic conditions have a direct impact on an advertiser's overall promotional expenditures, and clearly the economy also influences target audience selection, strategy development, and even media planning.

The Macroeconomic Influence

First, we will address a macroeconomic condition, the current economic health of a market. During periods of economic recession, many businesses choose to cut their advertising budgets, which are often perceived as nonessential. When this occurs, there is a ripple effect. The economic downturn in the United States, which began in late 2007, indicated times would be tight for many industries. Citing a Worldwide Partners survey of ad agency CEOs, *Advertising Age* noted about half (46 percent) reported that their clients had cut ad spending within the previous year. Just 1 in 10 said their clients were putting more money into marketing ("Rocky Road Ahead," 2008). Procter & Gamble Co., the world's biggest advertiser, slashed their ad spending by double digits in just one quarter of 2008. And, many of P & G's biggest global rivals, including Unilever, L'Oreal, and Johnson & Johnson, also cut U.S. spending according to TNS Media Intelligence, though not nearly as sharply or broadly (Neff, 2008). An Internet poll of consumers by WWP Group-owned Lightspeed Research for *Advertising Age* found that nearly 80 percent of respondents had changed their buying behavior in the previous few weeks, hitting product categories at all price points. Some 70 percent of respondents said they had curtailed overall spending. In particular, consumers appeared to be putting big-ticket purchases on hold. Only one-tenth of respondents had purchased a car in the prior three months—or planned on purchasing one in the next three (Creamer, 2008). The automotive business was bearing the brunt of consumer anxieties. After many years as one of the top three global marketers, General Motors dropped to No. 4 based on 2007 ad spending. During that year, General Motors was the only one of the Top 10 Global Marketers to cut ad spending, by 0.9 percent to $3.3 billion (Wentz, 2008). And, when the big auto companies cut back on advertising because sales were down, the local auto dealerships followed suit.

Such caution on the part of advertisers has a direct impact on a medium's bottom line. As a result of the economic downturn, in just the first three months of 2009, gross ad pages in magazines dropped a staggering 22 percent—and that coming off a dismal 2008. Conde Nast has folded *Domino*, Meredith has folded *Country Home*, Ziff-Davis has folded *PC Magazine*, Hearst has folded *Cosmo Girl* and *O at Home*, the *New York Times* has folded *Play*, and Hachette Filipacchi has folded *Home*. *Playgirl* and *Radar* are both gone. The formerly weekly, formerly

biweekly *U.S. News* is now a monthly. And, *TV Guide* magazine, once a 17 million-circulation goldmine, was sold in October 2008 to OpenGate Capital for $1, or $2 less than a copy at the supermarket checkout (Garfield, 2009).

Neither are the broadcast media immune. Broadcast stations are feeling the pain. Bernstein Research predicts a 20 percent to 30 percent drop in 2009 TV station ad revenue. Stations' share of TV ad dollars, according to TNS Media Intelligence, dropped to 26 percent in 2007 from 34 percent in 2000. And the TV networks are also experiencing an advertiser exodus. More than 70 percent reported having slashed their 2009 budgets, and 6 percent more said the cuts were on the way (Garfield, 2009).

But as the major corporations squeezed and streamlined their budgets in response to a cooling economy, they were wreaking havoc on more than just the media outlets in which they advertise. The carnage spread to the agencies that create and deliver the messages, forcing them to make cutbacks of their own. The slowdown of the economy resulted in agencies laying off staffers in record numbers. *Advertising Age* reported that according to figures provided by the Bureau of Labor Statistics, the U.S. advertising and media industry slashed 65,100 jobs as a result of the economic downturns that began in December 2007 and continued throughout 2008. More specifically, ad agencies cut 24,100 jobs and media companies eliminated the other 41,000 jobs. In percentage terms, the ad industry was faring worse than the overall U.S. employment market, which has lost 2.6 percent of jobs since the start of the recession. As of December 2008, the U.S. ad industry alone employed 1.59 million people (Johnson, 2009).

A weak economic situation in the domestic market may encourage marketers to look abroad for profits. The disastrous jolt to the U.S. financial markets put pressure on multinational marketers to do well in emerging markets such as China and India to offset the sluggish U.S. economy. Marketers are looking to Chinese and Indian consumers to purchase everything from packaged goods to durables and

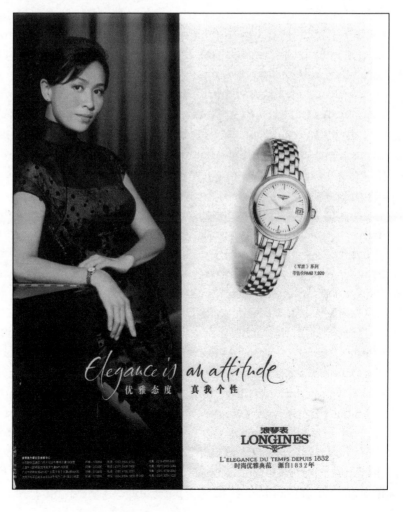

Figure 3.1: Watch manufacturer Longines targets upscale Chinese consumers

even to luxury brands. For example, American luxury marketer Coach has opened dozens of new stores in China, Hong Kong, and Macau and invested in advertising and created product lines specifically for the Chinese market, such as a special handbag to celebrate *Elle* magazine's twentieth anniversary in China. Indeed, mainland China is expected for become a significant market for luxury brands over the next several years. Experts note that there are plenty of rich Asians ready to snap up these luxury goods. Longines is but one exclusive watch manufacturer targeting Chinese consumers (see Figure 3.1). In 2007, China had 800,000 millionaires, including 250 people worth $1 billion or more. India, home to a rising middle class, also has more than 100,000 millionaires and is adding to that number faster than any other country in the world (Madden & Hall, 2008).

The Microeconomic Influence

Turning to microeconomic variables in analyzing a market's potential to purchase, marketers often examine its economic stage of development. Classifications of economic systems vary depending on the originator of the classification system as well as its intended use. The following system is commonly employed in the marketing literature.

Less-developed countries represent nearly three-quarters of the world's population. Included here are countries plagued by drought, long-term civil war, or large-scale breakdown of the rule of law. These economies lack nearly all the resources necessary for development, such as capital, infrastructure, political stability, and a trained workforce. Products sold in these countries are generally business goods used for the building of infrastructure (e.g., heavy machinery) or agriculture rather than consumer goods.

Newly industrialized countries include those nations whose economies are defined by change. Rapid economic growth in countries such as Malaysia, Taiwan, and South Korea, and more recently China and India, has created a new middle class of consumers with significantly different aspirations than their counterparts of a mere decade ago. These countries represent a growing number of consumers who have not only the need for but also the ability to purchase many consumer products.

Highly industrialized countries are those with mature economies. They are characterized by high levels of affluence, as measured by per capita income, distribution of wealth, and standard of living. Consumers in these countries typically have the capacity to purchase goods offered by advertisers. These countries also have well-developed infrastructures—communications, transportation, and financial and distribution networks necessary to conduct business effectively (O'Guinn, Allen, & Semenik, 2003).

Historically, the highly industrialized economies represented the greatest marketing opportunities for corporations. However, such markets also tend to have aging and even shrinking population bases, and as a result, markets for many goods and services may already be saturated. Less developed nations tend to have youthful and expanding populations and therefore offer potentially greater growth opportunities. While consumers in the United States and Europe are both graying, Europe is getting older even faster. According to United Nations forecasts, by 2050 the average age will go up from 39 to 48.5 in the European Union, and from 35.6 to 41.3 in the United States (De La Dehesa, 2004). Reports reveal that the dependency ratio—defined as the number of people over 65 as a percentage of the number of people 20 to 64 years old—will

rise by 2050 to 37 percent from 22 percent in the United States, but it will jump to 52 percent from 26 percent in the European Union (Brooks, 2005). This reflects, in part, the increase in life expectancy as a result of higher living standards and dramatic progress in the medical sciences. However, in many countries, it also reflects a fall in birthrates. As recently as the mid-1960s, every developed country was at or above the 2.1 children-per-mother replacement rate needed to maintain a stable population from one generation to the next. Today, every developed country is below it and some are far below it. In Germany, the fertility rate is 1.3 and in southern and central Europe, 1.2. Only the United States remains near the replacement rate—but just barely (Jackson, 2003).

These demographic trends have caused many advertisers to look to developing countries for their larger and more youthful markets. It is estimated that by the year 2050, the human population of the earth will be 9.07 billion (9,070 million). Of those, 62 percent will live in Africa, South Asia, and East Asia, and the combined populations of these three regions will by then be equal to the entire population of the world today (Dorling, Newman, & Barford, 2008). As Table 3.1 reveals, a significantly larger percentage of the population in many lower income countries falls into the 0–14 age grouping than in the higher income countries. However, even within these groupings, variation exists. Approximately one-third of the population in both the Philippines and India are currently under 14 years of age. In contrast, less than one-fifth of China's population are currently 14 years or younger. In fifteen to twenty years, these citizens will be in their late 20s to late 30s, the prime earning and spending years. These younger consumers are more likely to make large purchases such as a car, furniture, and appliances.

Table 3.1: Economic Development and Age Structure (percentage between 0–14 years)

LOW-INCOME ECONOMIES		UPPER-MIDDLE-INCOME ECONOMIES	
Afghanistan	46.9%	Malaysia	32.9%
Nigeria	43.3%	Venezuela	32.3%
Pakistan	41.1%	Brazil	27.3%
Vietnam	30.5%	Poland	17.0%
LOWER-MIDDLE-INCOME ECONOMIES		**HIGH-INCOME ECONOMIES**	
Philippines	35.5%	United States	20.9%
India	32.6%	France	18.7%
Algeria	32.3%	Germany	14.8%
China	19.5%	Japan	14.0%

Source: World Consumer Lifestyles Databook *for 2005. (2007).* Key Trends *(4th ed.).* United Nations Economic and Social Commission for Asia and the Pacific: *United Nations Statistical Yearbook* for Asia and the Pacific.

THE IMPACT OF THE CONSUMER ON THE INTERNATIONAL MARKETPLACE

Another appealing trend to international marketers is that many of these developing markets have a growing "consumer class"—defined as individuals whose purchasing power parity in local currency is more than US$7,000 a year (roughly the poverty level in Western Europe). The consumer

Figure 3.2: P & G targets Chinese consumers with Head & Shoulders ad

清凉挡不住　无屑我更酷

class now includes more than 1.7 billion people. High percentages in North America, Western Europe, and Japan (85 to 90 percent) are no surprise. But nearly half of the consumer class is now in developing nations. India and China alone account for 362 million of these consumers, more than all of Western Europe combined (Knickerbocker, 2004). Zheng Xinli, vice minister of the Communist Party's Central Policy Research Office, noted that 55 percent of China's population will be middle class by 2020, with 78 percent of city dwellers and 30 percent of those in rural areas reaching that status ("Chinese Consumers in 2020," 2009). As the country's middle class multiplies, demand for all varieties of goods skyrockets. "First they want new homes with electricity—witness the quadrupling prices since 2000 of steel, oil and copper. Then, as incomes rise, so does demand for everything from toothpaste to telephones, from automobiles to airplanes" (Gimbel, 2008, p. 156). Consumption in China's largest and most-developed markets, called first- and second-tier cities, has shown few signs of slowing in recent years, and multinational mar-

Figure 3.3: India's Tata introduces the world's cheapest car

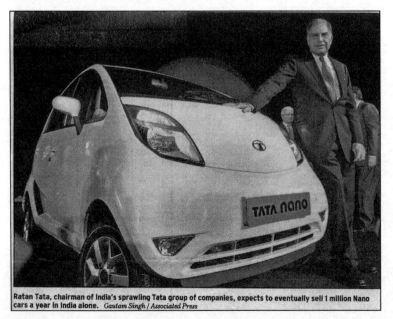

Ratan Tata, chairman of India's sprawling Tata group of companies, expects to eventually sell 1 million Nano cars a year in India alone. *Gautam Singh / Associated Press*

keters such as Procter & Gamble and Unilever are reaching out to hundreds of smaller cities and towns across China. Figure 3.2 presents a P & G Head & Shoulders shampoo advertisement targeting Chinese consumers. Predictions suggest that China will overtake Germany in 2010 to become the world's third largest ad market, trailing only the United States and Japan (Madden, 2008).

Table 3.2 reveals the varying degrees to which consumers possess goods in both developed and developing countries. As can be seen from the figures, there is tremendous variation in the ownership of durable goods. For example, automobile ownership ranges from 93 cars for every 100 households in the United States to less than 1 car per 100 households in India. For years, most cars in India were sold to state institutions and companies or ended up in taxi fleets. Until recently, cars were out of reach of ordinary Indians. That will soon change. India's Tata Motors has just introduced the Nano, a pint-sized vehicle designed to make car ownership accessible to millions (see Figure 3.3). The Nano—with a starting retail price of US$2,233—is a stripped down car: it is 10.2 feet long, with one windshield wiper, no radio, and hand-crank windows. The four-seater, with its 623cc rear engine, can travel up to 65 miles an hour and gets 55.5 miles to the gallon. The Nano does not have air bags or anti-lock brakes, neither of which is required in India. Tata says that the car emits less carbon dioxide than most motorbikes. The company expects to eventually sell 1 million Nanos a year in India alone, and has pledged to go to Europe and America with safer, cleaner but still ultracheap Nanos for the developed world (Kinetz, 2009).

Table 3.2: Possession of Goods (per 100 Households)

	SHOWER	WASHING MACHINE	REFRIGERATOR	AUTO	PHONE	COMPUTER
Argentina	93.6	49.5	83.8	58.9	69.8	26.6
Canada	99.6	85.7	99.1	86.4	88.7	59.1
China	42.7	2.6	6.7	3.0	27.1	15.7
Hong Kong	97.5	95.7	97.4	74.6	96.5	28.5
India	42.7	4.9	14.7	0.6	17.3	1.0
Japan	99.7	99.3	97.7	81.8	87.4	49.1
Mexico	68.7	41.0	68.7	23.0	31.0	9.2
Philippines	84.2	8.1	43.8	7.8	12.2	3.1
Singapore	99.6	95.4	99.4	43.4	96.7	63.7
South Africa	59.8	26.3	80.4	9.4	29.3	8.9
Thailand	67.0	5.0	70.4	35.4	29.7	9.8
United States	99.7	82.3	99.5	93.2	85.9	72.7
Venezuela	92.3	39.6	83.1	47.5	42.7	13.0
Vietnam	37.1	2.5	19.1	1.8	7.8	0.7

Source: International Marketing Data and Statistics. (2006). Euromonitor

THE ROLE OF PER CAPITA INCOME

A statistic commonly used to describe the economic condition of a country is per capita income, a widely accepted indicator of a country's economic development as well as the potential purchasing power of its individuals. Per capita income is often stated in relation to a country's total national income, or gross national product (GNP). The World Bank Atlas method of calculating gross national product (also known as GNI for gross national income) per capita converts national currency units to dollars at prevailing exchange rates, adjusted for inflation and averaged over three years. Because those rates do not always reflect differences in prices, purchasing power parities are united to convert GNP per capita estimates into international dollars. An international dollar buys the same amount of goods and services in a country's domestic market as US$1 would buy in the United States. Table 3.3 shows the wide range in the per capita income figures (both GNI per capita and purchasing power parity) between several nations. For example, Switzerland has a GNI per capita of US$59,880, while Ethiopia has a GNI per capita of little more than US$220. Statistics show that 60 percent of the world's population receive only 6 percent of the world's income. The high-income nations contain 17 percent of the world's population, yet receive 78 percent of world income (Ausaid, 2001).

Table 3.3: GNI per Capita and Purchasing Power Parity

COUNTRY	GNI PER CAPITA	PURCHASING POWER PARITY
Switzerland	$59,880	$43,870
United States	46,040	45,850
Germany	38,860	33,530
Japan	37,670	34,600
Singapore	32,470	48,520
India	950	2,740
Bangladesh	470	1,340
Uganda	340	920
Niger	280	630
Ethiopia	220	780

Source: Atlas of Global Development. (2009). Pp. 128–129.

Based on its GNI per capita, every economy is classified by the World Bank as *low income* (US$935 or less), *lower-middle income* (US$936 to US$3,705), *upper-middle income* (US$3,706 to US$11,455), and *high income* (US$11,456 or more). Low-income and middle-income economies are sometimes referred to as "developing economies." The use of the term is convenient, but it is not intended to imply that all economies in the group are experiencing similar development or that other economies have reached some preferred or final stage of development. Table 3.4 presents the classification of all World Bank member countries (185) and all other economies with populations of more than 30,000 (209 total) by income.

Table 3.4: World Economies by Income Classification

LOW-INCOME ECONOMIES (49)		
Afghanistan	Haiti	Rwanda
Bangladesh	Kenya	São Tomé and Príncipe
Benin	Korea, Dem. Rep.	Senegal
Burkina Faso	Kyrgyz Republic	Sierra Leone
Burundi	Lao PDR	Solomon Islands
Cambodia	Liberia	Somalia
Central African Republic	Madagascar	Tajikistan
Chad	Malawi	Tanzania
Comoros	Mali	Togo
Congo, Dem. Rep.	Mauritania	Uganda
Cote d'Ivoire	Mozambique	Uzbekistan
Eritrea	Myanmar	Vietnam
Ethiopia	Nepal	Yemen, Rep.
Gambia, The	Niger	Zambia
Ghana	Nigeria	Zimbabwe
Guinea	Pakistan	
Guinea-Bissau	Papua New Guinea	
LOWER-MIDDLE-INCOME ECONOMIES (54)		
Albania	Georgia	Namibia
Algeria	Guatemala	Nicaragua
Angola	Guyana	Paraguay
Armenia	Honduras	Peru
Azerbaijan	India	Philippines
Bhutan	Indonesia	Samoa
Bolivia	Iran, Islamic Rep.	Sri Lanka
Bosnia and Herzegovina	Iraq	Sudan
Cameroon	Jordan	Swaziland
Cape Verde	Kiribati	Syrian Arab Republic
China	Lesotho	Thailand
Colombia	Macedonia, FYR	Timor-Leste
Congo, Rep.	Maldives	Tonga
Djibouti	Marshall Islands	Tunisia
Dominican Republic	Micronesia, Fed. Sts.	Turkmenistan
Ecuador	Moldova	Ukraine
Egypt, Arab Rep.	Mongolia	Vanuatu
El Salvador	Morocco	West Bank and Gaza

(Table continued on next page)

UPPER-MIDDLE-INCOME ECONOMIES (41)

American Samoa	Grenada	Poland
Argentina	Jamaica	Romania
Belarus	Kazakhstan	Russian Federation
Belize	Latvia	Serbia
Botswana	Lebanon	Seychelles
Brazil	Libya	South Africa
Bulgaria	Lithuania	St. Kitts and Nevis
Chile	Malaysia	St. Lucia
Costa Rica	Mauritius	St. Vincent and Grenadines
Croatia	Mayotte	Suriname
Cuba	Mexico	Turkey
Dominica	Montenegro	Uruguay
Fiji	Palau	Venezuela, RB
Gabon	Panama	

HIGH-INCOME ECONOMIES (65)

Andorra	French Polynesia	New Caledonia
Antigua and Barbuda	Germany	New Zealand
Aruba	Greece	Northern Mariana Islands
Australia	Greenland	Norway
Austria	Guam	Oman
Bahamas, The	Hong Kong, China	Portugal
Bahrain	Hungary	Puerto Rico
Barbados	Iceland	Qatar
Belgium	Ireland	San Marino
Bermuda	Isle of Man	Saudi Arabia
Brunei Darussalam	Israel	Singapore
Canada	Italy	Slovak Republic
Cayman Islands	Japan	Slovenia
Channel Islands	Korea, Rep.	Spain
Cyprus	Kuwait	Sweden
Czech Republic	Liechtenstein	Switzerland
Denmark	Luxembourg	Trinidad and Tobago
Estonia	Macao, China	United Arab Emirates
Equatorial Guinea	Malta	United Kingdom
Faeroe Islands	Monaco	United States
Finland	Netherlands	Virgin Islands (U.S.)
France	Netherlands Antilles	

Source: (2009). http://web.worldbank.org/wbsite/external/datastatistics

Note that per capita figures are averages and give no indication of income distribution. Typically, the more developed the country, the more even the distribution of income. In many developing countries, however, there is a bimodal distribution income—a very rich segment of the population and a very large, very poor segment with no middle class. The following serves as a useful classification system.

Very low family incomes are subsistence economies characterized by rural populations whose consumption relies on personal output or barter. Some urban centers may provide markets.

Mostly low family incomes are economies that are beginning to industrialize. Most goods are produced domestically.

Very low, very high family incomes are economies that exhibit strongly bimodal income distributions. The majority of the population may live barely above the subsistence level, while a minority provides a strong market for imported or luxury items. The affluent are truly affluent.

Low, medium, and high family incomes are economies in which industrialization has produced an emerging middle class with increasing disposable income. However, due to traditional social class barriers, the very-low-income and very-high-income classes tend to remain.

Mostly medium family incomes are advanced industrial economies with institutions and politics that reduce extremes in income distribution. The result is a large and comfortable middle class able to purchase a wide array of both domestic and imported products and services (Kotler, 2000, p. 146).

THE INFLUENCE OF HOUSEHOLD INCOME

Household income may be a more telling statistic than per capita income. In many developing countries, extended families, rather than nuclear families, are the norm. For example, in Latin America the typical household includes aunts, uncles, cousins, grandparents, and sometimes even great-grandparents. Several family members may be wage earners, directly impacting the buying power of the family unit. And while the nuclear family is still the norm in much of the United States, today that unit typically includes two wage earners. As a result, international marketers often pair household income with household size in analyzing a market's willingness and ability to spend.

URBANIZATION'S INFLUENCE ON THE ECONOMIC ENVIRONMENT

One of the most telling economic indicators is the degree to which a country is urbanized. Table 3.5 shows the degree of urbanization for the world's four broad economic groupings. The averages for these groupings reveal a strong correlation between degree of urbanization and level of economic development. However, even within these broad economic groupings, there is significant variation. Typically, the more urbanized markets tend to be more appealing to marketers. Developing countries are generally much less urbanized, and as a result they tend to be less attractive markets, particularly for consumer goods. Even less developed countries, however, may contain sizable pockets of high-income consumers.

Table 3.5: Economic Development and Urban Population (as percentage of total population)

LOW-INCOME ECONOMIES	UPPER-MIDDLE-INCOME ECONOMIES
Nigeria—46.7%	Argentina—90.2%
Pakistan—39.4%	Russia—78.8%
Vietnam—20.7%	Mexico—75.3%
Cambodia—20.3	Malaysia—59.3%
LOWER-MIDDLE ECONOMIES	**HIGH-INCOME ECONOMIES**
Peru—74.0%	Hong Kong—100%
China—34.8%	United Kingdom—89.7%
India—30.0%	United States—78.1%
Thailand—23.4%	France—78.1%

Source: *World Consumer Lifestyles Databook for 2005. (2005) Euromonitor International.* United Nations Economic and Social Commission for Asia and the Pacific: United Nations Statistical Yearbook for Asia and the Pacific.

THE POSITIVE AND THE NEGATIVE OF ADVERTISING

Some economists view advertising in a positive light, arguing that it encourages consumption and thereby fosters economic growth. Not only does it inform consumers about available goods, but it also "facilitates entry into markets for a firm or a new product or brand; leads to economies of scale in production, marketing and distribution, which in turn leads to lower prices; and accelerates the acceptance of new products and hastens the rejection of inferior or unacceptable products" (Belch & Belch, 1990, p. 68). The critics of advertising have been significantly less favorable in their assessment of advertising's contribution to the economic environment. In particular, criticism has focused on marketing efforts in developing countries.

ADVERTISING TO THE BOTTOM OF THE PYRAMID:
FOUR BILLION CONSUMERS STRONG

Research has shown that it is during the recent period of increased globalization of the world economy that poverty rates and global income inequality have most diminished ("Globalization Is Narrowing the Poverty Gap," 2003). Data reveal that both absolute poverty and poverty rates have substantially declined over the past 30 years. The Australian Department of Foreign Affairs and Trade reports that the number of undernourished people in the world has been reduced from 920 million in 1970 to 810 million today (Burtless, 2002). Measures of income equality show that many developing countries (with Africa as a serious exception) are actually converging toward the richest countries' living standards. Nonetheless, four billion people—nearly two-thirds of the globe's population—are still at the bottom of the world's economic pyramid. Yet, even these "poorest of the poor" represent market potential, notes University of Michigan Business School professor, C. K. Prahalad (2004). Because of their vast numbers, this group represents a multi-trillion-dollar market. Prahalad argues that for companies with the resources and persistence to compete for the aspiring poor who are joining the market economy for the first time, prospective rewards include growth, profits, and incalculable contributions to humankind.

According to Prahalad (2004), Hindustan Lever Limited (HLL), a subsidiary of Great Britain's Unilever PLC, has been a pioneer among multinational corporations exploring markets at the bottom of the pyramid. While HLL has served India's small elite—those who could afford to purchase multinationals' products—for over half a century, in the 1990s, the firm drastically altered its traditional business model and began wooing a market that it had previously disregarded. HLL introduced a new detergent, called Wheel, which was specifically formulated to substantially reduce the ratio of oil to water in the product, responding to the fact that the poor often wash their clothes in rivers and other public water systems. The firm also changed the cost structure of its detergent business so it could introduce Wheel at a low price point. Finally, it created sales channels through the thousands of small outlets where people at the bottom of the pyramid are most likely to shop. As a result of these efforts, by 2004, HLL had an impressive 38 percent share of India's detergent market (Prahalad, 2004). Unilever benefited from its subsidiary's experience in the Indian market and has adopted the bottom of the pyramid as a corporate strategic priority in India, as well as other developing markets. For example, Unilever's Rexona brand mini-sized deodorant sticks, which sell for just 16 cents, are a huge hit in India, but also in the Philippines, Bolivia, and Peru (Pralahad, 2004). Unilever predicts that its sales in developing and emerging markets will overtake those in developed markets within five years. And Procter & Gamble investor presentations now routinely list "developing markets and low income consumers" as one of its three core growth strategies ("The Bottom of the Pyramid," 2007). For an increasing number of firms, an ever-growing share of their profits is coming from developing markets (See Table 3.6).

Table 3.6: Estimated Sales Distribution by Region for Major Multinationals/Products

COMPANY	NORTH AMERICA	LATIN AMERICA	WESTERN EUROPE	EASTERN EUROPE	ASIA/ AFRICA
Avon	38%	32%	11%	5%	14%
Colgate	33	26	21	3	17
Clorox	88	10	0	0	2
Gillette	43	11	30	4	12
Kimberly-Clark	59	11	19	1	10
P & G	51	8	22	5	14

Source: Neff, Jack. (2002, March 4). Submerged. Advertising Age, 73(9), 14.

CHANGES IN ADVERTISING SPENDING

As the financial crisis hit the world in 2007 and 2008, many advanced economies faced recession in 2009. ZenithOptimedia downgraded its forecasts for ad spending growth in 2008: from 3.7 percent to 3.5 percent for North America and from 3.9 percent to 3.7 percent for Western Europe, citing credit-crunch worries by investors, consumers, and advertisers in Western markets ["Ad Spend Forecast," 2008]. Aside from North America and Western Europe, forecasts for the rest of the world are up from 11.1 percent to 11.8 percent. Indeed, developing markets will contribute 62 percent of ad expenditure growth between 2007 and 2010, and increase their

share of the global ad market from 27 percent to 33 percent. By 2010, the top ten advertising markets in the world—in rank order—are expected to be: United States, Japan, United Kingdom, Germany, China, Brazil, Russia, France, Italy, and South Korea ("Ad Spend Forecast," 2008). Table 3.7 shows advertising spending worldwide, by region, between 2006 and 2010, as a percentage increase over the previous year.

Table 3.7: Advertising Spending Worldwide, by Region, 2006–2010 (as a percentage increase over prior year)

	2006	**2007**	**2008**	**2009**	**2010**
Africa, Middle East	25.9%	23.0%	12.8%	17.5%	18.6%
Asia-Pacific	6.6%	8.5%	8.5%	6.7%	7.5%
Western Europe	5.6%	5.7%	3.7%	4.3%	4.6%
Central & Eastern Europe	18.4%	22.3%	17.4%	15.1%	13.6%
Latin America	14.5%	16.3%	17.5%	13.6%	10.8%
North America	5.3%	2.7%	3.5%	2.7%	3.6%
Of which USA	5.2%	2.5%	3.4%	2.6%	3.6%
WORLDWIDE	7.3%	7.1%	6.6%	6.0%	6.5%

NOTE: *Includes newspapers, magazines, television, radio, cinema, outdoor, and Internet.*

Source: *ZenithOptimedia. (2008).*

THE IMPACT OF ADVERTISING IN THE DEVELOPING MARKETPLACE

It has only been in the past few decades that manufacturers and distributors have begun to aggressively target consumers in these developing markets. As a result, while a good deal is known about the role of marketing and advertising in countries with economic systems based on plenty, still relatively little is known about how advertising operates in situations of comparative scarcity and poverty. Yet, the debate regarding advertising's effects on developing nations is a heated one. On the positive side, advertising can serve to educate consumers by informing them of what goods are available and where they may be obtained. Recent research ("From 'My Generation,'" 2005) shows that 55 percent of young people in Mexico, 54 percent in China, and 68 percent in India agree that advertising is a good way to learn about trends and what things to buy. In fact, young consumers in developing countries appear to be even more receptive to advertising than those in developed countries—whereas only 30 percent in France, 32 percent in Germany, and 35 percent in the United States agreed that advertising was a good source of information about products ("From 'My Generation,'" 2005). Advertising can also enable consumers to compare goods, which often results in lower prices and improved product quality.

Further, advertising may stimulate the local economy by encouraging consumption. Agencies often offer employment to locals, as well as providing career training. And, it has the potential to improve living standards. Many of the messages aired in developing countries serve to promote desirable social aims—such as increased savings, reduced illiteracy, lower birth rates, and improved nutrition and hygiene.

Advertising has even been successfully employed in the fight against AIDS. For example, in conjunction with UNIFCEF, Clear Channel Outdoor mounted a global HIV/AIDS awareness campaign that will run in more than 50 countries on 6 continents. The goal of the campaign is to help the world's estimated 15 million children who are affected by and infected with HIV and AIDS. More than 2 million children are HIV-positive and more than 500,000 died in 2004 from AIDS-related causes ("Clear Channel," 2005). The campaign's chilling and creative picture—a hand-drawn family portrait of a young girl standing beside the graves of her mother and father—was developed by BesterBurke of Cape Town, South Africa. The image was selected from more than 300 entries from advertising agencies worldwide. Clear Channel Outdoor offices in both developed and developing countries are donating more than US$5 million in advertising space for the campaign. The ad was translated into local languages and accommodates local customs in each country ("Clear Channel," 2005).

A good deal more attention has been paid to the negatives associated with the efforts of international advertisers in developing countries. Charles Frazer (1990) points out that "the idea that marketing, and particularly advertising activities, come to have disruptive, perverse and subversive effects in other cultures, especially developing markets, travels under a variety of labels, including cultural dependence, social mobilization . . . and cultural imperialism" (p. 75). The dependency approach, claims Michael Anderson (1984), suggests that "imported western institutions and values intentionally or unintentionally generate dependency and function as a hindrance to the development of genuinely independent nations" (p. 42). According to social mobilization theory, writes John McGinnis (1988), "It is not economic development or moderniza- tion that leads to political instability, but the rate of rising expectations and the failure to satisfy those expectations" (p. 14). With regard to cultural imperialism, Herbert Schiller (1973) notes:

> No part of the globe . . . avoids the penetration of the internationally active American advertising agency. These transnational advertising agencies have made deep inroads into most of the already industrialized states, and many of the third world nations are experiencing the same loss of national control of the image-making apparatus and internal communications systems. Advertising, and the mass media that it eventually transduces are, therefore, the leading agents in the business of culture, and the culture of business (p. 129).

Regardless of the label, at the heart of the matter is the charge that international marketers attempt to re-create Western-style consumer cultures in countries outside the United States and Western Europe. Critics claim that consumers in these countries are particularly vulnerable to the efforts of international advertisers because they likely are poor and illiterate, lack experience with consumer goods, and have not been exposed to decades of media messages common in more developed markets. In addition, many developing countries lack legal systems for consumer protection. While there is much speculation on the possible impact of both multinational cor- porations and advertising agencies on developing countries, there exists little empirical evidence of these effects (Del Toro, 1986).

CHARGES AGAINST AND ARGUMENTS FOR ADVERTISING
IN DEVELOPING MARKETS

International Advertising Agencies' Influence on Local Advertising Institutions

Critics claim that international advertising agencies have the ability to dominate advertising in ways that small, local advertising agencies in weak, poor nations cannot. They suggest that powerful global agencies have a direct impact on a nation's efforts to build autonomous advertising institutions. In the 1960s many advertising agencies opened shop in developing markets—generally by setting up subsidiaries or purchasing local advertising firms. Further, these multinational agencies were often the driving force behind the creation of national and regional advertising associations, responsible for setting the criteria for agency accreditation (Fejes, 1990). These multinational agencies were typically staffed with Westerners who brought along not only their marketing skills but also their personal and professional values. Separating skills from values is difficult if not impossible, and tensions developed when host countries wanted some of the skills but not the full package of foreign professional values and styles (Anderson, 1984).

Because of their high levels of creative sophistication and innovation, multinational agencies more or less set the standard by which all advertising was measured. Local agencies were forced to provide similar services (such as audience research) and were also expected to reproduce the quality and style of multinational advertising in order to remain competitive. These conditions remain a problem. For example, for a number of years now, South African agencies have been receiving a large share of the awards at international advertising competitions. "Much of the work loses nothing in comparison to that of the best U.K. or U.S. agencies: it could as easily have been made in LA as SA. And that is the problem. For all the high production values and professional polish, there is nothing very African about South African advertising. The idea seems to have been to prove that 'look, we can do this stuff as well as anyone'—an attitude which is by no means particular to South Africa. Brazil, India, Eastern Europe—much of the work in what might be called advertising's 'developing world' is fixated with proving an ability to ape Western mores rather than tapping in to local culture. And you can't blame advertising alone for that. Clients and consumers look up to Western brands and Western media" ("Made in Africa," 2005, p. 41). One agency, however, is seeking to break out of this mold. Copywriter Stuart Stobbs of Netpound Tork, a Johannesburg outpost of BBDO, observed that, "There is a great desire among much of the South African advertising, design and communications industry to promote and use local concepts, thinking and visual culture in our work. Many people are talking about it and trying to push for it, but hardly anyone is doing it" (p. 41). To that end, the agency has begun using some of the talent at its doorstep, adopting South Africa's rich indigenous visual culture, from traditions of African art to vernacular trends such as barbershop signs and the decoration of township shacks. Netpound Tork's goal is to produce work with a specifically African flavor (p. 41).

Many developing nations, which at one time welcomed foreign agencies with open arms, have begun to pass regulations limiting ownership and investment in domestic agencies. The advertising agency is increasingly seen as a national communications system that should not be handed over to foreigners. For example, in Latin America, foreign investment is limited to 19 percent, and in India it is limited to 40 percent. In addition to ensuring that the majority of an agency's ownership rests in the hands of locals, many nations are taking steps to ensure

that agency personnel are also nationals and, as a result, are more likely to be familiar with the indigenous culture of the country. Unfortunately, all too often, foreigners are hired in decision-making roles, while locals are employed for the more routine tasks. In China, until quite recently, international agencies were required to have a local joint-venture partner before they could directly purchase media. As a result, locally hired people made up 80 to 90 percent of the staff at international agencies (Kloss, 2002). However, at the end of 2005, China's advertising sector was fully opened to the outside world. This meant that overseas agencies were able to set up wholly-owned advertising firms. It will be interesting to see if and how this will impact staffing in Chinese agencies in the future.

In an attempt to support local advertising institutions, a number of countries have passed a variety of laws. Among the strictest are those in Malaysia and Indonesia. Almost three decades ago, Malaysia instituted a requirement that all commercials must carry the Made-in-Malaysia (MIM) certificate. MIM—which certified that at least 80 percent of an ad's production costs were spent in Malaysia—was introduced to protect local production companies and acting talent from foreign competition, as well as Malaysian consumers from Western values embedded in foreign ads. However, Malaysian agencies ignored the MIM rules for 30 years with impunity, and many agency professionals believed it had "died a natural death." Recently, however, the Malaysian Ministry of Information has resurrected the MIM ruling (Hicks, 2007). In neighboring Indonesia, Communication and Information Minister Sofyan Djalil has decreed that foreign made ads are not to be aired on Indonesian TV stations. Further, a foreigner will only be allowed to work at a local production house if he or she has three Indonesians acting as assistants, "to ensure the transfer of knowledge to locals" (Hicks, 2007). How the rules will be enforced is yet to be decided. Fines administered by censorship bodies are the likely punishment. Interestingly, the Indonesian Association of Advertising Agencies (PPPI) has expressed support of the new regulation (Silk, 2007).

Advertising's Influence on the Domestic Media Scene

A major criticism of international advertising is that it promotes commercialism of the media, as well as introducing Western media content. Wherever international corporations operate, the local mass media have been summoned to promote sales of consumer goods. As a result, the structure of national communications systems, as well as the programming offered, has been transformed according to the specifications of international marketers. In terms of media structure, many developing countries shifted away from public- or state-financing models to the U.S. model whereby the media are supported by advertising. The broadcast media appear to be particularly susceptible to the lure of advertising dollars. Today, the overwhelming number of radio and television stations in developing markets, both government owned and private, are financed through advertising revenue. This model typically favors amassing profits over serving public needs. In Latin America, for example, 30 to 50 percent of newspaper content, over 33 percent of magazine content, and as much as 18 percent of television content is advertising. Not surprisingly, advertising clutter in many developing markets is even worse than in the United States.

With regard to media vehicles, multinational corporations generally prefer Western programming in which to air their messages. Because such reliance on imported foreign programming reduces opportunities for locals, governments increasingly are taking steps to ensure that a certain percentage of programming remains domestically produced. However, foreign styles

and production standards are often copied while traditional styles are abandoned. For example, the popularity of reality TV in the United States has spawned similar programming in many developing markets. *Mentor* and *Malaysian Idol* are among the 26 reality TV programs broadcast in that country. In response to the proliferation of such reality shows, there has been a call for television stations in Malaysia to be more creative and innovative in producing programs. Deputy Prime Minister Datuk Seri Najib Tun Razak noted that local television stations should not blindly follow Western TV programs because they could pose a threat to Eastern values and the identity of Malaysian society (Ali, 2005). Even when multinationals utilize local programs, they typically prefer entertainment-oriented programming over more culturally oriented offerings. Further, they tend to prefer broadcast media over print, so that advertising revenues tend to flow to the broadcast media rather than to print. The end result may well be ever-increasing costs for print media and ever-decreasing levels of readership, which does not bode particularly well for literacy levels. Finally, multinational corporations have been accused of attempting to influence media content by threatening withdrawal—thus exerting powerful pressure on local media.

It should be noted that some researchers have, in fact, emphasized the beneficial effects of advertising on the local media scene. Supporters claim that, given the limited governmental funding available in many developing countries, advertising support is indeed essential to the health of local media. For instance, international advertising revenues may help to make the media autonomous from politics (Pollay, 1986).

Advertising's Influence on Competition

Critics claim that firms which advertise heavily make it impossible for competitors in developing countries to enter the marketplace because of the enormous sums spent on advertising. In contrast, supporters claim that by encouraging competition among producers, advertising actually stimulates the economy. Because there is little consensus as to the impact of advertising on competition in developed markets, not surprisingly, there is also a good deal of debate over its role in evolving economies. Although no significant studies document advertising's effect on competition, some interesting statistics suggest there may be some validity to this criticism. For example, multinational corporations outspend local firms by six to one in advertising. With so much exposure, international brands generally have substantially higher recall levels among consumers than do local brands. For example, to gauge the promise of Africa as an advertising market, Leo Burnett recently conducted a survey of consumers in eight countries: South Africa, Nigeria, Zimbabwe, Ghana, Cameroon, Ivory Coast, Mozambique, and Kenya. Asked to name their favorite brands—local or international—African consumers picked big names and, interestingly enough, chose mobile phone names among their top four: Sony, Ericsson, Samsung, and Nokia. They were followed by Nike, Coca-Cola, Mercedes-Benz, Toyota, Panasonic, and Philips. Local brands had a hard time cracking the list in any country, though Tusker beer popped up at No. 3 in Kenya (Pfanner, 2005). Clearly significant status is associated with foreign brands of consumer goods. Alternatively, if multinationals do not meet the needs of "first-time" consumers, local competitors will. Nike, for example, was an early bird when it came to recognizing the importance of emerging markets, launching its world Shoe Project back in 1998. "The aim was to develop a shoe that would meet the needs—and price points—of first-time consumers. But the project soon got impaled on Nike's addiction to its existing high-cost, high-priced retail outlets—channels which fed its own internally-imposed high margin requirements" ("The

Bottom of the Pyramid," 2007). Indigenous competitor Li-Ning is now the biggest sports brand in China—and moving aggressively abroad.

Advertising's Influence on Consumerism

Critics claim that international marketers promote commercialism and consumerism in developing markets. For example, Malaysia's Consumer Association of Penang (1986) describes the situation as follows: "A worrying trend is the growing influence of negative aspects of Western fashion and culture on the people of the developing countries, including Malaysia. The advertising industry has created the consumer culture, which has in fact become our national culture. Within this cultural system people measure their worth by the size of their house, the make of their car and the possession of the latest household equipment, clothes and gadgets."

International advertising messages are said to stimulate artificial wants and needs and to encourage consumers to demand goods inappropriate for their level of development. Such charges are difficult to answer empirically. Distinguishing between what is a real or an artificial want or need is no easy task. Even in markets where there are no active selling and promotional efforts, demand for Western-style products appears to be widespread. For example, despite the 19-year trade embargo imposed on Vietnam (which was finally lifted in 1994), Coca-Cola was extremely popular in this market, one of the poorest countries in the world. Apparently, brand-conscious and America-loving Vietnamese consumers had been purchasing Coca-Cola on the black market for years (Saporito, 1993/1994).

It is of interest to note that the concern over commercialization and consumerism tends to be greatest in the developed—rather than the developing—nations. The 2004 Pew Global Attitudes study, which surveyed some 66,000 people in 44 nations, found that while 63 percent of the French say both are threats to their culture, the poorest countries, on the whole, did not see it that way. The survey reported that consumers in Lebanon (65 percent), Uzbekistan (57 percent), and Jordan (54 percent) say commercialism is no threat to their culture. Consumers in Turkey, Egypt, and Pakistan agreed. In Vietnam, 66 percent said commercialism was not a threat. In Nigeria, the figure was 65 percent, and in Angola, 56 percent (Peron, 2004).

While consumerism is generally attacked as a negative consequence of advertising, it may also benefit a host society. Advertisements may, for example, convey messages about higher standards of living to a society and, as such, be viewed as a force contributing to the betterment and advancement of people's lives (Kaynak, 1989). Several examples reinforce this point. About half of the world's population—some 3 billion people—prepare their meals on cook fires of wood, husks, dried dung, and other forms of biomass, according to the World Health Organization (WHO). These inefficient fires release carbon monoxide, soot, benzene, formaldehyde, and other toxic pollutants into the dwellings of these consumers. Cookstove air pollution is linked to some 1.6 million deaths a year, according to WHO estimates (Jaffe, 2008). To combat this problem, Colorado State University's Engines and Energy Conversion Laboratory and Envirofit International Ltd. are marketing a line of inexpensive and efficient cookstoves. These stoves burn cleaner and hotter—cutting emissions by up to 80 percent and requiring half as much fuel. Full-scale marketing began in 2008 and 16,900 stoves were sold in India within months. The three Envirofit models sell for about US$12, US$25, and US$40. The company has plans to expand to Africa and South America in the coming year. Envirofit's ultimate goal is to sell 10 million cookstoves worldwide (Jaffe, 2008).

Figure 3.4: Lifestraw provides clean drinking water to world's poor

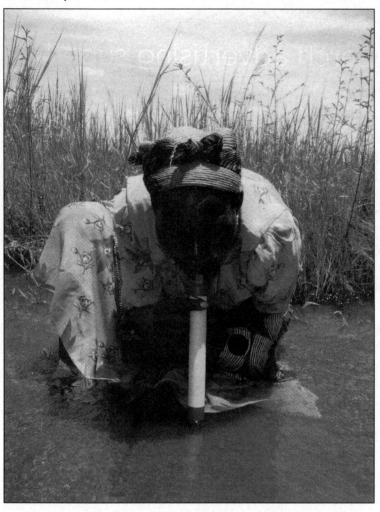

The Lifestraw is another example of a product that makes a positive contribution to the lives of consumers in developing countries. For more than one billion people in the developing world, dirty water is a fact of life—half the world's poor suffer from waterborne diseases. Indeed, about 6,000 people (mostly children) die every day because they do not have access to safe water. The personal, portable Lifestraw (see Figure 3.4) uses a specially developed halogen-based resin that filters out bacteria, viruses, and parasites, turning even the dirtiest water into water safe for consumption. One straw provides safe water for a single person for an entire year. The Lifestraw received the 2008 Saatchi and Saatchi award for world changing ideas (McCoy, 2008).

Advertising and the Allocation of Precious Resources

The criticism here is that scarce national resources are squandered for the production, promotion, and consumption of products that simply are not needed by consumers in developing markets. International businesses are accused of engaging in advertising to shift consumer behavior from rational consumption of locally produced goods to conspicuous consumption of foreign-made goods (Del Toro, 1986). To compete with foreign advertisers, local firms increasingly must also employ promotional techniques. These monies, it is argued, could be better spent assisting the local population via health and welfare programs. For example, in Kenya, one study (Khan & Maqbool, 1994) has documented that expenditures for soap advertising are higher than government expenditures for rural health care. Not only do businesses spend unnecessarily, but so do consumers in these countries, because the cost of many international products is significantly higher than that of local goods. U.S. products, in particular, carry a premium price. For instance, in India, Camay soap costs 27 cents while local soaps are priced at 19 cents; Head & Shoulders shampoo sells for US$4.77 while local shampoos are priced at US$2.00 (Khan & Maqbool, 1994). Clearly, the poor can ill afford such items, because the majority of their income

is spent on sustenance. The counterargument here is that while multinational corporations and their advertising agencies may change the patterns of consumption, they do not impact levels of consumption (Tansey & Hyman, 1994).

Regardless of perspective, the question remains, Who is to decide which expenditures are wasteful and which are not? From the viewpoint of many international marketers, this is a decision best left to consumers themselves. Critics argue, however, that multinational marketers should adapt the price of the product to levels realistic for consumers in developing markets. And some do.

The WHO estimates that diarrhea-related diseases kill 1.8 million people a year (Walker, 2007). Better hand-washing habits—using soap—is one way to prevent their spread. For several years, the World Bank has been involved in initiatives with multinationals, including Unilever, to address the issue. While global brands might seem like a recent phenomenon, Lever was already operating around the world when Lifebuoy entered the Indian marketplace more than 100 years ago. But perhaps the most significant change to the product itself in recent years has been Hindustan Lever's (a subsidiary of Unilever) introduction of Lifebuoy soap to Indian consumers in smaller, and thus cheaper, bars. A half-size, 50-gram bar costs about 5 rupees (or 2 ounces for roughly 12 cents). Five years ago, the company introduced a campaign called Glowing Health, which argues that even clean-looking hands may carry dangerous germs. It began a concentrated effort to take this message into tens of thousands of villages where the rural poor reside, often with little access to media. Lifebuoy teams visit the Indian villages several times using a "Glo Germ" kit to show schoolchildren that soap-washed hands are cleaner. The program has reached around 80 million rural folk—and the sales of Lifebuoy have risen sharply. The small bar has become the brand's top seller. Marketing a well-known product like Lifebuoy can be effective precisely because even the world's poorest citizens can be brand conscious. Punit Misra, the marketing manager who oversees Lifebuoy, notes "that such consumers will stick with a brand they trust, because money means that much more to them" (Walker, 2007).

And not just packaged goods can be priced reasonably—durables, too, can become affordable for consumers in developing markets. Researchers at the Massachusetts Institute of Technology Media Laboratory, led by founding chairman Nicholas Negroponte, developed an economy laptop (less than US$100). Having witnessed firsthand in Cambodia how computers can transform children's learning, Negroponte distributed 15 million "clockwork laptop" computers to children in the developing world during 2006, and another 15 million in 2007. Beyond the low price, the unique feature of this computer is its retractable winder used to generate electricity—vital given that the majority of children in the developing world do not have access to electricity or batteries (Rutter, 2005). Too often, Western brands are overpriced, delivering features and functions users do not need or that they can't afford. Unilever chief executive Patrick Cescau notes, "Instead of the traditional cost plus margin method of determine price, we've had to re-engineer our thinking. First, discover the price consumers can afford to pay. Second, design everything to deliver this price. The only way to do this is to re-engineer the entire supply chain, production and marketing process" ("The Bottom of the Pyramid," 2007).

Even consumers with low incomes can find discretionary income to spend on products with high value to them, as evidenced by the success of mobile telephony in sub-Saharan Africa. Despite being the poorest region in the world, the number of mobile telephone subscribers rose from 36 million in 2003 to 224 million in 2008 ("Special Report," 2009). And, multinationals note

that even the poorest of the poor can be choosy about brands. Executives at Hindustan Lever found that poor people can become just as discerning about brands as rich consumers. If brands exist as a store of value—a promise about the product's distinctive qualities and features—then offering poor consumers a real choice of brands means offering them a slightly better quality of life. Marketing well-made products to the poor is not just a business opportunity, it is a sign of commercial respect for people whose needs are usually overlooked (Balu, 2002).

Advertising's Influence on Rising Frustrations

In a related criticism, it is claimed that advertising creates demand for goods which consumers cannot possibly afford. The concern here is that the associated dissatisfaction and frustration might possibly lead to social unrest or even political destabilization. In selling goods in developing countries, advertisers may communicate with three major markets: (1) the urban-center dwellers, consisting of foreign expatriates as well as sizable pockets of both high- and middle-income locals who often are as sophisticated in their tastes as their counterparts in developed markets; (2) suburbanites living in outlying areas some 10 to 15 miles from the urban centers; and (3) the rural population, whose lifestyles remain quite provincial and whose incomes are quite meager (Hill, 1984). Note that nearly 80 percent of the population in most less developed countries live outside the cities and that the cultural and economic gap between the urban centers on the one hand and the villages or rural areas on the other is quite substantial (Hill & Hill, 1984). The problem lies in targeting promotional messages only to the most appropriate market segment. For example, international marketers may decide to offer a product to those consumers who are relatively well off with sufficient disposable income—primarily those in urban centers. This creates a taste for Western lifestyles and values that often trickles down to the lower classes. Inevitably, consumers in rural areas will seek ways to expend their limited resources to obtain these items. Ultimately, the lower sectors are perceived not simply as passive bystanders but as potential consumers of these products (Del Toro, 1986). Philippine author Renato Constantino (1986) voiced his concern: "In the Philippines for example, where estimates placed fully 70 percent of families below the poverty line, money sorely needed for food, shelter and basic health is often squandered on tobacco, cosmetics, soft drinks and the latest fashion jeans. Although the targets of transnational corporation sales are the elite and middle classes, their advertising is 'democratically' heard via transistor radios, seen on billboards and to a lesser extent on television" (p. 4). Further, in many developing countries upward mobility is virtually nonexistent. Generally, less than 10 percent of the population own 60 percent or more of a nation's wealth. Many consumers in these countries do develop a desire—whether through advertising or other stimuli—for goods they can ill afford. In Mexico, for example, U.S. soft drinks control over 75 percent of the market, and schoolchildren will save money to purchase Pepsi, which costs three to five times what a local soft drink would cost. However, little evidence indicates that consumer frustrations have resulted in demands for radical change. Nonetheless, governmental bodies in some developing markets are undertaking steps to avoid potential social or political unrest.

Advertising's Potential to Exaggerate Claims and Deceive Consumers

That advertising often exaggerates claims and deceives consumers is widely accepted as a valid concern by both consumers and the advertising industry. This problem has always been associated with advertising, but in developed countries, regulatory bodies developed alongside

the advertising industry, offer consumers some degree of protection. In contrast, many developing nations have no regulatory agencies to speak of. Further, there is often little self-regulation of advertising in developing markets, resulting in numerous instances of less than scrupulous advertising. And, consumers in developing markets, research shows, still have relatively high levels of trust in advertising, even if their counterparts in developed countries are more cynical. In the Philippines and Brazil, for instance, 67 percent of consumers said they generally trusted advertising—compared with 55 percent of Americans and just 28 percent of Danes who say the same (Pfanner, 2007). All this leaves consumers in developing nations open to misleading advertising.

One case makes the differences in ad regulation between developed and developing markets quite clear. Recently, GlaxoSmithKline (GSK) and Nestlé were censured for making unfounded nutritional claims about their products in the United Kingdom. TV ads for GSK's Horlicks health drink and Nestle's Maggi Noodles shown in the UK included suggestions that the products could make children taller, stronger, and more intelligent, as well as give them more powerful muscles. The companies were condemned by the British Advertising Standards Authority for making unsubstantiated claims and were banned from showing the ads again. Both companies claimed the ads were shown by accident and were intended for audiences in developing markets—not Europe. The case brought about calls for new global advertising regulations and highlighted some of the extraordinary claims brand owners make for their products in developing countries that they would have to struggle to get approved in developed markets ("Global Campaigns," 2008).

This is, of course, not the first time Nestle has been in hot water regarding its promotional tactics in developing countries. During the late 1980s, in areas where poverty and malnutrition were endemic among children, Nestle used outdoor billboards featuring pictures of healthy, happy babies being fed bottles of Nestle formula. Local mothers, who normally breast-fed their children, saw the ads and were convinced that the Nestle product could perform miracles. However, because literacy rates were low and there was little information to be had from manufacturers on how to properly use the product, the local mothers diluted the formula, using impure water. So instead of improving the baby's health, the formula actually caused diarrhea and death. In 1981, the United Nations World Health Assembly, which helps establish policy for the WHO, succeeded in winning a ban on marketing directly to new mothers with ads and free samples—tactics that had prompted millions of women in emerging markets to stop breast-feeding their infants in favor of foods that marketers touted as more nutritious—and a code of marketing practices was introduced that same year.

The UN code appears to have provided a challenge for several infant milk formula manufacturers. In 1999 alone, Nestle, Wyeth, and several other companies were accused of systematically violating the code in Poland, Bangladesh, Thailand, and South Africa. Most recently, China has been the site of aggressive marketing efforts by infant formula producers. While the percentage of mothers who breastfeed their babies in the United States has reached the highest level on record, at about 74 percent, it has dropped to less than 70 percent in China due to changing lifestyles as well as aggressive advertising by manufacturers. "For quite a while now infant formula companies have been making claims that we believe are not supportable by science. Quite often in East Asia the most appealing claims are they put ingredients in the milk that make the children smarter," said Dale Rutstein, the UN's Children's Fund (UNICEF) China communications chief (Blanchard, 2008). Regulation of advertising is addressed in greater detail in Chapter 4.

Problems in Assessing Advertising's Effects in Developing Markets

The most striking factor in the preceding discussion is the lack of empirical evidence regarding the effects of marketing and advertising in developing countries. The claims made are complex—and not easily substantiated or refuted. More often than not, arguments are based on anecdotal or scanty evidence, and conclusions clash depending on whose perspective is embraced (Del Toro, 1986).

Several problems are associated with assessing the influence of promotional efforts. First, in the debate regarding advertising's effects, the type of advertising often is not clearly defined. Criticisms are levied against advertising in general, yet advertising for specific product categories tends to generate more objections than others. For example, retail advertising, which brings together buyers and sellers and provides consumers with information about the local market, is generally not the target of criticism. Similarly, industrial advertising, directed not at the consumer population but rather at businesses, has received little criticism. This type of advertising also tends to be high in information content. Alternatively, advertising for brand-name products, such as soft drinks, sweets, alcoholic beverages, and, in particular, cigarettes, has received the greatest amount of criticism.

Second, in assessing advertising's effects, oversimplified models of buying behavior often are employed. Critics of advertising in developing countries ascribe great power to advertising, assuming advertising directly causes purchase behavior. Clearly many additional factors come into play in stimulating buyer behavior. Conceivably, a variety of underlying social and environmental factors (such as church and school) play a more significant role in stimulating wants and needs than does advertising.

Finally, advertising is a process in which a great many intervening variables—some of which are not all that clearly defined—play a role. For example, research regarding the impact of international advertising on indigenous culture is complicated by the methodological problems associated with identifying exactly what indigenous culture is. A multitude of factors may impact the culture of a society, and each must be taken into consideration when analyzing both positive and negative claims against advertising. Charles Frazer (1990) notes that, unfortunately, advertising effects are not separable from those of other social forces: "How advertising effects might be disentangled from marketing, mass media, social, political, cultural and individual impetus is indeed a staggeringly complex undertaking" (p. 76).

THE FUTURE OF ADVERTISING IN DEVELOPING MARKETS

Advertising in developing markets can have both positive and negative effects. It is, in many ways, a sword that cuts both ways. On the one hand, host nations obviously realize that international marketers and their agencies do make contributions to host societies, which is why they allow them to operate within their borders in the first place. Indeed, in numerous instances corporations and agencies are invited to enter these markets and are even offered concessions, incentives for foreign investment, and tax exemptions (Del Toro, 1986). A good many products have proven to be both of value to consumers in developing nations and profitable for international marketers. And, as noted, advertising has been employed in combating social ills and improving health and hygiene in many less developed markets.

On the other hand, there are real dangers associated with the use of marketing and advertising in developing countries. Overcommercialization of the media may well result in the decline of local programming unless protective steps are taken. Deceptive campaigns and the promotion of undesirable or dangerous products pose potential health and other risks for Third World consumers. Additional regulatory bodies are needed to fulfill a watchdog function. It is indeed possible to limit the negative effects with planning and regulation. Scholars and researchers must continue to attempt to understand the effects of advertising in developing markets. As Michael Anderson (1984) summarizes:

> Generalizations about the precise costs and benefits that the transnational advertising agencies bring to their host nations are difficult to make. This is because nations and their development policies and patterns, problems and pressures are in a constant state of flux and are products of various interwoven factors operating within and between nations. What can be said with some certainty, however, is that the presence of the multinational advertising agencies in any developing economy *does* generate some tensions and conflict. (p. 42).

CONCLUSION

Advertising clearly does not operate in a vacuum. We have learned that advertising both shapes and reflects a country's cultural environment. Similarly, advertising influences and is influenced by several additional environments. In this chapter we addressed the interrelationship between advertising and a country's economic environment. In particular, we highlighted the role that advertising plays in developing economies. In Chapter 4 we will explore political as well as legal environments.

REFERENCES

Ad spend forecast: As West slows down, developing markets propel growth. (2008, July 1). Retrieved March 25, 2009, from http://www.marketingvox.com/ad-spend-forecast-as-west-slows-down

Ali, Syed Azwan Syed. (2005, August 15). Call for TV programs portraying Malaysian values. *Malaysian General News*, p, 1.

Anderson, Michael H. (1984). *Madison Avenue in Asia.* Cranbury, NJ: Associated University Press.

Arens, William F., & Schaefer, David H. (2007). *Essentials of contemporary advertising.* New York: McGraw-Hill, Irwin.

Ausaid. (2001). *Global income and income distribution.* Retrieved August 15, 2002, from http://globaled. ausaid,gov.au/secondary/casestud/economics/I/glob-inc.html

Balu, Rekha. (2002, June). Strategic innovation: Hindustan Lever. *Fast Company,* Boston, pp. 120–136.

Belch, Michael A., & Belch, George E. (1990). *Introduction to advertising and promotion: An integrated marketing communications perspective.* Homewood, IL: Irwin.

Blanchard, Ben. (2008, September 18). Mother turned to formula to boost "nutrition": Ads push milk powder while breastfeeding rates fall in China. *The Vancouver Sun,* Vancouver, B.C., p. A11.

Brooks, David. (2005, January 4). A tale of two systems. *New York Times,* p. A19.

Burtless, Gary. (2002, June). Is the global gap between rich and poor getting wider? The Brookings Institution.

Chinese consumers in 2020: A look into the future. (2009). *Euromonitor International.* Retrieved March 25, 2009, from http://www.euromonitor.com/Chinese_consumers_in_2020_A_look

Clear Channel mounts first-ever global outdoor advertising campaign. (2005, October 27). *Business Wire,* New York, p. 1.

Constantino, Renato. (1986). Mass culture: Communication and development. *Philippine Journal of Communication,* 13–26. Quoted in Katherine Toland Frith & Michael Frith, *The stranger at the gate: Western advertising and Eastern cultural communications values* (p. 4). Paper presented at the International Communication Association Conference, San Francisco, 1989.

Consumer Association of Penang. (1986). *Selling dreams: How advertising misleads us.* Penang, Malaysia: CAP. Quoted in Katherine Toland Frith & Michael Frith, *The stranger at the gate: Western advertising and Eastern cultural communications values* (p. 4). Paper presented at the International Communication Association Conference, San Francisco, 1989.

Creamer, Matthew. (2008, October 6). Consumers curtail consumption. *Advertising Age,* p. 1.

De La Dehesa, Guillermo. (2004, September 15). Europe's social model will crumble without reform. *Financial Times,* London, p. 21.

Del Toro, Wanda. (1986, May 22–26). *Cultural penetration in Latin America through multinational advertising agencies.* Paper presented at the annual meeting of the International Communication Association, Chicago, Illinois.

Dorling, Daniel, Newman, Mark, & Barford, Ana. (2008). *The atlas of the real world: Mapping the way we live.* New York: Thames & Hudson.

Fejes, Fred. (1990, August 9–13). *Multinational advertising agencies in Latin America.* Paper presented at the annual meeting of the Association for Education in Journalism and Mass Communication, Boston, Massachusetts.

Frazer, Charles. (1990). Issues and evidence in international advertising. *Current Issues and Research in Advertising, 12*(1/2), 75–90.

From "my generation" to "my media generation": Yahoo! And OMD Global Study find youth love personalized media. (2005, September 27). *Business Wire,* New York, p. 1.

Garfield, Bob. (2009, March 23). Future may be brighter, but it's apocalypse now. *Advertising Age.* Retrieved March 25, 2009, from http://adage.com/print?article_id=135440

Gimbel, Barney. (2008, July 21). The new world order. *Fortune,* pp. 156–157.

Global campaigns: Brands behaving badly. (2008, October 30). *Marketing Week,* p. 20.

Globalization is narrowing the poverty gap. (2003). http://www.iccwbo.org/home/news_archives/2003/stories/globalization.asp

Hicks, Robin. (2007, June 1). Protectionism in Southeast Asia. *Media,* Hong Kong, p. 13.

Hill, John S. (1984). Targeting promotions in lesser-developed countries: A study of multinational corporation strategies. *Journal of Advertising, 13*(4), 39–48.

Hill, John S., & Hill, Richard R. (1984, Summer). Effects of urbanization on multinational product planning: Markets in lesser-developed countries. *Columbia Journal of World Business, 19,* 62–67.

Jackson, Richard. (2003, Winter). The real threat to world stability. *American Outlook.* http://www.hudson.org/American_Outlook/index.cfm?fuseaction=article_detail&id=2767

Jaffe, Mark. (2008, December 7). CSU turns up heat on better cookstove. *Denver Post,* p. B3.

Johnson, Bradley. (2009, February 9). Ad industry cut another 18,700 jobs in December. *Advertising Age,* p. 1.

Kaynak, Erdener. (1989). *The management of international advertising: A handbook and guide for professionals.* New York: Quorum Books.

Khan, Alam and Mir Maqbool (1994). Another Day in Bombay. *Advertising Age,* April 18, I-11

Kinetz, Erika. (2009, March 24). Will Nano be a driving force? *San Diego Union Tribune,* p. C1.

Kloss, Ingomar. (2002). *More advertising worldwide.* Berlin, Germany: Springer.

Knickerbocker, Brad. (2004, January 22). If poor get richer, does world see progress? *The Christian Science Monitor,* Boston, p. 16.

Kotler, Philip. (2000). *Marketing management.* Upper Saddle River, NJ: Prentice Hall.

Madden, Normandy. (2008, September 8). China's Olympic-year ad growth: 22%. *Advertising Age,* p. 12.

Madden, Normandy, & Hall, Emma. (2008, December 22). Marketers look outside U.S. for growth. *Advertising Age,* p. 3.

Made in Africa. (2005, May 3). *Creative Review,* London, p. 41.

McCoy, Susan. (2008, February 25). The fifth Saatchi & Saatchi award for world-changing ideas. *Advertising Age,* p. 31.

McGinnis, John. (1988). Advertising and social mobilization. Paper presented at the Association for Education in Journalism and Mass Communication, Portland, Oregon.

Neff, Jack. (2008, August 4). P&G, Unilever slash ad spending. *Advertising Age,* p. 1.

O'Guinn, Thomas C., Allen, Chris T., & Semenik, Richard J. (2003). *Advertising and Integrated Brand Promotion* (3rd ed.). Mason, OH: Thomson South-Western.

Peron, Jim. (2004, June). Anti-globalists are scarce in poor countries. *Freeman,* Irvington-on-Hudson, *54*(5), 37.

Pfanner, Eric. (2005, January 17). Marketers looking at Sub-Sahara on advertising. *International Herald Tribune,* Paris, p. 11.

Pfanner, Eric. (2007, October 1). Trusting ads—relatively on advertising. *International Herald Tribune,* Paris, p. 13.

Pollay, Richard W. (1986, April). The distorted mirror: Reflections on the unintended consequences of advertising. *Journal of Marketing, 50,* 18–36.

Prahalad, C. K. (2004). *The Fortune at the Bottom of the Pyramid.* New York: Pearson.

Rocky road ahead, say agency execs. (2008, August 21). Retrieved March 25, 2009, from http://www.marketingvox.com/ready-draft-rocky-road-ahead-say-ag

Rutter, Mark. (2005, October 12). Kids will power own computers: Third World students will get clockwork laptops. *The Toronto Sun,* p. 95.

Saporito, Bill. (1993/1994, Autumn/Winter). Where the global action is. *Fortune* [Special Issue], *128*(13), 63–65.

Schiller, Herbert I. (1973). *The mind managers.* Boston: Beacon Press.

Silk, Atifa. (2007, May 18). Why it's time to reason with Indonesian authorities. *Media,* Hong Kong, p. 23.

Special report: Developing world to overtake advanced economies in 2013. (2009, March 11). *Euromonitor.*

Tansey, Richard, & Hyman, Richard R. (1994). Dependency theory and the effect of advertising by foreign-based multinational corporations in Latin America. *Journal of Advertising, 23*(1), 27–42.

The bottom of the pyramid is where the real gold is hidden. (2007, February 8). *Marketing Week,* London, p. 18.

Walker, Rob. (2007, June 10). It's good business, but a strategy that saves lives as well. *Boston Globe,* p. D1.

Wentz, Laurel. (2008, December 8). GM falls out of top 3 global spenders. *Advertising Age,* p. 10.

Advertising and Political and Regulatory Issues

ADVERTISING AND THE POLITICAL ENVIRONMENT

The political environment of a country as well as the laws and regulations of that market influence, and are influenced by, commercial communications. Both the political system and the local laws shape a country's business environment and may directly affect various aspects of a marketing program, including whether a product can be sold in a particular country and how it can be promoted.

Political systems are generally divided into one of three broad categories: capitalism, socialism, and communism. Onkvisit and Shaw (1997, pp. 137–139) provide excellent definitions of these three systems. The philosophy of capitalism provides for a free-market system that allows business competition and freedom of choice for both consumers and companies. It is a market-oriented system in which individuals, motivated by private gain, are allowed to produce goods or services for public consumption under competitive conditions. Product price is determined by demand and supply. This system serves the needs of society by encouraging decentralized decision making, risk taking, and innovation. The results include product variety, product quality, efficiency, and relatively lower prices. There are degrees of capitalism: Japan is relatively less capitalistic than the United States. Although practically all Japanese businesses are privately owned, industries are very closely supervised by the state. Japan's government agencies vigorously advise companies what to produce, buy, sell, and so on. Japan's aim is to allocate scarce resources in such a way as to efficiently produce those products that have the best potential for the country overall.

The degree of government control under socialism is somewhat greater than under capitalism. A socialist government owns and operates the major, basic industries but leaves small businesses to private ownership. Socialism is a matter of degree, and not all socialist countries are the same. A socialist country such as Poland used to lean toward communism, as evidenced by its rigid control over prices and distribution. France's socialist system, in comparison, is much closer to capitalism than communism.

Communist theory holds that all resources should be owned and shared by all the people (i.e., not by profit-seeking enterprises) for the benefit of the society. In practice the government controls all productive resources and industries, and as a result the government determines jobs, production, price, education, and just about everything else. The emphasis is on human welfare. Because profit making is not the government's main motive, theoretically there is a lack of incentive for workers and managers to improve productivity. The former Soviet Union and China are the two largest communist nations. Yet, in recent years privatization has been the trend in both Russia and Ukraine, and China has been experimenting with a new type of communism by allowing its citizens to work for themselves. This "new" China is characterized by dramatic economic growth, as evidenced by an unprecedented 29 Chinese companies on *Fortune*'s 2008 ranking of the top 500 global companies. Indeed, China posted as many companies as Italy, Spain, and Australia combined (Mero, 2008).

It should be noted that no "pure" capitalist market or communist market exists: All countries share some features of both systems. Clearly, the role of advertising varies depending on the primary political orientation of each particular marketplace. While the traditional Soviet view of commercial advertising had long been to consider it a parasitic form of activity and a drain on the economy, it is a fallacy that advertising had not been employed in this communist market. Indeed, following the death of Joseph Stalin in 1953, communist leaders concluded that advertising, used in great moderation, could be employed to solve certain problems. Yet, the functions of capitalist and communist advertising were seen to be quite different. Capitalist advertising was perceived as serving a single company in its quest for sales in the face of continual excess supply and was therefore wasteful. Communist advertising was not intended to be competitive but instead worked to fulfill the overall economic plan by redirecting demand. Initially, Soviet advertising dealt only with political propaganda or public service announcements. Over time, Soviet managers were encouraged to advertise goods and services. One common use was to promote the sale of unacceptably large inventories. Another was to sell obsolescent goods, with obsolescence in certain cases being the reason for the unsatisfactorily large size of the inventory. Still another use was to move seasonally produced goods, especially if perishable.

Yet, since the failed coup of August 1991, the subsequent resignation of President Mikhail Gorbachev, and the relegation of the Union of Soviet Republics into official oblivion, much has changed regarding the role of marketing and advertising. In the early 1990s, many Western firms eyed the former Soviet Union as the next marketing frontier. Among those who entered the Commonwealth were Johnson & Johnson, Eastman Kodak, Holiday Inns Worldwide, Procter & Gamble, and Kellogg. Indeed, by 1994, Russian president Boris Yeltsin complained to the Russian *Duma* about the "Snickerization" of the country's economy, referring to the phenomenal success Mars, Inc., had in penetrating this market (a newspaper poll at the time revealed that only 15 percent of Russians had never tasted a Snickers bar). As with the expansion of Western agencies to other regions of the globe, advertising agencies followed their clients into

the new Commonwealth. Ogilvy & Mather became the first officially registered Western agency in the former Soviet Union when it formed a three-way joint venture with the Soviet shop Soyuztorgreklaman and Hungary's Mahir. Ogilvy & Mather was followed by Young & Rubicam, Bozell and D'Arcy, Masius Benton and Bowles, and others. Today, a blitz of commercial messages has taken this marketplace by storm.

POLITICAL ADVERTISING

Political advertising is an important part of the political process in nearly every country. Politicians and political parties utilize political advertisements to influence the opinions and decisions of voters. Worldwide, paid advertising for political parties or candidates in newspapers or via outdoor media such as posters or billboards is scarcely controversial. The practice is almost universally the same: advertising is permitted, subject only to limitations such as campaign spending ceilings or restrictions on content. However, many countries have followed a different course with regard to political advertising on radio and television (Ace Project, 2002).

Broadcast Media Issues

While publicly funded broadcast media are thought to have a certain degree of obligation to allow parties and candidates to communicate directly with the electorate, whether this access is free, paid, or, as is often the case, a mixture of the two varies significantly from one market to the next. Commonly, countries with a strong tradition of public ownership of broadcasting, such as France, Denmark, and Britain, have tended to be hostile to paid political advertising in the broadcast media, relying instead on free access to the media. The primary argument against paid political advertising is that all parties or candidates should have equal or fair access to direct broadcasting regardless of the state of their campaign financing.

Countries with a stronger commercial broadcasting tradition have tended to regard political advertising as quite acceptable. The argument here is that being allowed to spend money on advertising equalizes the debate between incumbent and challenger. Systems characterized solely by paid political advertising with no free direct access are rather uncommon. For many years, Finland was nearly a unique example on the continent, with most other examples to be found in the Americas. The United States is probably the best-known example of a system of paid political advertising and has rather complex legislation to regulate campaign financing. Congress in 1971 passed the Federal Election Campaign Act (FECA), a consolidation of previous reform efforts that limited the influence of wealthy individuals and special interests on the outcome of federal elections, regulated campaign spending, and mandated public disclosure of campaign finances by candidates and parties. Congress amended the FECA in 1974 to set limits on contributions by individuals, political parties, and political action committees. The 1974 amendments also established an independent agency—the Federal Election Commission (FEC)—to enforce the law, facilitate disclosure, and administer a public funding program. Congress made further amendments to the FECA in 1976 following a constitutional challenge in the Supreme Court case *Buckley v. Valeo;* major amendments were also made in 1979 to streamline the disclosure process and expand the role of political parties (Federal Election Commission, 1996).

Regarding the role of the media, Section 312 of the Federal Communication Act of 1934 requires that a commercial broadcast licensee afford federal candidates "reasonable access" to

its station facilities. This is an absolute legal right of access enjoyed only by federal candidates—candidates for president, vice president, the U.S. Senate, and the U.S. House of Representatives. Candidates for nonfederal offices (such as governor, mayor, etc.) do not have a legal right of access. Section 315 of the act requires that radio and television stations treat legally qualified political candidates equally when it comes to selling airtime. This applies to all legally qualified candidates in both primary and general elections, federal, state, and local. Simply put, a station that sells one minute to Candidate A must sell the same amount of time with the same audience potential to all other candidates for the particular office. The station, however, is not required to notify the candidates of their entitlement to equal opportunities. Rather, it is up to the candidate to request their equal opportunity rights within seven days of the first prior use by an opposing candidate. A candidate who cannot afford time does not receive free time unless his or her opponent is also given free time. The Lowest Unit Charge (LUC) was established by the Federal Communications Commission in the Federal Election Campaign Act of 1971 to protect legally qualified candidates from excessive advertising costs. Stations must offer candidates the rate it offers its most favored advertiser. Thus, if a station gives a discount to a commercial sponsor because it buys a great deal of airtime, the station must offer the same discount to any candidate regardless of how much time he or she purchases (Rowan, 1984). These principles are intended to ensure that political campaigns will not entirely become the preserve of those with the largest advertising budgets.

The vast majority of countries have a mixture of paid and unpaid direct access broadcasting. Typically the approach is to allocate parties a basic share of free direct access time, which can then be "topped up" with paid advertising if the party chooses to do so and can afford it. For example, the Canadian system is, in effect, a mixed one. Between elections there is an allocation of free party political broadcasts: 60 percent for the opposition parties and 40 percent for the governing party. In election periods, this system is overlaid by one of paid political advertising. However, there is a given amount of advertising time available, which is allocated to the parties according to a formula that they agree upon among themselves. They are then allowed to purchase advertising time up to the limit of their allocation (Ace Project, 2002). Each broadcast medium was required to allow 6.5 hours for political campaigning beginning with the 29th day before the elections and ending 2 days before them. Canadian television companies are also prohibited by law from earning profits at the expense of political parties by increasing their prices for campaign advertising. And much like in the United States, such advertising must be sold for the lowest price that is offered to nonpolitical advertisers.

Campaign Spending Issues

Because television is far and wide the most expensive advertising medium, those countries that prohibit the use of broadcast media typically spend far less on political campaigns. In the United Kingdom, political advertising has been prohibited on radio and television since the Television Act of 1954 created commercial television. Though TV advertising is illegal, UK parties are entitled to party election broadcasts and party political broadcasts—typically five-minute pieces produced by the party and shown on the same day on all principal TV channels. While paid ads in newspapers are legal, they are relatively unusual in British politics. Campaign expenditures are strictly limited in Britain. This means that national advertising campaigns are effectively restricted to billboards and hoardings (posters). As a result, political campaigns in

the United Kingdom are significantly less costly than those across the Atlantic. Every campaign has an election expenses limit based on the size of the electorate of the ward or constituency in question. A candidate who spends above that set limit can be unseated on the ruling of an election court (if elected) as well as face a significant fine or even a jail term. There is also a national expenditure limit for spending by the parties. Expenditures by third parties intended to influence the results of an election are counted as an election expense and must be authorized by the candidate's agent. This, however, is an extremely rare practice.

In previous elections in the United States, political parties took in record amounts of large "soft money" contributions. Congressional candidates were supposedly limited in the contributions they could take from individuals or political action committees per election. But the increasing elasticity—laxness, to some—of election rules allowed candidates to take in unlimited sums from any source by establishing separate soft money committees that ran ads and engaged in other activities on their behalf. Because it could be given in unlimited amounts of $100,000, $250,000, or more, soft money allowed corporations, labor unions, and wealthy individuals to wield tremendous influence over the political process. With their generous contributions, soft money donors did more than support the democratic process. They were making an investment. Many hoped that their contributions would pay off in the form of favorable policy decisions or bill endorsements at some later date. Similarly, political parties, which were supposedly limited in what they spend on congressional races, could pour in unlimited amounts through issue ads, which touted or criticized a candidate's position on an issue but refrained from explicitly telling viewers to vote for or against the candidate.

However, concerns about this system gave rise to several campaign finance bills, the most prominent of which was the McCain-Feingold bill, named for its primary sponsors, Senators John McCain and Russell Feingold. The main provisions of the bill were that it barred national parties from raising soft money on the national level, restricted it on state and local levels, and increased the size of contributions that can be given directly to candidates for federal office. The bill also restricted the ability of political action committees to mention candidates by name immediately before an election. President George W. Bush signed the bill into law, and it went into effect after the November 2002 elections (Broder, 2002). Restrictions on the ability of political action committees to mention candidates by name immediately prior to an election and the provisions regarding soft money were challenged in court but narrowly upheld in 2003 by the Supreme Court. The restrictions on political actions committees were narrowed by a 2007 Supreme Court decision that permitted advertising that was not overtly advocating voting for or against a candidate.

Despite reforms, money spent on campaign advertising in the United States has been rising steadily for decades, and the 2008 race marked a quantum leap. Tallies for political ad spending in the 2008 elections have been finalized: between $2.5 and $2.7 billion were spent on political ads during that election season—up over 30 percent from the $1.7 billion spent in 2004, according to figures from the ad measurement company TNS Media Intelligence (Atkinson, 2008). Television took the lion's share—with $2.2 billion. President Barack Obama, who at one point promised to participate in the federal campaign finance system, became the first major-party nominee to bypass public financing for the general election since the system began in the 1970s. Public financing for presidential candidates is funded by a $3 tax check-off on individual tax returns; however, in 2006 fewer than 8 percent of American taxpayers used the check-off to direct money to this

fund ("Taxpayers Elect Not to Pay," 2007). Obama decided to forgo the $84.1 million he could have received in public financing for the general election, as it would have forced him to cease accepting contributions after his party's national convention in August (MacGillis & Cohen, 2008). Senator John McCain, who accepted taxpayer funds, teamed up with the Republican National Committee to share advertising costs. Obama reported that he raised more than $750 million in his campaign for the White House, easily shattering the record amounts collected four years previously by President George W. Bush and Democratic candidate Senator John Kerry combined. Obama pumped an unprecedented $240 million into TV advertising during the general election. By comparison, Senator John McCain spent about $126 million. The previous TV ad record of nearly $190 million was set by Bush in 2004 (Schouten, 2008). During the final weeks of the 2008 federal election, Obama clearly overwhelmed McCain on the spending front, but the final round of campaign finance reports laid bare just how big the gap was. Obama and the Democratic National

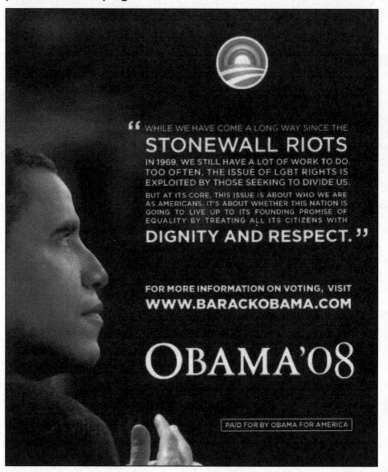

Figure 4.1: Print advertisement from the 2008 Obama presidential campaign

Committee spent more than $161 million from October onward, the vast majority of it raised by the campaign (see Figure 4.1 for an advertisement from the Obama campaign). By comparison, McCain and the Republicans spent $75 million. Obama's 2 to 1 advantage was buoyed by a late surge in contributions—the campaign reported receiving $104 million after October 15, bringing its total fund-raising for the entire campaign to nearly three-quarters of a billion dollars. The Obama campaign reported its money came from some four million donors. Obama's fund-raising success, and the advertising clout it provided him, makes it increasingly unlikely that future candidates will rely on public funds.

Content Issues

Given the general hostility of international law to prior censorship of any kind, there is a strong bias against attempts to control the content of political advertising in many countries. This is certainly the case in the United States. While product advertising is highly regulated, politi-

cal speech is protected by the First Amendment to the Constitution. Thus, under existing laws, control of the content of political advertisements would be considered a curtailment of freedom of expression. Many critics argue that because of the complete lack of regulation of this form of advertising, campaigns that are deceptive, misleading, or at the very least in bad taste are often the result. Undoubtedly, if manufacturers made similarly inflated and outrageous claims on behalf of their products, the Federal Trade Commission (FTC) would likely take immediate action.

Venezuela is another country that in most respects has an extremely unregulated system of political advertising. Yet, the Supreme Electoral Council (SEC) has the power to order the withdrawal of an advertisement that is not in "good taste" or that significantly misrepresents the position of the opponent. In Costa Rica the Supreme Election Tribunal can order a negative political advertisement off the air if it comprises a personal or unverifiable attack. In one such case, an advertisement suggested that the incumbent candidate's law degree was acquired illegally. The tribunal halted the broadcast of the advertisement after a single airing (Ace Project, 2002).

The concept of negative advertising in political campaigns has been hotly debated over the past few years. The term "negative advertising" is really a surrogate for "attack ads," which are just one form of campaign advertising. Political ads can be classified more accurately as being one of three ad types: attack, advocacy, or contrast. Attack ads focus on the opponent's liabilities and faults. Advocacy ads highlight a candidate's positive aspects. Comparison or contrast ads are spots in which the candidate makes claims both in favor of their own candidacy and in criticism of the opponent (Kolodny, Thurber, & Dulio, 2000). The debate over negative advertising centers on several issues:

- whether negative advertisements are better remembered by the public than positive ads;
- whether they are informative and influence voter decisions;
- whether they are factually misleading;
- whether they suppress voter turnout.

In terms of negative advertising's impact on memory, Garramone (1984) reported that nearly 60 percent of her survey respondents were able to recall the name of a sponsor or target of an attack ad. Merritt (1984) reported that 51 percent of her sample remembered seeing negative billboard ads. Johnson-Cartee and Copeland (1989) found that even after an election, two-thirds of survey respondents could recall and describe at least one negative political ad. Lang (1991) also reported that attack ads were recalled better than support ads. More recently, a study undertaken by Bradley, Angelini, and Lee (2007) found scientific evidence that negative political ads have both physiological and psychological effects on consumers. Focusing on the pre-attentive reflex of the eye known as the startle reflex, they found that those exposed to negative political messages experienced larger reflex reactions, indicating a greater desire to move away than when exposed to positive or neutral ad messages. It appears this is the very beginning of the primal fight-or-flight response and the body's physical reaction is to move away. Yet at the same time, viewers remembered the negative ads because their brains found them arousing. As viewing the ads is not perceived as a life-or-death situation, the brain has time to store the content of the messages.

There appears to be considerably less consensus regarding just how informative negative ads are. Garramone, Atkin, Pinkleton, and Cole (1990) found that negative commercials may be more informative than their positive counterparts. The informativeness of negative commercials was most evident when the commercials provided a contrast to the opponent's positive advertising or lack of advertising. However, the effect was somewhat less when both candidates attacked each

other compared to when only one attacked but was still greater than both positive advertising conditions. However, in a later study, Pinkleton and Garramone (1992) found that 72 percent of their respondents indicated attack political advertising to be "not very informative" or "not at all informative." And Roberts (1992) reported that on the average, people were between "disagree" and "disagree strongly" in response to "I find political ads that attack the opposing candidate to be very helpful in voting."

Some studies have concluded that regardless how informative negative ads are, they are nonetheless effective (Pinkleton, 1997; Faber, Tims, & Schmitt, 1993). Weigold (1992) concluded that while positive political messages raise the evaluations of the sponsoring candidate, negative political messages lower the evaluations of the targeted candidate. Weaver-Lariscy and Tinkham (1999) reported a sleeper effect. Their results indicated that a defensive ad following a negative message is initially effective; however, over a period of several weeks, the impact of the attack ad increases substantially. Similarly, an initial perception that the assailant has low credibility has only a temporary suppressive impact on the effectiveness of the attack or negative ad. More recently, a field study of young registered voters (aged 18–23) revealed that negative "attack" ads provoked more voter migration than positive ads (Phillips, Urbany, & Reynolds, 2008). The researchers, who used real ads from the 2004 U.S. presidential election, found that although negative political ads are explicitly disliked, they have a powerful impact on voters' mind-sets, which positive ads do not, and thus have the potential to change preferences in ways that benefit the advertiser. Negative ads apparently caused voters to both strengthen their resolve and to move away from the candidate they initially supported. More specifically, after viewing an ad that attacked their favored candidate, about 14 percent of voters "dug in their heels" and indicated stronger support for their favored candidate, who had been the subject of the attack. However, and perhaps more important, the researchers also found that 14 percent of young voters—after viewing an ad that attacked their preferred candidate—were influenced by the ad's content and weakened their support, moving in the direction of the advertised candidate. Viewing positive ads did not lead to significant voter movement. Overall, the findings suggest that there are potentially costs to as well as potential returns from running negative campaigns.

Other studies have concluded that negative political advertising is not effective or may produce only negative effects (Garramone, 1984; Merritt, 1984; Roddy & Garramone, 1988). Hill (1989) found that negative political ads had little impact on evaluations of the targeted candidate but produced negative evaluations of the sponsoring candidate. A study undertaken in the United Kingdom (Centaur Publishing, 2001) found that for every person who said that ads criticizing other political parties persuaded them to vote for the party responsible for the advertising, another five found such ads so irritating they actually made them vote against that party. But even on the issue of a backlash effect, the evidence is mixed. A study by Pinkleton (1997) found that evaluations of the sponsor became more positive when a moderately negative ad was presented but declined when a particularly negative ad was used. Roddy and Garramone (1988) concluded that a backlash effect was dependent on how the targeted candidate responded to the attack. In an investigation using data from tracking polls in a statewide election, Sonner (1998) found negative political ads can generate a serious backlash against the sponsoring candidate, particularly if the ads involve a highly personal attack not directly linked to a specific issue. Weigold (1992), in contrast, found "little evidence for any kind of boomerang effect."

In a survey of political consultants, Kolodny, Thurber, and Dulio (2000) found that 75 percent felt that negative advertising contributed a great deal or a fair amount to voter cynicism. Still, consultants did not think negative advertising accounted for as much voter cynicism as the news media's coverage of politics (91.5 percent) or politicians' poor performance in office (79 percent). When asked to identify examples of serious ethical problems in campaigns, 33 percent of consultants volunteered some form of negative campaigning. Though negative advertising was the most frequently mentioned, many other issues were mentioned as well. The most common complaint with negative advertising was the idea that false or misleading information was used in the ads. More of a gray area is the practice of making statements that are factually true but taken out of context. Sixty percent of consultants said this was a questionable practice. Not surprisingly, 98 percent of consultants said that producing contrast ads was an acceptable practice. Consultants were about evenly split on the evaluation of the practice of using negative ads to decrease turnout among certain groups or regions. However, consultants were split on the question of whether the use of negative advertising is on the rise (50 percent) or about the same as it has been (45.1 percent) (Kolodny, Thurber, & Dulio, 2000).

Alternatively, an investigation of voters conducted by Pinkleton, Um, and Austin (2002) found that although negative advertising is indeed perceived negatively and contributed to short-term disgust with campaigns, the results suggest that this strategy does not automatically increase cynicism or citizen apathy. What is clear is that there is no shortage of such negative ads. During the period 1952–2004, candidates averaged 40 percent attacks in their ad statements. During the 2004 race for president, 64 percent of the Bush campaign ads were negative versus 34 percent from the Kerry campaign (Teinowitz, 2008). But it appears that the 2008 race was one of the most negative in history. A University of Missouri study revealed that in this most recent race, the statements in Obama's ads were 68 percent negative compared to 62 percent for Senator John McCain. It appears the only campaign in history that matched this level of negativity was the first ever presidential TV spot campaign when Dwight D. Eisenhower had negative attacks in 69 percent of his ad statements (University of Missouri-Columbia, 2008).

Curtis Gans, head of the Committee for the Study of the American Electorate, noted that the United States is 139th out of 143 democracies in the rate of voter turnout (Whitley, 2001). There are several plausible reasons for this dismal public participation, but some researchers have suggested that the tendency to accentuate negative appeals turns people off, not only from the candidates but from the entire process. In a series of controlled experiments, researchers at the University of California, Los Angeles, found that exposure to negative rather than positive ad campaigns actually keeps people from voting (Iyengar, 1999). Their work spanned the full range of electoral contests. In study after study, the researchers found that negative advertising made voters significantly less likely to feel that their opinions mattered, or that elections made any difference, and most important, made them disinclined to vote (positive ad campaigns had exactly the opposite effect). This demobilization effect is not a result of voters becoming more disenchanted with the target of the attacks, nor is it a product of backlash against the attacker. Rather, voters simply dislike negativity and withdraw accordingly. As might be expected, people with no ties to the political parties are especially repelled by the tide of negative advertising.

However, it may be a mistake to infer that attack ads depress voter turnout. The results of a number of recent investigations suggest that alarm bells sounded by some previous research and by public officials may be exaggerated and that political negativity may indeed have a positive

effect on turnout. Negative ads typically incite anger or anxiety, both of which stimulate attention and engagement. And, where attention leads, response follows. Human beings have been honed to react more to negative information, and when voters dislike a candidate, they are more likely to cast their ballot (Begley, 2008). Goldstein and Freedman (2002), Djupe and Peterson (2002), and Niven (2006) suggest that negative campaign charges are just as likely to engage potential voters, leading to a stimulation effect when it comes to turnout. Despite promising during the primaries to run a different, positive campaign, as noted above, Barack Obama relied heavily on negative political messages in the 2008 presidential campaign. And it may well have paid off. Reports show that 62 percent of eligible voters turned out in the last presidential election—a 40-year record. Comparable turnout has not been seen since the Eisenhower, Kennedy, and Johnson elections of the 1950s and 1960s ("Voter Turnout," 2008). Granted, there were several unique aspects of the 2008 election, including the fact that the election was the first in which an African American ran for president, that it was the first time two senators ran against each other, and that it was the first time in 56 years in which neither an incumbent president nor a vice president ran. However, it just might have been all those negative political ads that mobilized citizens to go out and vote.

ADVERTISING AND THE REGULATORY ENVIRONMENT

The main purpose of government regulation is to protect the interests of a society from unbridled business behavior. "Some firms, if left alone, would adulterate their products, tell lies in their advertising, deceive through their packages, and bait through their prices" (Kotler et al., 1999, p. 175). While laws in the developed countries generally protect consumers from most of these practices, there still exist areas in the less developed parts of the world where consumer protection is lacking. Next, we examine how government regulation of advertising operates in different parts of the world.

ADVERTISING REGULATION

Many nations gained their independence from Western colonial powers only in the past 65 years. Creating a coherent sense of national identity and validating the local or national culture remain a primary concern in many parts of the world. Thus, advertising regulations are often driven by local cultural and social factors.

To understand how advertising regulation operates around the world we should understand that only 25 percent of the world's population can access mass media that are free of direct government control and intervention (Merrill, 1995, p. 70). Five main political/economic systems operate in the world; each has its own policies and structures for dealing with the media. Broadly, these systems are the libertarian/capitalist (e.g., the United States), socialist/capitalist (e.g., Japan, Australia, Singapore, and Britain), authoritarian/capitalist (e.g., Brazil, Thailand, and Malaysia), sectarian/authoritarian/capitalist (e.g., Saudi Arabia and Iran), and communist/planned economies (e.g., Russia and Vietnam). A country's advertising regulatory structure should be seen as a part of its overall political/economic system (Frith, 2002).

The sole libertarian/capitalist system—the United States—advocates complete freedom of speech and regulates the advertising industry only in the areas of deceptive advertising and illegal-product advertising. Industry "self-regulation" is the norm in this system.

Socialist/capitalist systems (e.g., Western Europe, Japan, Canada, Australia, and New Zealand) put more emphasis on social responsibility and hence have stricter rules to curb advertising deemed socially irresponsible. Industry self-regulation is also typical of these countries—even though the government may have established some advertising codes. Social responsibility plays a large part in the regulations of these countries. For instance, in Australia beer advertising cannot feature people engaging in adventurous sports—like car racing or boating—because this would imply that it was permissible to drink and drive.

Authoritarian/capitalist states (e.g., Malaysia, Brazil, Mexico, and Thailand) often have a tight grip on the advertising industry to ensure that it conducts itself in ways that conform to the sociocultural and political order. For example, Thailand cannot show Thais kissing in advertising because in the culture public displays of emotion are considered unacceptable.

Almost all sectarian states are authoritarian by nature (e.g., Saudi Arabia and Iran). They have strict social, cultural, and religious rules that must be observed by all media as well as the advertising industry. Freedom of speech exists according to the rules set by the political rulers and is further defined by local religious beliefs. In Saudi Arabia and Iran, for example, strict religious rules are followed for portraying women in media and advertising.

In a pure communist system (e.g., China and Vietnam), advertising would not be allowed. In fact, advertising was banned in China during the Cultural Revolution and in Vietnam after the Vietnam War. In the 1980s, however, as these countries gradually opened up to the global marketplace, both China and Vietnam began to permit advertisements. Indeed, so much has changed in China, in particular, that predictions suggest this country will overtake Germany in 2010 to become the world's third-largest advertising market, trailing only the United States and Japan (Madden, 2008).

Now we look at advertising regulation in several selected countries. We examine the spectrum of advertising regulation, starting with two Western markets—the United States and the United Kingdom. Next we examine two Eastern markets, first an economically highly developed country—Japan, and then Vietnam, a rapidly developing marketplace. Finally, we look at some of the regional bodies that are setting guidelines for advertisers.

United States

The United States—the sole libertarian/capitalist system—advocates nearly complete freedom of speech but still regulates the advertising industry—primarily in the areas of unfair methods of competition, illegal-product advertising, and deceptive advertising. While the freedom of non-commercial speech is afforded the widest possible protection under the First Amendment to the U.S. Constitution, historically U.S. advertising has been held to somewhat stricter standards. But in 1980, the U.S. Supreme Court held, in *Central Hudson Gas & Electric Corp. v. Public Service Commission,* that commercial speech regarding lawful activity that is not misleading may only be regulated when the government can show a substantial cause for regulating the speech. The trend in more recent cases has been to afford increasingly complete constitutional protection to commercial speech.

Several different U.S. government agencies have been given the power and responsibility to regulate advertising. The Federal Trade Commission (FTC) is the most widely empowered agency. The FTC's role is to regulate interstate and national advertising to ensure a free marketplace based on the dissemination of complete, truthful, and nondeceptive advertising to the buying public.

If the FTC decides that deception has indeed taken place, it moves quickly to stop the practice. The agency issues a consent decree that requests the advertiser to stop the objectionable campaign. By signing the consent decree, advertisers are not thereby admitting wrongdoing. Firms that fail to comply with the decree and the subsequent cease-and-desist order may be fined, and the FTC may require corrective advertising if it decides that a campaign has established lasting false beliefs. Under this remedy, the FTC orders the offending advertiser to create messages that correct any false impressions in the minds of consumers that could be attributed to their advertising.

Central to FTC enforcement is the concept of substantiating and documenting advertising claims. Advertisers must be prepared to prove, with objective supporting data, that the claims made in their advertising messages are indeed true. If a claim has not been reasonably substantiated before being disseminated to the public, then it is considered unlawful whether or not the FTC is able to prove it is false.

Other U.S. government agencies regulating advertising include the Federal Communications Commission (FCC, which prohibits obscenity, fraud, and lotteries on radio and television); the Food and Drug Administration (FDA, which regulates the advertising of food, drug, cosmetic, and medical products and prohibits false labeling and packaging); the Securities and Exchange Commission (SEC, which regulates the advertising of securities and the disclosure of information in annual reports); the United States Postal Service (which is responsible for regulating direct mail advertising and prohibiting lotteries, fraud, and misrepresentation in the mail); and the Bureau of Alcohol, Tobacco, and Firearms (which has the power to determine what constitutes misleading advertising in these product areas) (O'Guinn, Allen, & Semenik, 1998).

Self-regulation is the industry's attempt to police itself. In addition to avoiding government-mandated regulation, self-regulation in U.S. advertising generally has three objectives:

- to protect consumers against false or misleading advertising and against advertising that intrudes on their privacy through its unwanted presence or offensive content;
- to protect legitimate advertisers against false or misleading advertising by competitors;
- to promote the public acceptance of advertising so that it can continue as an effective institution in the marketplace (Rijkens & Miracle, 1986).

In the United States, the most comprehensive self-regulatory organization is the National Advertising Review Council, which was established in 1971 by several professional advertising associations in conjunction with the Council of Better Business Bureaus. The main purpose of the council is to promote and enforce standards of truth, accuracy, taste, morality, and social responsibility in advertising. The operating arms of the National Advertising Review Council are the National Advertising Division (NAD) and the National Advertising Review Board (NARB).

NAD is staffed by lawyers whose job is to evaluate complaints submitted by consumers, consumer groups, industry organizations, and competitors, as well as to examine referrals from local Better Business Bureaus and other local organizations. NAD also conducts its own industry monitoring. After NAD receives a complaint, it asks the advertiser to substantiate the claims made in the commercial message. If the substantiation is subsequently deemed inadequate, NAD requests that the advertiser modifies or withdraws the offending ad. If a satisfactory resolution

cannot be found, NAD refers the case to NARB. As an added encouragement for advertisers to comply, NAD makes its decisions public.

The 70 members of NARB represent national advertisers and advertising agencies as well as the public sector. A five-member panel assigned to each case reviews the complaint and the NAD's findings. In addition, the advertisers are permitted to present their case. If NARB concurs with NAD's decision, yet the advertiser still refuses to comply, NARB may refer the case to the appropriate governmental agency (usually the FTC).

While NAD and NARB are not empowered to order an advertiser to stop running a campaign or to impose any fines, the threat of appearing before the board acts as sufficient deterrent to most advertisers perpetuating—or even considering—deceptive or misleading advertising practices. This, along with the threat of negative publicity, means that only a small number of cases end up being referred to NARB for resolution.

Various ad industry associations have established voluntary guidelines for their members regarding advertising content. One of the most widely recognized industry standards of practice is that of the American Association of Advertising Agencies (AAAA). Founded in 1917, the AAAA is the national trade association representing the advertising agency business in the United States. Its membership produces approximately 80 percent of the total advertising volume placed by agencies nationwide. The AAAA Creative Code, which was first adopted in 1924—and most recently revised in 1990—promotes high ethical standards of honesty and decency in the creation of commercial messages. Their standards of practice and creative code can be accessed at http://www2.aaaa.org/about/association/Pages/standardsofpractice.aspx.

Other associations promulgating rules for self-regulation include the American Advertising Federation and the Association of National Advertisers. In addition, media associations (such as the National Association of Broadcasters, the Direct Marketing Association, and the Outdoor Advertising Association of America) are involved in monitoring advertising content. Individual media are also responsible for evaluating the advertising they receive for broadcast or publication. They may reject advertisements deemed deceptive, offensive, or even contrary to what they regard as "public standards." Finally, industry associations (such as the Wine Institute, the United States Brewers Association, and the Pharmaceutical Manufacturers Association) have established guidelines for advertising within their specific industries.

United Kingdom

Self-regulation of advertising plays an even more dominant role in the United Kingdom than it does in the United States. Self-regulation of nonbroadcast advertising began in the United Kingdom in 1961, when the Advertising Association established what became the Committee of Advertising Practice (CAP), the industry body that sets the rules for advertisers, agencies, and the media. CAP revises and enforces the British Code of Advertising, Sales Promotion and Direct Marketing. In 1962, the industry established the Advertising Standards Authority (ASA) under an independent chairperson, to adjudicate on complaints about advertising that appeared to breach the code. That same year, an official report on consumer protection by the Molony Committee rejected the case for an American-style Federal Trade Commission to regulate advertising by statute. The committee reported, "We are satisfied that the wider problem of advertising ought to be, and can be, tackled by effectively applied voluntary controls. We stress, however, that our conclusion depends on the satisfactory working of the new scheme, and in

particular, on the continued quality and independence of the ASA at its pinnacle" ("History of Ad Regulation," 2009).

The ASA's advertising standards codes are separated into codes for TV ads, radio ads, and all other types of ads. There are also rules for Teletext ads, Interactive ads, and the scheduling of TV ads (the codes can be read in full at http://www.asa.org.uk). The codes include specific rules for product categories (such as alcoholic beverages, and health and beauty), specific audiences (such as children), and marketing techniques (such as the use of environmental claims and prize promotions). The main principles of the advertising standards codes are that ads should not mislead, cause harm, or offend. Much as in the United States, advertisers must be able to prove the claims they make if challenged. The ASA regulates the contents of advertisements, sales promotions, and direct marketing both by monitoring ads to spot problems and by investigating complaints received.

A number of detailed case studies on the ASA's Web site provide insight into the process. One such case deals with a billboard for Opium, a perfume produced by Yves Saint Laurent Beauté. The billboard featured a woman laying naked on her back, with just one breast covered. The Opium ad had been placed in women's magazines for nearly six months prior to being featured on a billboard. During that period, it received only four complaints, and although they were investigated, the ASA deemed the ads to be in an appropriate medium. However, once the images appeared on billboards, they became the second most-complained-about ad of all time—with 948 complaints. Criticisms focused on the offensive imagery, the degradation of women, and the unsuitability of the ad in a public place. The ASA invited the advertiser to respond to the complaints. Yves Saint Laurent Beauté, Ltd., explained that it believed the image to be sensual and aesthetic and had not intended to offend the public. Nonetheless, the ASA Council came to the conclusion that the billboard was sexually suggestive and likely to cause serious or widespread offense. The advertiser was told to withdraw the ad immediately. As a consequence of the adjudication, Yves Saint Laurent Beauté, Ltd., had to pre-clear all Opium perfume billboards with the CAP Copy Advice team for a period of two years. International marketers are encouraged to consider that in terms of taste, what might hardly raise the eyebrows of consumers in one market, could quite possibly shock the sensibilities of consumers in another.

Consequences for advertisers who flout the rules can be quite serious—adverse publicity may result from the rulings published by the ASA weekly on its Web site. Further, advertisers can be denied access to newspapers, magazines, poster sites, direct mail, or the Internet. The ASA may also mandate that a marketer's ads must be pre-cleared prior to dissemination to the media—as in the case of Yves Saint Laurent Beauté, Ltd., above.

Since 1988, self-regulation has also been backed up by statutory powers under the Control of Misleading Advertisements Regulations. The ASA can refer advertisers who refuse to cooperate with the self-regulatory system to the Office of Fair Trading (OFT) or Ofcom—the regulatory body for the communications industry—for legal action. For instance, the ASA might refer an advertiser, agency, or publisher to the OFT if they persistently run misleading ads that breach the codes. Or, they can refer a broadcaster to Ofcom if a licensee is not abiding by the rules. However, this is considered a last resort and is rarely employed. The partnership between CAP, which writes the code, and the ASA, which adjudicates complaints, is the strength of the United Kingdom's self-regulatory system. CAP interprets ASA rulings to the industry and helps advertisers to comply with the code through "Copy Advice" and "Help Notes." Today—almost

five decades after CAP was established—advertisers in the United Kingdom overwhelmingly comply with the code.

Several additional bodies help to keep advertising standards high in the United Kingdom. Clearcast (previously the Broadcast Clearance Centre) pre-checks ads on behalf of television broadcasters before they go on the air—eliminating almost all problems before transmission. The radio Advertising Clearance Centre pre-checks national radio ads and ads for specific categories before they are aired. And the CAP Copy Advice team provides a pre-publication advice service for the ad industry to avoid problems with ads in other media.

Two regulations have just come into force in the United Kingdom that will provide consumers and businesses even greater protection from misleading advertising and clamp down further on other dishonest marketing activities. Both enable courts to fine companies and their directors and managers up to £5,000 (currently about US$ 8,200) for breaking the rules. The most serious violations could even lead to a two-year prison sentence. The first piece of legislation—the Consumer Protection from Unfair Trading Regulations 2008—aims to prevent firms from deceiving the public with advertising campaigns or unduly pressuring them into buying their products. It lists 31 practices that will always be considered "unfair." These include saying that the product is "free" when it is not, telling a consumer that if he or she does not purchase a product or service, the advertiser's or salesperson's livelihood will be in jeopardy, and claiming that a product has a quality mark when it does not. "For the first time, the manner in which a sale is being achieved is as relevant a concept as the content of an advert or pitch," notes Susan Hall, a partner at the British law firm Cobbetts. "This means that the hard sell so beloved of the typical used-car salesman will now become a criminal offence" (Hodge, 2008/2009). The legislation will likely put an end to questionable marketing practices. For instance, the exhortation to "buy now while supplies last" is potentially risky, as it has become a criminal offense to falsely state that a product will be available for only a limited time. And, "buy one, get one free" offers could fall afoul of the law, as well.

The second law—the Business Protection from Misleading Marketing Regulations 2008—bans advertisements that mislead and places strict controls on comparative campaigns. It also prohibits companies from presenting imitations or replicas of products bearing a protected trademark or of taking unfair advantage of the reputation of competitor's trademarks, brand names or country-of-origin information. For example, in Britain, supermarkets' house-brand look-alikes have long been the bane of major brands. The new legislation makes it an offense to promote a look-alike product with the intent of deliberately misleading consumers into believing a product is made by another manufacturer. Some are complaining that the rules are so wide-ranging that even reputable advertisers must ensure they are not breaking the law in the United Kingdom.

Japan

It took the Japanese a little over two decades to transform their war-ravaged country into one of the world's most affluent. While the country is also suffering from global economic crisis, most foreign economists would agree that Japan—the world's second largest economy—remains the main force driving Asia's economy.

Japan's rapid rise and its current economic strength are to some extent due to the impact of the United States on its industry and economy. Immediately following World War II, Japan's policies were influenced by the United States, as the major economic player in the Allied occu-

pation force. The United States provided the basic direction for the postwar reconstruction of the Japanese economy. With U.S. guidance, the Japanese set up a free trade system and enacted a series of measures, including an Anti-Monopoly Act that promoted fair and free competition by excluding monopolies and unfair business practices. By the mid-1960s, Japan had attained one of the highest economic growth rates in the world and had achieved the second largest GNP in the world by 1968.

U.S.-based advertising agencies started operating in Japan in the late 1950s. J. Walter Thompson was the first to open a Japanese branch, in 1956, followed by McCann-Erickson, Grey, BBDO, and Young & Rubicam. These agencies joined the major Japanese agencies, such as Dentsu, Hakuhodo, and Asatsu (Inoue, 1996).

Today, Japan is the second largest market after the United States in terms of total advertising expenditures. Japan's top five agencies are, in rank order, Dentsu, Hakuhodo, ADK, Daiko, and Tokyu. The largest three control 65 percent of media billings. Dentsu alone commands over one-fourth of Japan's advertising market (Madden, 2009), working with some 6,000 clients. By comparison, the industry's largest holding company, Omnicom, works for 5,000-plus clients across all of its properties (O'Leary, 2007). In terms of worldwide advertising billings, both Dentsu and Hakuhodo have been among the top ranking agencies worldwide for the past 10 years.

Because of U.S. postwar influence, advertising regulation in Japan is very similar to that of the United States. It is primarily based on the Anti-Monopoly Act and the Act Against Unjust Premiums and Misleading Representations. These laws prohibit misleading or false indications in advertising. The Ministry of International Trade and Industry (MITI) and the Japan Fair Trade Commission are the major authorities concerned with the advertising industry, and these bodies are responsible for enforcing the regulatory acts. These two bodies act in much the same way as the Federal Trade Commission does in the United States; that is, they do not censor or review advertising but act on complaints from competitors or complaints brought to their attention by staff members. These agencies have broad powers to pursue suspected violators and demand information from them in the way of substantiation of claims, endorsements, and product warnings and limitations.

As in the United States, complaints by consumers about individual advertisements are generally referred to a self-regulatory board. The Japanese self-regulatory organization that reviews consumer complaints is JARO (Japan Advertising Review Organization). JARO consists of representatives of advertising agencies, the media, and advertisers. Their activities include:

- receiving and processing inquiries and complaints concerning advertisements and representations;
- monitoring and giving guidance on advertisements and representations;
- compiling standards for advertisements and representations;
- promoting cooperation and linkages between advertisers, media, and advertising agencies;
- liaison work with consumer groups and administrative offices;
- education and PR activities for companies and consumers;
- establishing a role as an information center, and other tasks that may be deemed necessary (Inoue, 1996).

Much like the American Association of Advertising Agencies, the Japan Advertising Agencies Association's objectives include promoting the sound development of the advertising business and enhancing advertising activities. Member agencies account for approximately 70 percent of

Japan's total advertising expenditures. Much like the AAAA's Creative Code, the JAAA's Code encourages truthful advertising that complies with laws and regulations, and respect for human rights. However, the JAAA's Code also notes:

- Advertising must not work against sound social order or good customs of the society.
- Advertising must esteem grace and dignity to contribute to the establishment of sound and healthy life of the people.
- Advertising should give joy and excitement to the minds of the people through the relentless pursuit of creativity.
- Advertising should maintain dignity, and avoid expressions that may cause unpleasant impressions (http://:www.jaaa.nc.jp/engligh/introduction/5.html).

Although the U.S.-influenced Japanese constitution guarantees freedom of speech and expression, no established precedent says this freedom is applicable to advertising. Aside from the basic legal restrictions, advertising is guided by various customs and unwritten rules based on the cultural values held by the majority of the Japanese. These include indirect speech, using words or expressions with positive connotations, and avoiding words with negative connotations (Inoue, 1996).

The Japanese tend to use indirect speech rather than straightforward statements, even when they hold distinct opinions about something. And the Japanese rely on indirect phrases or euphemisms, and these roundabout ways of expression are generally considered more appropriate for polite conversation. The same holds true for advertising. Unlike Western ads that state the benefit in the headline, the "soft-sell" approach has historically been more common in Japan. Comparative advertising, which is quite common in the United States (and, in fact, encouraged by the Federal Trade Commission), has only recently become legal in Japan because of the cultural value of indirectness. To criticize a competitor in public was considered quite inappropriate. As Inoue (1996) notes, "The Japanese believe it is better for advertisers to be modest and cautious, so that their advertisements are not regarded as slanderous to their competitors" (p. 26). The Japanese prefer emotional and ambiguous expressions, and advertisers tend to demonstrate their comparative advantages in humorous or roundabout ways instead of identifying their competitors directly (Inoue, 1996).

Figure 4.2: Japanese ad for Kewpie Mayonnaise that employs the soft sell approach

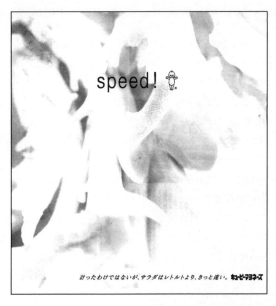

Rather than boasting about the benefits of the product, which would be seen as "putting oneself before the competition," the Japanese tend to use indirect speech and words that have positive connotations. Much of Japanese advertising is so soft a sell that it is often difficult to determine what the product is from viewing the ad. For example, a quick glimpse at the Japanese advertisement in Figure 4.2 would probably not reveal that this is a message promoting mayonnaise. Indeed, even reading the copy probably would not help much. The headline (in English) is simply, "Speed." The

single line of body copy tells the consumer that salads are as quick to prepare as prepackaged foods. The only hint that this is an ad for Kewpie Mayonnaise is the trade figure in the center of the ad and the product name in the lower right-hand corner. The suggestion that salads be prepared with Kewpie Mayonnaise is only implied.

Unlike many countries in Asia, Japan does not use censorship to control advertising content but prefers to let the industry regulate itself. The United States and Japan are similar in this and several other regards, which is hardly surprising considering the key guiding role the United States played in Japan's post–World War II reconstruction. As in the United States, Japanese government agencies dealing with advertising were not set up to censor or review individual advertisements but rather to investigate major concerns with the behavior of the corporations. As we shall see, in the case of Vietnam, this *laissez-faire* attitude to advertising is not a position held by all countries in Asia.

Vietnam

In a society that features a "free-market" economy—the United States, for example—advertising is viewed as an essential tool in building a healthy economy (Jeffreys, 1997). However, Vietnam's history and political ideology have shaped a very different perspective on the appropriate role of advertising. The Vietnamese government states its mission as follows:

> To build a socialist state of the people, by the people and for the people, with the alliance of the working class, the peasantry, and the intelligentsia as the foundation and the Communist Party as the leadership. To fully observe the right of the people to be the master, strictly maintain social discipline, exercise dictatorship toward all infringements upon the interest of the Homeland and the people. (Parry, 1996)

After the Vietnam War, advertising in the mass media was banned. Advertisements only began to reappear around 1990 when the economic reforms of *doi moi* were initiated. The government initially took a liberal attitude toward advertising. In December 1994, the government published its first set of directives for the advertising industry. The regulations were essentially to protect the national language and culture. Nonetheless, the government continued to hold advertising in low regard. At the Eighth Congress of the Communist Party in 1996, speaker after speaker "warned against the capitalistic 'social evils' threatening Vietnamese society and the need to stamp out all manifestations of 'fanatic democratism' and multi-party politics" (Parry, 1996). Among the so-called social evils identified by the government were prostitution, gambling, illicit drugs, and the Western-based practice of advertising (Mydans, 1996).

Initially, multinational ad firms were only allowed to do business in Vietnam if they formed an alliance with a Vietnamese agency. But this limitation did not keep U.S. agencies from dominating the tiny Vietnamese ad industry. U.S. agencies moving into the market included J. Walter Thompson, Leo Burnett, and Ted Bates Worldwide. Nonetheless, governmental policies dictated that Vietnamese executives were to be represented in these offices. Foreign agencies were once subject to government raids, offices were reportedly tapped, and agency staff tailed as the state battled to come to grips with the nature of the communications business (Silk, 2007). Restrictions were subsequently loosened, first allowing foreign agencies a 49 percent equity stake in joint ventures, and then in 2006, the cap was increased to 51 percent. Vietnam officially joined the World Trade Organization in 2007, and must now fall in line with its obligations. As such, ad agencies may be 100 percent foreign owned beginning in late 2009 (Hicks, 2008).

More detailed regulations were outlined in the Ordinance on Advertising, which became effective in 2002. While some areas of advertising regulation remain vague and hard to enforce, others like the use of Vietnamese language are strictly enforced. The spoken or written text of an advertisement must be in Vietnamese, except in the cases of internationally known words, commercial names, or words that cannot be translated into Vietnamese. And advertisements in printed media are permitted to be published in a foreign or ethnic minority language or in radio and television programs in a foreign or ethnic minority language. As shown in Figure 4.3, the billboard for Lipton Tea uses some English words.

Advertisements must also abide by the public morals and customs of the Vietnamese. The Ordinance on Advertising strictly prohibits the following:

- Advertising which discloses state secrets, or which harms national independence and sovereignty, defense, and security or the safety of society.
- Advertising which is contrary to the traditions, history, culture, ethics, or fine customs of the Vietnamese people.
- Using the national flag, flag of the party, the national emblem, the national anthem or its melody, portraits of leaders or of Vietnamese dong, or images or traffic signals or traffic notices for advertising.
- Advertising which has an adverse effect on urban beauty, landscape and the environment, and traffic order and safety.
- Advertising which arouses violence, which is shocking or which uses unhealthy language.

Advertising executives complain that there is no centralized censorship body to approve advertising concepts and that they have to spend the money to produce ads first, only to find out later if the ads can be used. Television stations and print media are all government sanctioned and can directly censor the ads they carry, seeking advice from the Ministry of Culture and Information when they are unsure of an ad's suitability ("Foreign Advertising Agencies in Vietnam," 1995). Ads may also be pulled as a result of consumer complaints. For example, a shampoo ad in which a woman says she likes her man to touch her hair was taken off the air after a single complaint. "Vietnam is conservative, culturally-aware, and patriotic. There are some things you just don' write about. But it's hard to tell what is taboo. There is no rule book and rules tend to change a lot," notes David Smail, ECD of BBDO Vietnam and a veteran of the local ad scene (Hicks, 2008).

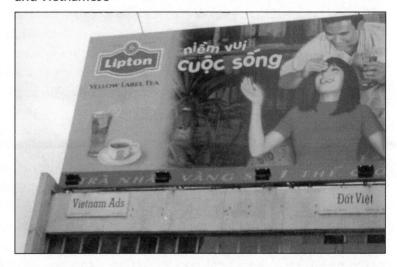

Figure 4.3: Lipton Tea billboard employing both English and Vietnamese

The population of Vietnam is one of the fastest growing in the world. It is potentially a huge consumer market, but the government's 10 percent tax on advertising expenditures, along with

their arbitrary interpretation and enforcement of regulations, may slow the development of the advertising industry in this country. Yet, for most multinationals, the opportunities continue to outweigh the obstacles.

BEYOND THE NATIONAL—REGIONAL AND INTERNATIONAL REGULATION

The European Union

In December 1992, 12 European nations—Belgium, France, Germany, Italy, Luxembourg, the Netherlands, Denmark, Ireland, United Kingdom, Greece, Spain, and Portugal—banded together to form the European Union (EU). Their first goal was to create a single, unified European market. In 1995, Sweden, Austria, and Finland joined, bringing the total to 15 members. By 2004, Poland, Hungary, the Czech Republic, Slovakia, Slovenia, Lithuania, Latvia, Estonia, Cyprus, and Malta had also joined. Most recently, in 2007, Bulgaria and Romania became members of the EU, bringing the total number of member states to 27. By lifting most physical, fiscal, and technical barriers to free trade among nations, the EU hoped that people, products, and services would be able to move among member nations with much the same ease as they cross U.S. state borders.

In 1984, the precursor to the European Union adopted legislation that went into effect in 1986, setting forth guidelines and standards for the protection of both consumers and businesses from misleading advertising. While it laid out a series of guidelines for determining unfair or deceptive advertising, Article 7 of the legislation nearly undermined the entire effort by stating that individual nations were not precluded from keeping or adopting provisions that would furnish more extensive protection for consumers, businesses, and the public. This served to put advertising regulation right back into the hands of member states.

Despite efforts to standardize EU advertising regulation, advertising differences across the European Union have been legion. Though minimum criteria regarding truth in advertising were established by the European Commission (EC), specific laws against misleading advertising differ widely from member state to member state. Audiences that may be appealed to and approaches that may be employed in advertisements are not uniform, causing endless headaches for international marketers. For example, Sweden, recognizing that children under 10 are incapable of telling the difference between a commercial and a program, and cannot understand the purpose of a commercial until the age of 12, has severely restricted TV ads appealing to children. Banned are all advertisements during children's prime-time television programming, and commercials featuring characters children are familiar with are prohibited until 9 p.m. during the week and 10 p.m. on weekends. Sweden would like other European countries to follow suit, and while Greece, Portugal, Great Britain, Denmark, and the Netherlands have come out in favor of strengthening regulations related to marketing to children, most other member states are satisfied with the status quo, which allows each country to decide on its own measures. And, while the EC has set criteria regarding comparative advertising, some member states have restricted the use of comparative claims in commercial messages.

The European Union has continued to work toward a legal framework to govern promotional marketing across the 27 member states. The Unfair Commercial Practices (UCP) Directive was passed in 2005 and went into effect December 12, 2007. The UCP Directive substantially reinforces existing EU standards on misleading advertising and sets new EU standards against aggressive commercial practices. The directive is designed to benefit both business and consumers.

Businesses benefit because the directive seeks to harmonize different rules among member states. European citizens benefit from the increased level of consumer protection. An extensive blacklist of schemes—the so-called dirty dozen—indicates what is banned by the directive (see Table 4.1 for the list). As with any European Union directive, it requires national rules to incorporate it into each national legal system (German, French, Italian law, etc.). It is difficult to predict the exact impact of the directive in any given market without consulting the national laws.

Table 4.1: The European Union's Unfair Commercial Practices Directive "Dirty Dozen"

1.	Bait Advertising: Lures the consumer into buying from a company by advertising a product at a very low price without having a reasonable stock available.
2.	Fake "Free" Offers: Falsely creating the impression of free offers by describing a product as "gratis," "free," "without charge" or similar if the consumer has to pay anything other than the unavoidable cost of responding to the commercial practice and collecting or paying for delivery of the item.
3.	Direct Exhortations to Children to buy advertised products or to persuade their parents or other adults via "pester power" to buy advertised products for them. Direct exhortation was banned for television, but the blacklist extends it to all media, most importantly to Internet advertising.
4.	False Claims about Curative Capacity—from allergies to hair loss to weight loss.
5.	Advertorials: Using editorial content in the media to promote a product where an advertiser has paid for the promotion without making that clear.
6.	Pyramid Schemes: A pyramid promotional scheme where compensation is derived primarily from the introduction of other consumers into the scheme, rather than from the sale or consumption of products.
7.	Prize Winning: Creating the false impression that the consumer has won a prize when there is no prize or taking action to claiming the prize is subject to the consumer paying money or incurring cost.
8.	Misleading Impression of Consumers' Rights: Presenting rights given to consumers in law as a distinctive feature of the advertiser.
9.	Limited Offers: Falsely stating that a product will only be available for a very limited time to deprive consumers of sufficient opportunity to make an informed choice.
10.	Language of After-Sales Service: Undertaking to provide after-sales service to consumers and making such service available only in another language without clearly disclosing before the consumer is committed to the transaction.
11.	Inertia Selling: Demanding immediate or deferred payment for the return or safekeeping of products supplied by the advertiser but not solicited by the consumer.
12.	Europe-Wide Guaranteed: Creating the false impression that after-sales service in relation to a product is available in a member state other than the one in which the product is sold.

The European Advertising Standards Alliance (EASA) was founded in 1992 to support self-regulatory bodies (such as the United Kingdom's Advertising Standards Authority) across Europe. EASA brings together national advertising self-regulatory organizations and bodies representing the advertising industry in Europe. Based in Brussels, EASA is the European voice for advertising self-regulation. It exists to help ensure that cross-border complaints are resolved as quickly and effectively as possible. EASA's *Blue Book*, published every 2 to 3 years, provides practitioners and regulators with a comprehensive overview of the scope and activities of the self-regulation systems in place and provides detailed analyses of the role of self-regulation; global self-regulatory

codes; national, European, and cross-border complaints statistics; and an overview of European legislation affecting advertising. For more information about EASA, go to www.easa-alliance.org.

The Gulf Cooperation Council

The Gulf Cooperation Council (GCC) consists of six member countries—Saudi Arabia, Qatar, Kuwait, Oman, the United Arab Emirates, and Bahrain. Among them, they control nearly half of the world's known oil reserves, and by the end of 2007 had accumulated US$1.8 trillion in foreign assets—the equivalent of 13 percent of the U.S. economy. The GCC was established in 1981 to, according to its charter, "effect coordination, integration and inter-connection among the Member States in all fields in order to achieve unity and stress the special relations, common qualities and similar systems founded on the creed of Islam, faith in a common destiny and sharing one goal defined by the Arab identity" (Tristam, 2008). The GCC is making a very committed attempt to become an effective trading bloc to rival the European Union. To this end, they are forging a common consumer and trade policy to ensure economic integration. A common currency is planned for 2010. An understanding of the advertising regulatory environment of these member states is essential for marketers interested in this region. Because Saudi Arabia is the largest and economically strongest member of the GCC, it is playing a dominant role in shaping the regulations that will govern all commercial activity among member states.

With regard to the marketing environment, religion takes precedence over all other cultural considerations in Saudi Arabia. Luqmani and colleagues (1989) explain: "The Saudi legal system is unique in that it identifies law with the personal command of the 'one and only one God, the Almighty'" (p. 59). The Islamic legal code known as the "Sharia" is the master framework to which all legislation is referred and with which it must be compatible. The Sharia is a comprehensive code governing the duties, morals, and behavior of all Muslims in all areas of life, including commerce. Sharia is derived from two basic sources, the *Koran* or Holy Book and the *Hadith*, which is based on the life, sayings, and practices of the Prophet Muhammad. The implications of religion on advertising regulation in Saudi Arabia are far-reaching (Luqmani et. al., 1989).

Several sets of Koranic messages hold special significance for advertisers and advertising regulators. The most important have to do with strict taboos dealing with alcohol, gambling, and immodest exposure. For example, according to the *Koran*, at no time may alcoholic beverages be consumed, and games of chance are illegal. Religious norms in several Islamic nations require that women cover themselves in advertising messages as well as in public. Therefore, international print messages may need to be modified by superimposing long dresses on models or by shading their legs with black. In addition, advertisers may not picture a "sensuous-looking female." Instead, a "pleasant-looking woman" in a robe and headdress with only her face showing is the typical model. Cartoon characters are often employed to present women in messages because they are less likely to violate the Islamic codes on exposure. Advertising messages may also be considered deceptive by religious standards. For example, according to Islam, fraud may occur if the seller fails to deliver everything promised, and advertising may need to use factual appeals based on real rather than perceived product benefits.

No specific governmental agency is responsible for controlling advertising behavior in Saudi Arabia. No self-regulatory industry group exists, and there is no evidence of plans to develop one. Companies are, however, involved in self-compliance, which may eventually lead to self-regulation. As Luqmani and colleagues (1989) state,

Possible violations are monitored in two ways. The government is involved through the Ministry of Commerce, which ensures that ads remain within legal bounds, and the Ministry of Information, which approves television commercials. Less formal oversight is provided by a voluntary religious group, the Organization for the Prevention of Sins and Order of Good Deeds. Members observe public and commercial behavior (including promotions) for any violations of Islamic law (p. 59).

The International Chamber of Commerce—Promoting Self-Regulation

The International Chamber of Commerce (ICC) was established in 1919 to promote the interests of international business. The ICC—today represented in over 100 countries—is the most important international body influencing the self-regulation of advertising. With the support of advertisers, agencies, and the media, the ICC has developed a formal, internal self-regulatory code for advertising. The ICC Code of Advertising Practice states that all advertisers have an overall duty to be "decent, honest, legal and truthful." The code goes on to state that advertisements "should be prepared with a due sense of social responsibility . . . and not be such as to impair public confidence in advertising." With these words, the ICC code moved away from addressing only "hard" matters that center on the deceptive character of advertisements and on proper substantiation of advertising claims. The ICC Code also encompassed "soft" issues, including matters of sex and decency in advertising. Boddewyn (1991) notes, "Reflecting these ICC principles, various clauses on decency, taste, public opinion and social responsibility are usually found in advertising self-regulatory codes and guidelines around the world" (p. 25).

Some self-regulatory bodies refuse to handle such soft issues, limiting themselves to hard issues of truth and accuracy. This is true of the United States' NAD/NARB system. Other bodies, including those in Germany and Canada, are not hesitant in dealing with "taste and opinion" complaints. Most bodies, however, stand in between hard and soft issues, occasionally agreeing to handle soft cases on the basis of the general principles they apply—particularly when gross breaches of social standards occur, as in matters of obscenity, racism, and denigration (Boddewyn, 1991).

In developing self-regulatory guidelines, many countries have turned to the ICC Code. Because latecomers often borrow from the ICC codes—as well as from codes outlined in the United States, United Kingdom, and Canada—voluntary codes often appear to resemble one another. In addition to its code of advertising practices, the ICC also outlines codes of practice in marketing, market research, and sales promotion.

The ICC (1998) has drawn up voluntary guidelines on interactive marketing and advertising designed to promote worldwide consumer confidence and minimize the need for regulatory intervention. The revised guidelines on advertising and marketing on the Internet cover such ethical issues as protection of user's personal data, messages directed at children, and the different sensitivities of global audiences. ICC recommendations to marketers include: revealing their identity when posting a message; disclosing the reason for collecting personal information on users; not sending unsolicited commercial messages to those who request not to receive them; and providing information to parents on ways to protect children's online privacy. The guidelines also caution marketers to ensure their messages are not perceived as pornographic, violent, racist, sexist, or otherwise offensive. Online advertising and marketing should be conducted according to the laws of the country from which the message originates, the ICC Code stipulates. "If business successfully adheres to this set of guidelines. . . we may well preclude the

imposition of restrictive bureaucratic legislation at the national, regional, and global levels," says John Manfredi, chair of the ICC Commission on Marketing, Advertising and Distribution, which drafted the guidelines ("ICC Draws Up New Code," 1998). Ad associations around the world are expected to incorporate the main provisions of these guidelines into their codes covering online advertising. Additional information about the ICC, as well as the complete code, can be accessed at http://www.iccwbo.org.

CONCLUSION

Industry, trade, and advertising associations have developed codes of ethics and guidelines in more than 50 nations, and the number is increasing every year. This is particularly true of developed markets and countries where advertising expenditures are relatively large. Increasingly, we are seeing movement toward self-regulation in developing markets as well.

REFERENCES

Ace Project. (2002). *Law or regulations on media during elections.* Retrieved August 15, 2002, from: http://www.aceproject.org/main/english/me/mec.htm

Atkinson, Claire. (2008, December 2). 2008 Political ads worth $2.5 billion to $2.7 billion. *Broadcasting and Cable.* p.1

Begley, Sharon. (2008, October 20). Ready, aim, fire. *Newsweek,* pp. 48–50.

Boddewyn, Jean J. (1991). Controlling sex and decency in advertising around the world. *Journal of Advertising, 20*(4), 25–35.

Bradley, Samuel D., Angelini, James R., & Lee, Sungkyoung. (2007). Psychophysical and memory effects of negative political ads. *The Journal of Advertising,* American Academy of Advertising, *36*(4), pp. 129–146.

Broder, David. (2002, April 24). Failed reform, fading parties: Supreme Court won't up hold campaign finance law. *The Plain Dealer,* Cleveland, Ohio, p. B9.

Centaur Publishing. (2001, March 8). Survey indicates that negative political advertising makes voters vote against offending party. *Marketing Week,* United Kingdom.

Djupe, Paul A., & Peterson, David M. (2002, December). The impact of negative campaigning: Evidence from the 1998 senatorial primaries. *Political Research Quarterly,* Salt Lake City, *55*(4), 845–861.

Faber, Ronald, Tims, Albert, & Schmitt, Kay. (1993). Negative political advertising and voting intent: The role of involvement and alternative information sources. *Journal of Advertising, 22*(4), 67–76.

Federal Election Commission. (1996). *The FEC and the Federal Campaign Finance Law.* Retrieved August 15, 2002, from: http://www.fec.gov/pages/fecfeca.htm

Foreign advertising agencies in Vietnam. (1995, February 24). *Business Times,* Singapore, p. 11.

Frith, Katherine T. (2002). International advertising and global consumer culture. In Kwado Anokwa, Michael Salwen, & Carolyn Lin (Eds.), *International communication: Theory and cases.* White Plains. NY: Longman.

Garramone, Gina. (1984). Voter responses to negative political ads. *Journalism Quarterly, 61,* 250–259.

Garramone, Gina, Atkin, Charles, Pinkleton, Bruce, & Cole, Richard. (1990). Effects of negative political advertising on the political process. *Journal of Broadcasting and Electronic Media, 34*(3), 299–311.

Goldstein, Ken, & Freedman, Paul. (2002, August). Campaign advertising and voter turnout: New evidence for a stimulation effect. *The Journal of Politics,* Malden, *64*(3), p. 721.

Hicks, Robin. (2008, January 10). Vietnam: The truth about the "New China." *Media,* Hong Kong, p. 18.

Hill, Ronald. (1989). An exploration of voter responses to political advertisements. *Journal of Advertising, 18*(4), 14–22.

History of ad regulation: Protecting consumers, testing claims (2009). Retrieved March 16, 2009 from http://www.asa.org.uk/asa/about/history

Hodge, Neil. (2008, December/2009, January). Condemned sells. *Financial Management,* London, p. 22.

ICC draws up new code of international online advertising. (1998, April 22). *Advertising Age,* p. 24.

Inoue, Osame. (1996). Advertising in Japan: Changing times for an economic giant. In Frith, Katherine (Ed.), *Advertising in Asia: Communication, culture and consumption* (pp. 11–38). Ames, IA: Iowa State University Press.

International Chamber of Commerce. (1998). *ICC guidelines on advertising and marketing on the Internet.* Retrieved August 10, 2002, from: http://www.iccwbo.org/home/ statements_rules/rules/1998/internet_guidelines.asp

Iyengar, Shanto. (1999, December 15). Negative political ads keep voters home. *News-day,* Long Island, New York, p. A67.

Jeffreys, Leo W. (1997). *Mass media effects.* Prospect Heights, IL: Waveland.

Johnson-Cartee, Karen, & Copeland, Gary. (1989). Southern voters' reactions to negative political ads in 1986 election. *Journalism Quarterly, 66*(4), 888–893.

Kolodny, Robin, Thurber, James, & Dulio, David. (2000). Producing negative ads: Consultant survey. *Campaigns and Elections, 21*(7), 56.

Kotler, Philip, Ang, Swee Hoon, Leong, Siew Meng, & Tan, Chin Tiong. (1999). *Marketing management: An Asian perspective.* Singapore: Prentice Hall.

Lang, A. (1991). Emotion, formal features and memory for televised political advertisements. In F. Biocca (Ed.), *Television and political advertising: Vol. 1. Psychological processes* (pp. 221–243). Hillsdale, NJ: Erlbaum.

Luqmani, Mushtaq, Ugar, Yavas, & Quraeshi, Zahir. (1989). Advertising in Saudi Arabia: Content and regulation. *International Marketing Review, 6*(1), 59–72.

MacGillis, Alec, & Cohen, Sarah. (2008, December 6). Final fundraising tally for Obama exceeded $750 million. *The Washington Post,* Washington, D.C., p. A5.

Madden, Normandy. (2008, September 8). China's Olympic-year ad growth: 22%. *Advertising Age,* p. 6.

Madden, Normandy. (2009, March 2). Japan's ad biz feels economy's squeeze. *Advertising Age,* p. 6.

Mero, Jennifer. (2008, July 21). Power shift. *Fortune,* p. 161.

Merrill, John. (Ed.). (1995). *Global journalism.* White Plains, NY: Longman.

Merritt, Sharyne. (1984). Negative political advertising: Some empirical findings. *Journal of Advertising, 3*(3), 27–38.

Mydans, Seth. (1996, April 8). Hanoi seeks Western cash but not consequences. *New York Times,* p. A3.

Niven, David. (2006, June). A field experiment on the effects of negative campaign mail on voter turnout in a municipal election. *Political Research Quarterly,* Salt Lake City, *59*(21), 203–211.

O'Guinn, Tom, Allen, Chris, & Semenik, Richard. (1998). *Advertising.* Cincinnati, OH: Southwestern.

O'Leary, Noreen. (2007, September 17). Dentsu rising. *AdWeek, 48*(33), 18.

Onkvisit, Sak, & Shaw, John J. (1997). *International marketing: Analysis and strategy* (3rd ed.). Upper Saddle River, NJ: Prentice Hall.

Parry, Richard Lloyd. (1996, July 14). Vietnam insists the future is red. *The Daily Yomiuri,* p. 22.

Phillips, Joan M., Urbany, Joel E., & Reynolds, Thomas J. (2008, April). Confirmation and the effects of valenced political advertising: A field experiment. *Journal of Consumer Research, 34*(6), 794.

Pinkleton, Bruce. (1997). The effects of negative comparative political advertising on candidate evaluations and advertising evaluations: An exploration. *Journal of Advertising, 26*(1), 19–29.

Pinkleton, Bruce, & Garramone, G. (1992). A survey of responses to negative political advertising: Voter cognition, affect and behavior. In L. N. Reid (Ed.), *Proceedings of the 1992 Conference of the American Academy of Advertising* (pp. 127–133). Athens, GA: University of Georgia, Grady College of Journalism and Mass Communication.

Pinkleton, Bruce E., Um, Nam-Hyun, & Austin, Erica Weintraub. (2002). An exploration of the effects of negative political advertising on political decision-making. *Journal of Advertising, 31*(1), 13–25.

Rijkens, Rein, & Miracle, Gordon E. (1986). *European regulation of advertising.* New York: Elsevier.

Roberts, M. (1992). The fluidity of attitudes toward political advertising, In L. N. Reid (Ed.), *Proceedings of the 1992 Conference of the American Academy of Advertising* (pp. 134–143). Athens, GA: University of Georgia, Grady College of Journalism and Mass Communication.

Roddy, Brian, & Garramone, Gina. (1988). Appeals and strategies of negative political advertising. *Journal of Broadcasting and Electronic Media, 32*(4), 415–427.

Rowan, Ford. (1984). *Broadcast fairness: Doctrine, practice, prospects: A reappraisal of the Fairness Doctrine and Equal Time Rule.* New York: Longman.

Schouten, Fredreka. (2008, December 3). Campaign cash haul obliterates records. *USA Today,* McLean, VA, p. A5.

Silk, Atifa. (2007, February 23). Vietnam enters new era for foreign ad agencies. *Media,* Hong Kong, p. 19.

Sonner, Brenda. (1998). The effectiveness of negative political advertising: A case study. *Journal of Advertising Research, 38*(6), 37.

Taxpayers elect not to pay for campaigns. (2007). USATODAY.com. http://wwwusatoday.com/news/washington/2007–04–17=preztax_N.htm?csp=34

Teinowitz, Ira. (2008, October 8). Study: 2008 race more negative than 2004. *Advertising Age.* Retrieved January 28, 2009, from http://adage.com/print?article_id=131577

Tristam, Pierre. (2008). *Glossary: Gulf Cooperation Council.* Retrieved January 23, 2009, from http:/middleeast.about.com/od/oilenergy/g/me080117.htm

University of Missouri-Columbia. (2008, November 21). Presidential candidates' television ads most negative in history. *Entertainment Newsweekly,* Atlanta, GA, p. 128.

Voter turnout. (2008). http://www.nonprofitvote.org/voterturnout2008

Weaver-Lariscy, Ruth Ann, & Tinkham, Spencer. (1999). The sleeper effect and negative political advertising. *Journal of Advertising, 28*(4), 13–31.

Weigold, Michael. (1992). Negative political advertising: Individual differences in responses to issue vs. image ads. In L. N. Reid (Ed.), *Proceedings of the 1992 Conference of the American Academy of Advertising.* Athens, GA: University of Georgia, Grady College of Journalism and Mass Communication.

Whitley, Tyler. (2001, February 17). Panel revised political ads bill. *Richmond Times Dispatch,* p. A6.

5

Global Consumer Issues

INTRODUCTION

While some regional and international organizations are emerging to regulate advertising, overall the enforcement remains largely the purview of nation-states. As advertising becomes more global and more multinational corporations engage in business on a transnational scale, the need to establish international guidelines has become more pressing.

The major organizations that have attempted to develop international advertising guidelines include the World Health Organization (WHO) and the various agencies of the United Nations: the UN Commission on Transnational Corporations; the United Nations Educational, Scientific and Cultural Organization (UNESCO); and the UN Conference on Trade and Development (deMooij, 1994). But these organizations lack the power to enforce global regulations. As Barbara Sundberg Baudot (1989) explains:

> These organizations lack the attribute of sovereignty, or the legislative authority of a world government to legislate enforceable regulation. Thus, their roles are restricted to the development of voluntary codes and guidelines whose effectiveness depends on moral suasion and public acceptance. (p. 36)

Previously, we have looked at government regulation of advertising, and in this chapter we will see how consumer groups can effect changes in advertising and business practices. We shall do this by tracing the history of consumer movements and then looking at current consumer issues that are related to global advertising practices.

CONSUMER MOVEMENTS

A "consumer" is one who consumes, while the word "consumerism" generally refers to what Philip Kotler (1981) defines as "a social movement seeking to augment the rights and powers of buyers in relation to sellers" (p. 49). As Kotler noted, "consumerism is enduring," and thus it affects every generation. In the early twentieth century, the issue that most concerned consumers was the quality of foods and drugs. Later, in the 1960s, Ralph Nader led U.S. consumers to demand greater safety from automobile manufacturers; in the 1980s, European consumers led a "green" movement that spread worldwide. In response to green environmental concerns companies like McDonald's stopped using plastics in favor of the more politically correct paper wrappings. Currently issues like "greenwashing" and an assortment of other moral, political, and economic issues have been taken on by consumerists, who assert that these issues need to be addressed on a global scale.

A SHORT HISTORY OF CONSUMER MOVEMENTS

According to one American historian (Warne, 1993), "fundamentally, it was advertising which was historically responsible for the birth and growth of the consumer movement here and abroad" (p. 91). Most textbooks on advertising trace the history of advertising regulation back to consumer concerns over the safety and quality of foods and patent medicines in the late 1880s. Nearly everyone has seen old drug ads selling a single tonic that promised to cure a person of diseases of the liver, the kidneys, and even scrofula. The ad in Figure 5.1 for Dr. Scott's Electric "flesh brush" that cured "rheumatism, gout, liver and kidney troubles and nervous disability" (among other things) is a good example of one of these early ads.

These types of products and the questionable business practices that accompanied them led to the creation of the National Consumer League, the first organized consumer group, which was founded in the United States in 1899. This organization was a force in lobbying for stricter government controls for foods and drugs. These lobbying efforts resulted in the Meat Inspection and Pure Food and Drug Acts of 1906 and The Truth in Packaging law in 1966, which gave consumers even more information about the ingredients in pro-

Figure 5.1: An 1882 ad for Dr. Scott's Electric Flesh Brush

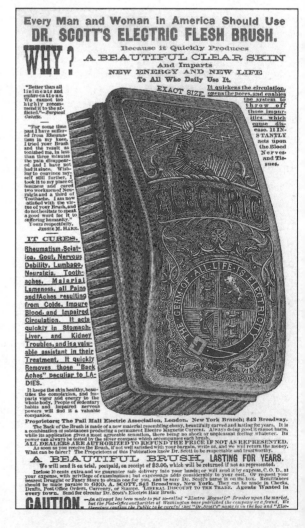

cessed foods. Most developed countries have adopted laws similar to those in the United States, requiring labels to show ingredients, processing (e.g., frozen or irradiated), conformance to standards of identity (peanut butter, for example, should contain mostly peanuts), and additives (e.g., preservatives). Over the years, consumer concerns over food and product safety and "unfair" or deceptive advertising practices have spurred better business practices. In addition, the U.S. consumer movement has been a model for consumer groups in other countries (Hamdan Adnan, 2000).

CONSUMER RIGHTS

In 1985 the United Nations passed its landmark Guidelines for Consumer Protection, which states that all citizens, regardless of their incomes or social standing, have certain basic rights as consumers. Over the years, these rights have been expanded to a total of eight. Together they form the basis for the work of the world consumer movement and Consumers International. These rights are:

- **Basic needs**: the right to basic goods and services that guarantee survival: adequate food, clothing, shelter, health care, education, and sanitation;
- **Safety**: the right to be protected against the marketing of goods or the provision of services that are hazardous to health and life;
- **Information**: the right to be protected against dishonest or misleading advertising or labeling. And the right to be given the facts and information needed to make an informed choice;
- **Choice**: the right to choose products and services at competitive prices with an assurance of satisfactory quality;
- **Representation**: the right to express consumer interests in the making and execution of government policy;
- **Redress**: the right to be compensated for misrepresentation, shoddy goods, or unsatisfactory services;
- **Consumer education**: the right to acquire the knowledge and skills necessary to be an informed consumer;
- **Healthy environment**: the right to live and work in an environment that is neither threatening nor dangerous and that permits life of dignity and well-being (www.consumersinternational.org).

The European Union and the U.S. government have been instrumental in attempting to balance consumer interests with those of multinational corporations. However, there is still a lack of consumer representation in government in many developing countries. Since the issues that concern consumers differ dramatically between the developing countries and the developed world, we will look at these issues separately.

CONSUMER ISSUES IN DEVELOPING NATIONS

Product Safety

Product safety is the biggest concern in less developed nations where consumer movements are still in their infancy. In recent years, the world's fastest growing market, China, has become embroiled in several product safety scandals, such as the tainted baby milk scandal in September 2008 and the contaminated pet food export in March 2007. In both cases, the food manufacturers used toxic ingredients like melanine that can cause death or kidney damage. In the case of the baby milk scandal, hundreds of Chinese children died or fell sick before the problem was discovered. These scandals damaged the reputation of Chinese companies both locally and abroad. Many Chinese consumers said they would never have imagined that a respected milk manufacturer like the Sanlu Company (see Figure 5.2), China's largest baby milk producer, would make and sell a product that could kill their children (Ramzy & Yang, 2008; Diwan, 2009). In fact, the Chinese government had set up testing bureaus to detect any potentially lethal ingredients in consumer products, but these testing agencies appeared to have missed the problem. There is still little enforcement of consumer safety in many developing countries.

Similarly, in 2009, India, which is one of the world's largest steel manufacturers, exported tons of steel to Germany. The steel was later found to have been contaminated with radioactivity. Although the German government claimed that no consumer products were affected, reports from France, Sweden, and the Netherlands stated that radioactive steel from India was discovered in the manufacture of buttons for elevator control panels.

Figure 5.2:
Advertisement for
Sanlu Baby Milk

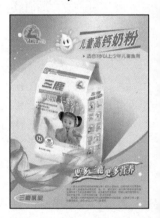

Illegal or incompetent certification by governments and professional organizations in developing countries is a serious problem threatening consumers' health and rights. Without strong consumer advocate groups, people in developing countries tend to trust the claims made by manufacturers or quasi-government monitoring organizations. In 2007, the Chinese media disclosed a corruption scandal in the National Committee of Oral Health (NCOH), a government-supported organization for the prevention of dental disease. The NCOH was found to have been illegally certifying oral health products for both global and local brands, including Crest toothpaste, Lion's toothbrushes, and Lotte Xylitol gum. In fact, it was reported that the NCOH had been receiving illegal donations from companies, sometimes as large as 10 million yuan (US$1.25 million). The Chinese government finally dismantled the NCOH but the impact was felt by consumers who felt cheated of creditability in the packaging, labeling, branding, and marketing material, including advertising, that had been going on for over 15 years (Zeng, 2007).

Branded Goods

Another issue, and one that Naomi Klein (1999) has written about in her book *No Logo,* is the concern that multinational corporations like Nike, The Gap, and Tommy Hilfiger produce

expensive "branded" goods in developing countries where their own factory workers cannot afford to buy the items they produce. As Klein (2000) has pointed out:

> The formula for these brand-driven companies is pretty much the same: get rid of your unionized factories in the west and buy your products from Asian or Central American contractors and sub-contractors. Then, take the money you save and spend it on branding—on advertising. (p. 3)

The concept of branding emerged almost a century ago, when companies like Quaker Oats and Levi Strauss introduced logos that allowed them to differentiate their brands from others in the marketplace (Sivulka, 1998). In the 1980s however, the concept was extended from a logo on the product carrying a meaning to the product itself carrying a meaning. So, for example, Nike became "Sports," Virgin-Atlantic became "Fun," and Diesel Jeans "created a movement," not a line of clothes (Klein, 2000). Building globally recognizable brands is a costly endeavor, and in an effort to cut production costs (so more and more profits could be channeled into advertising and "branding"), corporations like Nike, Reebok, and Tommy Hilfiger have moved their production outside the United States to the developing world's "free-trade zones"—free, that is, of taxes and wage or other labor regulations (Klein, 1999). Regardless of where these zones are located, Sri Lanka, Indonesia, Vietnam, China, or the Philippines, employees work between 14- and 16-hour days and receive low pay. In Indonesia for example, a woman working all day in a Nike factory would probably earn less than US$6 per day. This successful formula has allowed the big image-makers like Tommy Hilfiger, Ralph Lauren, and Nike to get close to a 400 percent profit mark-up (Klein, 2000, p. 7).

CONSUMER ISSUES IN DEVELOPED NATIONS: GREENWASHING

As consumers in the West become more and more aware of the impact of unbridled consumption on the environment, marketers and advertisers have begun to use these concerns to sell products. Chevron ran a multimillion-dollar advertising campaign, "People Do," featuring its employees in seductively pristine environments saving wildlife. Yet, in 1993 Greenpeace found that Chevron was a major contributor to political groups whose aim was to relax environmental regulations.

According to critics, over US$1 billion is spent annually in the United States by corporations on "greenwashing" ad campaigns. The term "greenwashing" refers to the various media campaigns that act to mislead consumers regarding the environmental practices of a company or the environmental benefits of a product or service.

TerraChoice Environmental Marketing, Inc., a consulting firm that monitors greenwashing, conducted a survey on 1,018 consumer products bearing 1,753 environmental claims and identified six patterns of greenwashing:

- **Hidden trade-off**: Claim made by a company that lauds its improved safety records or reduced pollution or its protection of areas like wetlands. Often it turns out that these types of reforms were forced on the company by regulators, and in some cases the cost of the project is less than the cost of the ads to publicize it.
- **No proof:** Any environmental claim that cannot be substantiated by easily accessible supporting information, or by a reliable third-party certification. Products labeled "green" or "environmentally friendly" or "eco-friendly" without any proof of claim would fall into this category.

- **Vagueness**: Claims that are so poorly defined or broad that their real meaning is likely to be misunderstood by the intended consumer. Here a chemical company or an SUV manufacturer might present itself in an ad with a beautiful shot of the environment with the hope that the ad will subconsciously link the company or product with the beautiful environment.

- **Irrelevance:** An environmental claim that may be truthful but is unimportant and unhelpful for consumers seeking environmentally preferable products. A manufacturer might claim that it is doing "pollution prevention" rather than tell the whole story, which could be that it is incinerating toxic waste.

- **Lesser of two evils:** These are "green" claims that may be true within the product category, but that risk distracting the consumer from the greater environmental impacts of the category as a whole. For example, an advertisement for an SUV might tell the reader that the car qualifies as a low-emission vehicle. But what the reader might not realize is that the EPA rating that the car buyer relies on does not factor in carbon dioxide, the primary culprit in global warming. Thus, the low-emission claim actually acts as a distraction rather than providing information to help the consumer live a greener lifestyle.

- **Fibbing:** Environmental claims that are simply false. Some firms hire PR companies to help them employ environmental rhetoric in their promotional materials. Or worse, companies can claim a commitment to the environment while quietly lobbying to avoid government regulation (www.terrachoice.com).

An example of greenwashing by a specific company is Shell, which has been accused of greenwashing in their advertising (see Figures 5.3 and 5.4). One of Shell's ads depicts the outline of its refinery emitting flowers instead of smoke, while another shows Shell's logo with a visual of a person imagining alternative and renewable fuel. Critics contend that in fact, Shell is deceptive and that in fact, only a small part of its profits are used to develop alternative energy that will have a low impact on the earth (Environmental LEADER, 2009; Ashley-Cantello, 2008).

Figure 5.3: Print ad by Shell in 2008

Figure 5.4: Print ad by Shell in 2009

What is the damage caused by a company seducing its customers with visions of the beauty of nature impressing consumers with tangential or irrelevant environmental claims? Basically, these practices are not only deceptive but they promote ignorance of the true issues and distract people from adopting behaviors that might actually help the environment. Mass media campaigns based on corporate greening distract consumers from the true facts. In America, for example, even though the nation has become committed to recycling in the past few decades, it has not significantly reduced its carbon footprint on the environment during that period. In fact, Americans drove 87 percent more in 2002 than in 1980, and between 1990 and 2002, driving increased by 35 percent. Americans continue to use a huge proportion of the earth's resources. It takes about 27 people in India to consume as much as a single American. Yet companies continue to try and convince Americans that purchasing a vaguely "green" product is going to help the environment or help stop global warming. Thus there is a great deal of confusion. It is not how we individually

"consume" that will reduce global warming, but how we collectively live, work, and consume that will help solve the problem.

In the United States, the Federal Trade Commission is reviewing its regulations and standards on environmental marketing claims. New guidelines are expected to be released in 2009. NGOs and consumer activists like Greenpeace (www.stopgreenwash.org) are trying their best to constrain the spread of misleading "green" claims.

CONTEMPORARY CONSUMER MOVEMENTS

We have traced the history of consumer movements and looked at some of the current consumer issues worldwide, and now we will look at how consumers can fight back against unethical advertising and business practices. Consumers worldwide are increasingly becoming aware of their rights in terms of the messages delivered by advertisers. With the introduction of the Internet, it has become increasingly easy for consumers to get together to exert an influence on companies. Consumers can now freely comment on Web sites and blogs about the content and format of advertisements and marketing events and even hold marketers accountable for the quality and safety of their products. There are also numerous non-governmental organizations (NGOs), consumer watchdogs, and individual consumer activists who serve as the guardians of product safety and alert the consumer to misleading advertisements. With the aid of the Internet and cyberspace technologies, individual consumers and consumer groups can now vote and post comments on the conduct of advertisers and manufacturers, forming what we could call the new, contemporary "e-consumer movement."

Thanks to Internet technologies and their applications, individual consumers can easily make comments, assemble other consumers, and exert an impact on advertisers and companies. Recently in the United States, some consumers launched a campaign that used the platform of eBay's popular Web site to garner support from other consumers to exert pressure on the decision by the Supreme Court that allows manufacturers to set minimum prices on products. As Brian Okin, chief executive of the online retailer Homecenter.com, said: "Getting consumers all fired up about this is one of the main ways to try and get the Supreme Court's decision overturned" (Pereira, 2008). The influence of individual consumers is becoming more and more important in market regulation and companies' strategies.

In China, where government enforcement of consumer issues is often lacking, Internet users and bloggers hold great sway. Before the 2008 Beijing Olympics, when Chinese nationalism was at a peak, Dior had to drop actress Sharon Stone from its ads in China after she suggested that the May 12 Sichuan earthquake that killed more than 68,000 could have been "karma" for the nation's policy on Tibet (see Figure 5.5). Internet bloggers were outraged at her comments and pressured the company to remove the billboards.

Figure 5.5: Billboard ad of Dior featuring Sharon Stone

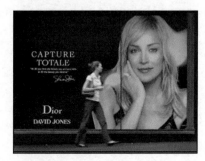

In a similar vein, a set of advertisements developed by Omnicom Group's TBWA Worldwide for two of their clients—Adidas in China and Amnesty International in France—also came under attack in China. TBWA developed a campaign to run in China before the Olympics that focused on Chinese pride, showing Chinese athletes supported by throngs of fans

(see Figure 5.6). At the same time, the agency's Paris office launched another ad campaign that ran in France on behalf of Amnesty International. This campaign showed Chinese athletes being tortured by Chinese authorities (see Figure 5.7). When the French ads began circulating on the Internet, the agency faced tremendous criticism in China. In fact, Chinese bloggers called for a nationwide movement of protest. The reactions of Chinese consumers threatened the management and business of TBWA, and Tom Carroll, chief executive of TBWA Worldwide, defended the agency by saying, "it is the action of one individual at our agency working on a pro bono account" and announcing they were investi

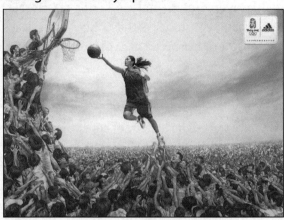

Figure 5.6: TBWA ad for Adidas in China during the 2008 Olympics

gating the matter and would take appropriate action to "ensure this never happens again" (Fowler et al., 2008). But nonetheless, the reputation of TBWA had become tarnished in China.

Figure 5.7: TBWA ad for Amnesty International that ran in Paris in 2008

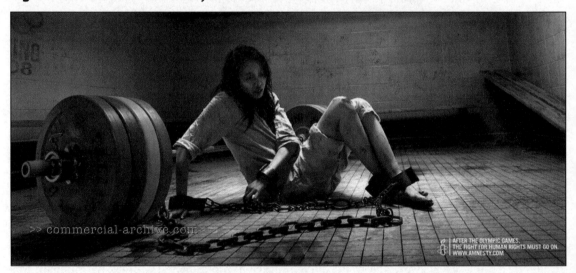

ANTI-ADVERTISING CONSUMER ORGANIZATIONS CULTURE

Segments of the North American population are striking back at their increasingly consumer-oriented culture. AdBusters, a Canadian-based organization, has the lofty goal of "transforming our commercial media culture and directing it toward ecological and social awareness" (Littlewood, 1999). Its online (www.adbusters.org) and off-line publications feature informational articles as well as spoofs on well-known ad campaigns. In one, an SUV surges through the wilderness under the slogan, "Nature—It'll Grow Back." In another, a slumped-over vodka bottle proclaims "ABSOLUTE IMPOTENCE," and in a third, a traffic accident scene shows a chalked symbol of the Absolut bottle reading "ABSOLUTE END." After the 2008 government bailout of the U.S. auto

industry, AdBusters ran an ad spoofing the car companies (see Figure 5.8). The intent of these "Un-ads," of course, is to undo billions of dollars' worth of careful product positioning. Despite a sustained bid to get its "non-commercials" aired on mainstream TV in North America, and more recently in Europe, in nearly every case AdBusters was refused. Nonetheless, its monthly magazine, *AdBusters,* is widely available in bookstores and newsstands across the United States and Canada.

Figure 5.8: Spoof ad in *AdBusters*

In *Culture Jam,* Kalle Lasn (1999) argues that America is no longer a country but is, rather, a multitrillion-dollar brand. "America" as trademark—™—is no different than McDonald's, Marlboro, or General Motors. It is an image "sold" not only to the citizens of the United States but also to consumers worldwide. These views are also shared in AdBusters's eponymous monthly newsletter. Further, the group organizes social marketing campaigns, such as "Buy Nothing Day," which has taken hold in 45 countries around the world. During the 24-hour consumer fast, shoppers are urged to cut up their credit cards.

AdBusters is by no means the only sign of a backlash against advertising. The Center for a New American Dream (www.newdream.org) is a not-for-profit organization dedicated to helping individuals and institutions reduce and shift consumption to enhance quality of life and protect the environment. Their primary goal is to encourage more Americans to adopt the center's motto of "More Fun, Less Stuff." Toward this end, they have conducted a highly successful "Kids and Commercialism" campaign that educated parents about the damaging effects of advertising on kids and offered guidance on raising healthy kids in a consumerist world. The campaign reached over 30 million Americans with media coverage in *Time, USA Today,* and the *Wall Street Journal* and on *CBS This Morning.* In addition, they reached more than 20 million people via the 30,000-plus *Simplify the Holidays* brochures distributed during the holiday season. The organization developed a network of nearly 600 local and national groups dedicated to promoting sustainable consumer practices and policies. Their views appear to be catching on, as their Web site (www. newdream.org) receives millions of hits each year.

A third group, Commercial Alert (www.commercialalert.org), was founded in 1998 by consumer advocate Ralph Nader to protect children and communities from the excesses of commercialism, advertising, and marketing. In particular, the organization focuses on issues of media violence, commercial corruption of the media, and the increasing commercialization of schools. Their stated mission is "to keep the commercial culture within its proper sphere, and to prevent it from exploiting children and subverting the higher values of family, community, environmental integrity and democracy."

These organizations, as well as many others around the world, such as the British Advertising Standards Authority (ASA) or Consumer's International (www.consumersinternational.org), are taking advertisers to task, questioning whether the content of various ads is appropriate.

CONCLUSIONS

While a pragmatist might argue that the purpose of any self-respecting capitalist enterprise is to create profits, consumerists will argue, but "at what cost?" Philip Kotler (1991) takes an interesting position. He asserts that consumerism is enduring, beneficial, pro-marketing, and ultimately profitable. He contends that businesses that seek to serve the long-term benefits of consumers will be most profitable. And, he points out that a "societal" marketing concept is an advance over the older paradigm that valued profits over consumer interests. Kotler (1991) notes:

> Consumerism is actually the ultimate expression of the marketing concept. It compels marketers to consider things from the consumer's point of view. It suggests consumer needs and wants that may have been overlooked by the firms in the industry. The resourceful manager will look for the positive opportunities created by consumerism rather than brood over its restraints. (p. 137)

If history is a good gauge, then the consumer movements of the past century have certainly brought about changes for the better in advertising and marketing practices within nation-states and globally. The consumer issues of this generation will require solutions that span nations, and hopefully will bring about improvements worldwide in the quality of foods, drugs, and workplace values.

REFERENCES

Ashley-Cantello, Will. (2008, May 1). *Advertising watchdog receives record complaints over corporate "greenwash."* Retrieved February 5, 2009, *http://www.guardian.co.uk/environment/2008/may/01/corporatesocialrespon-sibility.ethicalliving*

Baudot, Barbara Sundberg. (1989). *International advertising handbook: A user's guide to rules and regulations.* Lexington, MA: Lexington.

de Mooij, Marieke. (1994). *Advertising worldwide* (2nd ed.). New York: Prentice Hall.

Diwan, Piyush. (2009). *China milk scandal, Sanlu's former general manager escapes with life imprisonment and a fine.* Retrieved February 5, 2009, from *http://www.topnews.in/china-milk-scandal-sanlus-former-general-manager-escapes-life-imprisonment-and-fine-2114098*

Environmental LEADER. (2009, February 4). *Shell accused of greenwashing, again.* Retrieved February 23, 2009, from *http://www.environmentalleader.com/2009/02/04/shell-accused-of-greenwashing-again/*

Fowler, Geoffrey A., Vranica, Suzanne, & Ye, Juliet. (2008, July 14). *A TBWA disavows pitch as bloggers call for a boycott, Amnesty spot creates Olympic headache for ad shop.* Retrieved February 23, 2009, from *http://online.wsj.com/article/SB121598805607649301.html?mod=hpp_us_inside_today*

Hamdan Adnan, Mohammed. (2000). *Understanding consumerism.* Malaysia: Federation of Malaysian Consumer Associations.

Klein, Naomi. (1999). *No logo: Taking aim at the brand bullies.* New York: Picador.

Klein, Naomi. (2000, January 24). The tyranny of brands. *The New Statesman, 13*(589), 1–11.

Kotler, Philip. (1981, November–December). What consumerism means for marketers. *Harvard Business Review,* pp. 48–57.

Kotler, Phillip. (1991). *Marketing management: Analysis, planning, implementation and control* (7th ed.). Englewood Cliffs, NJ: Prentice Hall.

Lasn, Kalle. (1999). *Culture jam: The uncooling of America.* New York: Eagle Books.

Littlewood, F. (1999, February 17). Consumerism: Boom and bust. Fran Littlewood meets the founder of "culture jamming" group determined to add ethics to ads. *The Guardian,* p. 6.

Pereira, Joseph. (2008, December 5). *Minimum-price foes to use eBay in effort.* Retrieved February 5, 2009, from *http://online.wsj.com/article/SB122843970044881629.html*

Ramzy, Austin, & Yang, Lin. (2008, September 16). *Tainted-baby-milk scandal in China.* Retrieved February 5, 2009, from *http://www.time.com/time/world/article/0,8599,1841535,00.html*

Sivulka, Juliann. (1998). *Soap, sex and cigarettes: A cultural history of American advertising.* Belmont, CA: Wadsworth.

Warne, Colston E. (1993). In Richard L. Morse (Ed.), *The consumer movement: Lectures by Colston E. Warne.* Manhattan, KS: Family Economics Trust.

www.terrachoice.com

www.consumersinternational.org

Zeng, Candy. (2007, June 7). *Corrupt Chinese dental body defanged.* Retrieved February 5, 2009, from http://www.atimes.com/atimes/China_Business/IF07Cb02.html

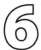

Advertising and Gender

INTRODUCTION

The representation of women in advertising has been a concern since the rise of the feminist movement in the United States in the 1960s. A tremendous amount of research has been conducted over the years on images of women in ads, and a large number of national and international conferences on the topic have been held. Generally the criticisms of advertising fall into three areas: the stereotyping of women into passive and less powerful players in society, the portrayal of women as sexual objects in ads, and the cumulative effect of these portrayals on women's self-esteem. In this chapter we shall begin by reviewing the literature on women in advertising and examining how issues of representation are expressed across cultures. Then we will look at issues of representation for men and gays in advertising.

STEREOTYPING STARTS YOUNG

The world of children's television is a gender-stratified world. Studies suggest that children's television is primarily a male world (Signorielli, 1991; Barcus, 1983). These studies confirm that there are more male characters depicted than female. Even animated product representatives like Tony the Tiger are predominately male (Pierce & McBride, 1999). Also, in children's commercials the male characters carry the action while female characters offer support. Marketers and advertisers sustain this gender bias by creating action-oriented products for boys (cars, guns, and action figures) and passive types of playthings for girls (dress-up dolls, kiddie cosmetics, and soft animals).

Advertisers further reinforce these stereotypes in the colors, settings, and behavior of each gender in the commercials. The male characters in boy-oriented commercials wear dark-colored clothing and are filmed against bright primary-colored backgrounds (dark green, blue, and gray). Commercials aimed at girls use pastel colors such as pink or white. Girls wear lighter-colored clothing. Boys are often filmed outside, while commercials aimed at girls are filmed in bedroom-style sets or in playrooms (Seiter, 1995).

In TV commercials boys run, shout, ride bikes, compete with each other, and take risks. Commercials aimed at boys have frequent cuts and many close-ups (Seiter, 1995). In commercials aimed at girls the camera techniques create a soft, warm, fuzzy feeling. Girls play quietly in their pastel bedrooms or watch boys in more active play.

When boys are shown playing with their toys, they are generally aggressive, even violent—crashing cars, or aggressively competing with action figures. Girls, in contrast, are shown playing quietly and gently. For girls a toy is a playmate; for boys a toy is a plaything.

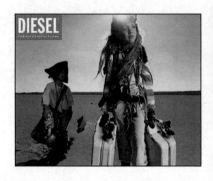

Figure 6.1: Diesel ad for kids

Cultivation theory suggests that repeated exposure to media messages leads a person to hold opinions or views of society that can be discordant with reality. When children internalize advertising and media stereotypes, gender myths can be perpetuated and children from a very early age may limit the roles they see themselves playing in society. Even very young girls are shown in advertisements for branded fashion goods, perhaps suggesting to children that fashion and beauty are what are most valued for women in society (see Figure 6.1).

TEENAGE GIRLS AND ADVERTISING

As girls grow into their teens, the media continue to play a significant role in the development of identity. In fact, much research has been done on images in the media and self-image in adolescents. One concern of critics is that advertisements present young girls with unrealistic beauty norms. Most advertisements that appear in magazines have been extensively retouched to remove even the slightest flaw. Techniques such as retouching led Lakoff and Scherr (1984) to accuse advertisers of creating a "cult of unrealizable beauty" (p. 290). Critics contend that the uniformly thin, perfectly proportioned models contribute to young girls' unhappiness with their own bodies and thus undermine self-confidence and reinforce problems like eating disorders (Freedman, 1986). In addition, Walsh-Childers (1999) notes that advertising photographers often focus on women's breasts, regardless of the product category. She contends that the idea that sexy equals big breasts has created feelings of inferiority in young girls, so that "plastic surgeons report that they now see girls as young as 14 seeking surgery to enlarge their breasts" (p. 82).

Richins (1991) studied attitudes and behaviors of college students exposed to advertisements and found that after viewing beautiful models, subjects rated average women as less attractive. In other words, images of highly attractive individuals can cause viewers to rate the attractiveness of more ordinary others lower than they would otherwise. In addition, she found that exposure to highly attractive images negatively affected the subject's feelings about their own self-appearance. As Richins (1991) notes, "while one may argue that temporary dissatisfaction is beneficial if it

stimulates consumers to buy products that improve their appearance . . . it is difficult to argue that such is the case here" (p. 83). She points out that the repeated exposure to idealized images may have a cumulative effect on self-feelings.

In fact, research on child development has shown that self-perceptions of physical attractiveness are markedly different for male and female adolescents (Martin & Gentry, 1997). Many researchers have noted that self-perceptions of physical attractiveness appear to decline systematically over time in girls but not in boys (Hartner, 1993; Block & Robins 1993). Boys tend to view their bodies as "process" and have a stronger view of themselves as holistic, while adolescent girls pay attention to individual body parts (Brown, Cash, & Mikulka, 1990). Advertisers contribute to this "body-as-object" focus for female adolescents by using difficult to attain standards of physical attractiveness in ads. An analysis of *Seventeen,* a magazine aimed at adolescent females, found that over a 20-year period from 1970 to 1990, models had become significantly thinner (Guillen & Barr, 1994). While the actual emotional effects of repeated exposure to ultrathin models in magazine ads have been somewhat inconsistent, Martin and Gentry (1997) found that female college students who were repeatedly exposed to very thin models in ads felt increased guilt, shame, insecurity, and body dissatisfaction.

GENDER STEREOTYPES

Gender stereotypes are learned through constant reinforcement. Although the terms "gender" and "sex" are often used interchangeably, these two concepts have very different meanings. Sex is biologically determined (male and female), while gender is culturally determined (masculine and feminine). Each culture has a set of general beliefs about what constitutes masculinity and femininity; these are known as gender roles. Stereotypes in advertising conform, for the most part, to cultural expectations of gender. To be feminine in the United States has historically meant to be attractive, deferential, nonaggressive, emotional, nurturing, and concerned with people and relationships (Wood, 1999). To be masculine has meant to be strong, ambitious, successful, rational, and emotionally controlled (Wood, 1999). This cultural script is written into the culture long before a baby is born. It is transmitted to children through family, peers, teachers, and the media. Interestingly, these stereotypes have reigned unchallenged for generations, and thus advertisers as well as public relations practitioners use these stereotypes to promote products and, in the case of political campaigns, the candidates. Yet, the macho language and approach in past political campaigns were challenged in the 2008 U.S. election. Hillary Clinton's strategists insisted that in order for her to win the election, her advertising campaign needed to show that she was "the right man for the job" by presenting herself in typically masculine ways. In her TV ads she demonstrated she was competitive, ambitious, tireless, focused, and highly skilled at the political game. Barack Obama, alternatively, presented what could be described as a classically feminine campaign. In his TV ads he was shown to be collaborative, interested in dialogue with his opponents, very human, feeling, and people-led. This was an interesting shift and it proved quite successful with American voters.

Advertising mirrors society, and therefore ads that use stereotypes not only reflect but also tend to reinforce the stereotypical representations that are already present in a culture. In the case of women, there has been overwhelming evidence that advertisements have historically presented "traditional, limited and often demeaning stereotypes" (Lazier & Kendrick, 1993, p. 202). Some

of these gender stereotypes have been concerns in the United States, so we will begin by outlining the general concerns about negative representations of women in Western societies. Later in the chapter we shall look at some of the research on advertising and women across cultures.

WOMEN AS SEXUAL OBJECTS

One of the main criticisms of advertising that emerged in the United States in the 1960s with the advent of the women's movement was feminists' concern that women's bodies were being used to sell everything from air conditioners to auto wrenches. While women in bikinis had been draped over cars and washing machines for decades, it was only in the 1970s that women began to take issue with this representation. Feminists complained that this type of portrayal "objectified" women.

Attractive bodies and sexual stimuli are often used to grab the viewer's attention and to lend interest to a product or service. According to Reichert et al. (1999):

> In *TV Guide*, more than 35 percent of network promotional ads contain some sort of sexual reference. An analysis of Clio award-winning TV spots revealed that 29 percent contained a seductively dressed model, and 27 percent contained at least a hint of sexual suggestion. (p. 7)

But has research conclusively proven that all this sex really sells? While female nudity and erotic content have become quite commonplace in contemporary advertising in both the United States and Europe, the question of whether all these sexy bodies really sell products still remains controversial. Many researchers contend that the effect of erotic appeals "may often be counterproductive" (LaTour, Pitts, & Snook-Luther, 1990). The earliest study on sex in advertising is still one of the most frequently cited. Steadman (1969) investigated the effect of sexy models on brand recall and found that nonsexual illustrations were more effective in producing recall of brand names than were sexual illustrations, and that this became more pronounced with the passage of time (one week later). Steadman concluded that sexual content interferes with brand-name recall, and this finding was supported by a number of other researchers (Chestnut, LaChance, & Lubitz, 1977; Alexander & Judd, 1978; Richmond & Hartman, 1982). In other words, if an advertiser uses a sexy model in the ad, the model may get noticed but the product may not.

Interestingly, Weller, Sibley, and Neuhaus (1982) reported that explicit sexual content can occasionally improve brand recall for males, but not for females. Finally, ads containing nudity can also elicit negative responses from readers. Unless there is a linkage between the product and nudity (such as in lingerie, cologne, or sunscreen products), ads containing nude or semi-nude models are often criticized as being "exploitive" when nudity is used merely to gain attention and is not in any way related to the product.

The acceptance of nudity in advertising changes based on culture. Showing "the full Monty" (a naked male torso and bare bottom) is quite popular in the United Kingdom. Attitude research has found that more than three-quarters of British adults think nudity in ads should be allowed if it is relevant to the product ("Attitude Research," 1995). Other European countries seem to have little problem with nudity. In Germany and Denmark, nudity in advertising is common. Likewise, the Italians and the French find nothing wrong with nudity in advertising. Asia and the Middle East are far more conservative when it comes to using the female body in advertising. In the Muslim world, use of the female body for sales purposes is strictly forbidden. With the

exception of Japan, most Asian countries are also conservative when it comes to nudity in ads, though this too is changing as Asian media become more globalized.

WOMEN AS PASSIVE AND SUBMISSIVE

Another critique that emerged from the women's movement in the United States centered primarily on the limited roles in which advertisers used women, that is, as mothers and housewives (Courtney & Lockeretz, 1971). While this has changed over time, and today women are shown in a variety of roles, there are still some limitations. For example, women's voices are seldom used as announcers in TV commercials because advertisers believe that women's voices lack authority. Women are still the ones primarily shown in ads for household products having to do with laundry, cooking, and so forth. And when posed for photos in ads, they are often shown in passive or submissive ways. Shields (1990) contends that historically the predominant "gaze" has been the male gaze. The "old masters" were just that, male painters. The male painted (active) whereas the woman posed (passive). In the world of painting, female models were the objects of the male gaze. Shields (1990) argues that "ways of seeing" are gendered, and that the male gaze is aggressive while the female gaze is submissive. Today, the painter has been replaced with the photographer. When women pose for the camera they often assume or are asked to assume a submissive or passive stance. While some might say that this "lowered eyes, head down" type

Figure 6.2: Body cant or bashful knee bend. These are fashion poses in which the model bends, and curves her body, bends her knee and points her toes, cocks her head, and generally assumes a contorted posture in which movement is arrested and she is presented as a "sight" to be gazed upon.

Figure 6.3: Recumbent figure. A model is shown reclining or semi-reclining on the floor or on the ground or lounging on a bed or sofa. While the passivity of such portrayals is apparent, the sexual innuendo also is obvious.

of positioning is feminine, Shields would argue that it is submissive. In ads, women often gaze away from the camera, while men in ads tend to gaze directly into the camera.

Goffman (1976) conducted the earliest research on the positioning of women in submissive or inferior poses in ads. He identified symbolic behaviors in advertising presentation that are conventions used by advertising photographers. In fact, these conventions can be used worldwide today (see Figures 6.2 to 6.6).

Griffin, Viswanath, and Schwartz (1994) contend that many of the Western advertising conventions and poses for women were being transferred cross-culturally by advertisers in conjunction with the growth of global media and global advertising.

Figure 6.4: Psychological or licensed withdrawal. This refers to poses for women where they appear to be drifting off (gazing away from the camera), daydreaming, or staring blankly out of the frame. Goffman suggested that this type of pose made women look as though they were mentally incompetent or vacant. The woman is shown to be "withdrawn" from reality and inactive (not acting on her surroundings).

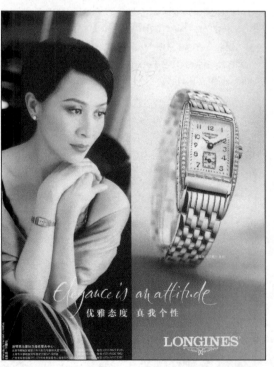

Figure 6.5: The engaging gaze. This is a passive pose where the model makes eye contact with the camera, engaging the viewer with seductive eye contact or a sexually seductive look.

Figure 6.6: Touching self. In these poses the model touches her face or covers part of her face with her hands. Goffman suggested that this pose made women look girlish, shy, and submissive.

Figure 6.7: "Fantasy rape" ad This Dolce & Gabbana "fantasy rape" ad ran in magazines throughout Europe before it was eventually banned based on consumer complaints.

WOMEN AS INFERIOR

Yanni (1990) suggests that advertising representations of women in patriarchal societies reflect their undervalued or inferior status (even today in the United States, women make 77¢ to every $1.00 made by men). She suggests that within a capitalist structure all work is assigned "value" and that women's primary use/value is sexual, in the house, and/or relatively lower paid office work.

Depictions of women in U.S. advertising have changed over time, and today there is an increased propensity to depict women as employed outside the home as business executives, professionals, and salespersons. Sullivan and O'Connor (1988) have noted that women are increasingly portrayed as "equal" to men, and, they concluded, "those responsible for the creation of magazine advertising have begun to recognize the increasing economic and social status of women in America" (p. 188).

However, in a study by Rudman and Verdi (1993), the authors examined the differences in sex role stereotyping, sexual display of body, and violent imagery between depictions of men and women in ads. They found that females are more likely to be placed in submissive positions; females are more often sexually displayed; and females are more often the subjects of violent imagery. The different ways males and females are portrayed give us insights into the social constructions of reality within a culture as well as what types of relationships are promoted between the sexes (see Figure 6.7).

WOMEN IN ADVERTISING ACROSS CULTURES

Some of the main criticisms of women's images in advertising in developing countries are similar to those of the developed world.

- Women are depicted as less intelligent and competent than men
- Women are shown as being servants to men
- Women are shown as objects of sexual pleasure

As one Korean author put this:

> For thirty years, media have been taken to task for reproducing and reinforcing stereotyped images of women. Yet unfair representations of women in media still prevail worldwide. Sex stereotyping has been so deeply ingrained, even glorified, that the women themselves have become desensitized to their own inferior portrayal. The prospects appear even gloomier as the globalization of media progresses. (Kyung-Ja, 2000, p. 86)

Perhaps the most comprehensive study of sex-role stereotyping across cultures was a 1999 review by Furnham and Mak (1999). These researchers compared and contrasted 14 previous studies on stereotyping from America, Australia, Denmark, France, Great Britain, Hong Kong, Indonesia, Italy, Kenya, Mexico, and Portugal. When contrasting the different settings in which men and women appeared across cultures, the researchers found that females were more often portrayed at home while males were portrayed in more diverse settings. Across cultures females were more likely to advertise products that are used at home whereas males were shown with products away from home. These researchers noted that studies done in more traditional societies show that sex-role stereotyping was stronger in less developed countries than in the developed countries, and they attributed this to the number of women working outside the home in the developed countries.

Figure 6.8: French ad

In certain areas, such as the portrayals of women in predominately housewife or "domestic management settings," researchers have found that Indian magazines far outstripped their American counterparts. But when comparing the use of "sexual pursuit" as a theme in ads (men pursuing women in an overtly sexual way), American magazines used these portrayals three times more often than the Indian magazines (Griffin, Viswanath, & Schwartz, 1994).

When comparing European portrayals of women in advertising with those of women in the United States, Wiles and Tjernlund (1991) found that in Swedish ads women were more frequently portrayed as professionals. American ads used women in "decorative" poses more frequently than did the Swedish ads. Comparing print ads from the United States and France, Biswas, Olsen, and Carlet (1992) reported that sex appeal was used more often in French than in U.S. advertisements. The

authors interpreted this as consistent with the perception that France is more liberal in terms of nudity in advertising than the United States (see Figure 6.8).

Comparing the portrayals of women in Japanese and American advertising, Sengupta (1995) noted that when shown in the home, American women were more likely to be shown "relaxing," while Japanese women were more likely to be shown "cooking, cleaning and doing other household chores" (p. 329). Cooper-Chen (1995) reported that in Japanese ads when women were portrayed in professional or working roles, it was most often as an entertainer or actress. In a study comparing images of young girls in a Japanese version of *Seventeen* magazine to an American version of the same magazine, the researchers reported that the Japanese models were posed as "cute" and "girlish" (smiling and giggling), while the Americans were posed with more serious expressions and looking more defiant and independent (Maynard & Taylor, 1999). In a study of women's portrayals in Chinese advertising, Cheng (1997) noted that women in Chinese television commercials wore more "demure" and less sexually suggestive clothing than did women in U.S. advertisements. This was also true in print advertising. Frith, Cheng, and Shaw (2004) found that Western models were shown more frequently portrayed as "sexy" in seductive dress and poses than Asian models in women's magazines in Asia. They concluded that when the ad strategy is that "sex sells," Western women are used more often than Asians in magazine ads.

GLOBAL MEDIA AND WOMEN'S MAGAZINES

One of the best examples of how transnational advertisers, their agencies, and global media collaborate is in the area of women's magazines (Frith, 2005). Today, for example, more than 35 international women's magazine titles, such as *Elle, Vogue, Cosmopolitan, Marie Claire,* and *Harper's Bazaar,* can be easily found on the magazine racks of shops throughout the world. According to the *International Herald Tribune* (February 13, 2004), the emergence of international women's magazines is driven by global brands in need of advertising vehicles. The speed of their expansion has been accelerated by market liberalization policies in most countries that allow for direct foreign investment in the print media.

Many women's magazines are part of larger media conglomerates. For example, *Cosmopolitan* and *Harper's Bazaar* are published by the Hearst Corporation, one of the three dominant magazine publishers in the United States (Hoover's online, 2004). As another major publisher, Condé Nast produces magazines such as *Vogue, Glamour, Brides,* and *Self* (McCracken, 1993). Hachette Filipacchi, the French publishing giant, publishes 238 titles worldwide

Figure 6.9: *Elle* magazine, the Singapore, China, and German editions

WOMEN'S PACK

including *Elle*, which is now available in over 35 different country editions (*International Herald Tribune*, February 13, 2004). These global magazines, with their transnational advertising, are produced by a handful of private Western corporations (Gershon, 1993). Bagdikian (1989) predicted that in the twenty-first century, "only five to 10 corporate giants would control most of the world's important newspapers, magazines, books, broadcast stations, movies, recordings and videocassettes" (p. 805).

The Role of Advertising in Global Women's Magazines

Although a certain amount of revenue comes from the purchase price of a magazine, advertising is an important financial source for most women's magazines. Bagdikian's (2000) explanation about the influence of advertisers on magazine articles shows this phenomenon clearly:

> The influence of advertising on magazines reached a point where editors began selecting articles not only on the basis of their expected interest for readers but for their influence on advertisements. Serious articles were not always the best support for ads. An article on genuine social suffering might interrupt the "buying" mood on which most ads for luxuries depend. (p. 138)

According to Earnshaw (1984), the reliance of the women's magazine industry on advertising means that advertisers can exert pressure on editors to produce publications that appeal to the audiences their advertisers want to reach; of which the most important audience segments are defined by social class and age. Magazines attract more advertising revenue when they provide the "right" target readers, who are generally the younger, richer women. For example, Bagdikian (2000) pointed out that magazines allow articles to be commissioned solely to attract the readers who are good prospects to buy the products advertised in the magazines. And herein lies one of the problems. Often, global women's magazines transmit consumer culture and consumer values to countries where the majority of people still live in poverty.

Figure 6.10: Fendi bib from the August issue of *Vogue India*

A recent issue of the *New York Times* carried a story titled, "*Vogue*'s Fashion Photos Spark Debate in India" (2008). The story described a 16-page fashion spread in the August 2008 issue of *Vogue India* that showed an old woman with missing front teeth holding a child in rags wearing a Fendi bib priced around US$100 (see Figure 6. 10). Another "fashion" photo showed a toothless, barefoot man holding a Burberry umbrella (costing about US$200). When questioned about the "tastefulness" of these images, Priya Tanna, *Vogue India*'s chief editor, said, "You have to remember with fashion you can't take it that seriously, we aren't trying to make a political statement or save the world" (Timmons, 2008, p. 1).

As the *New York Times* pointed out, "juxtaposing poverty and growing wealth presents a dilemma for luxury goods makers moving into developing countries. How do you sell a $1,000 handbag in a country where many are starving?"

Women's magazines are perceived as effective vehicles for reaching middle-class and middle-income women who are the most desirable targets for transnational advertisers. Not surprisingly, many international consumer brands tend to use international women's magazines as a global marketing tool. For example, international brands like Chanel can negotiate a deal with a global media owner such as Hachette Filipacchi to execute their global campaign, translated into many languages, through the 35 *Elle* country-editions in the United States, Europe, South America, and Asia (Frith, 2005). The demand of transnational advertisers for advertising space that offers a consistent look and feel across borders is increasing. Thus, for many women's magazines, transnational advertising has become a lucrative source of income.

The Role of Advertising in Local Women's Magazines

The entrance of global magazines has had an impact on local magazines, as local and international women's magazines now compete in each country to win readers. One marketing technique that is now common for both is to package the magazines with a bewildering array of gifts to entice customers to buy the magazines. These gifts, like shopping bags and free samples, can be worth twice the cover price of the magazine (*International Herald Tribune*, February 13, 2004). The global magazines can underwrite the costs of these gifts from advertising revenue, but it is harder for local magazines to compete.

Further, local women's magazines in Asia have started to change their content into formats favored by transnational advertisers. They now offer special editorial sections that introduce the history and product range of international luxury brands, such as Chanel and Burberry, in a bid to attract more transnational advertisers.

Advertising, especially transnational advertising, is an important source of revenue for both local and international women's magazines. Yet international women's magazines get the largest share of transnational advertising dollars and thus they play an important role in disseminating global ideas and materialistic values via their standardized and Western-oriented transnational advertising. In many countries, local women's magazines have chosen to follow the unquestioned lead of these international magazines, assuming that their readers favor foreign over local models, transnational over local products, and entertainment over more serious content.

ADVERTISING AND MASCULINITY

Like femininity, masculinity is historically and socially determined and the images of men also change over time. What is considered masculine in one era and in one society may not be the ideal of masculinity in another country or even in another era. In the United States, ads for men have historically presented a single individual, who is shown as the hardworking business type. This image of a man, functioning in isolation without the assistance of others, is a depiction of American manhood that is deeply rooted. One example of this stereotype is the icon of the cowboy, found in the Marlboro Man campaign—a solitary figure, "alone on the range," surviving in harsh environments, dependent only on his horse and his lasso. Some researchers, such as Patterson (1999), suggest that American individualism has provided three stereotypes of men:

- the cowboy, who is tough, unemotional, and alone;
- the Superman, who conquers the world and the women around him;
- the Mr. Universe, the achieving athlete or the muscleman.

In sampling ads from male-audience magazines in the United States including *Business Week, Esquire, GQ, Rolling Stone,* and *Sports Illustrated,* Kolbe and Albanese (1997) found that when men are shown in ads, the majority of depictions are full-body shots or shots from the waist up. Seldom are men's bodies "objectified" in the same way as women's, that is, ads showing only certain body "parts" like legs, lips, or eyes (Kolbe & Albanese, 1996). The researchers also found that 90 percent of all U.S. advertisements with sole males were shot with the camera angle level with the model and more than one-third of the models were looking directly at the camera (Kolbe & Albanese, 1997).

On the body type dimension, the majority of men in U.S. ads have had a physique that was strong and muscular. Katz (1995) notes that while advertising aimed at women encourages them to be thin, "there have been hundreds of ads for products designed to help men develop muscular physiques, such as weight training machines and nutritional supplements" (p. 135). He contends that "muscularity as masculinity" is a common theme in ads aimed at men in the United States.

The images of the ideal man have, however, changed over time. Note in Figures 6.11 and 6.12 how the different "ideal" physiques for a male are depicted.

Figure 6.11: A boxer on a 1948 magazine cover

Figure 6.12: The "evolved" male physique in a U.S. ad

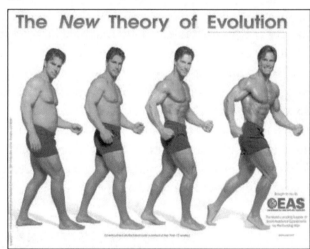

THE MALE IMAGE ACROSS CULTURES

Research conducted in the 1990s found that the traditional depictions of men were changing and that there was a notable increase in the use of the male body as a sexual object in the West. This trend has been termed the "feminization of masculinity" (Iida, 2005) and acknowledges the commercialization of masculine bodies. While the trend is apparent in advertising in the West, it is also widespread in advertising in Asia and reflects the rapid changes in Asian societies. Iida (2005) notes:

As I made my first research trip to Tokyo in 1996 after being away from Japan for about 7 years, I was astonished by the degree of change, more precisely the "improved appearance" of a class of young adolescent men who seemed to have a much keener awareness and interest in how they looked. (p. 56)

Figure 6.13: Modern Asian masculinity

The increasing presence of image-conscious men in Japan is called the "cult of male beauty," and Iida (2005) notes that it is apparent on TV screens as well as in men's magazines in Japan. She argues that the "feminization of masculinity" was brought about by the commercialization of cultures from the 1980s onward, which in turn brought about a cultural orientation that ascribed "greater significance to the adaptation of a feminine aesthetic" (p. 57). Today, young Japanese men sport colorfully dyed hair, color-coordinated outfits, and a well-honed fashion sense (see Figure 6.13). Ford et al. (1998) reported that in a content analysis of men's advertising in Japanese magazines, they found several traits previously associated with Japanese women (devoted, obliging, superstitious), and a dearth of stereotypically male traits (autocratic, blustery, severe). As societies become more globalized and trends move quickly across borders, this feminization of the male body challenges the phallocentric economy of the past and is opening up a space for men to redefine masculinity.

GAY ADVERTISING

Less than a decade ago, a TV spot for Ikea caused such a sensation that it was pulled from the air after it ran only once. It featured two middle-aged men shopping for a table, speaking to each other in tones that suggested they may have been "a couple." It was quickly pulled after the company received bomb threats. Times have changed. Today many mainstream companies like American Express and Absolut Vodka are running campaigns aimed at this lucrative target audience. In fact, there are specialized ad agencies that develop campaigns just for the gay, lesbian, bisexual, or transgender (GLBT) customer and product placements for the gay market. There is even an awards ceremony for the best advertising aimed at gays, called the GLADD Media Awards. In the United States alone, the buying power of gays and lesbians has been estimated to be more than US$450 billion (see Table 6.1).

Table 6.1: Buying Power of Niche Groups of Consumers in the United States

	MARKET POPULATION	BUYING POWER	BP PER CAPITA
African American	30 Million	$535 Billion	$17.8K
Gay American	16.5 Million	$450 Billion	$27.3K
Hispanic American	31 Million	$383 Billion	$12.4K
Asian American	11 Million	$229 Billion	$21.0K

Source: Selig Center for Economic Growth. University of Georgia. www.gaymarketexpress.com

There are also watchdog groups in the United States and the United Kingdom that monitor ads that appear homophobic. In 2008 a Snickers ad ran on British TV featuring the actor Mr. T (from the TV show *The A Team*) harassing a wussy speed walker in a yellow jumpsuit for being a "disgrace to the man race." The Mars candy company had to pull the commercial after U.S. gay rights activists complained that it was offensive to gays. Interestingly, while the ad never ran in the United States, it was viewed via the Internet worldwide and that alerted the Human Rights Campaign, a large U.S. gay civil rights organization, to complain. *Advertising Age,* a trade magazine for the ad industry, published an open letter criticizing Mars for perpetuating "the notion that the gay, lesbian, bisexual and transgender community is a group of second class citizens and that violence against GLBT people is not only acceptable, but humorous" (Sweeney, 2008). The commercial can be seen on YouTube under "Mr T Snickers commercial."

Figure 6.14: Gay advertising in Singapore?

While gay rights advocates can pressure companies in the West to improve or remove advertising that is offensive, this is not the case worldwide. Many countries in Asia have very conservative views on gays, and advertising aimed at the gay market in Asia must be so subtle that it can run without being noticed by the mainstream consumer. The billboard in Figure 6.14 ran for nearly a month in Singapore, a traditionally ultraconservative country, before it was removed.

CONCLUSIONS

While concepts of femininity and masculinity are culturally constructed and differ from region to region, much advertising focuses on physical appearances. Attractive men and women, combined with sexy appeals, are used to sell products across the globe. Additionally, right or wrong, the mass media consistently reinforce assumed linkages between physical appearances and people's feelings of self-worth (Englis, Solomon, & Ashmore, 1994). This emphasis on body image starts young, and it is reinforced via mass media vehicles like advertising.

In addition, marketing to gays, lesbians, and transsexuals has become a growing business worldwide, although not all countries allow blatantly gay advertising. Thus, in more conservative countries, like many in Asia, gay advertising runs but it runs below the radar.

REFERENCES

Alexander, Wayne, & Judd Jr., Bed. (1978). Do nudes in ads enhance brand recall? *Journal of Advertising Research, 18,* 47–50.

Attitude research unveils the naked truth. (1995, November). *Marketing.* p. 6.

Bagdikian, B. (1989, June 12). The lords of global village. *The Nation,* 805–820.

Bagdikian, B. (2000). *The media monopoly.* Boston: Beacon Press.

Barcus, F. Earle. (1983). *Images of life on children's TV.* New York: Praeger.

Biswas, Abhijit, Olsen, Janeen E., & Carlet, Valerie. (1992). A comparison of print advertisements from the U.S. and France. *Journal of Advertising, 21,* 73–81.

Block, Jack, & Robins, Richard. (1993). A longitudinal study of consistency and change in self-esteem from early adolescence to early adulthood. *Child Development, 64,* 909–923.

Brown, Timothy A., Cash, Thomas F., & Mikulka, Tracie. (1990). Attitudinal body image assessment: Factor analysis of the body-self relations questionnaire. *Journal of Personality Assessment, 55,* 135–144.

Cheng, Hong. (1997). Holding up half the sky: A sociocultural comparison of gender role portrayals in Chinese and U.S. advertising. *International Journal of Advertising, 16,* 295–319.

Chestnut, Robert, LaChance, Charles, & Lubitz, Amy. (1977). The decorative female model: Sexual stimuli and the recognition of advertisements. *Journal of Advertising, 6,* 11–14.

Cooper-Chen, Anne. (1995). *The second giant: Portrayals of women in Japanese advertising.* Paper presented at the AEJMC Annual Conference, Washington.

Courtney, Alice, & Lockeretz, Sarah. (1971). A woman's place: An analysis of the roles portrayed by women in magazine advertisements. *Journal of Marketing, 8,* 92–95.

Earnshaw, S. (1984). Advertising and the media: The case of women's magazines. *Media, Culture and Society, 6,* 411–421.

Englis, Basil, Solomon, Michael, & Ashmore, Richard. (1994, June). Beauty before the eyes of beholders: The cultural encoding of beauty types in magazine advertising and music television. *Journal of Advertising,* 49–63.

Ford, J., Voli, P., Honeycutt, E., & Casey, S. (1998) Gender role portrayals in Japanese advertising: A magazine content analysis. *Journal of Advertising, 27,* 113–124.

Freedman, T. (1986). *Beauty bound.* Lexington, MA: D.C. Heath.

Frith, K. (2005). Portrayals of women in global women's magazines in China. In T. Holden & T. Scrase (Eds.), *Medi@sia* (pp. 149–169). New York: Routledge.

Frith, K., Cheng, H., & Shaw, P. (2004). Race and beauty: A comparison of Asian and Western models in women's magazine advertisements. *Sex Roles, 50*(1/2), 53–62.

Furnham, Adrian and Mak, Twiggy (1999). Sex-role stereotyping in television commercials: A review and comparison of fourteen studies. *Sex Roles* 41 (5–6), 413–437.

Gershon, R. (1993). International deregulation and the rise of transnational media corporations, *Journal of Media Economics,* pp. 3–22.

Goffman, Erving. (1976). *Gender advertisements.* Cambridge, MA: Harvard University.

Griffin, Michael, Viswanath, K., & Schwartz, Dona. (1994). Gender advertising in the U.S. and India: Exporting cultural stereotypes. *Media, Culture & Society, 16,* 487–507.

Guillen, E., & Barr, S. (1994, September). Nutrition, dieting, and fitness messages in a magazine for adolescent women, 1970–1990. *Journal of Adolescent Health, 15*(6), 464–472.

Hartner, Susan. (1993). Processes underlying the construction, maintenance and enhancement of the self-concept in children. In J. Suls & A. G. Greenwald (Eds.), *Psychological perspectives of the self, Vol. 3*, Hillsdale, NJ: Lawrence Erlbaum.

Hoover's online. (2004). Retrieved March 30, 2004, from http://cobrands.hovers.com/global/cobrands/proquest/factsheet.xhtml?COID=40006

Iida, Yumiko. (2005). Beyond the "feminization of masculinity": Transforming patriarchy with the "feminine" in contemporary Japanese youth culture. *Inter-Asia Cultural Studies, 6*(1), 56–74.

International Herald Tribune. (2004, February 13). The West's glossy magazines go forth and multiply.

Katz, Jackson. (1995). Advertising and the construction of violent white masculinity. In Gail Dines & Jean Humex (Eds.), *Gender, race and class in the media: A text reader.* Thousand Oaks, CA: Sage.

Kolbe, Richard, & Albanese, Paul. (1996). Man to man: A content analysis of sole-male images in male-audience magazines. *Journal of Advertising, 25*(4), 1–20.

Kolbe, Richard, & Albanese, Paul. (1997). The functional integration of sole-male images into magazine advertisements. *Sex Roles, 36*(11), 12.

Kolbe, Richard, & Langefield, Carl. (1993). Appraising gender role portrayals in TV commercials. *Sex Roles, 28*(7/8), 393–415.

Kyung-Ja, Lee. (2000). Country experiences: Korea. In *Changing lenses: Women's perspectives on media.* Manila, Philippines: ISIS.

Lakoff, Robin, & Scherr, Raquel. (1984). *Face value: The politics of beauty.* Boston: Routledge & Kegan Paul.

LaTour, Michael, Pitts, Robert, & Snook-Luther, David. (1990). Female nudity, arousal and ad response: An experimental investigation. *Journal of Advertising, 19*(4), 51–62.

Lazier, Linda, & Kendrick, Alice G. (1993). Women in advertising: Sizing up the images, roles & functions. In Pamela Creedon (Ed.), *Women in mass communication* (pp. 199–219). Newbury Park, CA: Sage.

Martin, Mary, & Gentry, James W. (1997). Stuck in the model trap: The effects of beautiful models in ads on female pre-adolescents and adolescents. *Journal of Advertising, 26*(2), 19–33.

Maynard, Michael, & Charles Taylor. (1999). Girlish images across cultures: Analyzing Japanese versus U.S. *Seventeen* Magazine ads. *Journal of Advertising, 28*(1), 39–48.

McCracken, E. (1993). *Decoding women's magazines: From* Mademoiselle *to* Ms. New York: St. Martin's Press.

Patterson, Phillip. (1999). Rambos and himbos: Stereotypical images of men in advertising. In Paul Martin Lester (Ed.), *Images that injure: Pictorial stereotypes in the media.* Westport, CT: Praeger.

Pierce, Kate, & McBride, Michael. (1999). Aunt Jemima isn't keeping up with the Energizer Bunny: Stereotypes of animated spokes-characters in advertising. *Sex Roles, 40*(11/12), 959–968.

Reichert, Jacqueline L., Morgan, Susan, Carstarphen, Meta, & Zavoina, Susan. (1999). Cheesecake and beefcake: No matter how you slice it, sexual explicitness in advertising continues to increase. *Journalism Quarterly, 76*(1), 7–20.

Richins, Marsha. (1991). Social comparison and the idealized images of advertising. *Journal of Consumer Research, 18*, 71–83.

Richmond, David, & Hartman, Timothy. (1982). Sex appeal in advertising. *Journal of Advertising Research, 22*, 53–61.

Rudman, William J., & Verdi, Patty. (1993). Exploitation: Comparing sexual and violent imagery of females and males in advertising. *Women and Health, 20*(4), 1–14.

Seiter, Ellen. (1995). *Sold separately: Parents and children in consumer culture.* New Brunswick, NJ: Rutgers University Press.

Selig Center for Economic Growth, University of Georgia; www.gaymarketexpress.com

Sengupta, Subir. (1995). The influence of culture on portrayals of women in television commercials: A comparison between the United States and Japan. *International Journal of Advertising, 14*, 314–333.

Shields, Vickie R. (1990). Advertising visual images: Gendered ways of seeing and looking. *Journal of Communication Inquiry, 14*(2), 25–39.

Signorielli, Nancy. (1991). *A sourcebook on children and television.* New York: Greenwood.

Steadman, Major. (1969). How sexy illustrations affect brand recall. *Journal of Advertising Research, 9,* 15–19.

Sullivan, Gary, & O'Connor, P. J. (1988). Women's role portrayals in magazine advertising: 1958–1983. *Sex Roles, 18*(3 & 4), 181–189.

Sweeney, M. (2008, July 29). Offensive Snickers TV ad pulled. *The Guardian,* p. 8.

Timmons, H. (2008). *Vogue's* fashion photos spark debate in India, *New York Times,* September 1, pp.1–3.

Walsh-Childers, Kim. (1999). Women as sex partners. In Paul Martin Lester (Ed.), *Images that injure: Pictorial stereotypes in the media.* Westport, CT: Praeger.

Weller, R., Sibley, S., & Neuhaus, C. (1982). Experimental results concerning the effect of the female model in television commercials on product and brand recall. *Development Market Intelligence,* 468–472 (Las Vegas-Academy of Marketing Science).

Wiles, Charles, & Tjernlund, Anders. (1991). A comparison of role portrayals of men and women in magazine advertising in the U.S.A. and Sweden. *International Journal of Advertising, 10,* 259–267.

Wood, Julia. (1999). *Communication, gender and culture* (3rd. ed.). Belmont, CA: Wadsworth.

Yanni, Denise. (1990).The social construction of women as mediated by advertising. *Journal of Communication Inquiry, 14*(1), 71–81.

7

Advertising and Race

INTRODUCTION

In order to understand how advertising constructs race, we must learn how to read advertisements as cultural texts. For ads are not just messages about goods and services, but, as was noted in previous chapters, ads are social and cultural texts about ourselves and others.

The conventional way that marketers define "advertising" is to describe it as messages that "impart information about products which consumers use to make brand choices" (Domzal & Kernan, 1992, p. 49). The limitation of this definition is that it falls short of giving us the whole picture. Advertising does much more than impart product information; it tells us what products signify and mean. It does this by marrying aspects of the product to aspects of the culture. Embedded in advertising's messages about goods and services are the cultural roles and cultural values that define our everyday life and the lives of others.

For example, a TV commercial that won international awards for an automobile manufacturer showed the car being driven through various countries across the globe. In China the car passed by a group of Chinese people doing *tai chi* exercises on the Great Wall. In Mexico the car passed a Mexican farmer who was standing near the road wearing a big sombrero—the farmer smiled and waved at the driver. In this way, the viewer, who was sitting comfortably in his or her living room in a small town in the United States or Europe, was shown glimpses of how people live in other parts of the world. The viewer was given a quick glimpse of "the other."

Certainly not everyone in China does *tai chi*, nor does everyone in Mexico wear a sombrero, but the intrinsic nature of ads is to push for a sale, and in so doing, to exaggerate or magnify certain aspects of the product and the context in which the product appears. Thus, in the process

of "magnification," stereotypes of people are enhanced. From the advertiser's point of view, the bottom line is profit and sales. Advertisers have little time for character development. They must get their point across on TV in only 30 seconds. In magazines, the average reader spends about three or four seconds on each page; so again, the advertiser must compress the sales message. To show that a car is accepted by people worldwide, the easiest way to do this is to stereotype people worldwide.

At root, a stereotype is an expression of a mental schema that people use to organize information and to which meaning is attached. As such, stereotyping does not by definition carry negative or positive values. It is when we imbue the stereotype with a certain type of meaning that it becomes negative. Also, when stereotypes are magnified in ads they can be harmful in that the repetition of a stereotype naturalizes it and makes it appear "normal."

In this chapter we will look at some of the ways that racial and ethnic stereotypes are used in advertising. Advertisements reflect society, in a sometimes slightly distorted way, and by undressing (Frith, 1998) or demystifying ads we can begin to see the role advertising plays in the creation of racial and cultural stereotypes.

THE AD AS A CULTURAL TEXT

All advertisements rely on the cultural knowledge and background of the reader. People "make sense" of ads by relating them to a shared belief system—one that is held in common by most people within a society. Stereotyping, therefore, is based on cultural beliefs. As O'Barr (1994) has noted, before the civil rights movement of the 1960s, blacks were only featured in advertisements in subservient roles such as porters, cooks, and bellhops. This type of stereotyping appeared to be "common sense" until these representations were questioned by a large enough group of people.

In his book *Culture and the Ad: Exploring Otherness in the World of Advertising*, William O'Barr (1994) explains that all advertisements contain ideology. He defines "ideology" as "ideas that buttress and support a particular distribution of power in society" (p. 2) and notes that ideology is, by nature, always political. Because we are so deeply embedded in our own set of cultural beliefs, it is often difficult for us to see the ideas that buttress and support the social system within which we live. Wernick (1991) says that ideology is elided or hidden. In order to undress the ideological messages in advertising, O'Barr (1994) suggests that we examine the roles people play in ads. Who appears to be in charge? Who holds the power? Who is weak? Who is dominant and who is subordinate (O'Barr, 1994)? These types of questions allow us to begin to see the deeper social structures that are circulated and recirculated in advertising.

TOKENISM

We can determine the social relationships in an ad by asking questions about power and control. Who appears to be dominant in the ad? Who appears to be in a subordinate position? How is power expressed? We can ascertain the power positions by determining who appears to be featured or "in the foreground," or who is bigger or more "in control" of the situation in an ad (O'Barr, 1994). Just as Goffman (1976) examined how women were positioned in ads in subser-

vient or secondary roles, we can also look at representation of minorities in ads. Take Figure 7.1 for example.

On the surface, there appears to be no discrimination in this ad. It ran in a multicultural society and the advertiser probably wanted to use a variety of races in the ad. In fact, there are whites, blacks, and Asians in the ad. However, if you look more closely you might wonder why the Caucasian models are "foregrounded" while the black and Asian models are posed in the background. In fact, the Asian model is so far back we can barely see "The New Polo" shirt he is supposedly wearing. Unfortunately, when minorities are used in multicultural ads, there is often unequal representation. Sometimes the face is cropped; sometimes the black or the Asian model is standing in the background. Is this intentional or unintentional? Is this a form of discrimination, or merely an oversight? The fact that it happens repeatedly in ads gives a person cause to wonder. Even in Benetton ads, which ostensibly were concerned with fighting racism, the same type of cropping of the black face occurred (see Figure 7.2).

There is a buzzword among African American marketers. When a black is put into a white ad, it is called a "permission to buy." It is like saying, we know you're black, but it's ok, you can buy our product, too. (Berry, 1991, p. 18). "Tokenism" is the practice of making only a symbolic effort or doing no more than the minimum to show compliance with a societal standard. In the case of advertising, we often find that minority groups are given minimum concessions, that is, they are in the ads but they do not hold much power.

Figure 7.1: Ad for GAP

Figure 7.2: Benetton ad

DEMYSTIFYING THE AD

O'Barr (1994) suggests that in order to analyze how power is being depicted in an ad one should tell the story of the ad, then reverse the roles of the key people. By doing this, one can see the relationships between the characters. To understand gender relationships, one might substitute the woman model with a man. To understand ageism, one might substitute a young person with an older person, and to understand racial relationships, one might substitute a white person with a black. When the story is retold would the message be the same? How would the message change? What does this say about the roles or stereotypes that advertising perpetuates?

This type of analysis reveals the deeper social structures that often go unnoticed in advertising. The method's rationale is that exposure of cultural mores depends on one's ability to engage in self-conscious introspection, for only by viewing what appears "normal" from an outsider's perspective—that of "the other"—can common assumptions about natural behaviors be exposed as merely partial worldviews. O'Barr (1994) points out that asking these types of questions enables us to discover important facts about social relationships in our own society. He asserts that while equality is not precluded as a possible message in the discourse of advertising, advertisements are "seldom egalitarian" (p. 4). The most frequently depicted qualities of social relationships in advertising are: hierarchy, dominance, and subordination (O'Barr, 1994).

Figure 7.3: Multicultural group of models in a Lacoste ad

Myths are preexisting, value-laden sets of ideas derived from a culture and are transmitted through various forms of communication (Leiss, Kline, & Jhally, 1988). By retelling the story in an ad, using O'Barr's technique, one can demystify and historicize and expose the myths. Take for example the Lacoste ad in Figure 7.3.

The story being represented in the ad relates to a group of people who appear to be frolicking and who also appear to like wearing Lacoste clothing. There are two Caucasian models and one Asian model in the ad. It is interesting to note that the Caucasian males are in the

foreground and appear to be "in charge" of the fan that is blowing on the Asian female model. Now let us exchange the key players in the ad. When the story is retold with the roles reversed, would the message be the same? Imagine that the Lacoste ad features two Asian men models holding a fan on a Caucasian girl. Would this change the meaning of the ad? Would the reader wonder why there were so many Asians in the ad? Or, would the reader feel good that at least one white person was included in the group? In the United States, which has historically been a predominately white society, readers come to expect that groups of models in ads will be primarily white and the minority races will be given token representation.

HISTORICALLY FAVORED POSITIONS

We can also ascertain historically based power relationships by asking ourselves, are certain historically favored positions being expressed in an ad? Does the ad suggest that people who are of a certain race are stronger, more powerful, or more beautiful than others? Lester (1998) suggests that through its use of verisimilitude, that is, through its evocation of familiar commonsense roles, we enter into the discourses of advertising unthinkingly, enfolding both the product and ourselves within a structure of power relations that has been inscribed over 1,000 years of patriarchy, five centuries of European colonialism and U.S. neocolonialism, and 400 years of racism. Lester contends that we learn certain attitudes, beliefs, and knowledge about racial roles and relations, class, history, and politics and economics by viewing ads among other cultural products. Advertising not only defines its target audience but is a much broader audience that is inscribed in larger social discourses about the self and "the other."

Western superiority is often expressed in a variety of ways. It is rather like the story being told in the Donna Karan ad in Figure 7.4, which ran in *Elle*. In the ad we can

Figure 7.4: Donna Karan ad from *Elle* magazine

see the perpetuation of certain colonial myths. The white woman, in her white Donna Karan suit, is walking in the streets of a foreign city, past an Asian woman who is stereotypically wearing a straw hat. The white woman signifies power (note her size in comparison to the Asian woman). The story we read in the ad is that the white woman is visiting the Third World to "do business," as she is dressed in a business suit and carrying an attaché case.

If she were a tourist she would probably be dressed more casually and be carrying a camera. Perhaps the woman represents an executive from the Donna Karan corporation who has been sent to visit one of the Vietnamese factories where Donna Karan's US$300 suits are sewed by Vietnamese women who earn approximately US$2.00 per day.

STEREOTYPES OF MINORITY GROUPS IN THE UNITED STATES

Another way that racism occurs in advertising is through the types of images that are chosen to represent minority groups. Mayes (1998) notes that the portrayal of African Americans in advertising has gone through many changes. In pre–civil rights days, African Americans were depicted stereotypically in servitude as porters, cooks, and maids, but today, an advertisement might feature an African American woman in a business role. Licata and Biswas (1994) looked at representation, roles, and occupational status of black models in TV ads from the 1970, 1980s, and 1990s. They found that there was a significant increase in the percentage of blacks in ads over time. In 1967 only 4 percent of ads showed black models, but by 1974 they were included in up to 44 percent depending on geographic region. Of 213 commercials that were analyzed, 35.2 percent had at least one black model; however, the models tended to be shown with low-value products (soda or detergents, not cars, computers, or credit cards). Black models were three times more likely to be shown as athletes than whites. White models were twice as likely as blacks to appear as professionals or in business roles (Licata & Biswas, 1994).

Figure 7.5: Ad featuring two babies of different races

Even children get stereotyped in ads. Seiter (1995) notes that one of the "common" stereotypes of white infants and small children is the "go-getter." This is not a stereotype that is open to black children, who tend to be shown in ads as passive while the white infants are featured in active roles (see Figure 7.5). Seiter concludes that casting, camerawork, and direction all work together with storyline to create stereotypes in children's advertising.

The stereotypes of Asians in ads is more complimentary, as Asians, particularly Asian immigrants to the United States, have been described as "the model minority" (Cohen, 1992; Delener & Neelankavil, 1990). Perhaps this is because they have achieved more economic success than any other group in the country. Wikipedia reported that the median income of Asian households in the United States averaged US$57,518, compared to US$34,214 for Hispanics and US$48,977 for white Americans (http://en.wikipedia.org/wiki/Personal_income_in_the_United_States).

When Asians are used in U.S. ads, they tend to be featured in ads related to business. While this may seem complimentary, nonetheless it represents a stereotype whose prevalence could have negative consequences, not least of which is resentment from other groups. Taylor, Lee, and Stern (1995) compared the portrayals of African Americans, Hispanics, and Asian Americans in magazine ads and found that when Asians were featured in the ads, they were often shown in business suits or used in ads for technology products. The researchers also found that Asians were more likely than other minority groups to appear in background roles, and that Asian women were seldom depicted in major roles in ads. In fact, Asian women were seen less frequently than their male counterparts in ads (less than 1 percent of all ads had Asian women), and when seen were rarely in a nonbusiness setting (Taylor, Lee, & Stern, 1995).

The U.S. Bureau of the Census defines "Hispanic" as a person of any race who either speaks Spanish or has a Spanish-speaking ancestor. Hispanics are the fastest growing demographic segment in the United States, and while marketers like to claim that it is possible to market to Hispanic Americans as a single group, the concept of grouping 39 million people as one market ignores a considerable amount of cultural and demographic diversity. Although there has been a plethora of research on African Americans in advertising, there has been little done on the representation of Hispanics in ads. One study (Taylor, Lee, & Stern, 1995) found that Hispanics are the most underrepresented of all minority groups in advertising. While they made up approximately 14 percent of the total U.S. population, they were shown in only 4.7 percent of the ads in general interest magazines. When they were depicted in ads, Hispanics were generally used in family-oriented situations (Taylor, Lee, & Stern, 1995).

THE GLOBALIZATION OF WHITENESS

Minorities in North America

In the United States when black men and women are featured in advertisements, the models generally conform to traditional Eurocentric ideals. Many current ads feature black models who look almost white, due to their light-skinned complexions. Strutton and Lumpkin (1993) point out that empirical evidence dating back to the 1950s shows this stereotyping in the selection of black models by advertisers. Moreover, they note that a disproportionately large percentage of black models used in ads possess light skin and Caucasian features.

Historically for African American men and women, their social status was often determined by their skin color during the days of slavery. For example, fair-skinned women were judged more favorably than were dark-skinned women (Wade, 1996; Wade & Bielitz, 2005) and were preferred for easier jobs, better food and accommodation, and were more likely to be freed (Wade, 1996; Rockquemore, 2002). Recent studies have shown that light-skinned African Americans in the United States continue to be judged more attractive than those with dark skin (Rockquemore, 2002). Hunter's (2002) study on women's skin tone and beauty suggests that the relationship between skin color and beauty is seen as a form of "social capital" for women, which she defines as a form of prestige that is related to social status, and to social networks. Other researchers have found positive correlations between skin color and economic resource attainment, in terms of education and job opportunities (Thompson & Keith, 2001).

hooks (1992) has noted that advertising for hair care products marketed toward black women proliferates in magazines. The majority of the ads promote the alteration of black hair texture from its natural state into a "relaxed" or straightened state in order to attain social acceptance (hooks, 1992, 1995). She contends that the images of black beauty that abound in current advertising are still defined by dominant white societal discourses.

A similar situation exists for Hispanics. The Spaniards adopted a caste system formulated through color tone (Hunter, 2002) in New Mexico, where having lighter skin and European features was beneficial. These skin-color stratifications have persisted even in contemporary times (Hunter, 2002; Thompson & Keith, 2001; Robinson & Ward, 1995; Wade, 1996). Similarly in South America, whiteness and its related attributes, such as light skin and delicate features, is often linked with beauty (de Casanova, 2004).

In bell hooks's "Eating the Other," and in her *Black Looks: Race and Representation* (1992), she discusses this issue in relation to multiculturalism and notes that "when the dominant culture demands that the Other be offered as a sign that progressive social and political change is taking place, and that the American Dream can indeed be inclusive of difference—the acknowledged Other must assume a recognizable form" (p. 26). And, in the case of minority women, it is the white beauty standard to which they must conform. Joseph and Lewis (1981) conducted a content analysis of ads aimed at black and white women. They examined a number of magazines including *Essence* and *Cosmopolitan* and concluded that the image of women was constructed almost entirely through sexuality. They noted that the concept of female beauty for both black and white women was based on standards set by white males, who are the people most empowered in American society. In their reading of the ads, Joseph and Lewis (1981) felt that black women are encouraged to emulate white women by changing their appearance in order to be considered attractive: By alter-

Figure 7.6: An ad featuring famous black model Vanessa Williams

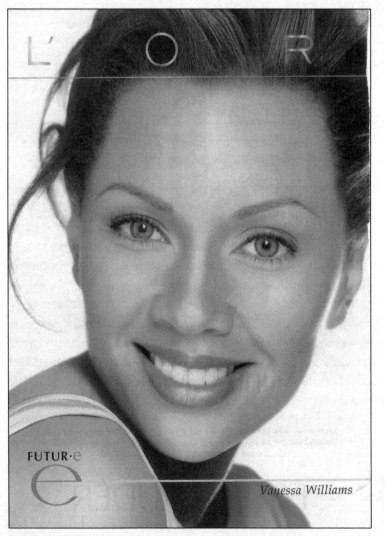

ing their physical state to appear with lightened skin and silky straight hair, black women can compete and thereby gain status and security. An example of an ad using a popular black model with white features is shown in Figure 7.6.

Advertisers have come under fire by media critics and scholars alike for their promotion of Eurocentric beauty standards and the preferential usage of lighter complexioned models in their ads (Brown, 1993; Keenan & Woodson, 1994). Brown (1993) points out that while diverse images of white women abound in advertisements, the diversity of black beauty is rarely shown.

Whiteness as Beauty among Asians

Advertising stressing that "pale skin" is beautiful is quite common to women worldwide. The underlying proposition is that if a woman's skin color differs from the white convention of beauty, a woman needs to use beauty products to "lighten" her skin (Wade, 1996; Sahay & Piran, 1997; Goon & Craven, 2003; Wade & Bielitz, 2005; McCarthy, 2006).

Ads for skin-lightening creams are prevalent throughout Asia. Goon and Craven (2003) note that Southeast Asian women are motivated by the many television advertising messages that equate beauty with being "fair." However, they contend that this emphasis on fair skin and whiteness could possibly be linked to the British colonial presence in parts of Southeast Asia. Similarly, Sahay and Piran (1997) describe how the history of early Aryan invasion as well as later British colonization could explain the preference for lighter skin color in Southeast Asia and India. These authors argue that Asian women may see lighter skin as a form of social capital left behind by the former colonial system that continues to exert a hegemonic influence over popular culture.

Goon and Craven (2003) argue that "whiteness" as a concept of beauty is a racialized and imperialist interpretation, one that promotes a hierarchy of power between whites and nonwhites long

Figure 7.7: Asian ad featuring a Caucasian who is "Dior White"

DiorWhite

www.dior.com

DIORWHITE FOUNDATION
THE BRIGHT SIDE OF PROTECTION

Introducing Dior exclusive Makeup Whitening Technology, with licorice extract, trio-vitamin association and UV protection:
• A perfect brightness and translucency of complexion
• Dark spots shaded off for a visibly lightened and soft looking skin
• A weightless sensation of comfort with special extra-fine coated powders

Authorized Retailers: Isetan Scotts • Metro Far East • Metro Paragon • Robinsons Centrepoint • Robinsons Raffles City • Seiyu Bugis • Takashimaya

Christian Dior
PARIS

after colonialism. Further, advertisements that promote whiteness through the use of fairness creams sell the idea that one needs to be white, in response to the looks of others: a reaction to a gaze, which is "colonizing." Through the promotion of these products, the value of each woman becomes intrinsically tied to attaining a fair skin tone. Binary oppositions are deliberately set up with the promotion of these creams, such as perfect skin versus imperfect skin, and fairer versus darker (Goon & Craven, 2003). Also highlighted is the inherent contradictory nature of these advertisements; on the one hand, they purport to be advocating a "natural" or "true" beauty in users, however on the other hand, they bring about this lightening by artificially stopping the natural production of melanin within the body. The result is a "hybrid creature," a doll with Asian features and Caucasian skin, which the authors refer to as the reconstitution of colonial-ized values through the application of state-of-the-art scientific modification (Goon & Craven, 2003). The ad in Figure 7.7 appeared recently in women's magazines throughout Asia. It features a very fair Caucasian woman who is "Dior White."

In India, there is a Rs.950-crore (approximately US$195 million) market for fairness creams, in order to meet the ever-increasing demand for lightening products, no doubt fueled by ideal, "white" portrayals of beauty in the media. This market is expected to grow by 20 percent this year. The major brands competing for this slice include Fairever by CavinKare Pvt. Ltd., FairGlow by Godrej Consumer Products, and Fair & Lovely by Hindustan Lever Limited (Challapalli, 2002). The most successful of fairness creams seems to be Fair & Lovely.

Colaco (1998) suggests that desire for fairness among Indian women is closely linked to the caste system. The *Brahmins* (priests) were historically the top class and were associated with the color white, while the *Shudras* (untouchables) were the lower class and were associated with being dark. He traces the origins of caste delineation back to when the Aryans defeated the darker-skinned Dravidians and other non-Aryans. They then installed a caste system, based on differentiation according to color. For Hindu women, beauty is measured by how fair her skin is, contributing to the success of facial products. But the advertising of fairness creams has become controversial in recent years. In 2003, a Fair & Lovely fairness cream television commercial in India stirred dissent with women's rights groups when it blatantly associated fairer skin with beauty and success ("India Debates 'Racist' Skin Cream Ads," 2003). In the ad, an aspiring air hostess is unable to get a job or a husband due to her dark skin, and thus her father laments that a son would have provided for him better. However, the girl's life is dramatically changed for the better when she begins to use the Fair & Lovely cream, becomes fairer, and realizes her dreams and does her parents proud. The All-India Democratic Women's Association denounced the commercial as "racist," demeaning to women, as well as claiming it portrayed the wrong kinds of values to the young by equating fairness with beauty. The company Hindustan Lever Limited quickly pulled the advertisement, claiming it had already run its course. As a result, the Indian government, too, began looking into other advertisements, especially those in the skin-lightening industry.

In Malaysia, lightening creams are also extensively marketed. In 2002, Unilever ran a com-mercial for Pond's Skin Lightening Moisturizing Cream. The commercial showed a Malay college student who was unable to get a second glance from the boy sitting next to her; but, after using the cream and appearing to achieve skin tone several shades lighter, she manages to get the boy's attention (Prystay, 2002). Women's groups in Malaysia reacted negatively to the advertisement, claiming that it promoted racism and bias toward people who were darker skinned.

In addition to perpetuating stereotypes, there have also been claims that the creams cause damage to the skin. Some creams go beyond simply acting as a sun block to actually inhibiting the production of melanin, a pigment that protects the skin against the sun, because it has the "unfortunate" effect of darkening the skin tone. Nineteen women were hospitalized in Hong Kong in January 2002 due to mercury poisoning from a "lightening" cream they used, which was imported from China.

CONCLUSIONS

Whether done intentionally or unintentionally, advertisers continue to compartmentalize racial and ethnic groups in ways that reinforce separateness. In so doing, advertising can reify certain power structures in society that contribute to ongoing racial problems. Furthermore, by presenting "whiteness" as the superior beauty type to women worldwide, companies capitalize on a stereotype that allows them to advertise whitening creams that claim to lighten skin color. Thus, the global beauty standards set by advertising promote a global class system where fair-skinned women are the ideal beauty.

REFERENCES

Brown, Clinton. (1993, February 1). Which black is beautiful? *Advertising Age,* p. 16.

Challapalli, S. (2002). All's fair in this market. *The Hindu Business Line*

Cohen, Judy. (1992, Spring). White consumers' response to Asian models in advertising. *Journal of Consumer Marketing, 9,* 17–27.

Colaco, J. (1998). *The caste system of India.* Retrieved December 29, 2006, from http://www.colaco.net/1/caste.htm

de Casanova, E. M. (2004). "No ugly women": Concepts of race and beauty among adolescent women in Ecuador. *Gender & Society, 18*(3), 287-308.

Delener, Nejdet, & Neelankavil, James P. (1990, June–July). Informational sources and media usage: A comparison between Asian and Hispanic subcultures. *Journal of Advertising Research, 30,* 45–52.

Domzal, Teresa J., & Kernan, Jerome B. (1992). Reading advertising: The what and how of product meaning. *Journal of Consumer Marketing, 9*(3), 48–64.

Frith, Katherine T. (1998). *Undressing the ad: Reading culture in advertising.* New York: Peter Lang.

Goffman, Erving. (1976). *Gender advertisements.* Cambridge, MA: Harvard University Press.

Goon, P., & Craven, A. (2003). Whose debt? Globalisation and whitefacing in Asia. *Intersections: Gender, History and Culture, 9.* Retrieved March 18, 2006, from

http://wwwsshe.murdoch.edu.au/intersections/issue9/gooncraven.html

hooks, bell. (1992). *Black looks: Race and representation.* Boston: South End Press.

hooks, bell. (1995). Straightening our hair. In Diana George & John Trimbur (Eds.), *Reading culture: Contexts for critical reading and writing.* New York: HarperCollins.

Hunter, M. L. (2002). "If you light you're alright": Light skin color as social capital for women of color. *Gender & Society, 16*(2), 175-193.

India debates "racist" skin cream ads. (2003, July 24). *BBC.* Retrieved March 20, 2006, from http://news.bbc.co.uk/2/hi/south_asia/3089495.stm

Joseph, Gloria, & Lewis, Jill. (1981). *Common differences: Conflicts in black and white feminist perspectives.* New York: South End Press.

Keenan, Kevin, & Woodson, Laurence A. (1994). *Colorism in advertising: Issues related to race and gender in mainstream and African American women's magazines.* Paper presented to the AEJMC Advertising Division, Atlanta, Georgia.

Leiss, William, Kline, Stephen, & Jhally, Sut. (1988). *Social communication in advertising.* Ontario, Canada: Nelson.

Lester, Elizabeth. (1998). Finding the path to signification: Undressing a Nissan Pathfinder direct mail package. In Katherine T. Frith (Ed.), *Undressing the ad: Reading culture in advertisements* (pp. 19–34). New York: Peter Lang.

Licata, Jane, & Biswas, Abhijit. (1994). Representation, roles, and occupational status of black models in television advertisements. *Journalism Quarterly, 70*(4), 868–881.

Mayes, Ernest M. (1998). As soft as straight gets: African American women and mainstream beauty standards in haircare advertising. In Katherine T. Frith (Ed.), *Undressing the ad: Reading culture in advertisements* (pp. 85–108). New York: Peter Lang.

McCarthy, S. (2006). "Blonde is beautiful" mystique. *USA Today.* Retrieved March 20, 2006, from the LexisNexis database.

O'Barr, William. (1994). *Culture and the ad: Exploring otherness in the world of advertising.* Boulder, CO.: Westview Press.

Prystay, C. (2002). Critics say ads for skin whiteners capitalize on Malaysian prejudice. *The Wall Street Journal Online.* Retrieved March 19, 2006, from http://www.calbaptist.edu/dskubik/white_skin.htm.

Robinson, T. L., & Ward, J. V. (1995). African Americans and skin color. *Journal of Black Psychology, 21*(3), 256-274.

Rockquemore, K. A. (2002). Negotiating the color line: the gendered process of racial identity construction among black/white biracial women. *Gender & Society, 16*(4), 485-503.

Sahay, S., & Piran, N. (1997). Skin-color preferences and body satisfaction among South Asian-Canadian and European-Canadian female university students. *The Journal of Social Psychology, 137*(2), 161-171.

Seiter, Ellen. (1995). Different children, different dreams: Racial representation in advertising. In Gail Dines & Jean M. Humez (Eds.), *Gender, race and class in media: A text reader* (pp. 99–107). Thousand Oaks, CA: Sage.

Strutton, David, & Lumpkin, James R. (1993). Stereotypes of in-group attractiveness in advertising: On possible psychological effects. *Psychological Reports, 73,* 507–511.

Taylor, Charles, Lee, Ju Yung, & Stern, Barbara. (1995, February). Portrayals of African, Hispanic and Asian Americans in magazine advertising. *American Behavioral Scientist, 38*(4), 608–621.

Thompson, M. S., & Keith, V. N. (2001). The blacker the berry: Gender, skin tone and self-esteem and self-efficacy. *Gender & Society, 15*(3), 336-357.

Wade, T. J. (1996). The relationships between skin color and self-perceived global, physical, and sexual attractiveness, and self-esteem for African Americans. *Journal of Black Psychology, 22*(3), 358-373.

Wade, T. J., & Bielitz, S. (2005). Differential effect of skin color on attractiveness, personality evaluations, and perceived life success of African Americans. *Journal of Black Psychology, 31*(3), 215-236.

Wernick, Andrew. (1991). *Promotional culture: Advertising, ideology and symbolic expression.* Newbury Park, CA: Sage.

Advertising and Children

In many Western countries, and particularly in the United States, kids and teens are perceived by advertisers as an increasingly lucrative market. In 1992, U.S. advertisers spent $6.2 billion; in 1997, that amount jumped to $12 billion; and it was estimated that in 2007 advertisers spent a whopping $15 billion advertising to young consumers. Currently, in the United States there are nearly 50 million children aged 11 or under (25 million ages 0–5, and more than 24 million ages 6–11), and another 24 million between the ages of 12 and 17 ("America's Children in Brief," 2008). In 2002, children ages 4–12 spent $30 billion—money they saved from gifts, allowances, and odd jobs. Those ages 12–17 spent $170 billion during that same year—an average of $101 a week per teen. Further, children under 12 influence another $500 billion in expenditures—either directly ("I want that *SpongeBob SquarePants* DVD") or indirectly ("I know Sally would want this pair of Hannah Montana Crocs"). Kids even influence what were once considered adult purchases. As the resident technology experts in many homes, they often choose what sort of TVs, stereos, and computers their parents buy. And when parents decide on a vacation destination, or even a specific brand of vehicle, their children heavily influence those decisions, as well. Simple math explains why advertisers are willing to spent $15 billion in advertising directed to young consumers—they will get $700 billion in return sales (Kendle, 2007).

While a few innovative advertisers had already begun to appeal to children as early as the 1920s, the 1950s were the seminal decade in the development of marketing to children. This was the decade in which the number of children increased dramatically as a result of the baby boom, and economic prosperity brought a multitude of consumer goods within reach of the

typical family. Parents who had suffered through the deprivations of the Depression and World War II vowed that their children would experience the affluence they had missed. During the subsequent six decades, marketers' appeals to children have only increased. Candy, cereal, and toys were the product categories most frequently promoted early on, while today marketers of higher-end products increasingly appeal to youngsters. The Caymen Islands' department of tourism buys ads on Nickelodeon, a children's cable channel, promoting expensive holidays. And Beaches Resorts has teamed up with *Sesame Street* to make its resorts more attractive to kids. An issue of *Sports Illustrated for Kids* featured an ad for Chevrolet's Venture minivan—the "Warner Brothers Edition"—which includes a flip-down monitor and built-in video player to "entertain a small army of kids for miles." "We look at kids as small people with big opinions," says Karen Francis, brand manager for the Venture. Honda launched an advertising campaign on Disney's ABC Kids channel, and Hummerkids.com offers games and coloring pages to teach kids about the joys of owning a colossal sport-utility vehicle.

Any company that fails to target children will soon find itself at a competitive disadvantage. Manufacturers are well aware that establishing loyalty early on ensures a market for their brands in the future. And the definition of "early" just keeps getting younger and younger. Researchers have shown that by the time they are six months old, babies who have watched commercial television have already begun to recognize corporate logos. Jim McNeal, who heads a youth marketing consultancy, notes that American children become "brand conscious" at about 24 months. At three years of age, one out of five American children is already making direct requests for specific brand name products (Center for a New American Dream, 2002). And by 36–42 months they make the connection that a brand can say something about their personalities—for example, that they are cool or smart. Brands that kids are most aware of include Cheerios, Disney, McDonald's, Pop-Tarts, Coke, and Barbie. McNeal, who has also studied children's consumer behavior in Beijing, says, "In China, kids' brand habits look very much like those in America. They can write the 'M' for McDonald's before they can write their name" (Comiteau, 2003). At Chuck E. Cheese, the child-themed pizza restaurant with a dancing mouse as its spokesperson, marketing director Richard Huston notes, "We're trying to influence kids as early as we can, maybe 2." At Saatchi & Saatchi, a New York advertising agency, the 80 members of its Kid Connection division aim to implant awareness of a brand—namely, General Mills, the division's biggest client—in preschoolers. One study found that 2- to 5-year-olds demonstrate brand knowledge and influence similar to that displayed by older children in decades past. Today's 3- to 5-year-olds behave like kids 5 and up when playing with action figures and dolls. And, by the time kids reach first grade, they are typically loyal to one brand within each of the major product categories they regularly consume, such as cereal, candy, and soft drinks (Comiteau, 2003). In short, kids are getting older younger. At age 10, the average child has memorized as many as 400 brand names. James B. Twitchell, a professor at the University of Florida and author of the book *ADCULT USA,* notes, "These people have not bought cars. They have not chosen the kind of toothpaste they will use. This audience is Valhalla. It is the pot of gold at the end of the rainbow" (Schwartz, 1998). Brand loyalty means big profits for companies, who estimate that each future consumer is worth $100,000 to the company.

HOW CHILDREN RESPOND TO ADVERTISING

Academic interest in advertising to children has been keen since the 1970s. McNeal (1969) was the first academician to declare children a market. Since then, the bulk of the research on advertising and the youth market has focused primarily on process and outcome effects. Raju and Lonial (1990) provide an excellent overview of two decades of research on the topic. Process effects investigations concentrate on the extent to which children attend to advertising messages, their ability to distinguish commercials from programming, and the extent to which they understand the nature of advertising. Investigations of communication outcome effects concentrate primarily on the impact of advertising on children's attitudes and behavior relating to the advertised products and services, the influence of advertising messages on the parent-child relationship, and the socialization of children.

Process Effects

The concept of age-related cognitive development pervades the literature concerning children and the processing of advertising. Swiss psychologist Jean Piaget was the first to articulate theories of cognitive development, which stress the evolving nature of children's abilities to process information about the world around them. According to Piaget (1970), cognitive development advances in four stages:

Sensory-motor intelligence (0 to 2 years). During this period, behavior is primarily motor. The child does not "think" conceptually, though cognitive development is seen.

Preoperational thought (2 to 7 years). This period is characterized by the development of language. The child's thinking about objects and ideas is still poorly organized, and only dominant features of a stimulus are used to make judgments.

Concrete operations (7 to 11 years). During these years, the child develops the ability to apply logical thought to concrete problems. The child can think conceptually and organize ideas in a coherent manner.

Formal operations (11 to 15 years). During this period, the child's cognitive structures reach their greatest level of development. The child becomes able to apply logic to all classes of problems, think in abstract terms, and use all aspects of a stimulus to make judgments.

American children's attention to advertising has been examined primarily with studies using observers (usually parents) to unobtrusively watch children viewing television in a natural home environment. In general, most studies of children's attention to television show a decrease in attention from programming to commercials. For example, commercials were ranked last of 11 types of television content in percentage of time watched while the material was aired (Bechtel, Achelpohl, & Akers, 1972). Children watched commercials 55 percent of the time, compared to 76 percent for movies. Ward (1978) found that children watch only 50 percent of the advertisements and that this percentage gets smaller as more ads are presented in sequence. Another investigation found all children exhibited a drop in attention to commercials compared to attention to the program, but that this difference was more pronounced among the older children (Ward, Levinson, & Wackman, 1972). It is likely that the inability of younger children to differentiate advertisements from programs is responsible for sustaining their attention to commercials.

A study by Levin, Petros, and Petrella (1979) exposed 3-, 4-, and 5-year-olds to 10 seconds of both program material and advertisements and asked the children to identify the segments. The researchers found that all age groups could successfully identify the segments at a rate higher than chance. However, a number of other investigations have found that preschoolers often do not understand the difference between programs and commercials (Rubin, 1974; Stephens & Stutts, 1982). Robertson and Rossiter (1974) found that first graders were less capable than older children of distinguishing between programming and commercial messages. Stutts, Vance, and Hudelson (1981) found that although 78 percent of 3-, 5-, and 7-year-olds claimed to understand "what a commercial is," only the 7-year-olds exhibited an adequate understanding of the concept. Just 20 percent of the 5-year-olds and 3 percent of the 3-year-olds demonstrated a similar understanding. Stephens and Stutts (1982) placed a program segment in the middle of a cartoon program—where a commercial would normally appear. Five-year-olds responded to this program segment as though it were a commercial. It appears that while very young children may, in fact, be able to identify ads, the identification appears to be based on superficial audio or video cues rather than on a true understanding of the difference between programs and commercials. These findings, along with considerable regulatory pressure, led the networks to utilize various audiovisual techniques to more clearly separate programming and commercials on television directed primarily to children under age 12. An example is the use of "Face," the character on the Nickelodeon Network, who announces to children they will be taking a short break to watch commercial messages. Interestingly enough, several studies have failed to demonstrate that separators are effective in helping younger children distinguish between commercials and programming (Butter et al., 1981; Stutts, Vance, & Hudelson, 1981).

Just as there are important age-related differences in children's attention to advertising, as well as their ability to distinguish programming from promotions, there are also critical differences in their abilities to discern the intent of advertising. The younger the child, the less likely they are to be able to understand that advertising is designed to persuade and that biased information may be provided. Such age-related differences in the comprehension of advertising are at the heart of the concerns over advertising directed at children.

Butter and colleagues (1981) discovered that 90 percent of preschool children do not understand the reason why advertisements are presented on television. Rubin (1974) found that children in the preoperational stage of Piaget's (1970) framework had a more limited understanding of the purpose of advertising than older children in later stages of cognitive development. Ward (1972) found that kindergartners showed no understanding of the purpose of advertising. This finding was reinforced by a more recent study by the American Psychological Association, which noted that when the viewer is younger than 8, the whole notion of "commercial" means nothing. Dale Kunkel, author of *The Report of the APA Task Force on Advertising and Children,* explains that, "Children under 8 tend to accept ad claims as being truthful. They process it as legitimate information. They can't understand the motives and persuasive intent" (Stanley, 2007, p. 29). By second grade, youngsters begin to understand that the intent of a commercial is to sell something. Fourth and sixth graders knew more and were even able to comment on the techniques employed in the creation of advertisements (Ward, 1972). Older children (10–12) are more likely to acknowledge that advertising does not always tell the truth and come to develop a healthy skepticism of commercial claims (Robertson & Rossiter, 1974). However, a general understanding and a skeptical attitude may not be sufficient. Children between the ages of 8 and 12 generally do not invoke

their knowledge of persuasive influence attempts while watching television commercials unless explicitly encouraged to do so (Brucks et al., 1988). Thus, it appears that having cognitive and attitudinal defenses does not necessarily mean older children are using them.

Outcome Effects

Regarding outcomes, several types of effects have been identified in the literature. Here we focus on the impact of advertising on children's attitudes and product preferences as well as advertising's effect on the parent-child relationship.

Attitudes toward Advertising

Clearly, if children like advertising, there is a greater likelihood that they will be persuaded by it. A number of investigators have found that overall attitudes toward advertising become less positive with age. Robertson and Rossiter (1974) found that first graders rated television commercials much more favorably than did fifth graders, with the percentage of children who indicated that they like all commercials declining from 69 percent to just 25 percent. In interviewing children ranging in age from 5 to 12, Ward (1972) found that distrust of commercials increases with age. Robertson and Rossiter (1977) found that age predicted attitudinal defenses in children better than any other factor, and that older children were more skeptical of and negative toward TV commercials. Regarding behavior, Robertson and Rossiter (1974) asked children whether they wanted "all" products advertised on TV. The researchers found an age-related decline: 53 percent of first graders said yes, but only 6 percent of fifth graders did so. Asking whether children wanted "most" things advertised on television, Ward, Wackman, and Wartella (1975) found a less substantial decline. Apparently, overall attitudes toward advertising become more negative with age, a finding that should be of significant concern to marketers.

Influence on Product Preferences

A recent study (Tanner, 2007) powerfully demonstrated advertising's influence on product preferences among youngsters. When preschoolers sampled identical McDonald's foods in name brand and unmarked wrappers, the unmarked foods always lost the taste test. Even grocery store items tasted better to children when they were wrapped in the familiar packaging of the Golden Arches. The study included three McDonald's menu items—hamburgers, chicken nuggets, and French fries—as well as store-bought milk, juice, and carrots. Children received two identical samples of each food on a tray—one in McDonald's wrappers or cups and the other in plain, unmarked packaging. The children were asked if they tasted the same or whether one was better. McDonald's-labeled samples were the clear favorites—for example, almost 77 percent said the labeled fries tasted best and 54 percent preferred McDonald's-wrapped carrots. Fewer than one-fourth of the children said both samples of all foods tasted the same. The study clearly suggests that branding and advertising appear to have a direct impact on children's perception of taste.

Parent-Child Relationship

Marketers of products targeted at children have long been interested in the dynamics of children's asking their parents to purchase things for them. And critics of marketing to children have long decried the fact that much advertising encourages kids not only to want things but also to nag their parents to purchase those items.

A survey of 109 mothers of 5- to 12-year-old children conducted by Ward and Wackman (1972) found that purchase influence attempts based on advertised products decrease as children become older, but that parental yielding increases with age. It appears that younger children ask for more, but get less, while older children ask for less but get more. Isler, Popper, and Ward (1987), using a diary method, examined purchase requests among 3- to 11-year-olds and parental responses. The researchers found that over a 28-day period, 250 children made 3,374 explicit purchase requests, or an average of 13.5 requests per child (the range of requests was from 3 to 125). The average number of requests varied markedly by age, from 24.9 among the sample of 3- and 4-year-olds, to 13.3 for 5- to 7-year-olds, decreasing to 10.4 for 9- to 11-year-olds. The study also revealed the ways in which children ask for things and how their mothers respond. Most often, children "just ask" (81 percent of the requests) and pleading or bargaining was significantly less frequent (13 percent of the requests). Mothers agreed to buy in response to two-thirds of the requests and refused in response to one-third. In general, mothers were more agreeable to purchasing less expensive products, and were most reluctant to purchase more expensive ones. Parents reported that the vast majority of children (74 percent) took the refusal to buy as "OK."

In another investigation, Atkin (1975) observed 516 mother-child pairs during grocery shopping and found 62 percent of parents acceded to a child's request or demand. "Conflict" occurred in 65 percent of the cases in which children's requests were denied and "unhappiness" in 48 percent. Conflict and unhappiness appeared to be greatest among 6- to 8-year-olds, but these negative responses were seldom intense or persistent. In a second investigation, Atkin (1975) found that one-sixth of children report arguing with their mothers "a lot" and one-third "sometimes" after denial of requests for toys. The findings of these studies confirm that children ask their parents to buy products, but it does not appear that these requests lead to frequent or dysfunctional conflict.

A recent investigation ("Children, TV and Toys," 2002) of outcome effects was designed to determine whether commercials were actually the cause of children's requests. Researchers conducted an experiment among third and fourth grade children in two similar elementary schools. One school used an 18-lesson, 6-month-long curriculum designed to reduce children's use of TV, videos, and video games; the other school did not use this curriculum. The researchers questioned the children and parents in both schools about the children's toy requests before and after the curriculum was used. By the end of the school year, children in the intervention school reported about 70 percent fewer requests than the children in the nonintervention school. Parent reports indicated about a 60 percent reduction in the intervention school. The researchers concluded that these findings suggest that reducing television viewing is a promising approach to reducing the influence of advertising on children's behavior.

HARMS CAUSED BY ADVERTISING AIMED AT CHILDREN

As evidenced by the discussion above, longstanding concerns regarding the impact of advertising on children stimulated considerable academic research in the 1970s and 1980s. Significantly less attention has been devoted to this topic in recent years, despite the growth in marketing communications now targeting children. Yet the debate over advertising to children continues to be one of the most controversial topics in advertising discourse. Despite claims in the business

press that kids are becoming increasingly sophisticated and astute in their judgments about the marketplace, there is little hard evidence to suggest that children's understanding of advertising and how it works can be accelerated beyond their capacities at key points in their cognitive development (Moore, 2004). And, some critics are quick to blame marketers for a variety of ills, including the growing lack of spontaneity in childhood play, negative influences on children's sense of self, and, most recently, even childhood obesity.

Play

Experts, for example, worry about the lack of spontaneity as children increasingly play with licensed characters—often spin-offs from TV shows or movies—that come with their own, pre-scripted stories. German psychologists Strick and Schubert have found evidence backing what many adults have suspected for some time: Children don't need all those "must-have" toys (see Poulter, 1999). In attempting to prove that children could play creatively without toys, Strick and Schubert persuaded a nursery in Munich to keep playthings in cupboards for three months out of the year, leaving the children nothing but tables, chairs, blankets, and their imaginations. Initially the children appeared bored, but by the second day their attitudes had changed. They had become excited about the thought of making their own fun, building dens and putting on shows. Schubert noted, "We find that the children concentrate better, integrate better into groups and communicate better than the children who didn't take part."

Sense of Self

Other psychologists believe that the scale and extent of commercial marketing actually compromise children's sense of identity. A study by the British National Consumer Council found that young people feel pressure to have the latest "in vogue" items. Girls, in particular, experience feelings of inadequacy and discomfort as a result of images of perfection promoted in advertisements. Further, the study revealed that the more consumerist children were—those who were most "brand aware" and who cared most about their possessions—the more likely they were to be dissatisfied. And perhaps surprisingly, children in Britain were found to be even more consumer oriented than their American counterparts—and less satisfied than U.S. children with what they have to spend (Mayo, 2005). Berkeley, California, psychologist Kanner notes that, "Basically, the message in advertising is that you're desirable or good or successful or popular if you have things. You're a loser if you don't. You're consciously making kids feel bad. When that happens day in and day out, it's incorporated into their identity, a sense of who they are" (O'Crowley, 2000).

Parents apparently concur. The Center for the New American Dream recently conducted a Kids and Commercialism survey and found that 78 percent of parents think advertising puts too much pressure on children to buy things. Seventy percent think advertising aimed at children has a negative effect on their values and worldview. Almost two-thirds of parents say their children define their self-worth in terms of possessions. And a majority admitted buying things for their children against their better judgment because of the "nag factor"—a built-in button created by advertisers (Burns, 1999).

Obesity

The most serious charge has been leveled against food and beverage marketers who target young consumers. Developmental experts believe negative trends in children's health correlate with the increased advertising efforts directed toward them. Obesity rates in kids around the globe have skyrocketed. The statistics—in both developed and developing countries—are hard to argue with. In the United States, the prevalence of childhood obesity has risen significantly over the past three decades. In 1971 only 4 percent of 6- to 11-year-old children were obese; by 2004, the number had leaped to 18.8 percent. In the same period, the figure rose from 5 percent to 13.9 percent among children ages 2 to 5, and from 6.1 percent to 17.4 percent in the 12- to 19-year-old group. If overweight children are included, today 32 percent of all U.S. children carry more pounds than they should (Kluger, 2008). And the situation does not look much better across the pond. A European Union report shows that one in five EU schoolchildren is now overweight—a total of 14 million—a figure that includes at least 3 million youngsters who fall into the obese category (European Report, 2005).

But childhood obesity is not unique to Western countries. It appears that China has not only entered the era of obesity, but is also "super-sizing its children as fast as its economy" (MacLeod, 2008, p. 1). The prevalence of overweight and obese children has increased by 28 times between 1985 and 2002 (Walsh, 2006). Today, 8 percent of 10- to 12-year-olds in China's cities are obese and an additional 15 percent are overweight (MacLeod, 2007). The prevalence of childhood obesity has also rapidly increased in countries as diverse as Brazil, Egypt, Ghana, and Haiti. Indeed, worldwide, 10 percent of children are now estimated to be obese or overweight (Hawkes, 2007).

Obese children are at an increased risk of morbidity from a number of diseases, including type 2 diabetes, coronary heart disease, hypertension, angina, lung disease, and cancer. Overweight youngsters are also more likely to suffer from asthma, cholesterol disorders, obstructive sleep apnea, orthopedic ailments, and a variety of other medical problems. Given the stigma associated with being overweight, these children may also suffer from psychological burdens, including shame, low self-esteem, and even depression. Finally, 80 percent of overweight children are likely to end up as obese adults. One recent study found that as a result of obesity, children in the United States today "could be the first generation of the modern era to live shorter lives than their parents" (Zarembo, 2008). Of all known and suspected risk factors for obesity—and there are many—ranging from rising incomes and falling food prices, to the challenges of preparing healthy meals in households where both parents work, and a dramatic increase in sedentary behavior—the finger for this problem has nonetheless been pointed directly at food marketers. The food industry's global ad budget is a whopping $40 billion, a figure greater than the GDP of 70 percent of the world's nations ("Health Groups Warn," 2004). And, in 2006 major U.S. food and beverage companies spent about $1.6 billion in marketing their products to kids (Freking, 2008). See Table 8.1 for a breakdown of U.S. ad expenditures for youth-targeted advertising by food category (Dart, 2008). Figures for the United Kingdom are quite similar. Children in the United States, and around the world, are clearly being bombarded with an unprecedented avalanche of food advertisements.

Table 8.1: Youth Marketing by Food Category in the U.S. (in millions)

Carbonated Beverages	$492.5
Restaurant Foods	$293.6
Breakfast Cereals	$236.6
Juice & Non-carbonated Beverages	$146.7
Snack Foods	$138.7
Candy/Frozen Desserts	$117.6
Prepared Foods & Meals	$ 64.3
Baked Goods	$ 62.5
Dairy Products	$ 54.5
Fruits & Vegetables	$ 11.5

Source: Federal Trade Commission as reported in Dart (2008).

Television advertising remains marketers' prime tool for selling food to kids (Spake, 2003). Research has revealed that kids see an average of more than 10 food ads every hour they watch television, and that fast foods and sweets comprise 83 percent of the advertised foods (Harrison & Marske, 2005). Ads for healthier options—such as fruits, vegetables, dairy products, meats, poultry, and fish—are seldom seen. Beyond television, there are a multitude of other promotional practices designed to make children desire specific food products, including Web sites, in-school marketing, sales promotions, product placement, event sponsorships, and movie tie-ins.

In 2004, the World Health Organization (WHO) called on governments, industries, and civil societies to act to reduce unhealthy marketing messages. Since then,

> In a range of countries—such as Brazil, Thailand, and the United States—discussions were held, proposals released, bills tabled, and executive orders drafted. But overall, between April 2004 and April 2006, only three countries passed or implemented new statutory regulations or government guidelines. None of these new regulations imposed prohibitive restrictions on food marketing to young people. In November 2006 new statutory restrictions were adopted in the United Kingdom to "reduce significantly the exposure of children under 16 to the advertising of food and drink products that are high in fat and sugar." Thus, the number of countries with statutory regulations or government guidelines on food marketing to children increased from 12 in March 2004 . . . to 16 by the end of 2006. (Hawkes, 2007, p. 1963)

In an assertive move, Ofcom, the regulatory body for the communications industries in the United Kingdom, mandated that as of January 2007 marketers would be banned from advertising junk foods on any TV show at all times of day and night and on all channels with a higher than average audience of viewers under age 16. A rating system, developed by the Food Standards Agency, would determine which foods are junk foods based on their fat, sugar, and salt content ("Junk Food Ads Trimmed," 2006). Only self-regulatory efforts were called for by the health commissioner for the European Union in 2007. Commissioner Markos Kyprianou encouraged the food and drink industry to better regulate itself as the 27-nation bloc attempts to curb rising obesity levels. However, the official threatened that if obesity levels continue to rise, the EU may consider introducing tougher advertising and labeling restrictions in three years' time. And in 2008, the U.S. Federal Trade Commission issued a report detailing the pervasiveness of food

marketing to children. The report was conducted as part of a congressional inquiry into rising childhood obesity rates. It recommended that all food and beverage companies adopt and adhere to "nutritional standards for products marketed to children" (Clifford, 2008), clearly suggesting a preference for the food industry to police itself. Self-regulation indeed appears to have developed significantly faster than statutory regulation.

To assist in the worldwide efforts to foster improved diet and health and curb childhood obesity, in 2006 the International Chamber of Commerce (ICC) issued a global framework that promotes high ethical standards for the marketing of foods and beverages. The new Framework for Responsible Food and Beverage Marketing Communications is an annex to the ICC's Advertising and Marketing Code. The framework's "guideposts" for food and beverage marketers are outlined in Table 8.2. In the United States, the advertising industry's self-regulatory body that oversees marketing to children—the Children's Advertising Review Unit—announced intentions to enforce a new level of oversight for food ads. While outright bans on marketing food to children have been debated in many countries, it is notable that both Sweden and Quebec, which have banned all advertising to children, still face high obesity rates. Time will tell whether a proposed ban on ads for all unhealthy foods and drinks during prime-time television—set to take effect in South Korea in 2010—will have the intended effect of slimming down South Korean kids.

Table 8.2: "Guideposts" from the International Chamber of Commerce's Framework for Responsible Food and Beverage Marketing Communications

- Marketing communications must not encourage excess consumption.
- Portion sizes must suit the occasion.
- Health and nutrition claims must be backed by sound science.
- Foods not intended as meal substitutes should not be presented as such.
- Food and drink promotions must not undermine the importance of a healthy lifestyle.
- Using fantasy and animation to market to children are acceptable but must not mislead them about nutritional benefits.
- Marketing should not lead a child to believe a product will make him or her more popular, smarter, or more successful in school or in sports.
- Sales promotions must present the conditions of a premium offer or contest in language a child can understand, spelling out the products that must be purchased to receive the offer, the terms of entry, the prizes, and chance of winning.

Source: www.iccwbo.org

In response to criticisms of the U.S. food industry for advertising's role in childhood obesity, a coalition of 14 major food companies formed in 2006. Members of the coalition, called the Children's Food and Beverage Advertising Initiative and run by the Council of Better Business Bureaus, pledge to either stop aiming ads at kids or to promote only what the council calls "better-for-you products" in ads aimed at children. For example, Kraft Foods announced it would stop advertising its least healthy foods to children under the age of 12. The phase-out will cover products such as regular Kool-Aid beverages, Oreo and Chips Ahoy! Cookies, several Post children's cereals, and many varieties of Lunchables lunch combinations. Kellogg reformulated several products—including cold cereals Apple Jacks, Froot Loops, and Corn Pops—so that they meet the com-

pany's declared nutritional requirements for children. And Burger King has begun offering a new Kids Meal, featuring macaroni and cheese that meets its nutritional criteria. However, its children's menu still continues to feature a double hamburger with 420 calories and 22 grams of fat. Under the initiative, companies also promise to devote 50 percent of their ads targeting kids to "further the goal of promoting healthy dietary choices and healthy lifestyles." They will also continue to reduce their use of licensed characters, product placement, and ads in schools.

Coca-Cola, Pepsi, Nestlé, and Mars are among a group of 11 food and beverage companies that signed a European Union pledge to stop marketing unhealthful foods to children under 12 on the continent. By the end of 2008, the group promised to stop funding junk food ads on TV, in print, and on the Internet

Figure 8.1: Subway advertisement promoting a healthful diet for kids

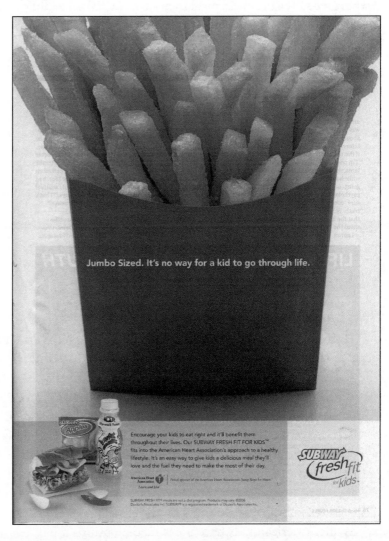

aimed at kids under age 12. Altogether, the 11 companies represent more than 50 percent of the food and beverage marketing budgets aimed at kids across Europe. Stephan Loerke, managing director of the Brussels-based World Federation of Advertisers, said, "The announcement demonstrates how self regulation continues to respond in a timely and proactive way to societal concerns" (Hall, 2007).

Clearly these steps are an effort to ward off stricter government regulation. Critics of the self-regulatory approach in the U.S. are concerned by the lack of industry-wide definitions of exactly what "advertising to children" entails and what exactly "better foods" means. Currently, each company defines for itself what these terms mean. In Europe, the 11 marketers have agreed that they will only advertise products that "fulfill specific nutrition criteria based on accepted scientific evidence and/or applicable national and international dietary guidelines" (Hall, 2007).

Some marketers have used the controversy to their advantage. Subway tells moms that, "Jumbo sized is no way for a kid to go through life (see Figure 8.1). The copy suggests, "Encourage your

kids to eat right and it'll benefit them throughout their lives. Our SUBWAY FRESH FIT FOR KIDS™ fits into the American Heart Association's approach to a healthy lifestyle. It's an easy way to give kids a delicious meal they'll love and the fuel they need to make the most of the day."

MEANS OF REACHING CHILDREN

A study by the Kaiser Family Foundation (Rideout, Roberts, & Foehr, 2005) examined a nationally representative sample of more than 2,000 U.S. children ages 8 to 18 in order to quantify and categorize kids' media exposure. Kaiser researchers found that the time kids spend watching TV, listening to music, surfing the Web, and using other forms of media averages more than 44 and ½ hours per week—the equivalent of a full-time job, with a few extra hours thrown in for overtime. And, given that about a quarter of the time that young people are using media, they are using more than one medium at a time (for example, both reading and listening to music), they are actually exposed to the equivalent of 8 and ½ hours a day of media content, though they pack that into less than 6 and ½ hours of time.

Traditional Media

Television

Historically, the bulk of all advertising dollars directed at children—nearly 65 percent—has gone to television. This is understandable, given that children watch television far more than they use any other form of mass communication. Kids 8–18 spend an average of three hours a day watching TV (almost four hours when videos, DVDs, and prerecorded shows are included). Music also dominates youth media—young people spend about 1 and ¾ hours a day listening to the radio or to CDs, tapes, or MP3 players. Interactive media come next, with this audience averaging just over one hour a day on the computer outside of schoolwork, and just under 50 minutes a day playing video games. Reading is close behind, at an average of 43 minutes a day spent reading books, magazines, or newspapers for something other than schoolwork (Rideout, Roberts, & Foehr, 2005).

While American kids have more media options today, television remains by far the dominant medium. TV-watching time is highest among kids 8–10 years of age—about 3 hours and 17 minutes per day. Those ages 11–14 spend just a fraction less time with TV (3 hours and 16 minutes). Among 15–18 years olds, TV-watching time drops down to just over 2 and ½ hours. But younger kids are spending time in front of the TV set as well. Forty-three percent of youngsters ages 4–6 spend two or more hours watching TV each day. For those ages 2–3, the figure drops just slightly to 41 percent. Children watching commercial television are exposed to commercial messages. Estimates suggest that the average child will view some 40,000 television spots each year. By the time a child reaches 18, he or she will have spent more time watching TV than in the classroom (Rideout, Roberts, & Foehr, 2005).

The Kaiser study also analyzed parental monitoring and children's media environments. It found that over half of the children ages 8 to 18 (53 percent) had no TV-watching rules; however, among the youngest children in the study (8- to 10-year-olds), just over half (55 percent) said there were some TV rules in the home. The most common rule is to have homework or chores done before watching TV. Significantly less common were rules about how much TV

kids could watch. Indeed, in many young people's homes, the TV appears to be a nearly constant companion. Two-thirds live in homes where the TV is usually on during meals and half live in homes where the TV is left on most of the time, whether anyone is watching it or not. Children are increasingly viewing television without adult supervision. Television sets are found in the bedrooms of 68 percent of young people ages 8 to 18. Among children 6 to 11, that proportion was 41 percent, and among those under 6 it was 24 percent (Rideout, Roberts, & Foehr, 2005).

Until about 15 years ago, most kids had access to only four channels, today the typical American home has access to an average of 93 channels. And, while children's programming was previously relegated to the ghettos of Saturday morning and a couple of after-school hours, now a host of networks have filled the airwaves with a seemingly endless array of cartoons, contests, and true-life dramas. Most of kids' viewing has shifted from commercial broadcast outlets to cable. In any given day, two-thirds of 8–18 year-olds watch cable TV, while just under half watch broadcast (a nearly exact reversal of the situation in 1999, when 69 percent watched broadcast TV and 50 percent watched cable) (Rideout, Roberts, & Foehr, 2005).

Disney, which completed its transition from pay- to basic-cable delivery, was advertising-free for more than 19 years. However, in the spring of 2002, parents of small children got some bad news when Disney announced it had begun taking on sponsors. The channel's early sponsorship deal with McDonald's brought 15-second messages to children during the Playhouse Disney program bloc, aimed at kids ages 2 to 5. The deal eliminated one of TV's last commercial-free havens for parents concerned about their kids being "branded" at an early age ("Selling McDisney," 2002). The network's preschool bloc, *Playhouse* Disney, which airs Monday through Sunday from 6 a.m. to 12 p.m., is tops among kids ages 5 and under. The Disney Channel is also the biggest kid on the block among the slightly older set. For the fifth consecutive year, the network ranked as television's number one network in prime time among kids aged 6 to 11, and among tweens aged 9 to 14, the Disney Channel also extended its streak in prime time to seven straight years at the top (Lew, 2008). The Disney Channel is the home of the wildly popular program *High School Musical 2*. From the airing of the first *High School Musical,* a made-for-television movie about a hunky jock and a straight-A girl who discover a mutual passion for performing, in January 2006, a sequel was virtually assured. The film made its debut to an audience of nearly 8 million viewers and generated $100 million in profits from DVD and soundtrack sales, touring concerts and ice shows, and numerous other brand extensions. Indeed, the sequel became the most watched show of any kind in basic cable history (Itzkoff, 2007). See Figure 8.2 for an ad promoting *High School Musical.* And, since its premiere in the United States, *High School Musical 2* has debuted in more than 150 countries and territories, reaching more than 170 million viewers worldwide ("Disney Channel Tops Ratings," 2008). Other popular programs include *Hannah Montana, The Cheetah Girls,* and *The Suite Life—On Deck.*

Now in its 29th year, Nickelodeon has grown to become one of the most watched television networks by kids in the United States. Nickelodeon's "kids first" philosophy is a key element to its business successes, which in addition to TV, now include feature films, consumer products, Internet, and publishing. Nickelodeon TV programming is seen in more than 92 million households in the United States and is the most widely distributed kids' network in the world, reaching 203.8 million households in 156 territories worldwide via 35 channels and 19 branded program blocs, 9 mobile TV channels, 32 Web sites, and 5 broadband services across Africa, Asia, and the

Figure 8.2: Advertisement for Disney's popular *High School Musical* TV show

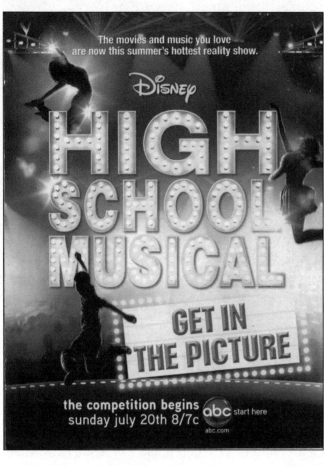

Pacific Rim, CIS/Baltic Republics, Europe, Latin America, and the United States (Nickelodeon Corporate Profile, 2008). .

Nickelodeon operates four premier digital networks: NOGGIN, a commercial-free educational digital network for preschoolers; Nicktoons Network, the 24-hour home of kid TV's most popular animated hits; The N, a nighttime network for teens; and Nickelodeon Games & Sports (GAS), the first and only digital network dedicated to games and sports. NOGGIN, which airs from 6 a.m. to 6 p.m., is akin to preschool on TV, designed to help kids learn early literacy, social studies, basic math, science, movement, and art skills. Nick Jr. is a specially designed programming bloc airing on Nickelodeon weekdays from 9 a.m. to 2 p.m. and is completely dedicated to preschoolers ages 2–5. Among this younger crowd, popular programs include *Dora the Explorer; Go, Diego, Go; Blue's Clues; Blue's Room; Lazy Town;* and *The Backyardigans.* See Figure 8.3 for a cross-promotion between popular Nickelodeon program characters and Crocs. Hot programs among slightly older viewers watching the advertising-supported Nicktoons Network include *SpongeBob SquarePants*—with more than 5.5 million kids regularly tuning in to that show alone each week, as well as *The Fairly Odd Parents, Jimmy Neutron,* and *Invader Zim.*

The TEENick programming bloc is a Saturday and Sunday night destination for the network's tween (kids 9–14) viewers. TEENick shows that continue to dominate the tween landscape include *Zoey 101, Romeo!,* and *Ned's Declassified School Survival Guide.* According to the network, The N's mission is to be the authentic voice for teens and help them figure out their lives with relevant, topical programming both on-air and online. In late 2007, NOGGIN and The N became 24-hour stand-alone networks and no longer shared channel space (Jensen, 2007). By inhabiting its own space, The N, which appeals to both 9- to 14-year-olds as well as 12- to 17-year-olds, is the only cable network specifically aimed to these age groups, potentially giving it an advantage over its rivals, whose schedules also include programs for other demographic groups. The network is available in some 60 million homes, and the median age for the mostly female viewers is 16. The network's top-rated prime-time program, *Degrassi: The Next Generation,* is a quintessential anxiety show for 15-year-olds; during daytime hours, the network shows reruns of programs

including *Drake and Josh* and *The Amanda Show*. Nickelodeon describes The N as a place for viewers "who are exploring adulthood without jumping in with both feet."

Time Warner's Cartoon Network was launched in 1992 on the strength of the old Hanna-Barbera cartoon library; today it reaches 60 million homes with a mix of original and archival animation. Cartoon Network's sweet spot is with boys 6 to 11, who have made *Chowder, Ben 10,* and *Code Name: Kids Next Door* the network's highest-rated shows. Teens 12–17 tune in for *Goosebumps* and *Dragon Ball-Z* (Hampp, 2008a). The network looks like it has a hit with a new computer-animated series: *Star Wars: The Clone Wars,* which became the channel's most watched series premiere ever. The *Star Wars* spin-off made its debut in October 2008, with more than 4 million total viewers tuning in. *Clone Wars* chronicles the adventures of Anakin Skywalker, Obi-Wan Kenobi, Yoda, Ahsoka Tano, and

Figure 8.3: Nickelodeon's program characters customize Croc shoes

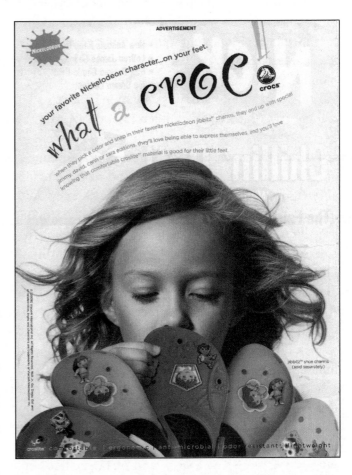

other *Star Wars* characters as they battle against the dark side. The network also showcases a movie each week, including the TV premieres of films such as *Ant Bully, Hoodwinked, Monster House,* and *Open Season.*

ABC Family, aimed primarily at older teenagers, is owned by Disney-ABC Television Group, a division of the Walt Disney Company. Previously known as Fox Family, the network was sold to ABC in 2001 for $5.2 billion (Barnes, 2008). The sale included the Fox Kids Network, which provided the new ABC Family with hours of children's programming, as well. The popular *Kyle XY*–a hit series about a mysterious teenager who has no significant memories of his childhood—had given the channel the most viewers in the network's history until *The Secret Life of the American Teenager* premiered in the summer of 2008. The program is part of a network makeover, which includes significantly edgier fare. *The Secret Life of the American Teenager* opened with a 15-year-old girl getting pregnant at band camp, and subsequent scenes depicted two teenagers, each asking adults for free condoms. However, at the end of each episode, characters appear in public service announcements discussing ways to prevent teenage pregnancy. In the fall of 2008, *Samurai Girl* premiered; the special three-night event was based on a young adult novel series. The show tells the story of a teenager who discovers that her adoptive father leads the Japanese mob. She, in turn, trains as a samurai to fight the criminal empire. If successful, *Samurai Girl* will

return as a full-fledged series. ABC Family hopes these shows, along with the established teen-age soap opera *Greek*—about the fraternity scene at a fictitious university—will give it a needed ratings boost. The challenge for the network has been finding series that are provocative enough for younger viewers yet still wholesome enough to draw parental approval.

Not all television programming is aimed at kids, tweens, and teens—and with good reason. Recent research has revealed that the median age for infants to be regularly exposed to TV is 9 months. The average daily viewing time is 1 hour a day for children younger than 12 months, and more than 90 minutes a day by 24 months (Barrett, 2007). The American Academy of Pediatrics recommends that children under 2 not be allowed to watch television. However, according to a recent *Parents* magazine survey, nearly 90 percent of parents ignore this recommendation. It appears that even babies 6–23 months of age are couch potatoes—with 14 percent watching two or more hours of television per day. And, nearly half (43 percent) of kids under the age of 2 watch at least some television every single day (Stanley, 2007). As a result, networks are now target-ing the youngest preschoolers and even babies. In 2005 PBS launched Kids Sprout, a 24-hour preschool channel—with a twist. While the network carries advertising—it refuses to air sugary cereal and snack ads and instead promotes healthy lifestyles. Further, 100 percent of the advertis-ing appearing on Kids Sprout is parent directed. Sprout exposes viewers to no more than three to four commercial minutes per hour, and sponsors have included Huggies/Pull-Ups and Mott's Applesauce. PBS officials note that ventures like Sprout will ensure that public television survives uncertain times. The programming is preschool friendly, with a line up that includes hit shows such as *Bob the Builder, Sesame Street,* and *Barney and Friends.* Currently available to some 37 million homes, Kids Sprout is viewed primarily on video on demand through a deal with the primary owner, Comcast Corp., which has a 40 percent stake in the company. Other investors include Hit Entertainment, PBS, and Sesame Workshop (Hampp, 2008b).

BabyFirstTV began airing in the United States in 2006 as a subscription-based network avail-able via satellite and cable—and promptly generated a heated national debate. Its programs air 24 hours a day, seven days a week, and are targeted to children ages 6 months to 3 years. Of the 500 hours of content on the network now, 80 percent are produced by BabyFirstTV. In addition, there are no commercials on the network. As mentioned above, the American Academy of Pediatrics has stated that children younger than 2 should be kept away from television altogether. Critics note that interaction with people is crucial to early child development. In response, the folks at BabyFirstTV say their product is designed to be watched by babies and parents together in an interactive manner. Guy Oranim, chief executive officer of BabyFirstTV, says that the channel's content is carefully screened to ensure it is positive and educational and that the channel encour-ages parents to make sure their babies do not go overboard on television but instead include it in a balanced schedule. "One of the reasons we created BabyFirstTV is that we thought there was no good programming for babies on TV, and according to the research that is out there, most of the babies are watching TV anyway" (Ollivier, 2008). Indeed, it appears that 43 percent of 3-month-olds in the United States are watching television regularly—and only about half the infant viewing time is in what researchers classify as a children's educational category. The remaining viewing time is roughly split between children's noneducational programs, baby DVDs or videos, and grown-up television (Barrett, 2007). Since its launch, BabyFirstTV has found its way to 30 countries, making the network available to some 80 million homes (McClain, 2008).

This boom in television programming for the very young is not mirrored in all markets. For example, France's broadcast authority has banned French channels from marketing television shows to children younger than 3 to shield them from developmental risks it says television viewing poses at that age. The ruling cites health experts as saying that "television viewing hurts the development of children under 3 years old and poses a certain number of risks, encouraging passivity, slow language acquisition, over-excitedness, troubles with sleep and concentration, as well as dependence on screens" (Ollivier, 2008). The ruling ordered warning messages for parents on foreign baby channels that are broadcast in France—such as Baby TV, which is owned by Rupert Murdoch's News Corp., and BabyFirstTV, which has ties to News Corp.'s Fox Entertainment. French cable operators that air foreign channels with programs for babies have been ordered to broadcast warning messages to parents. The messages will read, "Watching television can slow the development of children under 3, even when it involves channels aimed specifically at them" (Ollivier, 2008).

An increasing concern is that many of the programs featuring commercial products aimed at children constitute little more than program-length commercials. Early examples of toy-inspired shows include *My Little Pony, The Care Bears,* and *Strawberry Shortcake.* By 1990, critics identified 70 programs that were based on commercial products, like the *Muppets, The Smurfs, He-Man,* and *The Masters of the Universe.* The danger is that such shows blur the boundary between advertising and programming. Further, Action for Children's Television (a powerful watchdog organization established in 1968) has charged that such program-length commercials have displaced other kinds of children's shows. Critics also claim that broadcasters are using these programs to circumvent the commercial limits of the Children's Television Act. While there have been attempts to regulate this kind of programming aimed at children, it is currently permitted by the Federal Communications Commission. The FCC has not prohibited such programs for fear of jeopardizing positive shows such as *Sesame Street,* which has also inspired countless lines of toys.

Toys

Closely related to children watching television is the concept of licensing. "In brand licensing, a company with an established brand rents that brand to other companies, allowing them to use its logo on their products" (Wells, Burnett, & Moriarty, 2000). Licensed toys represent an ever-larger share of the total toy market. According to figures by the Licensing Industry Merchandisers Association (LIMA), the entertainment/character licensing category—the largest of all licensed categories—took in $2.6 billion in royalties in 2004, accounting for 44 percent of the industry. Toys and games make up the largest subsection, representing 28 percent of all revenue, followed by software and video games at 14 percent, apparel (10.5 percent), foods and beverages (7 percent), gifts and novelties (7 percent), and accessories (6.5 percent) (Johannes, 2006).

Licensing television program characters clearly makes sense. When a youngster becomes enthralled with a character on a TV show, it marks the beginning of a special relationship. The child wants that character to step out of the small screen and inhabit the real world: as a stuffed toy at bedtime, a backpack for school, a T-shirt for hanging out in, or a video game for play. *Sesame Street* has been a fixture on PBS since 1969 and local versions have also been on the air in other countries for many years—the German and Mexican versions celebrated their 30th anniversaries in 2003. Overall, the show is seen in 77 countries around the globe. The show's characters—Elmo, Big Bird, and the rest—generate over $1.5 billion a year in spin-offs, two-thirds of which is generated in the U.S. market (Westcott, 2002). *Sesame Street* boasts more than 400

licensees. Of course, characters can step out of the big screen as well. *Spider-Man* is an example of a licensing success story. The superhero has become one of the largest boy brands, reaching more than $1 billion in worldwide sales each year, according to Tim Rothwell, president of the worldwide consumer products group for Marvel Entertainment. Sony Pictures' 2002 release of *Spider-Man* helped fuel the cartoon character's popularity. From toys, bedding, apparel, electronics, packaged goods, and health and beauty products, there are few categories the character has not touched. Figure 8.4 presents an ad for Crest's Spider-Man SpinBrush. More than 300 licensees supported the release of *Spider-Man 3,* which appeared in film theaters in the summer of 2007.

British characters have been particularly effective in capturing the imagination of children around the world. *Teletubbies* was launched in the late 1990s on the British Broadcasting Corp. (BBC), and soon thereafter became a global hit. The show has been credited with lowering the age of TV audiences to below 3 years of age, which was the previous benchmark. *Teletubbies* is a strong toy franchise that has also spawned books, magazines, and video and audio products. In addition to the Teletubbies, other successful British characters include Thomas the Tank Engine, and Bob the Builder. Launched in 1984, Thomas is still one of the top preschool properties in the world. Crucially, it is just as big in Japan and the United States as it is in its domestic market. In Japan, half a million children flocked to a theme park that opened in 1988 dedicated to Thomas the Tank Engine. Toys, followed by videos and apparel, are its major category. *Bob the Builder,* a stop-motion animation series aimed at preschoolers, launched on the BBC in 1999 and has now been sold to over 100 countries. Hasbro came onboard as the master toy licensee after the show launched on Nick Jr. in the United States in 2001. Lego and Brio have signed multiterritory deals as well. Bob has even become a successful music artist, topping the U.K. singles chart (Westcott, 2002).

Figure 8.4: Advertisement for Crest's Spider-Man SpinBrush

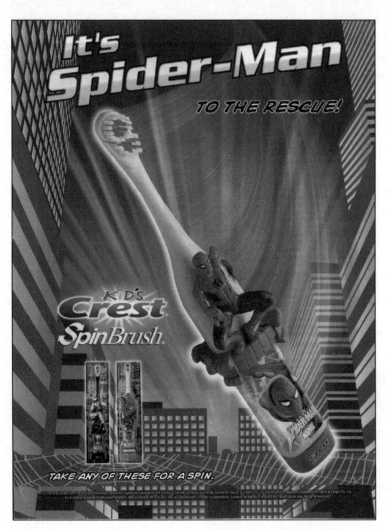

Magazines

In contrast to television, print media that target children receive less than 10 percent of advertising dollars. Nonetheless, in the United States, at least a dozen new children's magazines have been introduced every year since 1990 (Finholm, 1998). Half die within a year, but the trend continues. The reason is simple: the major audience for magazines is baby boomers—and now that they are parents and grandparents, they purchase the publications for their offspring. Magazines currently exist for every age range. While the Cricket Magazine Group publishes educational magazines for all levels of readers, two of their publications appeal to the youngest. Moms can read stories to the littlest ones from *Babybug,* designed specifically for infants and toddlers. *Ladybug* appeals to 2- to 6-year-olds. This quality magazine is filled with poems, stories, and art—some of it authored by children. *Nick Jr.* also appeals to the same age segment and packs its magazine with coloring pages, hidden pictures, and mazes. *Disney Princess,* which targets girls ages 4 and up, is filled with magical stories and a collectible poster. *Chickadee,* with its comics and simple crafts and science experiments, appeals to 6- to 9-year-olds. Another publication designed for this audience is *Nickelodeon,* an award-winning entertainment and humor magazine.

Kids aged 8–12 love *Zillions,* the junior edition of *Consumer Reports,* and so do parents because it dissects the ads aimed at young shoppers. Kids test some of the latest "must-have" toys and games and rate them. Articles like "Toy-Ad Tricks, Would You Fall for Them?" help kids become savvy about advertising. The magazine, which was published from 1980 to 2002, is now an online publication. *National Geographic Kids* presents articles of interest to kids ages 8–14, dealing with nature, world cultures, and science. *Sports Illustrated for Kids,* which appeals to kids 8 and up, is devoted to sports. The publication includes articles on sports figures of note, games, cartoons, fiction, and advice from athletes. Figure 8.5 presents an ad that appeared in a recent issue of *Sports Illustrated for Kids* fea-

Figure 8.5: Dwight Howard appears in a Got Milk campaign in *Sports Illustrated for Kids*

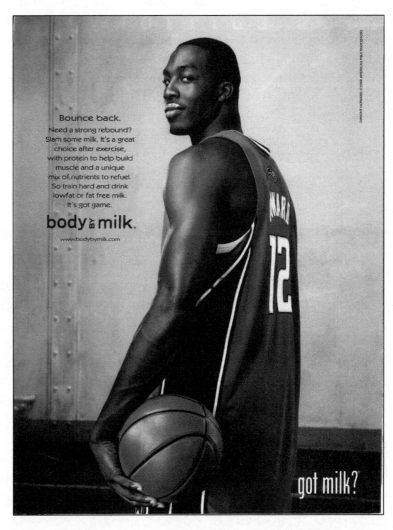

turing basketball player Dwight Howard in a Got Milk campaign. And *American Girl* speaks to preteens with stories, arts and crafts, and Q&As such as, "What should you say when you get a gift you don't want?" *Discovery Girls* is yet another magazine that targets girls 8–12, offering advice, fashion and beauty tips, and celebrity profiles.

An abundance of young adult magazines includes *Boy's Life* (articles and fiction for 8- to 18-year-old boys, published by the Boy Scouts of America); *Girl's Life* (a publication for girls 10 and up—a five-time Parent's Choice Award winner); *Cosmo Girl* (a teen version of *Cosmopolitan*, for girls 12–17); *J-14 Magazine* (the #1 teen celebrity magazine); *Seventeen* (a fashion and beauty magazine tailored for those in their teens), and *Teen Vogue* (which focuses on clothes and trends for young women).

Radio and Music

While kids enjoy a wealth of choices in television and magazine entertainment, their choices are far more limited on the radio. The only 24-hour-a-day, seven-day-a-week radio network is Radio Disney, which reaches an estimated 3.2 kids and tweens ages 6–14 each week ("About Radio Disney," 2008). Another 2.4 million moms tune in as well. According to the network's Web site, kids help pick the music that is played and are encouraged to interact via a toll-free phone line to the station. The network's current play list, driven by listener requests and representing major record labels, includes recording artists Miley Cyrus (Hannah Montana), Jonas Brothers, The Cheetah Girls, and Carrie Underwood. Its broadcasts are heard in 55 U.S. markets—including 18 of the top 20—that reach 61 percent of the nation. The network owns and operates 56 AM stations and 7 FM stations and continues to expand its reach in North America and worldwide. In the United States, Radio Disney's programming is syndicated nationally, with all music and DJ banter produced in Dallas and piped live to local stations via a 24-hour satellite feed from Disney-owned ABC Radio Networks (Radio Disney's parent). Five and one-half minutes of every hour are set aside for local advertising and promotions, with station-based "promotional DJs" (typically one per station) handling public service announcements, promos, and community events (Coleman, 2004). Radio Disney can also be heard internationally in Japan, United Kingdom, Argentina, Paraguay, and Uruguay.

Nontraditional Media

Inside the Classroom

America's schoolchildren are 43 million strong and their combined buying power is greater than that of many nations. These facts have not been ignored by marketers in the United States. Until fairly recently, public elementary and secondary schools were among the few remaining "marketing-free zones." However, commercialism in schools is clearly on the rise. This is an outgrowth of the difficulties marketers have experienced reaching young people through traditional media channels. The youth market is an increasingly fragmented audience, exposed to ever-increasing advertising clutter as a result of the proliferation of new kids' products. U.S. advertisers have been forced to explore new avenues to reach this desirable group. Increasingly, schools are being used to deliver promotional messages to America's children.

Sponsored educational materials (SEMs) are teaching aids and classroom-ready curricula provided by corporations and organizations. SEMS include booklets, pamphlets, filmstrips, study guides, posters, book covers, videotapes, and CD-ROM computer programs. Today, more than

12,000 companies or individuals are sponsoring these materials and reaching almost 20 million elementary and secondary students in the United States (Mueller & Wulfemeyer, 1993). A leader in this category is Lifetime Learning Systems of Fairfield, Connecticut. Hundreds of companies and entities have hired the firm to peddle their products (or ideologies) in the academic setting, including the Coca-Cola Company, the National Frozen Pizza Institute, the Snack Food Association, and even the government of Saudi Arabia. In its promotional literature, Lifetime claims to reach 63 million young people every year and that its materials "combine both strong commercial appeal and sound educational information." For example, the BIC "Quality Comes in Writing" educational program and Web site created for BIC, the national leader in the manufacturing of writing instruments, and in cooperation with Lifetime Learning Systems, are designed to help students in grades 4 through 6 improve their writing and communication skills. Students' abilities are stimulated through a variety of assignments, including writing journal entries from the perspective of a famous person (see Figure 8.6 for a sample assignment), decoding a rebus story, interviewing classmates to write a biography, and studying and writing ballads. The program's components include a teacher's guide that offers suggestions for introducing each activity, as well as follow-up activities, a four-color poster of writing hints to display in the classroom, and 30 take-home booklets to promote parental involvement in the writing process outside the classroom.

Critics point out that most SEMs are provided not for altruistic reasons but as a means of targeting a very lucrative captive market. Opponents to advertising-sponsored educational aids question the objectivity and educational value of these materials. They wonder how such aids can provide impartial instructional content when the overriding objective for sponsoring firms is the endorsement of their brands. For instance, Campbell's Soup provided schools with a poster, pamphlet, and other materials for use in science classes. The company's "Prego Thickness Experiment" instructed students how to scientifically prove that Campbell's spaghetti sauce was thicker than the sauce made by rival Ragu. Similarly,

Figure 8.6: BIC and Lifetime Learning Systems join to promote writing skills in schools

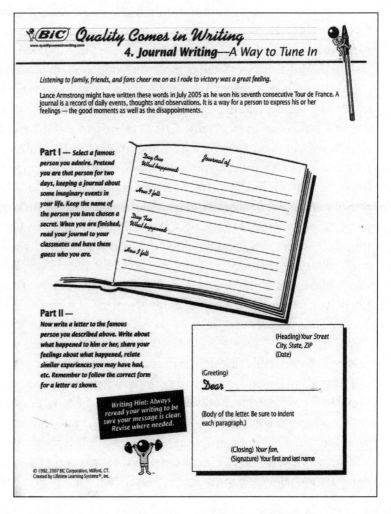

nutrition posters from Burger King, personal finance materials from a credit card company, and Johnson Wax's sponsorship of programs on the environment are examples of corporations providing information that may be in conflict with accepted curricula or at least represent a conflict of interest for the sponsoring firm (McGowan, 1993).

Proponents of SEMs say educators would not use materials that are subjective or lack educational value. Corporate sponsors claim they provide innovative materials that enhance the curriculum, and with today's budget shortfalls, corporations are filling a critical need by providing increased learning opportunities and materials for schools. Indeed, a survey of elementary and secondary schoolteachers found that the majority of educators felt the materials were well-designed and featured useful, up-to-date, real-world examples, and most did not perceive the SEMs as overly commercial (Mueller, Wulfemeyer, & Penny, 1999). "Teachers are so overwhelmed with their total job that they welcome anything that will aid them in making their subject area more attractive to students, easier to grasp, and save teacher time in making up original material. If an industry can offer all of those things, a teacher is just grateful—to hell with where it comes from" (Cearley, 1999).

Critics of in-school advertising argue that public school classrooms and playgrounds should be areas in a child's life that are free from commercial pressures (Wartella, 1995). Some suggest that spending class time on advertised messages takes time away from more substantive instruction. Another criticism of in-school advertising is that contradictory messages are sent to the students. In today's curriculum, children are taught about the importance of environmentalism, then, through advertising, encouraged to embrace consumption, the antithesis of environmentalism (Manilov, 1994). Other mixed messages include nutritional values versus the promotion of fast foods and snacks and the commercial emphasis on physical appearance.

Yet, proponents claim the opportunities offered by advertisers will benefit education. With tax dollars scarce, school fund-raisers are forced to move beyond the traditional bake sale and Parent-Teacher Association raffle. The trend toward privatizing education has been seen as a viable alternative to the reliance on dwindling public funds (Molnar, 1994). As schools face reduced financial resources, using advertising to generate much-needed funds has proved to be a solution for some schools. Public-private partnerships between educators and corporations can provide public schools with equipment and educational materials at corporate expense. The sponsoring corporations are seen to be supporting public education and at the same time benefiting by getting their advertising messages, brand names, and logos distributed through the school system. And, apparently parents are not opposed to the idea either. According to a recent survey from the publications *Marketing* and *Today's Parent*, an overwhelming majority of moms and dads (90 percent) are open to corporate involvement in schools. Caroline Connell, editor-in-chief of *Today's Parent*, notes that "a lot of parents see up close the economic reality that school boards face. They want to see their kids have the advantage of the programs and the resources, but it may only be available through corporate funding (Young, 2008).

Above and beyond sponsored educational materials, a myriad of marketing activities can be found in today's public schools. However, one of the most controversial attempts to communicate with students as consumers is *Channel One*. Launched in 1990, the 12-minute daily television news and current affairs program targeted at teens features 2 minutes of commercial messages. Schools promise to show *Channel One* in exchange for approximately $50,000 worth of audiovisual equipment—television monitors and satellite dishes, plus installation and technical assistance.

Critics of *Channel One* point out that the two minutes of advertising daily adds up to a full school day every year. Educators, in particular, express concern regarding the loss of control over the curriculum. Consumer advocacy groups, such as UNPLUG, AdBusters, and the Center for the Study of Commercialism, have targeted *Channel One* as a social detriment for children. Educational groups, such as the National Parent-Teacher Association, the National Education Association, and the National Association of Secondary School Principals, have lambasted *Channel One* for its overt commercialism. Other critics argue that schools with more money for educational materials (i.e., those that can afford to) are more likely to say "no" to advertising-sponsored programs. A University of Massachusetts analysis of schools that receive *Channel One* found that schools spending the least on educational materials were three times more likely to receive the program than schools spending more on materials. Additionally, the study found *Channel One* disproportionately located in low-income schools. The researchers concluded that students in poorer neighborhoods might be receiving an "unequal education," subjected to the propaganda of corporate America, which may not have education as its prime objective (Morgan, 1993). Fueling the fire, a recent study found that students were more likely to remember the advertising than they were the news stories shown on *Channel One*. And, students reported buying or having their parents buy the products advertised on the show, including fast food and video games, according to researchers ("Study," 2006).

In spite of the criticism of *Channel One*, some studies have discovered positive benefits associated with its presence in public education. Tiene and Whitmore (1995) found that most public schools subscribing to *Channel One* use the television equipment provided for a variety of other purposes: showing instructional television programs, school announcements, special events, and student productions. More than 80 percent of the schools surveyed indicated an increase in the use of educational television since subscribing to *Channel One*. Forced exposure to national and international news stories also aided students in developing a better understanding of current events. Wulfemeyer and Mueller's (1992) study of values present in *Channel One*'s advertising did not find an exorbitant amount of blatant materialism. And Johnston (1995) found that most teachers using *Channel One* have favorable impressions of the program and consider advertising a small price to pay for the benefits. Further, *Channel One* has a longstanding policy of accepting only age- and subject-appropriate advertising and no longer accepts ads for non-nutritional foods such as candy, soda, and snacks. Despite nearly two decades of controversy, *Channel One* is now delivered daily to more than 270,000 classrooms and reaches over 6 million high school students (Frazier, 2007). A single 30-second spot on the program costs advertisers upwards of $198,000.

Outside the Classroom

Schools are becoming increasingly innovative in providing advertisers with the means to spread their commercial messages inside the venue of public education. One way in which advertisers can communicate with students is via wall media. Back in the mid-1980s, Whittle Communications introduced "Connections" wall posters to schools. Published 14 times per year, each issue is made up of a series of themed poster boards. The list of sponsors includes Procter & Gamble, Coca-Cola, and Levi Strauss. In 1988, American Passage introduced "Gymboards." Designed for locker rooms, the left panel of the board is for editorial content, to the right is a chalkboard for use by gym instructors, and the center panel is a display area for national advertisements. Sports & Educational Enterprises has launched Campus Communication Centers—a

wall medium designed for display in school lobbies. Each unit contains an electronic moving message board, a four-week calendar, a bulletin board, and three national advertisements. School newspaper supplements are also increasingly seen on campuses. Inside, Inc., has launched *Inside,* a magazine distributed to 400,000 students in 400 schools.

Sampling is also big on elementary, middle, and high school campuses. Thousands of students receive bags filled with free samples of shampoo, deodorant, mouthwash, and feminine hygiene products—items that research shows enjoy the highest level of brand loyalty. Sampling Corporation of America (SCA), one of the nation's largest in-school marketers, works with packaged-goods firms that wish to reach students from kindergarten to college. The firm estimates it reaches over 70 percent of kids aged 6–12 and 85 percent of high school students. In addition to product samples and money-off coupons, the "goody bags" include "how-to" information packets aimed at specific grade levels or age groups. For example, packets for teens are accompanied by literature about changes that the age group faces, how to deal with conflict, and where troubled teens can go for support. The materials are developed by SCA with contributions from outside specialists for certain topics. Bags are given away at school events, such as kindergarten orientations, open houses, health classes, and graduations.

A number of cash-strapped school districts have brokered deals to sell ads on school buses. Selling ads on the sides of school buses brought in over $50,000 in revenues for one school district in Colorado. Major advertisers have included local TV stations, recreational centers, and even the U.S. Army. The school district notes that there have been no parental complaints since the program began in 2006 (York, 2008). The trend has also caught on in Arizona, Massachusetts, and Michigan—with hopes that the advertising will bring in up to $900,000 annually. Other school districts around the country have introduced ads inside the buses—via BusRadio. Indeed, over one million students in 24 states listen to BusRadio every day. According to the company's Web site (www.busradio.net), BusRadio is the first and only radio show delivered exclusively to school buses nationwide. Participating buses are installed with BusRadio systems and receive daily original programming, which is packed with age-appropriate top-40 music, kid-friendly news, as well as messages about staying healthy and safe. BusRadio programming targets three distinct audiences: elementary, middle, and high school students. Of course, the show also includes "minimal, carefully selected sponsorships" of which participating districts receive a portion of the revenue. The company promises that with BusRadio on board, the noise levels drop, kids stay in their seats, and the bus ride is safer and more fun than ever.

An ever-growing number of school districts in the United States are entering into exclusive "pouring rights" contracts with soft drink corporations, predominantly the Coca-Cola Company and PepsiCo. In exchange for direct payments, school districts agree to sell only one company's products in vending machines and at all school events. Contract conditions also frequently include the prominent display of advertising and marketing materials on school grounds and may even include incentive payments for greater sales at the school site ("Nutrition Policy Profiles," 2002). For example, Pepsi was named exclusive vendor in Denver, Colorado, schools, administrative offices, stadiums, and gyms—a deal that was expected to generate at least $5.4 million for the schools over a five-year period—including $1.5 million of it as a donation (Schwartz, 1998). A San Jose, California, school district signed a deal making the Pepsi-Cola company the exclusive soft drink vendor for its schools. The deal was worth $3.5 million to the district (Gumbel, 1999).

According to a 2005 Government Accountability Office report, nearly 75 percent of U.S. high schools, 65 percent of middle schools, and 30 percent of elementary schools had exclusive contracts for the 2003–2004 school year (Pinson, 2006). The exclusive contracts are rapidly turning into a turf war between Coca-Cola and Pepsi-Cola. In fact, one Georgia teenager who wore a Pepsi shirt to his school's Coke Day was suspended for insubordination (Ward, 2006).

U.S. fast-food restaurant chains have managed to introduce not only their corporate names but also their products into school breakfast and lunch programs around the country and around the world. School breakfasts in the United States often include highly sugared cereals. In addition, General Mills sponsors teaching materials and computer software on the importance of breakfast, and its "Big G Box Tops for Education" program donates money to schools for box tops students collect. About 9 percent of elementary schools participating in the school lunch program (in which the government subsidizes the cost of school lunches) offer brand-name fast foods—a number expected to balloon in the coming years (Levine, 2000), a number that has ballooned in the subsequent years. The most popular vendors are Domino's, Taco Bell, and Pizza Hut, with Pizza Hut delivering to over 4,000 school cafeterias. The food industry gains access to elementary schools by marketing its programs and materials to school food service personnel, administrators, teachers, and other professionals, on the promise of increased student participation in the school lunch program and needed funds and materials for their chronically underfunded schools (Levine, 2000). By the time kids reach middle and high school, the appearance of fast-food items on the lunch menu is commonplace.

Both Inside and Outside the Classroom

The appropriateness of advertising directed toward children and teens is a controversial topic that stirred debate long before these relatively recent attempts at tapping the student market. And marketing in the classroom has drawn the bulk of the criticism in recent years. To date, policy in none of America's states governs advertising in the public schools. Decisions are usually made by each district's superintendent or may be left to the discretion of individual principals. Until the issue of the role of advertising in the classroom is resolved, states, school districts, and teachers should develop systematic procedures for reviewing and evaluating commercial messages and media targeted at young people. In 1990, educators at a meeting hosted by the University of Wisconsin at Milwaukee developed a series of eight principles for corporate involvement in the schools (see Table 8.3). The National Parent-Teacher Association, the American Association of School Administrators, the National Association of State Boards of Education, and the National Education Association have endorsed these rules. Compliance is, of course, voluntary.

School-business relationships based on sound principles can contribute to high-quality education. However, compulsory school attendance confers on educators an obligation to protect the welfare of their students and the integrity of the learning environment. Therefore, when working together, schools and businesses must ensure that educational values are not distorted in the process. Positive school-business relationships should be ethical and structured in accordance with all eight of the principles in Table 8.3, set by the Consumers Union Education Services (1990, p. 3).

Table 8.3: National Principles for Corporate Involvement in Schools

1	Corporate involvement shall not require students to observe, listen to, or read commercial advertising.
2	Selling or providing access to a captive audience in the classroom for commercial purposes is exploitation and a violation of the public trust.
3	Since school property and time are publicly funded, selling or providing free access to advertising on school property outside the classroom involves ethical and legal issues that must be addressed.
4	Corporate involvement must support the goals and objectives of the schools. Curriculum and instruction are under the purview of education.
5	Programs of corporate involvement must be structured to meet an identified education need, not a commercial motive, and must be evaluated for education effectiveness by the school and district on an ongoing basis.
6	Schools and educators should hold sponsored and donated materials to the same standards used for the selection and purchase of curriculum materials.
7	Corporate involvement programs should not limit the discretion of schools and teachers in the use of sponsored materials.
8	Sponsor recognition and corporate logos should be for identification rather than for commercial purposes.

Educators can also take advantage of the opportunity afforded by *Channel One* and other student-oriented advertising vehicles by using the commercial content as a catalyst for discussions on how to interpret advertising messages and techniques. This could serve to encourage students to become more discriminating consumers of both commercials in classrooms and, more important, commercials in everyday life outside the classroom.

While the United States has been the frontrunner in the rush to open school doors to marketers, other nations have followed suit. The squeeze on school resources is so serious in some Canadian districts that they have sanctioned public-private partnerships in which the private sector funds the construction of schools. Nova Scotia is an example of one such district (Smith, 2003). In England, corporate funding of education has grown so fast that 85 percent of British schools have allowed promotion in their classrooms (Cohen, 2001). Changes announced in Britain in 2001 will allow private companies to manage public schools, though firms would be limited to the management of underperforming schools. In France, where education is tightly controlled by the central government, and the law forbids any kind of direct advertising in schools, commercial companies have managed to infiltrate thinly disguised publicity into the classroom. For example, Colgate teaches children how to brush their teeth; the Leclerc supermarket chain tells them about the European Union's single currency, and the state power monopoly provides material in favor of nuclear energy (James, 2001). Germany, which also has fairly strict standards regarding corporate visibility in the classroom, is one of the countries that makes a special case for technology. Its D21 program, launched in 2000, is a wide-ranging arrangement between public and private sectors that involves several hundred companies and is geared toward bringing schools up to date with computer technology (Smith, 2003). While other developed countries in Europe, as well as Asia, tend to have traditions that muffle corporate presence in the classroom, the commercial advance appears to be gaining ground there as well.

Via the Internet

According to the study conducted by the Kaiser Family Foundation, nearly all young people ages 8–18 have used a computer (98 percent) and gone online (96 percent). While schools may have been the first to bring computers into young people's lives, today the majority go online primarily from their homes. More than eight in ten American kids have a computer at home and three-quarters have a home Internet connection. One-third have a computer in their bedroom, and one in five have an Internet connection there as well. They spend an average of just over one hour every day on the computer—excluding schoolwork. On a typical day, just over half of all young people use a computer for recreation (Rideout, Roberts, & Foehr, 2005).

Shopping: Going online used to be thought of as primarily an educational experience for kids, but increasingly it is a shopping experience. YouthPulse, a syndicated research study of youth, projects that the 8- to 21-year-old age group currently spends at a rate of about $22 billion per year online, or about 16 percent of their total spending. The study notes that the average number of purchases made by 13- to 17-year-olds who shop online is between five and six annually. Eighteen- to 21-year-olds are shopping online more frequently, with about 15 online purchases annually.

But the impact of the Internet on youth commerce is not limited to their online spending. In addition to the $22 billion young consumers spend online annually, about $20 billion more is spent on "clicks and mortar" purchases—products they buy in traditional stores but first research online. So the Internet has about double the impact of its direct purchases (Harris Interactive YouthPulse, 2005). On a per capita basis, there appears to be limited online spending before the early teenage years, a dip in online spending in the later teen years, followed by considerable growth in the post–high school years (see Table 8.4).

Table 8.4: Impact of the Internet on Youth Spending

	AGES 8–12	**AGES 13–15**	**AGES 16–17**	**AGES 18–21**
Annual Online Spending	$51	$424	$321	$827
Annual Offline Spending First Researched Online	$168	$442	$361	$504
Total Annual Impact of Online on Spending	$218	$866	$682	$1,330

Source: Harris Interactive YouthPulse 2004. (2005, February). Trends & Tudes.

YouthPulse discovered several barriers to online shopping by young consumers. The No. 1 hurdle among tweens is that parents have forbidden them from doing so. Among teens and young adults, shipping charges are the most common obstacle. And, all ages reported challenges in finding a way to pay online. Not having a credit card or other mechanism to pay is a barrier to online shopping for many young people. While they might be willing to borrow a parent's card for an online purchase, they generally do not like the lack of autonomy in decision making that poses to them. YouthPulse notes that teens and young adults are far more likely than younger kids to be concerned about the security of online purchasing (see Table 8.5).

Table 8.5: Have You Ever Wanted to Buy Something Online, But Haven't Because . . .?

	AGES 8–12	AGES 13–21
Parents would not allow you	51%	27%
Didn't have way to pay	30%	42%
Didn't want to pay shipping	12%	45%
More expensive online	12%	29%
Didn't want to give address	8%	12%
Weren't sure you could trust site	7%	30%
Couldn't find what you wanted	7%	25%
Not enough information about product	6%	33%
Not sure credit card would be safe	5%	24%

Source: Harris Interactive YouthPulse 2004. (2005, February). Trends & Tudes.

Privacy Issues: As revealed in Table 8.5, even kids and teens are concerned about privacy issues. The Center for Media Education (CME) petitioned the Federal Trade Commission to investigate what it considered exploitative marketing on the Internet. CME contended that a number of well-known national brands used Web sites that were advertisements in disguise and unfairly targeted children. According to CME, the Web sites "were designed to capture the loyalty and spending power of children." Other Web sites invaded children's privacy by offering prizes and rewards in exchange for personal information. For example, at Mars, Inc.'s Web site, children were asked to help in the so-called Imposter Search to ferret out a fake M&M candy—by supplying the names and e-mail addresses of playmates. The site provided a form dubbed "Alert Your Friends!" that stated, "If we're going to catch the Imposters, we're going to need all the help we can get. That's where you come in." When youngsters filled in the answers, the site zapped out an automatic e-mail that went to the new recipient—and appeared to have been sent by the friend who supplied the names (Sandberg, 1997).

As a result of such online ploys, in October 1999 the U.S. Federal Trade Commission (FTC) issued the Children's Online Privacy Protection Rule, which required children's Web site operators to post comprehensive privacy policies on their sites, notify parents about their information practices, and obtain parental consent before collecting personal information from children under the age of 13. The rule, which went into effect on April 21, 2000, was issued to implement the Children's Online Privacy Protection Act (COPPA), passed by Congress in 1998. In February 2001, the FTC announced that the Children's Advertising Review Unit (CARU), the children's arm of the advertising industry's self-regulatory program established in 1974, had been approved as the first "safe harbor" program under the terms of the COPPA. Safe harbor programs are industry self-regulatory guidelines that, if adhered to, are deemed to comply with the act. This program is unique because it recognizes the important role industry can play as a partner with government to protect children's privacy on the Internet ("US FTC: First Safe Harbor," 2001).

In addition to issues of privacy, parental consent, and collection of personal information, CARU's guidelines also concern age-appropriate content and links to other Web sites that do not comply with CARU guidelines. The CARU's Guidelines for Online Privacy Protection are outlined in Table 8.6. Following concern expressed by CARU, several sites have been forced to modify their Web sites to comply with CARU's guidelines. For example, WB Television Network

and Warner Music/London-Sire Web sites lacked comprehensive privacy policies, and Marvel Entertainment's Web site collected extensive information from minors, while The Cartoon Network's Web site featured a game that was inappropriate for younger children. If a Web site fails to comply with CARU's guidelines, CARU may refer the matter to the FTC for Children's Online Privacy Protection Act enforcement, which carries penalties of up to $11,000 per violation (LaRochelle, 2001). The FTC has brought a number of actions against Web site operators for failure to comply with COPPA requirements. In September 2006, the FTC levied substantial fines against the Web site Xanga. Xanga.com agreed to pay a $1 million fine to settle the complaints that accused the social-networking site of violating the act. The civil penalty was the largest ever for a COPPA violation. The federal agency accused Xanga.com of collecting, using, and disclosing personal information from children under the age of 13 without first obtaining parental permission. While the site said kids under 13 could not join, it allowed visitors to create accounts, even if they provided a birth date indicating they were under the legal age. In addition to failing to notify parents, Xanga.com also failed to provide parents with control over their kids' information. The site had created 1.7 million accounts during the five-year period for users who indicated they were under age 13. Xanga.com cofounder and chief executive John Hiler acknowledged that the system intended to screen out underage users was inadequate. To correct the shortcomings, Xanga.com added employees whose sole responsibility was to act on account deletion requests from parents. The site also created a flagging system that allows Xanga users to flag others who are underage or are posting material in violation of Xanga's terms of service (Gonsalves, 2006). The FTC holds workshops and has set up telephone hot lines to help sites comply with the guidelines.

Table 8.6: CARU's Guidelines for Online Privacy Protection

	DATA COLLECTION
A)	In collecting information from children under 13 years of age, advertisers should adhere to the following guidelines: advertisers must clearly disclose all information collection and tracking practices, all information uses, and the means for correcting or removing the information. These disclosures should be prominent and readily accessible before any information is collected. For instance, on a Website where there is passive tracking, the notice should be on the page where the child enters the site. A heading such as "Privacy," or "Our Privacy Policy" or similar designation is acceptable if it allows an adult to click on the heading to obtain additional information on the site's practices concerning information collection, tracking and uses.
B)	Advertisers should disclose, in language easily understood by a child, 1) why the information is being requested (e.g., "We'll use your name and email to enter you in this contest and also add it to our mailing list") and 2) whether the information is intended to be shared, sold or distributed outside the collecting company.
C)	Advertisers should disclose any passive means of collecting information from children (e.g., navigational tracking tools, browser files, etc.) and what information is being collected.
D)	Advertisers must obtain prior "verifiable parental consent" when they collect personal information (such as email addresses, screen names associated with other personal information, phone numbers or addresses) that will be publicly posted, thereby enabling others to communicate directly with the child online or offline, or when the child will be otherwise able to communicate directly with others.

(Table continued on next page)

E)	For activities that involve public posting, advertisers should encourage children not to use their full names or screen names that correspond with their email addresses, but choose an alias (e.g., "Bookworm," "Skater," etc.) or use first name, nickname, initials, etc.
F)	Advertisers should not require a child to disclose more personal information than is reasonably necessary to participate in the online activity (e.g., play a game, enter a contest, etc.).
G)	Advertisers must obtain prior "verifiable parental consent" when they plan to share or distribute personal information to third parties, except parties that are agents or affiliates of the advertiser or provide support for the internal operation of the Website and that have agreed not to disclose or use the information for any other purpose.
H)	When an advertiser collects personal information only for its internal use and there is no disclosure of the information, the company must obtain parental consent and may do so through the use of email, coupled with some additional steps to provide assurance that the person providing the consent is the parent.
I)	When an advertiser collects and retains online contact information to be able to respond directly more than once to a child's specific request (such as an email newsletter or contest) but will not use the information for any other purpose, the advertiser must directly notify the parent of the nature and intended uses of the information collected and permit access to the information sufficient to allow a parent to remove or correct the information.
J)	To respect the privacy of parents, advertisers should not maintain in retrievable form information collected and used for the sole purpose of obtaining verifiable parental consent or providing notice to parents if consent is not obtained after a reasonable time.
K)	If an advertiser communicates with a child by email, there should be an opportunity with each mailing for the child or parent to choose by return email or hyperlink to discontinue receiving mailings.

AGE-SCREENING/HYPERLINKS

A)	On Websites where there is a reasonable expectation that a significant number of children will be visiting, advertisers should employ age-screening mechanisms to determine whether verifiable parental consent or notice and opt-out is necessitated under the Data Collection provisions above.
B)	Advertiser should ask screening question in a neutral manner so as to discourage inaccurate answers from children trying to avoid parental permission requirements.
C)	Age-screening mechanisms should be used in conjunction with technology, e.g., a session cookie, to help prevent underage children from going back and changing their age to circumvent age-screening.
D)	Since hyperlinks can allow a child to move seamlessly from one site to another, operators of Websites for children or children's portions of general audience sites should not knowingly link to pages of other sites that do not comply with CARU's Guidelines.

Source: Children's Advertising Review Unit (CARU) Guidelines for On-line Privacy Protection from CARU Website (www.caru. org) Section entitled Self-Regulatory Program for Children's Advertising, Eighth Edition (2006).

Many parents are concerned that the Children's Online Privacy Protection Act may simply not be enough. They look to software such as America Online's Parental Control program and browser options such as Surfmonkey.com to help prevent kids from visiting sites they prefer to block. But it is increasingly difficult to keep abreast of the latest marketing ploys, as more are on the way every day. Wireless Internet technology allows advertisers to direct messages to mobile computer users—via Internet-linked cell phones or personal digital assistants—based on their

location and cell phone number. Increasingly, children between the ages of 10 and 16 in high- to medium-income areas are carrying cell phones. Software can automatically e-mail or call kids on their cell phones with an ad when they walk past a store—for instance, sending along a few seconds of a new hit song along with a dollar-off digital coupon for a CD (Harrington, 2000). Clearly, new technologies will present challenges to parents hoping to protect their children from being microtargeted with ads that will give undue power to the commercial message.

Online Games

Estimates suggest that 98 percent of children's sites permit advertising, and that more than two-thirds of Web sites designed for children rely on advertising as their primary revenue stream (Moore, 2004). But obvious tactics, such as banner ads and buttons, have proven less than successful in enticing youthful consumers. Today, sites are employing more creative techniques. Some 55 percent of children's and teens' sites now feature games. Although original games with no commercial tie-ins still exist, they have been joined by a growing army of product-related offerings. In-game advertising, or "game-vertising," is a highly sophisticated, finely tuned strategy that combines product placement, behavioral targeting, and viral marketing to forge ongoing relationships between brands and individual gamers.

Marketing through such interactive games apparently works particularly well for fast food and beverage advertisers. Coca-Cola, Pepsi, Mountain Dew, Gatorade, McDonald's, Burger King, and KFC, for example, were the "most recalled brands" by online game players, according to a 2006 survey conducted by Phoenix Marketing International (Chester & Montgomery, 2008). Marketers can not only incorporate their brands into the storylines of popular games, but they can also use software that enables them to respond to a player's actions in real time, changing, adding, or updating advertising messages to tailor their appeal to that particular individual.

For example, at Viacom's Neopets.com—which targets 8- to 17-year-olds—young gamers create and "take care of" virtual pets, earning virtual currency (neopoints) to pay for the pet's upkeep by participating in contests and games. Worldwide, some 10–13 million people visit the Web site each month, and 40,000 more sign up each day. Thirty-nine percent of Neopets players are under 12 years of age, and another 40 percent are ages 13–17 (Ritchel, 2006). The site earns substantial advertising revenues from "User Initiated Brand Integrated Advertising"—activities or games built around advertisers' products and services that help build relationships and generate revenues with Neopets visitors. For example, participants can earn points by buying or selling "valuable commodities" such as McDonald's french fries, or winning games with names like "Cinnamon Toast Crunch Umpire Strikes Out." Food companies that have sponsored various activities on Neopets include McDonald's, Frito-Lay, Nestlé, Kelloggs, Mars, Procter & Gamble, General Mills, Draft Foods, and Carl's Jr. (Chester & Montgomery, 2008).

The above list is clearly heavy on food marketers, many of which have generally agreed to limit the nature and volume of television ads aimed at kids. But those agreements have not always extended to the Internet. Their potential audience is huge. Studies show that one-third of Internet users play online games at least once a week. Millions of children and teenagers play games on sites like Addicting Games, Miniclip Games, and Disney.com; and social-networking sites like MySpace and Facebook are also becoming popular platforms for gaming. With a series of customized sites for different age groups (preschoolers, tweens, teenage boys, moms), Nickelodeon calls itself the "biggest gaming network in the country." The company promotes the claim that its gaming audience is over 25 million unique visitors per month. The N, Nickelodeon's teenage

network, has dozens of games for children 12–17. Slightly younger players are directed to Nick. com, which draws an average of 7.9 million visitors per month. The youngest players of all are welcome on the sites of Nick Jr. and NOGGIN, where games are meant to be played by children "on the laps of their moms." While the television version of the preschool program NOGGIN is mostly commercial free, the channel's Web site displays advertising. Ads for Target, Circuit City, Six Flags, and Orlando vacations are aimed at parents, but the young faces and bright colors likely appeal to children as well. In the online games market, its stiffest competition comes from Yahoo.Games, which has about 15.5 million unique visitors per month. With more than 12 million visitors a month, Disney.com is also a leader in the arena (Stelter, 2008).

McDonald's is not limiting its gaming efforts to Neopets. McDonald's outlets in 40 European markets are handing out some 30 million Happy Meal CD-ROM premiums sporting Fairies & Dragons characters and corresponding games designed and executed by Canada's Fuel Industries agency. The restaurant chain, however, is not eschewing a physical premium. Boys and girls will receive one of four Fairies or Dragons toys with the Happy Meal, but the difference is the Fairies are perched on plastic clamshell CD cases, while the Dragons' "eggs" hatch to reveal the CD-ROMs. And like many Web/toy hybrids, the real interaction with the promo begins when kids pop the disks into their home computers and find that their given Fairy or Dragon is sitting on their monitor's desktop waiting to be fed, nurtured, and played with. This may be the first time McDonald's has licensed characters developed by an advertising agency for a promo, diverting from the norm of hooking up with established content partners like Disney and DreamWorks for movie- and TV-based tie-ins. McDonald's went for the approach largely because it was able to share the content in a way it would not have been able to with a promo piece based on a completed film or series. Indeed, McDonald's specified that the effort should complement the idea of healthy living, and that the games should be designed to enable short, multiple play sessions so kids would not sit in front of the computer for hours at a time. To that end, the games on each disk play out in about 10 minutes per session but contain roughly 10 hours of total game play. Additionally, Fuel had to ensure that the games used nonverbal cues and directions to move the play forward, as the CD-ROMs were being distributed in 11 languages (Castleman, 2008).

Virtual and Three-Dimensional Advertising

Three-dimensional environments are said to be on the cutting edge of digital marketing. These "virtual worlds" are complex, multilayered enterprises that combine many of the most popular online activities—such as instant messaging, interactive gaming, and social networking—into increasingly elaborate settings in which individuals create their own online identities through avatars—virtual talking cartoon-like representations of a person (Chester & Montgomery, 2008). One retailer has taken this concept to a whole new level. Students may visit Taubman's shopping centers or their Web site (http://www.findyourgo.com) and transform a regular photo of themselves into a custom talking avatar. The characters may be customized down to their clothing, hair color, and background. Users can also record a personal voice message, type a message for the computer, or speak or select a clever prerecorded message that humorously tells parents why they need the attached wish list to succeed in school. The customized avatar may be e-mailed to friends and family as well as posted on a user's MySpace page, blog, or Web site for others to view. Not only will parents get to view their child's wish list and access weekly sales information organized by shopping categories, they can also learn about the trendiest back-to-school items and voice their opinions by voting on featured products. To launch the avatar program, many

Taubman's shopping centers hosted in-mall events that featured Pixmen—people equipped with LED screens suspended over their heads via a backpack-like device. The Pixmen walked among shoppers, educating them about the avatar program, and directed traffic to center court. There, teams handed out findyourgo lip balm and showed visitors how to create their own avatars on-site from the center's avatar kiosk or from home. Taubman's provides a perfect example of digital and nontraditional coming together for a campaign that will wow parents but that students will also find cool ("Taubman Centers," 2007). It is estimated that 20 million children will be members of a virtual world by 2011, up from about 8.2 million in 2007 (Barnes, 2007). One thorny issue with virtual worlds, particularly for advertisers targeting younger kids, is a lack of standards in an industry that is under intense scrutiny. Another challenge is just what exactly constitutes success—defining what it means to connect effectively with users.

Marketing Ecosystems

Beyond in-school advertising, Internet advertising, online games, and three-dimensional worlds—kids "marketing ecosystems" also encompass cell phones, instant messaging, and buzz campaigns.

Mobile Marketing: A recent poll of kids ages 6–18 about cell phone usage found that 74 percent of 13- to 18-year-olds owned their own phone, but that only 26 percent of 6- to 12-year-olds were owners. Among the younger group, 81 percent said they never send text messages. In contrast, 54 percent of the older owners said they send text messages "all the time" or "once in a while" (Knapstein, 2007). The texting phenomenon has given rise to acronyms like "paw" (parents are watching), "lol" (laugh out loud), "g2g" (got to go), and "ooc" (out of control). And, marketers are getting increasingly hip to text message lingo. In ads for a new line of Degree deodorant, Unilever is highlighting "OMG! Moments" (read "oh my gosh"). Print ads (see Figure 8.7) running in magazines such as *Seventeen* and *Cosmo Girl* show teen girls

Figure 8.7: Degree deodorant ad featuring text messaging lingo

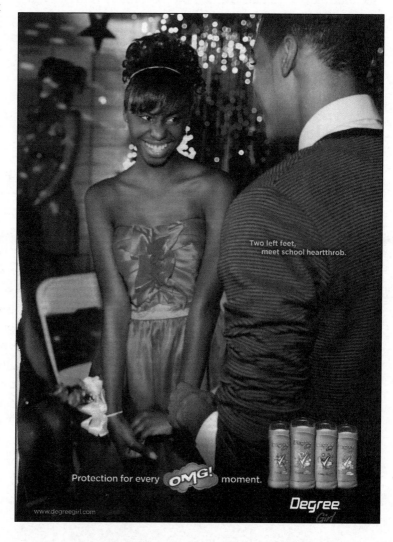

experiencing awkward moments. "We wanted to show teens that we understand them and know how they communicate with their friends," noted David Lang, president of WWP Group's MindShare Entertainment, which created the print, TV, and online effort (Vranica, 2008). Not to be outdone, PepsiCo's Frito-Lay, McDonald's, AT&T, and Cingular have also tried to demonstrate their street cred to the teenage set by using text-messaging abbreviations in their commercials. A Cingular spot using the shorthand has drawn a huge audience—attracting more than one million views on YouTube. The ad, for an unlimited texting plan offered by the carrier, featured a mom questioning her daughter, Bethann, about all the texting she was doing. Bethann's response: "omg, inbd" (translation: "oh my gosh, it's no big deal"). She explains to her mom that she is texting her "bff Jill." In response to the success of the campaign, BBDO, owned by Omnicom Group, created two other spots that feature the same family using text lingo in other situations.

Cell phones have become one of the most important digital platforms for marketing to young people. They enable firms to directly target users based on previous buying history, location, and other profiling data. Youthful mobile users will increasingly be sent personally tailored electronic pitches, designed to trigger immediate purchases and timed to reach them when they are near particular stores and restaurants. The McDonald's McFlurry mobile marketing campaign, for example, was designed to "create a compelling way to connect with the younger demographic." Six hundred McDonald's restaurants in California urged young cell phone users to text message to a special phone number to receive an instant electronic coupon for a free McFlurry dessert. Kids were encouraged to download free cell phone wallpaper and ring tones featuring top artists and to e-mail the promotional Web site link to their friends. To round out the campaign, ads on buses, billboards, "wildpostings" near high schools, and even skywriting airplanes promoted the "Text McFlurry 73260" message (Chester & Montgomery, 2008).

It appears that young people do not mind receiving messages about products on their phones, according to data collected by the research firm Nielsen Mobile. Nielsen says teens are nearly twice as likely as adults to trust and respond to pitches on mobile phones. "For them, responding to an ad that's relevant by sending a text or following a link on their phone is a logical brand engagement," notes Nic Covey, director of insights at Nielsen Mobile. It appears that only about 4 percent of young people who sign up for texts ask to stop getting them. And, 2–4 percent of those who see or receive ads on mobile phones click on them to find out more information. On the Internet, in contrast, click-through rates are generally closer to 0.01 percent (Semuels, 2008). Soon transactions will also be able to be made by phone. In Japan, Mizuho Bank introduced bar-code transactions through mobile phones, allowing users to purchase items at retail stores simply by waving their debit-card-loaded phones over the items (McCaughan, 2007). It likely will not take long for this feature to make its way to foreign shores.

Instant Messaging: Instant messaging—the near synchronous back and forth between computers—is the fastest, most popular means of communication among young people. AOL recently reported that 66 percent of Americans 13–21 now prefer instant messaging to e-mail. And, according to the Pew Internet & American Life Project, of the 87 percent of 12- to 17-year-olds (or 21 million young people) who are regularly online, 75 percent use instant messaging (82 percent of them by the seventh grade) (Israel, 2006). The three major instant messaging formats are AOL's AIM, Yahoo's Messenger, and MSN's Messenger. All three promote themselves aggressively to advertisers that want to permeate and surround kids' ongoing conversations, providing marketers with a variety of strategies, including "takeover" ads that flood a site's homepage with interactive

commercials, as well as branded "bots" and buddy icons. The "M&M Always IMvironment" features the brand's popular "spokescandies." "There is a new way to add a little more MScM to your day," the site chirps. "Chat with friends about life, love and chocolate with this cool IMV. There's an M in everyone." IMvironments are animated backgrounds that customize the appearance of an instant message window (Chester & Montgomery, 2008).

Buzz Marketing: Buzz marketing (sometimes called "peer-to-peer," "word-of-mouth," or "viral" marketing) has become a useful tool among those marketing to youth. Market researchers target key, influential young people who can serve as "brand sirens," promoting products to their peers through instant messaging, social networking sites and blogs—and even slumber parties. These approaches are becoming standard advertising techniques not only among teens but also among elementary schoolchildren. Firms recruit popular kids—dubbed "connectors," "thought leaders," or "influencers"—through the Internet, either through their own sites (such as Procter & Gamble's Tremor.com, which boasts 200,000 "of the most influential teens in the U.S.") or by monitoring youth-heavy sites for visitors who post attention-getting messages.

Word of mouth has always been a popular way to share consumer opinion; however, here youthful participants in buzz marketing are paid in free products or discounts—and are not required to disclose that "I get free stuff if I say this." The Girls Intelligence Agency (GIA), for example, provides boxes of promotional materials to organized slumber parties and promises advertisers that its girl agents are "dedicated to spreading the word on GIA-endorsed products." "Winning a chance to be a GIA slumber party host is a very exclusive experience," the site notes. Moms and daughters apparently "get totally into it," decorating bedrooms and creating snacks to fit the theme. The Web site explains that "GIAheadquarters.com maintains a 'big sis' relationship with agents," who look to GIA for support and guidance. GIA members get free stuff by earning points for completing surveys and referring friends. The agency then shares the girls' feedback with clients, which use it to sell them even more stuff. The Web site tells girls that they are "ruthless spies saving the world from making more lame stuff for girls. You talk, IM, e-mail . . . we listen and decode and translate . . . to help companies go from LAME to SWEET" (Dunnewind, 2004).

REGULATION OF COMMERCIAL MESSAGES TARGETED TO CHILDREN

Parents, educators, and, in particular, regulators have been concerned about the amount of advertising directed at children for nearly six decades. Three basic views regarding advertising to children exist (Sandage, Fryburger, & Rotzoll, 1989). First is the view that directing any advertising to children is wrong. The desire to restrict advertising to children is based on a number of concerns. Many critics believe that advertising promotes superficial values and a consumption ethic. They argue that children are inexperienced consumers and thus are easy prey for sophisticated marketers. And, as any parent can attest, advertising influences children's demands for just about everything. Such demands often lead to an environment of parent-child conflict. A second view holds that advertising directed toward children may be permissible under certain conditions. Third is the viewpoint that advertising is a part of life: Children must learn the skills needed to function in the marketplace as part of the consumer socialization process. According to this view, any special care needed for children is best handled through self-regulation by the advertisers, agencies, and the media. Countries vary in their perceptions of children as a market, and a particular country's position on advertising to children may vary over time.

Since the 1970s, in the United States a great deal of concern has been expressed over appealing to children as consumers. By then, marketers were already spending over $400 million a year advertising in children's programming (Sivulka, 1998). A 1977 study found that the average child watched more than 1,300 hours of television annually, which resulted in exposure to some 20,000 commercials per year (National Science Foundation, 1977). Much of the controversy during this time centered on television advertising. Critics argued for greater regulation because of children's inability to evaluate advertising messages and make purchase decisions.

In response, the Federal Trade Commission initiated proceedings to study the possible regulation of children's advertising. The FTC's recommendations included: (1) a total ban on television advertising directed to children "too young to understand the selling purpose of, or otherwise comprehend or evaluate" commercials tentatively identified as aimed toward children below 8 years of age; (2) an additional ban on television advertising for "sugared products, the consumption of which poses the most serious dental health risks" directed to older children, tentatively identified as being ages 8 through 11; and (3) a requirement that television advertising directed to older children for sugared products not included in the proposal be "balanced by nutritional and/or health disclosures funded by advertisers."

These recommendations were intensely debated and strongly opposed by the advertising industry. And several major advertisers argued that the First Amendment to the Constitution provides the right to communicate with those consumers who made up their primary target audience (Enis, Spencer, & Webb, 1980). Opponents also suggested that it was the parent's responsibility to help children understand advertising messages and to refuse to comply with unreasonable demands. The FTC proposal was subsequently rejected. Outside of the Children's Online Privacy Protection Rule discussed previously, the FTC's current stance toward children's advertising is focused primarily on cases of alleged deception. In recent years, the FTC has tackled commercials featuring a toy helicopter that appeared to be able to hover and fly under its own power, a ballerina doll that seemed to stand alone and twirl without human assistance, and a paint sprayer toy that was made to look easier to use than it was.

Action for Children's Television was instrumental in getting the House of Representatives and the Senate to approve the Children's Television Act in October 1990. This act placed a 10.5-minute-per-hour cap on commercials in weekend children's television programming and a 12-minute-per-hour cap for weekday programs. The rule went into effect January 1, 1992, and stations voluntarily report to the Federal Communications Commission whether they are complying with the guidelines when their licenses come up for renewal every three years. The act also outlined rules requiring that commercial breaks be clearly distinguished from programming and officially barred host selling, tie-ins, and other practices that involve the use of program characters to promote products. Programs based on a toy or children's product cannot contain advertising for that product within the program although it may directly follow the program.

Stations found in violation of these guidelines may be fined. Some of the stiffest fines have gone to Nickelodeon's parent company, Viacom Inc. (which agreed to pay the U.S. Treasury a $1 million penalty), and ABC Family's owner Walt Disney Company (which agreed to pay the government $500,000). During a routine FCC audit of programming carried by Cox Communications, Inc.'s San Diego, California system, the agency found Nickelodeon violated commercial limits on November 1 and 8, 2004. After a subsequent inquiry, the FCC said Viacom acknowledged that from October 1, 2003, through August 10, 2004, there were 591 instances in which Nickelodeon

programs inadvertently contained commercial matter in excess of FCC limits, and that there were 145 instances in which Nick aired "program-length commercials." If a program on a kids' network contains commercials that feature the characters from that show, the entire program is considered a commercial. Nickelodeon blamed human error and computer system problems that occurred in commercial logging systems for the violations. The FCC discovered the ABC Family violations during routine audits during the fourth quarter of ABC 2003 programming carried by Time Warner Cable's Hawaii system and Charter Communications, Inc.'s Spring, Texas, operation. The network had violated agency rules in 31 half-hour episodes that it ran from July 1, 2003, through July 12, 2004, by running commercials for products that were featured in the actual programming. A representative from ABC Family noted that the violations occurred as a result of a computer traffic system ABC had previously used that did not read for notations regarding special children's advertising restrictions, and commercials were unintentionally placed in related shows (Donohue, 2004).

Self-regulation by the advertising industry has attempted to fill the void. In 1974 the National Advertising Division (NAD) of the Council of Better Business Bureaus set up a group charged with helping advertisers deal with children's advertising in a manner sensitive to children's special needs. The Children's Advertising Review Unit (CARU) was established to review and evaluate advertising directed at children under the age of 12. The CARU general guidelines address the following nine areas: deception; product presentations and claims; disclosures and disclaimers; endorsements; the blurring of advertising and editorial/program content; premiums, kids clubs, sweepstakes, and contests; online sales; sales pressure; and unsafe and inappropriate advertising to children. For a complete overview of these guidelines, go to http://www.caru.org.

In addition to these guidelines, previously noted guidelines for online privacy protection have been added. The CARU recognizes that it is important to many companies that they are able to communicate directly with children. However, only by voluntarily complying with these guidelines will they be able to avoid potential conflict with those who believe advertising directed to children should be strictly regulated or banned altogether. Eight core principles underlie the CARU's guidelines.

1. Advertisers have special responsibilities when advertising to children or collecting data from children online. They should take into account the limited knowledge, experience, sophistication, and maturity of the audience to which their message is directed. They should recognize that younger children have a limited capability to evaluate the credibility of the information, may not understand the persuasive intent of advertising, and may not even understand that they are being subjected to advertising.

2. Advertising should be neither deceptive nor unfair, as these terms are applied under the Federal Trade Commission Act, to the children to whom it is directed.

3. Advertisers should have adequate substantiation for objective advertising claims, as those claims are reasonably interpreted by the children to whom they are directed.

4. Advertising should not stimulate children's unreasonable expectations about product quality or performance.

5. Products and content inappropriate for children should not be advertised directly to them.

6. Advertisers should avoid social stereotyping and appeals to prejudice, and are encouraged to incorporate minority and other groups in advertisements and to present positive role models whenever possible.

7. Advertisers are encouraged to capitalize on the potential of advertising to serve an educational role and influence positive personal qualities and behaviors in children, e.g., being honest, respectful of others, taking safety precautions, and encouraging in physical activity.

8. Although there are many influences that affect a child's personal and social development, it remains the prime responsibility of the parents to provide guidance for children. Advertisers should contribute to this parent-child relationship in a constructive manner.

As excellent as these guidelines are, the primary problem is that the CARU does not have the power to enforce them; while the FTC, which has the power, cannot issue sweeping regulations. The FTC can only respond to complaints on a case-by-case basis.

Other countries have been more aggressive in regulating marketing to children. The Canadian province of Quebec has long banned advertising to children on television and radio. Recently a bill was introduced seeking to extend the ban across the entire country ("The Media and the Message," 2008). New Zealand's government has indicated it intends to eliminate advertising during all children's programs. While advertising to children is allowed in Malaysia, guidelines are very strict. Advertising in Malaysia is self-regulated by what is referred to as the Malaysian Code of Advertising Practices (Mirandah, 2005). In addition to guidelines quite similar to those of the CARU in the United States, Malaysia's code stipulates:

- Use of children in advertisements is discouraged unless the products that are advertised have a direct bearing on them.
- No advertisement is allowed that encourages children to enter strange places or to converse with strangers in an effort to collect coupons, wrappers, labels, or the like. The details of any collecting scheme must be submitted for investigation to ensure the scheme contains no element of danger to children.
- No advertisement dealing with the activities of a club is allowed without the submission of satisfactory evidence that the club is carefully supervised, and there is no suggestion of the club being a secret society.
- Children seen in advertisements must be reasonably well mannered and well behaved.

To date there are no continent-wide rules regarding marketing to children in Europe, but in Norway, Austria, and the Flemish part of Belgium no advertising is allowed around children's programs. Greece does not allow advertisements for toys to be screened between 7:30 a.m. and 10 p.m., and the Republic of Ireland restricts advertisements in its preschool programming. Italy, Poland, Denmark, and Latvia are studying plans for tighter regulation. Sweden has taken the strongest line on the issue and bans all television advertisements aimed at children under 12. This rules out not just advertising for toys and candy, but also many ads for products with wider family appeal: McDonald's in Sweden, for instance, cannot employ the clown Ronald McDonald in any of its TV ads. The ban applies only to broadcasts originating in Sweden. While some satellite channels based in London—like Nickelodeon's Nordic service—forgo advertising in deference to local sensitivities, others are not so scrupulous. The Swedish government pushed hard for its ban to be extended across Europe, partly under pressure from domestic commercial broadcasters who complained that they faced unfair competition. As a result of these efforts, it appears that an increasing number of European countries may be softening their objections to such a proposed ban (Hill, 2000). It remains to be seen whether a European Union–wide ban on broadcast ads aimed at children will be imposed in the near future.

CONCLUSION

This chapter has explored the issues related to targeting children as consumers. Regardless of the level of regulation or self-regulation in a particular marketplace, parents can do much to inhibit materialistic behavior, as well as police the commercial messages aimed at their children—thereby helping them become savvy consumers. One effective means of combating commercialism is by simply setting limits to purchase behavior and by discussing with children the differences between wants and needs. When children beg for the latest toy, parents should discuss why they want the new object before saying no or giving in. By talking about the root cause of a want, parents may be able to diffuse the youngster's fixation on the item.

Regarding commercial messages targeted at children, parents can take an active role if they begin to teach media literacy—helping children to be critical viewers and consumers of the media.

1. Parents can mute the television during commercials or watch commercials with their children to help them understand that the purpose of advertising is to sell products. They should explain to a child that the products advertised on TV or elsewhere are made to seem as appealing as possible, and that not all information about a product may be included in the ad.

2. Parents and children should do research before making a purchase. For example, parents should encourage the child to look carefully at a toy and its package in the store and to ask friends for their experiences. Together they should try to determine how the product actually performs, what pieces come with it, and how much assembly is required. Parents can teach a child to watch and listen for key phrases such as "pieces sold separately" or "batteries not included."

3. Parents can explain how special effects, production techniques, camera work, or editing are used to enhance a product's operation in commercials. For example, many ads show toys being used in imaginary settings in ways that do not represent how they may work in the home. Parents should help the child focus on the part of the ad that shows a product's real-life operation.

4. In some ads, products may look easy to play with or operate. The truth is they may require hours of practice before they can be used as shown. Parents should remind children that because of different levels of skills and talents, not all toys are appropriate for all kids.

5. Once a child owns a particular toy, parents should talk about its performance. Does it perform the way the child thought it would perform? Is another toy a better buy?

6. If a child falls for a deceptive ad, teach him to complain. Write the FTC, the TV station that aired the ad, and the product manufacturer. (Schnabel, 1997)

REFERENCES

"About Radio Disney." (2008). Retrieved October 1, 2008 from http://radio.disney.go.com/about/about_advertising_ops.html.

America's children in brief: Key national indicators of well-being. (2008). Retrieved September 16, 2008, from http://childstats.gov/americaschildren/demo.asp

Atkin, Charles. (1975). *The effects of television advertising on children, Report # 1–8.* East Lansing: Michigan State University.

Barnes, Brooks. (2007, December 31). Web playgrounds of the very young. *New York Times,* New York, p. C1.

Barnes, Brooks. (2008, July 1). ABC Family adds edgy content as a part of network makeover. *The San Diego Union Tribune.* Retrieved October 1, 2008 from http://www. Signonsandiego.com/uniontrib/20080701/news_1c01tvm

Barrett, Jennifer. (2007, May 7). Study: 40 percent of 3-month olds watch TV regularly. *The Salt Lake Tribune,* Salt Lake City, p. 1.

Bechtel, Robert, Achelpohl, Clard, & Akers, Roger. (1972). Correlates between observed behavior and questionnaire responses on television viewing. In E. A. Rubinstein, G. A. Comstock, & J. P. Murray (Eds.), *Television and social behavior, Vol. 4* (pp. 274–344). Washington, D.C.: Government Printing Office.

Brucks, M., Armstrong, G. M., & Goldberg, M. E. (1988, March). Children's use of cognitive defenses against television advertising: A cognitive response approach. *Journal of Consumer Research, 14,* 471–482.

Burns, M. C. (1999, December 30). TV turns kids into target market. *The Post Standard,* Syracuse, NY, p. M2.

Butter, Elio J., Popovich, Paula, Stackhouse, Robert, & Ganner, Roger. (1981, April). Discrimination of television programs and commercials by preschool children. *Journal of Advertising Research,* 53–56.

Castleman, Lana. (2008, May). McDonald's is lovin' custom content. *Kidscreen,* Toronto, p. 26.

Cearley, Anna. (1999, January 7). ZAPME! Lets company, schools swap computers for ad time. *San Diego Union Tribune,* p. B-1.

Center for a New American Dream. (2002). Just the facts about marketing and advertising to children. www.newdream.org/campaign/kids/facts.html

Chester, Jeff, & Montgomery, Kathryn. (2008, July/August). No escape: Marketing to kids in the digital age. *Multinational Monitor,* Washington, *29*(1), 11–17.

Children, TV and toys. (2002, December). *Health Alert,* p. 3.

Clifford, Stephanie. (2008, July 30). Tug of war in food marketing to children. *New York Times,* New York, p. C5.

Cohen, Nick. (2001, September 9). Class struggles: Private firms already milking public education have been given a further boost to sell direct to children. *The Observer,* London, p. 25.

Coleman, Todd. (2004, April 4). Radio Disney knows tweens are the ones to watch. *Chicago Sun-Times,* p. 8.

Comiteau, Jennifer. (2003, March 24). First impressions: When does brand loyalty start? Earlier than you might think. *AdWeek,* pp. 26–27.

Consumers Union Education Services. (1990). *Selling America's kids.* Mount Vernon, NY.

Council of Better Business Bureaus. (1983). *Self-regulatory guidelines for children's advertising* (3rd. ed.). Children's Advertising Review Unit (CARU), National Advertising Division.

Dart, Bob. (2008, July 30). Food pitches to kids use every avenue. *The Atlanta Journal,* p. C4.

Disney Channel tops ratings. (2008, January 4). Retrieved October 1, 2008 from http://www.worldscreen.com/newscurrent.php?filename=disney01

Donohue, Steve. (2004, October 25). Kids' networks fined over ads. *Multichannel News.* Retrieved October 1, 2008, from http://www.multichannel.com/article/CA474705.html

Dunnewind, Stephanie. (2004, November 20). The big grab for the teen market; teen recruits create word-of-mouth "buzz" to get their peers hooked on new products, helping companies bypass traditional advertising. *Seattle Times,* p. C1.

Enis, Ben, Spencer, Dale, & Webb, Don. (1980). Television advertising and children: Regulatory vs. competitive perspectives. *Journal of Advertising, 9*(1), 19–25.

European Report (2005). Consumers: Kyprianou launches EU platform against obesity. Retrieved March 16, 2005 from http://web.lexis-nexis.com.libproxy.sdsu.edu/universe/document?_m=db84139b84376b8c46

Finholm, Valerie. (1998, December 15). The best of children's magazines. *The Hartford Courant,* Hartford, CT, p. F4.

Frazier, Mya. (2007, November 26). Channel One: New owner, old issues. *Advertising Age,* Chicago, 78(47), 10.

Freking, Kevin. (2008). *FTC: Kids target of $1.6 Billion in Food Ads.* Retrieved July 28, 2008, from http://hosted.ap.org/dynamic/stories/C/CHILDREN_MARKETING_FOOD?SITE=CAGRA&SECTION=HOME&TEMPLATE=DEFAULT

Gonsalves, Antone. (2006, September 8). Xanga to pay $1 million for violating Children's Protection Act. *InformationWeek.* Retrieved October 1, 2008, from http://www.informationweek.com/news/internet/ebusiness/showArticle

Gumbel, Andrew. (1999, September 6). California outlaws the Pepsi-sponsored schoolday. *The Independent,* London, p. 14.

Hall, Emma. (2007, December 17). Food marketers pledge no more kids' ads in the European Union. *Advertising Age,* Chicago, *78*(50), 2.

Hampp, Andrew. (2008a, February 25). Tale of the tape: Nickelodoen vs. Cartoon Newtork. *Advertising Age,* p. 12.

Hampp, Andrew. (2008b, February 25). Kids Sprout grows by targeting parents, not their offspring. *Advertising Age,* p. 13.

Harrington, Mark. (2000, April 2). Kids' Online privacy gets protections: Web sites for children will need parents' permission to gather personal data. *Portland Press Herald,* Portland, ME, p. 2A.

Harris Interactive YouthPulse. (2005, February). Are young consumers shopping on the web? In Kelly Bagnaschi & John Geraci (Eds.), *Trends & Tudes.*

Harrison, Dristen, & Marske, Amy. (2005). Nutritional content of foods advertised during the television programs children watch most. *American Journal of Public Health, 95*(9), 1568–1574.

Hawkes, Corinna. (2007, November). Regulating food marketing to young people worldwide: Trends and policy drivers. *American Journal of Public Health,* Washington, *97*(11), 1962–1973.

Health groups warn: Children at risk for junk food marketing. (2004). *Nutrition and Food Science, 34*(1), 42.

Hill, Amelia. (2000, February 6). Euro storm over "pester power" TV. *Scotland on Sunday,* p. 6.

Isler, Leslie, Popper, Edward, & Ward, Scott. (1987, October–November). Children's purchase requests and parental responses: Results from a diary study. *Journal of Advertising Research,* pp. 28–39.

Israel, Betsy. (2006, November 5). The overconnecteds. *New York Times,* New York, p. 4A, 20.

Itzkoff, Dave. (2007, August 20). Move over Mickey: A new franchise at Disney. *New York Times,* New York, p. 1.

James, Barry. (2001, October 15). Profiting from pupils: Sponsorship and ads gain grounds in schools. *International Herald Tribune,* Paris, p. 12.

Jensen, Elizabeth. (2007, August 13). A coming of age at Nickelodeon: Noggin and N will get their own channels. *New York Times,* New York, p. C5.

Johannes, Amy. (2006, May 1). Licensed to thrill. *Promomagazine.* http://prmomagazine.com;mag/marketing_licensed_thrill

Johnston, J. (1995, February). Channel One: The dilemma of teaching and selling. *Phi Delta Kappan,* pp. 437–442.

Junk food ads trimmed. (2006, November/December). *Multinational Monitor,* Washington, *27*(6), 4.

Kendle, Jeanine. (2007, November 24). About children: Ad media influence powerful with kids. *Daily Record,* Wooster, OH, *108*(169), p. 1.

Kluger, Jeffrey. (2008, June 23). How America's children packed on the pounds. *Time,* pp. 66–69.

Knapstein, Karen (2007, April). Cell-phone-savvy. *Scholastic Parent & Child,* New York, *14*(6), 62.

LaRochelle, Mark. (2001, September). Online privacy update: Enforcing COPPA. *Consumer's Research Magazine,* p. 43.

Levin, S. R., Petros, T. V., & Petrella, F. W. (1979, March). *Preschoolers' discrimination of television programming and commercials.* Paper presented at the Biennial Meeting of the Society for Research in Child Development, San Francisco, California.

Levine, Jane. (2000, January). Junk food marketing goes elementary. *The Education Digest,* Ann Arbor, MI, pp. 32–34.

Lew, Irene (2008, January 4). Disney Channel tops ratings. *WorldScreen.com*. Retrieved October 1, 2008, from http://www.worldscreen.com/newscurrent.php?filename=disney01

MacLeod, C. (2007, January 9). *Obesity of China's kids stuns officials*. Retrieved July 28, 2008, from http://www.usatoday.com/news/world/2007-01-08-chinese-obesity_x.htm

Manilov, M. (1994, Spring). Whittling away students' education: Impact of *Channel One* programs in the classroom and how they impact environmental awareness. *Environmental Action*, pp. 17–19.

Mayo, Ed. (2005). Shopping generation. *Young Consumers*, World Advertising Research Center, *Quarter 3*, 43–49.

McCaughan, Dave. (2007, January 22). Tokyo. *Advertising Age*, Chicago, IL, 78(4), 18.

McClain, Buzz. (2008, April 21). Does TV help babies or hold them back? *McClatchy-Tribune News Service*, Washington, p. 1.

McGowan, W. G. (1993). Class ads: Corporate advertising in the classroom. *Scholastic Update*, 12(14), 14–15.

McNeal, James. (1969, Summer). The child consumer: A new market. *Journal of Retailing*, pp. 2–22.

Mirandah, Patrick. (2005). Advertising to children in Malaysia. *Young Consumers*, World Advertising Research Center, pp. 74–76.

Molnar, A. (1994, September). Education for profit: A yellow brick road to nowhere. *Education Leadership*, pp. 66–71.

Moore, Elizabeth. (2004, June). Children and the changing world of advertising. *Journal of Business Ethics*, Dordrecht, 52(2), 161–167.

Morgan, M. (1993). *Channel One in the public schools: Widening the gaps*. Amherst, MA: University of Massachusetts.

Mueller, Barbara, & Wulfemeyer, K. Tim. (1993). Commercial speech directed at captive minds: The regulation of advertising in public secondary schools. *High School Journal*, 76(2), 110–117.

Mueller, Barbara, Wulfemeyer, K. Tim, & Penny, Sharon. (1999). Students for sale: An analysis of in-classroom marketing via sponsored educational materials. In Yves Evrard, Wayne Hoyer, & Alain Strazzieri, (Eds.), *Proceedings of the third International Research Seminar on Marketing Communications and Consumer Behavior* (pp. 427–437). France: La Londe.

National Science Foundation. (1977). Research on the effects of television advertising on children, p. 45.

Nickelodeon Corporate Profile. (2008). Retrieved October 1, 2008 from http://www.nickmarriottpress.com/facts/nickelodeon.php

Nutrition policy profiles: Soft drink contracts in schools. (2002, May). *Prevention Institute*. http://www.preventioninstitute.org/CHI_soda.html

O'Crowley, Peggy. (2000, February 28). Backlash builds against ads that target children. *Newhouse News Service*, p. 1.

Ollivier, Christine. (2008, August 21). TV for babies? Not in France: Regulator prohibits marketing programs to children under 3. *Chicago Tribune*, p. 18.

Piaget, Jean. (1970). The stages of the intellectual development of the child. In P. H. Mussen (Ed.), *Readings in child development and psychology*. New York: Harper and Row.

Pinson, Nicola. (2006, Summer). Soda contracts: Who really benefits? *Rethinking Schools Online*. http://www.rethinkingschools.org/archive/20_04/soda204.shtml

Poulter, Sean. (1999, December 2). Children play more happily without toys. *Daily Mail*, London, p. 21.

Raju, P. S., & Lonial, Subhash C. (1990). Advertising to children: Findings and implications. *Current Issues and Research in Advertising*, 12(1–2), 231–274.

Rideout, Victoria, Roberts, Donald, & Foehr, Ulla. (2005, March). Generation M: Media in the lives of 8–18 year olds. A Kaiser Family Foundation Study, pp. 1–49.

Ritchel, Matt. (2006, June 26). Skip the sitter and feed your virtual pet by cell phone. *New York Times*, New York, p. C2.

Robertson, Thomas, & Rossiter, John. (1974, June). Children and commercial persuasion: An attribution theory analysis. *Journal of Consumer Research*, pp. 12–20.

Robertson, Thomas, & Rossiter, John. (1977, Winter). Children's responsiveness to commercials. *Journal of Communication*, pp. 101–106.

Rubin, Ronald. (1974, October). The effects of cognitive development on children's responses to television advertising. *Journal of Business Research*, pp. 409–419.

Sandage, C. H., Fryburger, Vernon, & Rotzoll, Kim. (1989). *Advertising: Theory and practice.* New York: Longman.

Sandberg, Jared. (1997, June 9). Ply and pry: How businesses pump kids on Web. *Wall Street Journal*, pp. B1, B4.

Schnabel, Megan. (1997, December 2). Ads that target kids have become a commercial success. *Roanoke Times and World News*, p. 1.

Schwartz, Henry. (1998, August 17). Schools for sale? *Marketing News*, p. 12.

Selling McDisney to the very young. (2002, March 4). *Electronic Media*, Chicago, p. 8.

Semuels, Alana. (2008, May 26). Advertisers chase texting, talking teens, young people don't mind receiving messages about products on their cell phones. *Charleston Daily Mail*, Charleston, WV, p. D2.

Sivulka, Juliann. (1998). *Soap, sex and cigarettes: A cultural history of American advertising.* Belmont, CA: Wadsworth.

Smith, Rick. (2003, February 18). International education/A special report: Is tide starting to turn on advertising in school? Http://www.iht.com/articles/2003/02/18/rover_ed3_.php?page=2

Spake, A. (2003, November 17). Hey kids! We've got sugar and toys. *U.S. News and World Review*, p. 62.

Stanley, T. L. (2007, October 15). Babes in adland. *BRANDWEEK*, pp. 29–32.

Stelter, Brian. (2008, March 18). Web games abounding in tie-ins. *New York Times*, New York, p. C1.

Stephens, Nancy, & Stutts, Mary Ann. (1982). Preschoolers' ability to distinguish between television programming and commercials. *Journal of Advertising*, 11, 16–26.

Study: Ads on student channel remembered more than stories. (2006, March 6). *San Diego Union Tribune*, p. A6.

Stutts, Mary Ann, Vance, Donald, & Hudelson, Sarah. (1981). Program-commercial separators in children's television: Do they help a child tell the difference between Bugs Bunny and The Quick Rabbit? *Journal of Advertising*, 10(2), 16–48.

Tanner, Lindsey. (2007, August 7). Kids in taste-test study prefer food in McDonald's wrapper. *San Diego Union Tribune*, p. A1.

Taubman Centers let back-to-school shoppers create a life-like virtual version of themselves. (2007, August 13). *PR Newswire*, New York, p. 1.

The media and the message. (2008, August). *Today's Parent*, Toronto, Canada, 25(8), 88, 90.

Tiene, D., & Whitmore, E. (1995). Beyond Channel One: How schools are using their schoolwide television networks. *Education Technology*, pp. 38–42.

US FTC: First safe harbor approved for children's online privacy protection act. (2001, February, 2). *M2 Presswire*, Coventry, UK, p. 1.

Vranica, Suzanne. (2008, April 3). Marketers try to be "kwel" with text-message lingo: Ads with abbreviations aim to reach teens. *Wall Street Journal*, New York, p. B7.

Walsh, Bryan (2006, August 18). No longer starving in China. *Time.* Retrieved July 18, 2008, from http://time.blogs.com/global_health/2006/08/no_longer_starv.html

Ward, David. (2006, June 19). Ambush marketing: Sponsors play hardball with corporately incorrect. *The Guardian*, London, U.K., p. 3.

Ward, Scott. (1972, April). Children's reactions to commercials. *Journal of Advertising Research*, pp. 37–45.

Ward, Scott. (1978, October). Researchers look at the "kid vid" rule: Overview of session. *Advances in Consumer Research*, pp. 7–11.

Ward, Scott, Levinson, D., & Wackman, D. B. (1972). Children's attention to television advertising. In E. A. Rubinstein, G. A. Comstock, & J. P. Murray (Eds.), *Television and social behavior, Vol. 4* (pp. 491–516). Washington, D.C.: Government Printing Office.

Ward, Scott, & Wackman, Daniel. (1972). Television advertising and intra-family influence: Children's purchase influence attempts and parental yielding. In E. A. Rubinstein, G. A. Comstock, & J. P. Murray (Eds.), *Television and social behavior, Vol. 4.* Washington, D.C.: Government Printing Office.

Ward, Scott, Wackman, Daniel, & Wartella, Ellen. (1975). *Children learning to buy: The development of consumer information processing skills.* Cambridge, MA: Marketing Science Institute.

Wartella, E. (1995, February). The commercialization of youth: Channel One in context. *Phi Delta Kappan,* pp. 448–451.

Wells, William, Burnett, John, & Moriarty, Sandra. (2000). *Advertising: Principles and practice.* Upper Saddle River, NJ: Prentice-Hall.

Westcott, Tim. (2002, October). Mommy, will you buy me that? *WorldScreen.com.* Retrieved October 1, 2008, from http://www.worldscreen.com/featuresarchive.php?filename=1002m.

Wulfemeyer, K. Tim, & Mueller, Barbara. (1992). Channel One and commercials in classrooms: Advertising content aimed at students. *Journalism Quarterly, 69*(3), 724–742.

York, Emily Bryson. (2008, September 15). Strapped for cash, schools eye bus ads. *Advertising Age,* p. 4.

Young, Leslie. (2008, June 30). Reading, writing . . . and advertising. *Marketing,* Toronto, Canada, 113(11), 15.

Zarembo, Alan. (2008, May 28). Child obesity rate in the U.S. hits plateau, researchers say. *Los Angeles Times.* Retrieved July 18, 2008, from http://articles.latimes.com/2008/may/28/science/sci-obesity28

Advertising of Controversial Products

INTRODUCTION

Many question the wisdom of allowing controversial goods and services to be promoted. Tobacco and alcoholic beverages advertising has traditionally been criticized, with concern being expressed over both the marketing of dangerous and addictive products and the targeting of women, teens, and minorities. Other product categories that have generated debate include contraceptives, feminine hygiene products, firearms, gambling, and state-run lotteries. More recently, concern has arisen over the advertising of pharmaceutical products. While the promotion of many of these product areas is already regulated, serious efforts are underway to impose more stringent constraints or even bans on the advertising of these products altogether. Research has revealed that these product categories appear to be perceived as sensitive in many countries around the world (Shao & Hill, 1994). This chapter will take a closer look at the marketing of tobacco, alcohol, and pharmaceutical products.

TOBACCO ADVERTISING

In the early 1900s smoking was considered an undesirable habit. "Moralists blasted cigarettes, referring to them as coffin nails and gaspers. Henry Ford deemed cigarette smokers unemployable in a 1914 pamphlet. Others held that the cigarette smokers were most likely criminals, neurotics or possibly drug addicts" (Sivulka, 1998, p. 166). World War I and aggressive marketing changed the public's perception of tobacco. During the First World War, cigarettes gained

wider acceptance when both soldiers and civilians found cigarettes more convenient, cheaper, and more sanitary than chewing tobacco.

More than a century has passed, and a million cigarette ads later we have come full circle. In the United States, cigarette smoking is no longer considered fashionable as consumers have finally confronted the health hazards associated with smoking. According to Jacobson and Mazur (1995), hard evidence regarding the hazards of tobacco actually began to accumulate as early as 1900, when medical experts noticed a suspicious increase in lung cancer, and tobacco juice was first used to induce cancer in a test animal. The authors note that in 1938, Dr. Raymond Pearl, professor of biology at Johns Hopkins Medical School, released a study showing that smoking reduces life expectancy. The most serious efforts by the public-health community to reduce tobacco use started in 1964 with the release of the first Surgeon General's Report, which announced that cigarette smoking was a "health hazard of sufficient importance to the United States to require remedial action." This ultimately had two direct influences on the marketing of cigarettes: First, in 1965, warning notices had to be printed on every pack ("Caution: Cigarette smoking may be hazardous to your health"); and second, in 1971, broadcast ads for cigarettes were officially outlawed under the Federal Cigarette Labeling and Advertising Act. Finally, in 1972 health warnings in ads were mandated, but debates ensued over the size of typeface needed to comply with the law's requirement of "clear and conspicuous display."

During the 1980s, determined regulators and lawmakers continued the battle against the cigarette industry. Then Surgeon General C. Everett Koop spearheaded a crusade against cigarette smoking that significantly raised the awareness of the dangers of smoking among health officials, lawmakers, and the general public. Statistics suggest that tobacco use is the leading preventable cause of death in the United States. It kills more than 440,000 Americans and costs the nation nearly $157 billion in health care bills each year (Givel & Glantz, 2004). Worldwide, there are about 1.2 billion smokers, half of whom will die from diseases caused by smoking. Smoking causes 5 million deaths per year, and if present trends continue, 10 million smokers per year are projected to die by 2025 (Hatsukami, Stead, & Gupta, 2008).

One need not even be a smoker to be affected by cigarettes. Secondhand, or environmental, tobacco smoke has been classified as a "known human carcinogen" by the Environmental Protection Agency (EPA). A comprehensive study released by the EPA in 1992 revealed that secondhand smoke causes as many as 3,000 lung cancer deaths and as many as 50,000 deaths from all causes among nonsmokers each year (Cowley, 1992). Subsequently, numerous states passed "clean indoor air" laws as the health risks associated with secondhand smoke became clear. According to the Centers for Disease Control and Prevention (CDC), 46 percent of Americans show biologic exposure to the deadly toxins found in cigarettes. Even more startling are the millions of children this statistic includes. Recent studies indicate that 21 million or 35 percent of children are exposed to secondhand smoke on a regular basis. Secondhand smoke is especially harmful to young people and is responsible for more than 100,000 lower respiratory tract infections and also is the cause of thousands of hospitalizations each year ("New CDC Report," 2008).

TARGET MARKETS: WOMEN, CHILDREN, AND MINORITIES

The level of cigarette advertising is among the highest of any consumer item. In 2005, tobacco companies spent $13.4 billion to market their products in the United States alone, according to

the Federal Trade Commission (FTC) ("Tobacco Marketing," 2008). Although both the level of cigarette advertising and the social costs of cigarette use are substantial and well documented, the link between advertising and usage remains a controversial subject, and the research on the subject has produced mixed results (Saffer, 1998). Cigarette companies have long denied that their commercial messages encourage consumers to smoke. Instead the industry "insists that its ads are intended to persuade existing smokers to switch brands." However, there are no more than a half-dozen major cigarette manufacturers in the United States, and two of those (Philip Morris and RJR Nabisco) control nearly 75 percent of the market. So if a smoker changes brands, there is a good chance he or she will switch to another brand of the same parent company (Jacobson & Mazur, 1995).

The primary objective of all advertising, in fact, is market expansion. And it makes sense that if you market a product that kills your customers, you must recruit new ones. Public health advocates have long argued that advertising increases total consumption, and in particular consumption among women, children and teens, and minorities. Some years ago a model named David Goerlitz, during a photo shoot for a Winston ad, asked a group of R. J. Reynolds executives if any of them smoked. One of them replied: "Are you kidding? We reserve that right for the poor, the young, the black and the stupid."

The basic rationale behind the market segmentation strategy is "that a variety of marketing programs (unique combinations of products, advertising, packages, pricing, distribution, etc.) each designed to better match the psychology and interests of a separable segment, will ultimately generate more sales and profit than would a single undifferentiated marketing program, so-called mass marketing. But selective targeting can be benign or beneficial, only if the product is. If the product is unwholesome, even addictive and lethal, segmentation's efficiency delivers more death and disease, not more benefits, and provides a disservice, not a service" (Pollay, Lee, & Carter-Whitney, 1992, p. 45). It is death and disease

Figure 9.1: Lucky Strike's slogan "Reach for a Lucky Instead of a Sweet" appealed to women

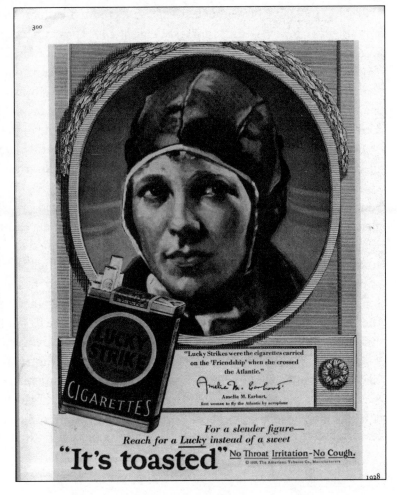

that have been delivered via the target marketing efforts directed at females, young people, blacks, Hispanics, and Asians.

Targeting Women

At the beginning of the twentieth century, society did not consider smoking an acceptable social practice for women. But during World War I, the number of women who took up smoking increased as cigarette tobacco became milder and cigarettes made it easier to smoke without "rolling one's own." Cigarette manufacturers realized the potential of this untapped market. "One 1912 ad for Velvet Tobacco showed a respectable woman sitting with a man who was smoking, 'I wish I were a man,' she mused, suggesting that she might like to smoke. Some ads hinted at this daring idea, while others took a more direct approach. In 1926 the Newell-Emmett agency daringly presented a poster showing a romantic moonlit seaside scene and a gentleman lighting his Chesterfield with a woman perched beside him saying, 'Blow some my way.' These four words shocked many people. Yet Chesterfield resolutely carried on with its campaign paving the way to the vast women's market" (Sivulka, 1998, p. 167). The Lucky Strike brand, not wanting to miss out on a profitable market segment, began its own aggressive advertising campaign. Early on, the cigarette was associated with women's liberation. In 1929 the American Tobacco Company orchestrated a parade of cigarette-puffing feminists down Fifth Avenue in New York to protest the taboo on women smoking in public (Ewen, 1976, p. 160). One early Lucky Strike campaign ("Reach for a Lucky instead of a sweet") was credited with creating more women smokers than any other single advertising effort (see Figure 9.1). The connection between smoking and weight loss was firmly established in women's minds, even though the FTC ruled in 1930 that tobacco firms must stop claiming that smoking cigarettes could control people's weight.

In the mid-1930s, the ratio of male to female smokers was three to one. By 1985, men and women smoked in roughly equal numbers (Warner, 1995, pp. 4–5). Today, female smokers in the United States will soon exceed male smokers, and women younger than 25 already smoke more than men. Apparently, more men are quitting smoking and fewer take up the habit in the first place. Worse still, research suggests that women have up to triple the chance of developing lung cancer, given similar smoking habits as men (Rosenberg, 1997). The rate of lung cancer deaths (deaths per 100,000 population) among women increased 72 percent between 1979 and 1994. Because scientists estimate that 85 percent of all lung cancer deaths are directly due to smoking, the rise in women's lung cancer and associated deaths is tied to the shift in marketing cigarettes to women in the 1960s and 1970s. During that time, Virginia Slims, a cigarette specifically aimed at women, hit the market. Revitalizing the association with the feminist movement, the campaign employed the theme "You've come a long way, baby." The message of each and every version of the Virginia Slims campaign is clear—women are now free to smoke when and where they please. Interestingly enough, the same campaign also makes a barely veiled reference to tobacco's reputation as an appetite suppressant, implicit in the use of "Slims" and "Superslims" in the product name. Needless to say, the models portrayed in the commercial messages are all quite slender.

At about the same time the Virginia Slims campaign was introduced, tobacco companies also began sponsoring women's sporting events. "By aligning themselves with prime examples of aerobic health, tobacco companies subliminally refute the health hazards of smoking. The Virginia Slims Tennis logo, for instance, depicts a woman holding a tennis racket in one hand and a cigarette in the other" (Jacobson & Mazur, 1995, p. 154). According to the American Lung

Association, smoking rates more than doubled among 12-year-old girls from 1967 to 1973 during the marketing campaign. Lung cancer's latency period (the time it takes to develop cancer from exposure to smoking) is typically 30 to 50 years. So the bulge in women's lung cancer cases reflects the surge in smoking long ago and portends a continuing rise if the rate of women who quit smoking does not increase.

According to World Health Organization (WHO) data, about 12 percent of women worldwide smoke, and that figure is expected to rise to 20 percent by 2025 (Zuckerbrod, 2006). Aggressive tobacco company marketing is nudging up the female smoking rates in both developed as well as developing countries. In the United States, a slew of cigarettes have been introduced to appeal to women—including Eve, Misty, and Capri. R. J. Reynolds, in an attempt to compete with the two brands that do particularly well with women—Virginia Slims and Newport—recently introduced Camel No. 9. The name evokes the women's fragrance Chanel No. 9, as well as a song about romance, "Love Potion No. 9." The cigarettes are packaged in an ebony box with a tiny pink camel and pink-foil package lining. The slogan reads: "Light and luscious." RJR promoted the brand by giving away packs at nightclubs, distributing cents-off coupons, and running ads in magazines, including *Cosmopolitan, Flaunt, Glamour, Vogue* and *W.* Cheryl Healton, president and chief executive of the American Legacy Foundation in Washington, is particularly concerned about the ads in *Cosmopolitan* and *Glamour* because both have large numbers of young readers. "That means R. J. Reynolds is looking for initiation, appealing to young girls to up their market share," she has said (Elliott, 2007).

In many less developed markets, ads for cigarettes also feature slender, attractive, modern-looking women smoking. Benson & Hedges promotes its Superslims to Hispanic women in *Elle* magazine's Mexico edition (see Figure 9.2). Lorraine Greaves, executive director of the British Columbia Center of Excellence for Women's Health, notes that ad campaigns geared toward women overseas have "served to change cultural beliefs about women and smoking." For example, in

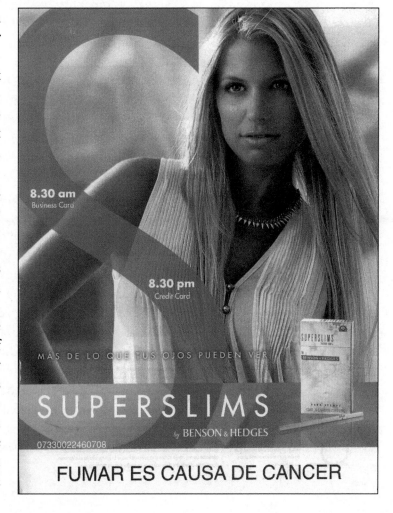

Figure 9.2: Benson & Hedges ad for Superslims targeting women in Mexico

Turkey, where it used to be quite unacceptable for a woman to be seen with a cigarette, the rate of smoking among women is creeping toward that of men (Zuckerbrod, 2006).

Targeting Children

Many proponents of tobacco advertising bans have argued that commercial messages encourage young people to smoke. Since smoking kills people, each year tobacco companies have to replace two million American smokers. Children are an ideal audience because research has shown that nearly 90 percent of adult smokers began smoking while in their teens. The average young smoker begins at age 13 and becomes a daily smoker by 14. Every day more than 4,000 U.S. adolescents smoke their first cigarette, and 1,000 of them will become regular smokers. One-third of them will die a premature death as a result (Steenhuysen, 2008). While the tobacco industry has long denied the assertion, even advertising executives believe that tobacco firms target children. In one survey, about two-thirds of the 300 advertising executives questioned said they believed the goal of cigarette advertising is to target teenagers. And 82 percent of those surveyed think teenagers are getting the smoking message (Parker-Pope, 1996). Over 85 percent of all young people who smoke prefer Marlboros, Camels, or Newports—the three most heavily advertised brands. And company documents revealed that cigarette firms have a long history of targeting teens and children. R. J. Reynolds memos show that the No. 2 cigarette maker targeted teens as young as 13 in a plan to steal their competitors' youngest smokers. Reynolds even created a brand aimed at young boys. Code-named Project LF, a 1987 memo stamped "RJR Secret" says the company created a "Wider-circumference non-menthol cigarette targeted at young adult male smokers—primarily 13- to 24-year-old male Marlboro smokers" (Neergaard, 1999).

Other RJR papers illustrate that the highly popular Joe Camel campaign targeted teens despite the firm's repeated denials. A 1973 marketing memo said that to "help lure younger smokers away from Philip Morris' Marlboros, the leading teen brand, comic-strip-style copy might get a much higher readership among young people than any other type of copy." Shortly thereafter the Joe Camel cartoon debuted in France. It appeared in the United States in 1987. RJR provided the papers to California attorneys as part of a $10 million settlement of lawsuits brought by San Francisco and other communities that accused Joe Camel of targeting teens (Neergaard, 1999). Prior to 1988, only 1 percent of smokers under age 18 smoked Camel cigarettes. This figure jumped to 33 percent with the introduction of Joe Camel, and the cigarette subsequently became the No. 2 brand among teens. In 1997, under pressure from a variety of groups, R. J. Reynolds finally agreed to discontinue the use of Joe Camel as a spokesperson for its brand in the United States.

In a U.S. study examining awareness of product logos among young children 3 to 8 years old, 82 percent recognized Dr. Seuss's Cat in the Hat and the Energizer Bunny, while a surprising 73 percent recognized the Joe Camel logo and 27 percent recognized the Marlboro logo (Henke, 1995). It is interesting to note, however, that when asked whether "cigarettes were good or bad for you," 97 percent of the children reported that cigarettes were bad for you. The children were also asked to identify the appropriate target audience for cigarettes. A majority of the youngsters reported that cigarettes are for adults, and 27 percent volunteered the response that cigarettes are appropriate for "nobody." These findings suggest that for young children, recognition of brand advertising symbols does not necessarily result in a positive effect for a product category or belief in the appropriateness of the product for children.

Yet, a longitudinal investigation by the Cancer Prevention and Control Program at the University of California at San Diego directly links tobacco promotions and advertising to a progression toward smoking in teens who a few years earlier had no intention of starting to smoke. In 1996 the researchers re-interviewed over 1,700 California teenagers who just three years earlier had indicated they were resolved against smoking. The results found that those teens who in 1993 had a cigarette promotional item or wanted one, or who had a favorite tobacco advertisement, were three times more likely to have thought about or tried smoking or actually become a smoker than the other groups. Promotional items the study found to be influential to the onset of smoking included products available through coupons inside cigarette packages, such as T-shirts, sunglasses, towels, mugs, coolers, headphones, and inflatable rafts. Interestingly enough, the researchers found no correlation between a teen's initial smoking and whether that teen had friends or family members who smoked (Clark, 1998). A World Health Organization global study of 13–15-year-olds found that more than 55 percent of them reported seeing cigarette ads on billboards during the previous month, and 20 percent owned an item featuring a cigarette brand logo (WHO, 2008). Most recently, *The Role of the Media in Promoting and Reducing Tobacco Use,* a 684-page review of more than 1,000 scientific studies, presented the definitive conclusion that tobacco advertising and promotion are causally related to increased tobacco use among youth ("Tobacco Marketing," 2008).

And when cigarette marketers are not crafting advertising and promotional campaigns to appeal to kids, they are developing products that do. Until they were discouraged from marketing them in 2007, R. J. Reynolds was promoting youth-enticing fruit-flavored cigarettes. Attorneys general of 40 states agreed that in selling candy-flavored cigarettes, R. J. Reynolds was violating its 1998 agreement not to market to kids. The company agreed to stop marketing those products under candy, fruit ,and alcoholic beverage names such as "Midnight Berry," "Twista Lime," and "Winter Mocha Mint." A new Harvard study claims that in recent years, the tobacco industry has manipulated menthol levels in cigarettes to hook youngsters and maintain loyalty among smoking adults. Young people, the study notes, tolerate menthol cigarettes better than harsher nonmenthol cigarettes. In low-level menthol cigarettes, the menthol primarily masks harshness, making it easier to begin smoking. Indeed, 44 percent of smokers age 12–17 prefer menthol cigarettes. As smokers become accustomed to menthol, they prefer stronger menthol sensations. The study contends that Philip Morris employed a two-pronged strategy to compete better in the menthol market. The company introduced a new low-level menthol brand, Marlboro Milds, to compete with cigarettes like Newport, which contains a low level of menthol. At the same time, Philip Morris raised the menthol levels in its Marlboro Menthol brand by 25 percent to appeal to adult smokers. Since then, Philip Morris's share of the menthol market has increased, and it is currently the second-largest seller of menthol cigarettes in the United States. Menthol cigarettes currently make up about 28 percent of the $70 billion cigarette industry in America (Saul, 2008).

Targeting Minorities

The targeting of ethnic groups by cigarette manufacturers is not a new phenomenon. Pollay, Lee, and Carter-Whitney (1992) document that racial segmentation by the cigarette industry was quite well established by the 1950s. Pollay noted that "this segregation involved more than buying space in black magazines and appealing to ethnic pride with black models. Blacks were first subject to less and then to more advertising than whites. Endorsements from athletes were

five times more likely to be employed for black audiences than for white audiences, and blacks were not offered filtered brands until years after whites. In short, the cigarette industry treated the black and white markets separately, but not equally" (p. 45).

Tobacco firms have been accused of pouring millions of dollars over the decades into creating addicts among ethnic communities—and apparently they have been quite successful. Overall, about 20 percent of the U.S. population smokes (Meller, 2001). While only about 16 percent of the overall Asian American population smokes, rates are significantly higher among Vietnamese Americans (26.5 percent) and Korean Americans (27.2 percent). Among Hispanic Americans, 23 percent of the population smokes. This segment is considered particularly appealing to the tobacco industry because Hispanics tend to be much more brand-loyal than their non-Hispanic white counterparts. Among African Americans the figure stands at 25.7 percent (30 percent among males and 22 percent among females). African Americans currently bear the greatest health burden. More than 45,000 African Americans die each year from smoking-related illnesses, giving them a higher death rate due to lung cancer than any other race (CDC, 1998). The highest incidence of smoking is among the American Indian/Alaska Native population, where fully 40 percent smoke (Carmona et al., 2004).

Evidence of cigarette manufacturers' particularly aggressive marketing efforts, some critics say, are minority neighborhoods plastered with countless tobacco-touting billboards as well as minority publications filled with cigarette ads. According to one study, in predominantly Asian neighborhoods, tobacco billboards are 17 percent more prevalent than in predominantly white neighborhoods (Warmbrunn, 1998). In many Latino neighborhoods, 80 to 90 percent of billboard advertising is for tobacco or alcohol (Chelala, 1998). And, a recent study revealed the concentration of pro-smoking signage is approximately 70 percent higher in African American neighborhoods. Results revealed that there are about 2.6 times as many advertisements per person in African American areas as compared to Caucasian areas (Todd, 2007). According to a review by the American Cancer Society, the leading advertisers in several black-oriented magazines are cigarette makers. Overall, black-owned and black-oriented magazines receive proportionately more revenues from cigarette advertising than do other consumer magazines. In addition, stronger, mentholated brands are more commonly advertised in black-oriented than in white-oriented magazines. Indeed, expenditures for magazine advertising of mentholated cigarettes increased from 13 percent of the total ad expenditures in 1998 to 49 percent in 2005 (Connolly, 2007).

Studies have shown that over 70 percent of black smokers prefer menthol cigarettes (Hocker, 2008). Researchers say menthol causes smokers to inhale more deeply and is associated with higher carbon monoxide concentrations, and menthol cigarettes create more cancer-causing agents than non-menthol cigarettes. In 1989 RJR Nabisco launched Uptown, a menthol cigarette designed to appeal to black smokers. But when RJR test-marketed Uptown in Philadelphia, it drew bitter protests from the National Association of African Americans for Positive Imagery (NAAAPI) as well as then Secretary of Health and Human Services Louis Sullivan, who accused the tobacco manufacturer of promoting a "culture of cancer among blacks." Ultimately, RJR Nabisco was forced to scrap its plan to introduce Uptown, at an estimated loss of nearly $10 million. Currently, the three most popular brands among black smokers are Newport, Kool, and Salem, all menthol cigarettes. A quick look at Kool's Web site reveals the "DJ Downloads" section, which features video clips from up-and-coming African American DJs. The "Lounge" section of the site features the "Be True Video," a 60-second montage laden with black faces,

language, and imagery. "It's a way of being," the ad begins, showing a black man and woman, with half of a white woman's head in the background. On an image of another black man holding both a trumpet and a cigarette in one hand come the worlds "It's about uptown attitude." The photo then switches to another black man and a woman—he's leaning into her and the copy reads "mixed with a downtown vibe." The ad continues, "It's about pursuing your ambitions and staying connected to your roots," and then appears a photo of a black man wearing headphones and standing at turntables. Jazz and hip-hop imagery is pervasive, with trumpets, keyboards, and guitars throughout. Of the 13 individuals whose faces appear in the ad, eight are black, two are white, one is Asian, and two are ambiguous (Barg, 2007). See Figure 9.3 for a print version of the "Be Cool" ad campaign).

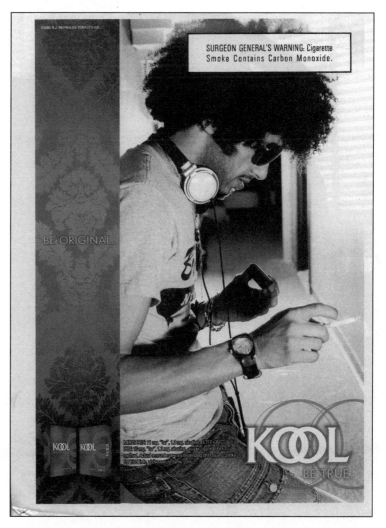

Figure 9.3: Kool menthol-flavored cigarettes appeal to African American smokers

To lure black smokers, R. J. Reynolds sponsors concerts, tours, and parties. In 2006 the cigarette manufacturer sponsored the Kool New Jazz Philosophy Tour, and in 2007 the Kool South Beach Bash in Miami. And Kool is dominant in the bar scene as well. At club events, lights flash Kool's colors—green and blue. Everyone in attendance willing to give Kool reps (dressed in skimpy green and blue outfits) their name and address receives two free packs of cigarettes. Free drinks are available at the Kool stand. Besides seven-foot Kool banners, there is a video screen showing Kool ads, a Kool table with new flavors of cigarettes on it, Kool-logo drink napkins, Kool logos on the straw holders in the bar, and a Kool logo taking up the entire display of the cigarette machine by the front door, with more than half the slots in the machine containing Kool cigarettes (Barg, 2007).

Many cigarette ads aimed at ethnic communities are printed in the native language (Vietnamese, Chinese, or Spanish)—with the exception of the surgeon general's warning, which is printed in English. The discrepancy seems too glaring to be merely an oversight. If consumers are only literate in one language, they may well be unaware of the dangers associated with smoking. A campaign

to change these ads was spearheaded by the San Francisco Vietnamese American community in large measure because of the high incidence of smokers among male Vietnamese—estimated to be 35 percent, about 1.5 times that of the general population. The result: the Federal Trade Commission issued a policy amendment in 1998 requiring advertising disclosures, such as the surgeon general's warning, to be in the language of the ad's target audience (Fernandez, 1998).

When the tobacco firms are not creating high-octane cigarettes and persuasive advertising messages to sway the ethnic audience, they are wooing minority groups via generous donations. RJR Nabisco doled out more than $800,000 over two years to minority-run groups, from the Congressional Hispanic Caucus to the Korean American Liquor Market Association. Philip Morris has been one of the biggest contributors to the Congressional Black Caucus's nonprofit foundation, donating amounts in excess of $250,000 (Hocker, 2008). In addition, the National Urban League, the United Negro College Fund, and the National Association for the Advancement of Colored People (NAACP) have all received money from the cigarette manufacturers. Tobacco companies also make a practice of buying goodwill by sponsoring inner-city youth groups and backing ethnic festivals.

INCREASING REGULATION OF CIGARETTE ADVERTISING

Like alcohol, tobacco is a product that can legally be sold in nearly every country in the world. Nonetheless, the marketing and advertising of tobacco face increasingly severe restrictions, particularly in the United States and other Western countries.

United States

In 1994, the heads of seven top U.S. tobacco companies swore before Congress that nicotine was not addictive. This blatant lie ushered in a wave of litigation on the addictive nature of tobacco products. In November 1998, tobacco producers and 46 states came to a $246 billion settlement to resolve state claims for health costs related to smoking. As part of the settlement, stricter guidelines related to the marketing of cigarettes were imposed. Gone were outdoor billboard messages; advertisements on the sides of buses, in subways, and on top of taxis; stadium advertising; branded merchandise such as caps and T-shirts; payment for product placement in movies and on TV; and point-of-sale advertising excessive in size.

In 1999, representatives of the tobacco firms recanted their statements and finally admitted that nicotine is indeed addictive. And in late 1999, the U.S. Justice Department filed a sweeping civil lawsuit against the nation's largest tobacco companies. It sought to force cigarette makers to give up profits that were "ill-gotten" through what it said were efforts to conceal the dangers of smoking that go back to the 1950s. The suit alleged that beginning in 1954 tobacco executives met at the Plaza Hotel in New York to plan a long-term campaign to conceal the health risks of smoking. The lawsuit accused the tobacco industry of promoting biased research, wrongly asserting that nicotine was not addictive, and falsely denying that they were targeting their products to children. The federal suit did not specify how much would be sought in damages.

The lawsuit sought to recover billions of dollars the federal government spent on smoking-related health care for elderly Medicare patients, military veterans, and federal employees, expenses not covered by the settlement that the industry reached in 1998. The defendants included Philip Morris, The Liggett Group, American Tobacco, British-American Tobacco, R. J. Reynolds Tobacco,

Brown & Williamson Tobacco, and Lorillard Tobacco. Along with these companies, which sell 98 percent of the cigarettes in the United States, the suit also named two industry groups, the Council for Tobacco Research USA and the Tobacco Institute (*New York Times* News Service, 1999). The Clinton administration and the Food and Drug Administration (FDA) proposed very strict regulations regarding the promotion and advertising of tobacco, including a ban on magazine advertisements that have a 15 percent or greater readership among those under 18, a ban on billboard ads within 1,000 feet of a school or playground, a ban on the sponsorship of sporting or entertainment events as well as a ban on cigarette machines in stores and restaurants. The Bush White House inherited the lawsuit from the previous administration and proposed even more stringent regulation, including banning terms such as "low tar" and "light," requiring that health warnings cover 50 percent of cigarette packs and advertisements, in addition to eliminating cigarette vending machines (Zuckerbrod, 2002).

With the number of promotional venues rapidly shrinking, U.S. manufacturers have relied heavily on the print media. However, both magazines and newspapers have begun to turn away tobacco dollars. *The New Yorker, Good Housekeeping, Seventeen,* and *Reader's Digest* have all voluntarily banned tobacco advertising. The *New York Times* published its last cigarette advertisement on April 26, 1999. While cigarette advertising in 1998 accounted for less than 1 percent of the *Times*'s advertising revenue, it nonetheless came to nearly $10 million—not a sum to be given up lightly. A spokeswoman for the *New York Times* said, "We don't want to expose our readers to advertising that may be dangerous to their health." She pointed out that the *Times* does not accept ads for handguns, mace, tear gas, or other legal but dangerous products. Other newspapers have made the same decision, including the *Seattle Times, The Christian Science Monitor* and the *Desert News* of Salt Lake City. But the *Times*'s spokeswoman recognized that "most American newspaper publishers contend that it is their duty to maintain a free flow of information that requires they adopt as few restrictions as possible on the advertising of legal products (Profitt, 1999).

With increased scrutiny, some cigarette manufacturers have even voluntarily pulled campaigns from print media. In 2005, for the first time since Philip Morris created the Marlboro Man in 1955, no Marlboro ads ran in U.S. consumer magazines or newspapers (Johnson, 2007). After a series of public attacks from some members of Congress (specifically regarding the promotion of Camel No. 9 in women's magazines such as *Cosmopolitan* and *Us Weekly*), R. J. Reynolds decided not to advertise its brands in newspapers or consumer magazines during 2008. RJR spokesperson Jan Smith called it a "business decision" and said that the 2008 marketing strategy would focus on three areas: age-restricted, adult-only facilities such as bars and clubs, direct communication with age-verified smokers, and retail stores where cigarettes are sold (Ives & York, 2007).

Tobacco firms in the U.S are likely to face increased regulation yet again. Many proponents of tobacco regulation have urged the government to grant the FDA authority over tobacco products. On April 2, 2009, antismoking forces won a long-awaited victory as the House passed legislation (voting 298–112) to give the federal government key controls over the tobacco industry for the first time. The measure gives the FDA broad authority to regulate—but not ban—cigarettes and other tobacco products. The Obama White House supports the legislation, a shift from the Bush administration, which had threatened to veto a House-passed measure in 2008. The measure will allow the agency to regulate the contents of tobacco products, make ingredients public, prohibit flavoring, require much larger warning labels, and strictly control or prohibit market-

ing campaigns, especially those geared toward children. Most important, it grants the FDA the authority to impose additional marketing restrictions and counter tobacco companies' efforts to get around specific restrictions (Werner, 2009).

Canada

Canada was the first country to put warning illustrations on cigarette packages. Government research found that warnings with pictures were 60 times as likely to stop or prevent smoking as were words alone. According to statistics, more than 70 percent of adults and nearly 90 percent of youth in Canada, where warnings came into force in 2000, believe the images are effective. While such graphic warnings on packaging appear successful in deterring tobacco use, only 15 countries—representing just 6 percent of the world's population—mandate pictorial warnings (Ramakant, 2008). Canadian legislation also bans tobacco advertising on broadcasts, billboards, street kiosks, bus panels, and shop displays and imposes restrictions on promotions in mailings and magazines. A complete ban on tobacco companies' sponsorship of sporting and other events went into effect in 2003.

Canada has also taken aim at tobacco promotions at the retail level. Tobacco displays that were once front and center at convenience stores are now banned in almost every province and territory in Canada—hidden from view with blank flaps, cupboard doors, or even shower curtains. Alberta's tobacco display ban went into effect on July 1, 2008. Ontario, Quebec, and British Columbia introduced similar laws earlier that year. New Brunswick and the Yukon Territory plan to introduce bans in 2009. Prior to the display ban, manufacturers paid retailers a handsome fee to ensure their brands received a prime spot on the wall. The various bans will mean "millions lost to small business," said Dave Bryans, president of the Canadian Convenience Store Association (Lunau, 2008). He predicted 30 percent of convenience stores will go under within three years just because of the ban. And yet, even in provinces where display bans have been in place for some time, tobacco companies' payments to retailers have gone up. Saskatchewan banned cigarette displays in 2002; that year tobacco manufacturers paid $879,176 to the province's retailers. By 2007, payments had grown to $1.85 million. The increase in Manitoba, where the ban took effect in 2004, is even more dramatic, jumping from $2.2 million that year to $4.9 million in 2007. In 2007, across Canada, tobacco companies paid out $108 million to retailers—an average of about $3,500 to each of Canada's 31,000 convenience stores (Lunau, 2008).

What could these companies possibly be paying for? Quite a lot, it turns out. Store owners receive money from tobacco firms for everything from sharing information on customer purchases to stocking certain brands on prime shelf space, even when it is behind a barrier. Retailers are shifting from being simple counter clerks to an essential part of the tobacco industry's marketing strategy. They can provide information and recommendations. Health advocates find the shopkeepers' expanded role troubling. Indeed, many are concerned that tobacco companies might start paying clerks to push their brands, thereby getting around traditional restrictions on advertising by simply passing on verbal messages of which there is no record (Lunau, 2008). Canada's Tobacco Act and regulations, the World Health Organization notes, are being used as a model in some 40 other countries worldwide.

European Union

Europe's culture of smoking appears to linger, despite increasingly strict regulations. Overall, smokers account for 30 percent of all adults in the European Union (EU), whereas the figure in the United States stands at 20 percent (Meller, 2001). Smoking rates vary rather significantly from one European country to the next—ranging from a high of 48.2 percent in Greece to just over 21 percent in Belgium (see Table 9.1) (Passariello, 2009). But smoking has become a heavy burden for Europe's state-run social-welfare systems, with smoking-related diseases costing well over $100 billion annually. And, each year some 500,000 Europeans die prematurely from smoking (Passariello, 2009).

Table 9.1: Percentage of People Ages 15 and Older Who Smoke Daily in Selected EU Countries

COUNTRY	PERCENTAGE
Greece	48.2
Austria	40.7
Spain	29.9
United Kingdom	28.4
France	27.1
Germany	26.7
Italy	22.2
Belgium	21.6

Source: World Health Organization (as cited in Passariello, 2009).

David Byrne, health commissioner for the European Union, is on a mission to lower Western Europe's average smoking rate to that of the United States (Alvarez, 2003). The EU passed a law banning tobacco advertising from radio, television, and print as of 2005 (something that several European countries had already done). Tobacco sponsorships of sporting events, like Formula One racing, were also outlawed. Tobacco companies could no longer call their cigarettes "light" or "mild," because all cigarettes are considered deadly. Cigarette manufacturers were mandated to reduce tar levels as well. All over Western Europe, black and white warnings—required by law—appeared on cigarette packs. The blunt messages, which cover 30 to 40 percent of the package read, "Smoking Kills" or "Smoking May Cause a Slow and Painful Death."

However, not all laws are harmonized throughout the EU. Consider the issue of public smoking. Led by examples set by Ireland and Norway, many EU countries have passed stricter laws banning smoking in public places. Currently two-thirds of European countries have bans or restrictions on smoking in most indoor public places ("Smoking Levels in the WHO European Region Have Stabilized" 2008). However, each country is allowed to set its own policy. Thus, in Portugal the ban only extends to smoking in public buildings (which does not include hotels) and public transport when the journey lasts more than an hour. In Germany, their ban covers public transport (with the exception of mainline trains), cinemas, theaters, and restaurants—with the exception of single-room pubs. And while Greece has passed a law that makes government buildings smoke free, bars and restaurants need only provide a nonsmoking section. In Austria, small bars and restaurants can choose if they want to be nonsmoking. Larger establishments have to dedicate at least 50 percent of their space to a separate nonsmoking area.

Of course, passing a law is one thing, enforcing it is something else entirely. For example, restaurants in both France and Greece are supposed to provide nonsmoking areas, but they almost never do. In Belgium, smoking sections in restaurants and train stations are regularly ignored. In some southern European countries, such as Italy, smoking in front of "no smoking" signs is especially tantalizing to tobacco consumers. However, in Ireland, so-called pub police troll the watering holes, and lawbreakers are subject to fines of about $3,000 for each offense. Clearly, national laws differ widely throughout the European Union.

Britain is the first EU country to mandate that the dangers of smoking be highlighted with graphic images printed on all tobacco products by the end of 2009. Images will include a diseased lung (see Figure 9.4 for an example of such a warning on a Marlboro cigarette package sold in the U.K.), a chest cut open for heart surgery, and a large tumor on a man's neck. Alan Johnson, the Westminster Health Secretary, is confident the 15 graphic images, chosen following a public

Figure 9.4: Graphic warning on a Marlboro cigarette package sold in the United Kingdom

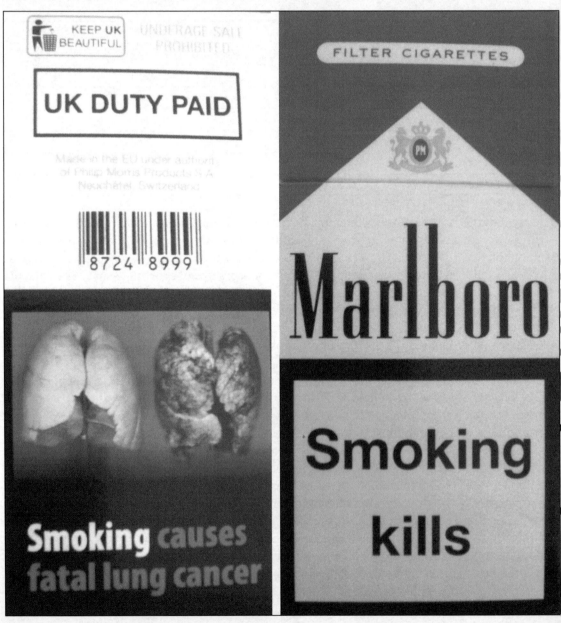

consultation, will have a significant impact because the effectiveness of written warnings alone on cigarette packages has diminished. Cancer researchers estimate that, in Britain, between 5,000 and 10,000 people will stop smoking as a result of the graphics—saving around 2,500 lives per year (Chiesa, 2007).

TOBACCO FIRMS ARE FIGHTING BACK

In many instances, increasing regulation of tobacco products has proven counterproductive. It has forced cigarette marketers into becoming more creative and innovative (some would argue, conniving) in their approaches to reach target audiences. These approaches include the types of products offered, the media employed to carry their promotional messages to smokers, as well as ever-more innovative promotional tactics—such as brand stretching. Consumers can now enjoy an ever-increasing variety of smokeless tobacco products, can order their smokes online, and sport nontobacco products branded with their favorite logo.

Smokeless Tobacco

With recent legislation around the globe banning cigarette smoking from most workplaces, restaurants, and even bars, many smokers are left feeling rather ostracized. In response, tobacco manufacturers are offering consumers another option for using tobacco when and where they are not permitted to smoke. There has been a proliferation of smokeless tobacco products (chewing tobacco, snuff, and tobacco packets) introduced to the marketplace. R. J. Reynolds Tobacco Company is unveiling three dissolvable smokeless products in its latest bid to make its tobacco more accessible within a society that is clamping down on smoking. The dissolvable products— a pellet (Camel Orbs), a twisted stick the size of a toothpick (Camel Sticks), and a film strip for the tongue (Camel Strips)—debuted at the U.S.'s National Association of Convenience Stores convention in the fall of 2008. The products are made of finely milled tobacco that come in the flavor styles of fresh and mellow. The products last from 2 to 3 minutes for the

Figure 9.5: R. J. Reynolds Tobacco Company recently expanded its test of three Camel Snus

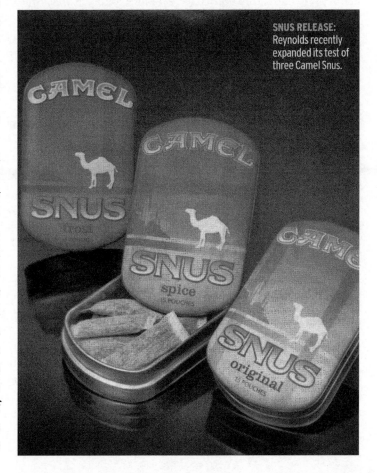

SNUS RELEASE: Reynolds recently expanded its test of three Camel Snus.

strips, 10 to 15 minutes for the orbs, and 20 to 30 minutes for the sticks. Reynolds plans to test the new products in Indianapolis, Indiana; Columbus, Ohio; and Portland, Oregon.

These products join Camel Snus, another smokeless product being touted as the industry's best bet in a post-smoking environment. Camel Snus are a pinch of steam-cured tobacco nestled in a tiny tea bag–like pouch (see Figure 9.5). Unlike traditional fermented dipping tobacco, Snus do not need to be spit out; they simply remain under the upper lip until the nicotine fix kicks in. RJR expanded its three flavors of Camel Snus—original, frost, and spice—into more test markets including New York, Washington, Atlanta, Miami, Chicago, Minneapolis, Seattle, San Francisco, and Los Angeles. Not to be outdone, Philip Morris introduced a line of Marlboro Snus.

The tobacco firms are congratulating themselves for introducing tobacco products less harmful than conventional cigarettes. Indeed, according to the American Cancer Society and the medical journal *The Lancet,* if every smoker in America were to switch to snus, substantial reductions in heart disease and certain cancers would be evident in a decade's time (though the Cancer Society notes on its Web site, "Smokers who delay quitting by using smokeless products while continuing to smoke increase their risk of lung cancer") (Brodesser-Akner, 2008). Others do not see these efforts as so benign. "These products appear to be part of a continuing effort by RJR and other tobacco companies to get around the growing number of smoke-free laws and give smokers new ways to sustain their addiction in places they cannot smoke," notes Matthew Myers, president of the Campaign for Tobacco-Free Kids (Craver, 2008). Young people, in particular, have fewer negative images of the consequences of smokeless tobacco use than they do of cigarette use, even though these products are highly addictive and can lead to cancers of the mouth, pharynx, larynx, and esophagus as well as damaged gum tissue that can lead to a loss of teeth and reduce the ability to taste and smell. A national survey conducted by the Centers for Disease Control and Prevention in 2005 found that 8 percent of high school students had used smokeless tobacco in the previous 30 days. Prevalence was significantly higher among male (13.6 percent) than among female (2.2 percent) students (Morrison, Krugman & Park, 2008). Of the 12 to 14 million smokeless tobacco users in the United, States, one-third are younger than 21 years old and more than half developed their habit before the age of 13 (Nemours Foundation, 2007).

Although the 1998 Master Settlement Agreement (MSA) is more widely known, the Smokeless Tobacco Master Settlement Agreement (STMSA) was passed for the smokeless tobacco industry at the same time as the MSA. This agreement was reached between the state attorneys general and the U.S. Smokeless Tobacco Company, which represents 58 percent of the smokeless tobacco market and was the only smokeless tobacco company to participate. The marketing provisions of the STMSA are similar to those established in the MSA. Nonetheless, it appears that the STMSA has had a limited effect on the advertising of smokeless tobacco products to youth; both before and after the agreement, smokeless tobacco companies have advertised heavily in magazines with high adolescent readership, such as *Motor Trend, Outdoor Life,* and *Road and Track* (Morrison, Krugman, & Park, 2008).

Cigarettes on the Web

A serious concern is whether the Web will turn into a way to evade restrictions on tobacco advertising. Online tobacco sales are not yet a large slice of the industry's overall sales volume nationwide, although a definitive study has yet to be conducted. However, the number of Web vendors of cigarettes rose from 88 in 2000 to 772 in 2006 (Savage, 2007). Among them are Nicotinecity.com, Cigarettesbymail.com, and Halfpricecigarettes.com, which warns that "smoking half price cigarettes will still kill you, you'll just die richer." Some, like Barbi's Butts, are based on Indian reservations. Others are the online outposts of small tobacco retailers and distributors

across the United States and abroad (Fairclough, 2001). Most sites offer cartons of cigarettes for about one-third less than the price at the corner shop. *Tobacco Reporter* magazine estimates that annual Internet sales of cigarettes will reach $10 billion within the next five years (Szynal, 2002).

The proliferation of sites has antismoking activists and government officials worried. They fear that the widespread sale of cheap—and often untaxed—cigarettes will lead to increases in cigarette consumption and eventually cost state governments billions in lost tax revenue. They also say Internet sales could make it easier for kids to get their hands on cigarettes. And they worry that Web sites could turn into a powerful new marketing tool. States are increasingly turning to shippers and delivery services, such as UPS or FedEx, saying they must see to it that certain products, including tobacco, are delivered only to adults. Maine, for example, adopted a law requiring shippers who deliver tobacco products to obtain a signature from an adult and see a government-issued ID card (Savage, 2007). But lawyers for the shippers argue that forcing delivery services to check on who is receiving a particular product disrupts the timely and cost-effective flow of packages to businesses and homes. Many argue that tobacco should be added to the list of items banned from mail delivery. It remains to be seen what role shippers and delivery services will play in the distribution of tobacco products.

Brand Stretching

The inventiveness of tobacco companies in evading restrictions on promotional efforts is remarkable. Tobacco firms are increasingly employing a marketing technique known as "brand stretching"—the use of tobacco brand names on nontobacco products and services. The technique is used to skirt laws designed to protect the public from smoking-related illnesses. Marketers are taking advantage of a European Union Directive issued in 1998, which stated that tobacco names used for other products may continue to be used "provided the appearance is clearly distinct from the use of the tobacco product." For example, Marlboro Classics is a trademark licensed to the Valentino Fashion Group, an Italian company that operates a chain of clothing shops, specializing in western-style jeans, suede jackets, and boots. The line has very successfully, and very obviously, adopted the traditional Americana imagery used in Marlboro's cigarette advertising—reinforcing the link by also using similar fonts and layouts. Marlboro Classics are advertised in mainstream media. According to Ann Hee Kyet, Philip Morris International's corporate affairs manager, "This is not an advertising platform for Philip Morris" (Benitez, 2007). By establishing a separate company, Philip Morris can argue that they no longer have anything whatsoever to do with cigarettes and thus are not covered by the ban. Others have followed suit. Camel cigarettes has introduced a line of boots. Dun-hill claims that its line of branded clothing for upper-middle-class consumers is actually more lucrative than selling cigarettes. However, governments are toughening their stance on so-called brand stretching by requiring all brand extensions to apply for a license to trade. The onus will be on proving such brands are not really "covert" cigarette advertising (Rogers, 1998).

Cigarette advertising has long been illegal in Malaysia, but Benson & Hedges also found brand stretching to be an effective way around this limitation. It re-branded a chain of trendy bistros in the 1990s, and the Benson & Hedges Bistro became one of Kuala Lampur's hot spots. The bistros had the cigarette company's logo emblazoned all over them, and the emphasis was one opulent luxury—from polished hardwood tables and plush armchairs to the Western menu and waiters in starched white linen aprons. The B & H label coffee, the manager proudly informed patrons, is blended in London. Of course, Benson & Hedges coffee could be advertised on television—even in restricted markets ("Mastering the Dark Arts," 2004). Even so, several studies have

shown that people do link advertisements for brand-sharing products with the corresponding cigarette brand (Benitez, 2007). It appears that brand stretching will increasingly be employed by companies as more avenues for promoting tobacco products are closed through legislation.

SELLING CIGARETTES IN DEVELOPING MARKETS

Increased public awareness of the health risks of smoking along with increasing regulation has had an effect. Smoking is down from 42 percent of U.S. adults in 1965 to under 20 percent today (Steenhuysen, 2008). And smoking rates in other industrialized countries are decreasing at a rate of about 1 or 2 percent per year. In contrast, smoking rates in developing countries are on the increase. A recent World Health Organization report documents the shift in tobacco's death toll, with 80 percent of the more than 8 million tobacco-related deaths projected to occur in the developing world by 2030 (WHO, 2008). Table 9.2 presents developing countries with the highest incidence of smoking.

Table 9.2: Smoking Prevalence among Population Aged 15+ (2004)

COUNTRY	HIGHEST % SMOKING	COUNTRY	LOWEST % SMOKING
Turkey	52.5%	Nigeria	14.4%
Slovakia	49.6%	United States	17.7%
Ukraine	45.7%	Sweden	18.0%
Argentina	45.0%	Hong Kong, China	18.2%
Romania	44.3%	Canada	20.5%
China	43.0%	Australia	21.3%
Russia	41.5%	Germany	21.9%
Vietnam	41.5%	Czech Republic	22.1%
Venezuela	40.6%	Italy	22.6%
India	38.0%	New Zealand	22.9%
Indonesia	37.7%	Colombia	23.3%
South Africa	36.5%	Finland	23.6%
Philippines	35.9%	United Kingdom	24.8%
South Korea	34.7%	France	25.4%

Source: World Consumer Lifestyles Databook. (2005). Euromonitor (4th ed.).

Since the early 1980s, U.S. trade officials, with help from the Office of the U.S. Trade Representative, have led a sustained campaign to open markets in a number of countries where health information is scarce. As Table 9.2 above suggests, central and Eastern European markets have proven particularly appealing. Western tobacco companies have made postcommunist economies offers that are difficult to refuse: hundreds of millions of dollars in investments and hundreds of thousands of jobs. U.S. and European tobacco companies now own all of the cigarette factories in the Czech Republic, Hungary, Slovakia, the Baltic States, and Kazakhstan as well as some of the biggest in Poland, Ukraine, and Russia. The World Health Organization estimates

that in 1995 about 17 percent of all deaths in the region were caused by tobacco use. This figure is expected to increase to 22 percent by 2020 (Tkach, 1998).

Demonized as a public health menace in the United States and Western Europe, "Big Tobacco" is nurturing a different reputation in the central and Eastern European markets: local hero. Tobacco money flows to hospitals and schools, student scholarship and athletic programs, and the Red Cross. Police and fire brigades get support too, along with orphanages, senior citizens groups, and the disabled. Many argue that these community sponsorships have helped sway government officials from enacting tough anti-tobacco legislation. In response to the charges, cigarette manufacturers defend the programs as legitimate public relations efforts and note that it is important to shoulder the welfare burden in these markets. "We want to be good corporate citizens and avoid the impression that we are Western occupiers," said a spokesperson for British-American Tobacco (Beck, 1998). And, when Western advertising began to provoke a nationalistic backlash in Russia, a new brand of cigarette appeared. "Peter the Great" cigarettes were designed, according to the inscription on each pack, "for those who believe in the revival of the traditions and grandeur of the Russian lands." And yes, the brand was introduced by R. J. Reynolds ("Selling Death Overseas," 1998).

With a population of 1.3 billion people and about 350 million smokers, China represents another prime target for tobacco firms. While U.S. smokers consume 450 billion cigarettes a year, those in China consume approximately 17 trillion—making China the largest consumer of tobacco in the world. Indeed, Chinese consumers smoke about one-third of the world's cigarettes. About two-thirds of Chinese men and just under 4 percent of Chinese women are smokers. However, the number of women smokers is on the rise, and young Chinese women are increasingly likely to be an important target group for growth for tobacco firms. According to one survey, among Chinese adolescents aged 11–20, almost half (47.8 percent) of males and 12.8 percent of females were experimenting with tobacco. Lung cancer in China has been increasing at a rate of 45 percent per year. Smoking continues to be a major risk factor for mortality in China, with almost 700,000 premature deaths attributed to tobacco use in 2005 (Nainggolan, 2009). It is estimated that if Chinese continue smoking at the rate they do, more than 3 million people a year will die of tobacco-related illnesses. After China was admitted to the World Trade Organization, the tariffs on foreign tobacco were slashed from 40 percent to 10 percent, and the tariffs on foreign cigarettes were reduced from 36 percent to 25 percent (Hays, 2008).

The Chinese National Tobacco Corporation (CNTC) is the world's largest tobacco company. A monopoly, it employs 520,000 workers, produces 500 brands, and has 183 factories. In hopes of expanding production with Western technology, CNTC has set up more than 10 joint ventures with foreign companies such as Philip Morris, R. J. Reynolds, and British-American Tobacco. These three Western tobacco firms alone spend around $20 million annually advertising cigarettes in China (Hays, 2008). Although cigarette advertising in the print and electronic media has been banned since 1995, foreign companies get around the rules by prominently displaying their logos and brand names without showing cigarettes or people smoking.

American cigarettes packing genetically altered, high-nicotine tobacco have been exported to Asia, the Middle East, and other regions. Brown & Williamson began work on the genetically altered, nicotine-rich plant as far back as 1981. The Food and Drug Administration first learned in 1994 that the company had been using the higher nicotine leaf in U.S. cigarettes during 1993 and 1994. After the FDA informed Congress, the tobacco firm assured the governmental agency

it would stop using the leaf. In a deposition for New York State's class-action lawsuit against the major tobacco companies, Roger Black, Brown & Williamson's director of leaf blending, stated that the company quietly resumed the use of high-nicotine tobacco in the U.S. in 1995. The deposition also revealed that Brown & Williamson added twice as much of the nicotine-rich leaf to cigarettes sold overseas as it did to brands sold in the United States (Lewan, 1998).

A Public Citizen's Health Research Group study showed that cigarettes sold in Asia, Africa, South America, and Eastern Europe give consumers less warning about the risks of smoking. The study suggested that non-Americans are being denied vital information available in the United States. While packages in the United States must carry labels warning that cigarette smoke contains carbon monoxide and that smoking can cause cancer and heart and lung disease, the warning label on a package of Marlboro cigarettes sold in an Asian market simply stated, "Be careful not to smoke too much" (Monroe, 1998).

The result of such aggressive marketing tactics—much as in the United States and Western Europe—has been the increased regulation of cigarette advertising in developing markets. For example, Turkey has one of the world's highest smoking rates. Of the country's 71 million citizens, 60 percent of men smoke, as do 20 percent of women. And, 11.7 percent of schoolchildren smoke as well. Indeed, the expression "smoke like a Turk" has even entered the lexicon of several European languages as a way to describe an excessive smoker. However, a far-reaching bill that aims to tackle the country's widespread smoking habit is working its way through the Turkish parliament. The bill would expand an existing—though often poorly enforced—ban on smoking in certain public areas to the private sphere. It would mandate nonsmoking areas in restaurants and coffeehouses, forbid drivers with passengers in their cars from taking a puff, and even outlaw the appearance of cigarettes in films shown on television (smoking censors will have them blurred out). The reforms Turkey plans to implement are an attempt to bring their laws in line with European Union laws (Schleifer, 2008).

The South Korean government imposed very heavy restrictions on cigarette marketing in 1996, prohibiting all electronic and print advertising (except 60 insertions per annum in certain magazines), consumer promotion, sampling, branded sponsorships, and signs outside shops or on shop windows. Such severe restrictions would appear to spell an end to commercial communications on the part of cigarette manufacturers. However, there is no restriction on verbal communication. Taking into consideration the importance of interpersonal relations in Korea along with the fact that Korean consumers appreciate novel ideas, British-American Tobacco, Korea, launched their "Ambassador Program." Professionally attired young adults working in convenience stores were given the assignment to inform consumers attempting to purchase a competitor's product of the British-American line of cigarettes. Since consumers switching to a British-American brand would still have to pay full price, it was not considered a sampling activity. The program turned out to be a great success for British-American Tobacco, with 46 percent of consumers switching to one of their brands. And since the "ambassadors" helped the retailers at the counter during the times they were not busy with the cigarette customers, the shop owners also welcomed the idea of having a free and professional helper.

The World Health Organization is urging developing countries to file lawsuits against multinational tobacco companies. They argue that the tobacco industry must be held accountable at the national and international levels through legislation, litigation, and any other means. WHO believes that litigation may well be the most effective of the tools in controlling cigarette consumption. While filing lawsuits was initially conceived in the United States, it has been carried out against

the tobacco industry in more than a dozen countries. For example, a huge lawsuit is being brought against British-American Tobacco (BAT), Philip Morris, and International Tobacco, Ltd., by the Nigerian government, concerning the way Nigerians were targeted by the cigarette companies in the 1980s and 1990s. The tactics used in that period appear to have been particularly successful. Smoking increased by 50 percent during a single decade in Nigeria. The number of young women smoking increased tenfold. The Nigerian government blames this rapid rise in smoking directly on the tactics of the cigarette companies (Bannatyne, 2008). The Nigerian government accuses the multinational cigarette manufacturers of hooking young Africans on tobacco to replenish a market that is dwindling in the West. The government's case is built around documents it says demonstrate that tobacco firms identified teenagers as a target market in a country where 18 billion cigarettes are sold every year. The government's lawyer for the case, Babatunde Irukera, notes "Documents we have refer to ways of increasing the number of YAUS in Nigeria. We have expert testimony that says YAUS means 'young and underage smokers.'" Among the documents is one from Philip Morris in 1981 that reads, "Today's teenager is tomorrow's potential regular customer, and the overwhelming majority of smokers first begin to smoke while still in their teens." A decade later, BAT said in an internal report on the smoking habits of young Nigerians: "New smokers enter the market at a very early age, in many cases as young as 8 or 9 seems to be quite common." The government contends that these and other documents were the basis of a strategy to target young people with campaigns to glamorize smoking. Akinbode Oluwafemi, of the Coalition Against Tobacco in Nigeria, has said "They target young and underage persons in their marketing and sales strategy. They organize and participate in concerts with recognized pop stars, using advertorials with young beautiful women and rich-looking men, flashy cars and mansions to lure these youth into smoking at a young age so as to make them lifelong smokers. Thus, while there is a significant decline in smoking rates in the United States and Europe, the smoking rates increase by at least 20 percent each year in this country" (McGreal, 2008).

HOW CAN THE PUBLIC BEST BE PROTECTED?

Several investigators have questioned the effectiveness of bans on cigarette advertising. Two older investigations employing international data (Hamilton, 1975; Stewart, 1993) found that bans have no significant effect. The third investigation (Laugesen & Meads, 1991) suggests that newer laws have restricted advertising efforts to a greater degree and have in fact resulted in lower cigarette consumption. Duffy (1996) reviewed several cigarette advertising ban studies using national data and reported little or no effect. The data suggested that advertising bans lead to media substitution, so that a total ban on all forms of cigarette promotion is needed if bans are to be successful. And, as we have seen in the examples cited, wily marketers ultimately find ways around advertising bans.

However, recent research published in the *Journal of Health Economics* suggests that bans on advertising and promotions may have a significantly greater impact in developing versus developed markets. The study showed that the introduction of comprehensive bans on tobacco advertising reduced per capita consumption 23.5 percent in developing countries between 1990 and 2005, while partial bans cut per capita consumption by 13.6 percent. However, the effects were much less dramatic in wealthier markets, where controlling advertising led to a 6.7 percent drop in per capita consumption. It appears that in rich countries a lot of products are advertised heavily and tobacco ads simply get lost among them. Further, the authors of the study suggest,

consumers in wealthier countries are much better informed about the dangers of smoking. In contrast, in developing markets, consumers are far more sensitive to advertising, because tobacco advertising has much greater prominence (Kahn, 2008).

Counteradvertising has been shown to directly influence consumption rates. Studies by Lewit, Coate, and Grossman (1981), Schneider, Klein, & Murphy (1981), and Baltagi and Levin (1986) included measures of counteradvertising, and all conclude that counteradvertising was effective in reducing cigarette consumption. A review by Flay (1987) of 56 counteradvertising campaigns also concluded that counteradvertising is effective in reducing cigarette consumption. The California Department of Health Services waged a highly effective $28 million antismoking campaign in the early 1990s. A study revealed that during the campaign cigarette sales fell at a rate of 164.3 million packs a year—more than triple the annual decline in smoking before the campaign. The researcher who conducted the study estimates that the ads cost the tobacco industry $1.1 billion in lost sales. The success of the campaign has convinced a growing number of health officials and lawmakers that a well-financed advertising offensive that portrays smoking in an unflattering light is the single most effective way to cut down on smoking (Shapiro, 1993).

Another approach to curbing smoking is to raise the price of cigarettes. The Centers for Disease Control and Prevention (CDC) said a statistical analysis of smoking habits since 1976 suggests raising cigarette prices by 50 percent. Such a hike in cigarette prices would cut overall consumption by 12.5 percent, with even greater declines among minorities and young adults. Increasing the price of cigarettes would cut consumption by 7 percent among whites, 16 percent among blacks, and almost 95 percent among Hispanics, according to the CDC's predictions (Tribune News Services, 1998).

This approach has been put to the test in the state of California. In 1988, voters passed Proposition 99 that increased cigarette taxes by 25 cents per pack—and one-quarter of that revenue increase paid for the California Tobacco Control Program (CTCP). The program was initially directed at increasing smoking cessation, but later targeted its efforts at reducing exposure to environmental smoke, reducing youth access to cigarettes, and countering pro-tobacco messages. According to a recent study, it is estimated that smoking rates among Californians dropped by 25 percent due to higher cigarette prices as well as the efforts of the CTCP—translating into more than 50,000 lives that will have been saved by the year 2010 in this state ("California Anti-smoking Laws," 2007).

Currently, 25 states have a state excise tax less than $1.00 per pack of cigarettes. These low-taxing states are mostly concentrated in the southeast and central United States and include several tobacco-growing states. Although 42 states and the District of Columbia have increased their cigarette taxes since 2000, only 23 states have laws requiring that a portion of their excise taxes be dedicated to health, cancer control, or tobacco control programs. In 2008, states allocated a total of $717.2 million for tobacco control programs; however, for every dollar spent on tobacco control, the tobacco industry spends nearly $24 ("Distilled Spirits Council," 2008). Globally, most governments levy a sales tax on tobacco products at the retail level. These taxes can add up to quite a significant amount. For example, Philip Morris has an 18 percent market share globally; it sells 6 of the top 20 cigarette brands in the world, with Marlboro being the most popular brand. Of the $67 billion Philip Morris collected in 2006 from the sale of tobacco products worldwide, about $31 million—or 46 percent—went toward excise taxes (Lo, 2007).

But perhaps the most effective approach to curbing cigarette consumption is a multipronged one. The Framework Convention on Tobacco Control (FCTC), the World Health Organization's

international treaty, was adopted in 2005 with the goal of reducing the harm caused by tobacco products. To date, 168 countries have signed the treaty ("The Perverse Prosperity," 2008). Countries that ratify the treaty are required to implement scientifically proven measures to reduce tobacco use and its horrific toll on public health. In February 2008 WHO released a report that recommended a comprehensive package of six effective tobacco control policies—dubbed MPOWER— that have demonstrated results in helping countries to stop the diseases, deaths, and economic damages caused by tobacco use. "M" stands for "monitor" tobacco use and prevention policies. "P" stands for "protect" people from tobacco smoke. "O" stands for "offer" help to quit tobacco use. "W" stands for "warn" about the dangers of tobacco use. "E" stands for "enforce" bans on tobacco advertising, promotion, and sponsorship. And, "R" stands for "raise" taxes on tobacco (Ramakant, 2008). The WHO reports that not even a single country implements all the recommended tobacco control efforts, and that 80 percent of countries do not fully implement even one of the recommendations (WHO, 2008). Tobacco killed an estimated 100 million people during the twentieth century—and could kill 1 billion if nothing is done to restrain tobacco companies from pushing their products (Anonymous, 2008).

ALCOHOL ADVERTISING

Similarities are evident in the controversies that surround alcohol and tobacco advertising. Consumption of both alcoholic beverages and cigarettes has been linked with serious public health concerns. Alcohol is considered one of the United States' most serious health problems. Its complications kill 100,000 Americans annually. It can kill outright or lead to cancers, cirrhosis of the liver, heart disease, and fetal alcohol syndrome. Research shows that alcohol abuse literally changes the structure of the brain—programming users to return again and again to the source of pleasure even though most of them know it will ultimately harm them. Some 15 million Americans abuse alcohol, according to federal studies. Worse, as many as 40 million more may be at risk of becoming problem drinkers. Alcohol is the cause of or a contributing factor in almost every community and family tragedy. More than 100,000 U.S. deaths are caused by excessive alcohol consumption each year (Harwood, 2000). Alcoholism increases a drinker's odds of developing cancer of the throat, larynx, colon, kidneys, rectum, and esophagus. It also contributes to immune system irregularities and brain damage. During 2004, nearly 17,000 deaths occurred as a result of alcohol-related motor vehicle crashes. This represents approximately 39 percent of all traffic fatalities and amounts to one alcohol-related death every 31 minutes. Alcohol-related car crashes are the number one killer of teens. And, alcohol use is also associated with homicides, suicides, and drownings—the next three leading causes of death among youth (Center for Substance Abuse Prevention, 1993). It is estimated that alcohol abuse costs the United States some $175 billion a year—significantly more than the $114 billion annually for other drug problems or the $137 billion for smoking (Rice, 1999).

Interestingly enough, the two industries use highly similar defenses. Alcoholic beverage companies, like tobacco firms, argue that until wine, beer, or liquor products are ruled illegal, they should be legally permitted to promote their sale via advertising campaigns. The alcoholic beverages industry has the support of advertising organizations such as the American Association of Advertising Agencies, whose president argued, "If the product is legal, then both its producers and its legal users are entitled under our Constitution to the full benefit of truthful, non-deceptive

advertising" (Farris & Albion, 1980). And much like cigarette manufacturers who argue that they are not promoting smoking but rather using commercial messages to influence brand selection, the beer, wine, and liquor manufacturers suggest that instead of encouraging people to drink more they are inducing a preference for one brand over another via advertising. It is true that advertising does work to "shift consumers from one brand to another, but to suggest that it does not help bring in new consumers and encourage current users to consume more begs credulity" (Hacker, 1998).

Alcohol Advertising and Consumption

Much research has been conducted to determine the variables that influence alcohol consumption. Price, availability, and social influences have been found to affect consumption (Parker, 1998). The impact of advertising on the consumption of beer, wine, and spirits (as well as other products) is complex and not fully understood. Advertising effects may well be present, but they are often difficult to detect or measure and the results of investigations are often contradictory. For example, an early study by Galbraith (1958) revealed that both aggregate alcohol consumption and brand preference are affected by advertising. In contrast, a more recent investigation (Frank & Wilcox, 1987) found no evidence of a statistically significant relationship between total advertising and consumption of beer, but did find a weak significant relationship for wine and distilled spirits. And, in its 1990 report to Congress, the Department of Health and Human Services stated that "research has yet to document a strong relationship between alcohol advertising and alcohol consumption" (Becker, 1992).

However, a lack of conclusive evidence does not prove that no relationship exists. In 1995, Jacobson and Mazur wrote, "If alcohol advertising does not get people to drink, why does the industry spend $1.1 billion a year on it? Certainly, each company wants a bigger slice of the existing market pie. But the net effect of all booze companies seeking a bigger slice is that the pie itself is likely to expand, or at least less likely to contract" (p. 174). Today, alcohol companies spend close to $2 billion per year advertising in the U.S. alone. From 2001 to 2007 they aired more than 2 million television ads and published more than 20,000 magazine ads (Jernigan & Wedekind, 2008).

Advertising professionals are quick to argue that strong advertising has a direct influence on sales. Note the success of the Absolut Vodka campaign. Twenty years ago, Absolut Vodka represented no more than 2 percent of the vodka market in the United States and was a very small piece of the overall vodka market. TWBA first acquired Absolut's advertising business in 1980 when the brand started distribution in the United States. That year, Absolut sold about 12,000 cases. The agency created a two-word headline ("Absolut Perfection") that became the campaign's signature. The visual consisted of the Absolut bottle with a halo. The basic theme of the campaign remained virtually unchanged for two decades. By 2007 Absolut had become the No. 2 U.S. vodka brand, trailing only Smirnoff and also broke the 5-million-case mark for the first time (Mullman, 2008a). In an attempt to fend off far pricier vodka brands, such as Grey Goose, Belvedere, and Chopin, that have entered the market over the past 10 years, Absolut recently introduced a global multimedia campaign themed "It's an Absolut World." Since the introduction of the new campaign, global case shipments have jumped 9 percent, and Absolut gained market share in the increasingly competitive U.S. market. See Figure 9.6 for an example of Absolut's current advertising campaign.

To encourage consumption of its products, the alcoholic beverages industry appeals to the heavy user. Ten percent of the adult population drinks almost 60 percent of all alcoholic beverages consumed, so the industry relies heavily on alcoholics and binge drinkers (Jacobson, Taylor, & Baldwin, 1993).

Figure 9.6: Ad from the highly successful Absolut Vodka campaign

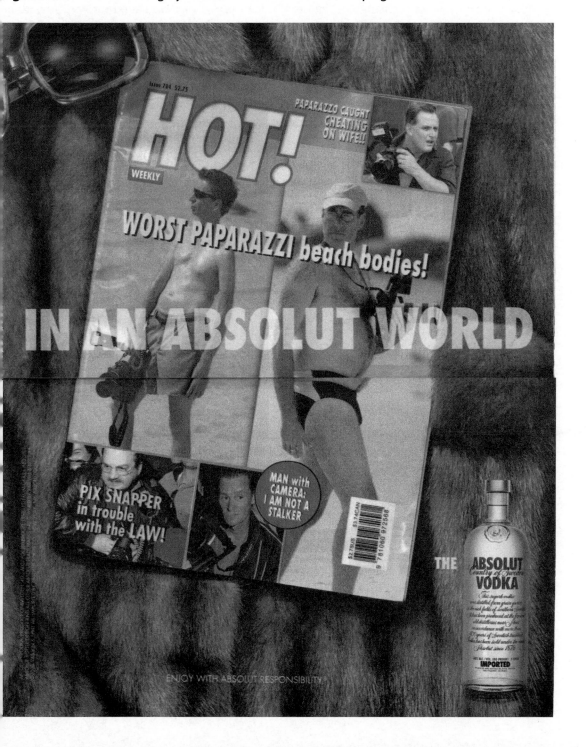

Regulating Alcohol Advertising

In the United States, alcoholic beverage advertisements are controlled as to what they can say, how they can say it, and where they can say it. Visual aspects of the message are also regulated. For example, advertisers cannot show the product being consumed, nor can they show people who might appear to be underage holding alcoholic beverages of any kind. In 1988, U.S. anti-alcohol advocates won a federal law that requires alcohol manufacturers to put health warnings on bottle labels. There is also an ongoing battle to have these same warnings included in alcohol ads. The Sensible Advertising and Family Education Act of 1993 called for warnings to be included in both print and broadcast advertisements. However, the bill was opposed by powerful alcohol and advertising industry forces, including the Beer Institute, the American Association of Advertising Agencies, the National Association of Broadcasters, and the Ad Council. The bill was withdrawn shortly before the scheduled Senate committee vote when it appeared the effort would fail (Mundy, 1994). In addition to federal regulations, various states also have specific liquor laws. California, for example, bans the offering of any premium, gift, or free goods in connection with the sale of alcohol. As a result, a Superior Court judge imposed a temporary restraining order against Anheuser-Busch when the company attempted to introduce its "Bud Rewards," campaign in that state. The promotion in North Carolina, where it was legal, offered Budweiser duffel bags, mugs, T-shirts, caps, and other items in exchange for points accumulated by buying Budweiser beer. Under the system, the more beer you drank, the more stuff you won ("Coors Brewing Company," 1999). Concerned citizens and legislators continue to lobby for greater regulation of alcohol advertising.

Some countries have more lenient guidelines on the marketing of alcoholic beverages than does the United States, while others have restrictions that are even more stringent. Practices that would not be deemed as acceptable in the United States are practiced in Japan. For example, Anheuser-Busch introduced Buddy's, a beer created for the Japanese market that contains less malt but more alcohol than most other beers. This allowed Anheuser-Busch to advertise both the product's lower price and to advertise it as "extra strong," a claim backed up by its alcohol content, which is 20 percent higher than Budweiser's. The use of celebrities to advertise hard liquors in television advertising is also tolerated. And while cigarette manufacturers in Japan are not allowed to target women, alcohol advertisers can do so freely (Taylor & Raymond, 2000).

At the other extreme is France—the only EU nation to have a full ban on alcohol advertising. However, after an eight-year battle to outlaw tobacco advertising and sponsorships, the European Union noted it has no plans for an EU-wide ban on alcohol advertising. A spokesperson for EU Health Commissioner Padraig Flynn stated that while Mr. Flynn is implacably hostile to smoking as a potential killer habit, "alcohol, taken in moderate quantities, can be good for you" ("Commission Denies Any Plans," 1998).

In 1999, all alcohol advertising (as well as all tobacco-product advertising) was banned from Nepal's radio and television stations. The ban is a culmination of a government public service campaign questioning some of the themes—"glamorous," "brave," "modern," and "Western"— used in the industry's advertising. The beers sold in Nepal include licensed brands of European, Indian, and other Asian brewers. Among them are Carlsberg and Tuborg from Denmark, San Miguel from the Philippines, Kingfisher from India, and Shanghai from Thailand. The alcohol content of beer does not have to be disclosed on beer labels and some brands are said to be "extra strong." "Here beer is not used as a mild drink," noted Bhoj Raj Pokhrel, secretary of the Health

Ministry. "Many people drink beer as a substitute for hard liquor, that is why beer advertising was also banned" (Bhattarai, 1999). The ban is likely to have a significant impact on the advertising industry, since together alcohol and tobacco advertising account for about 40 percent of Nepal's advertising revenue.

As in cigarette marketing, confront alcoholic beverage manufacturers with regulations, and they will find a way around them. In 1998, Poland's parliament ruled to keep a longstanding general ban on all alcohol advertising. But while it is illegal to advertise beer in Poland, it is impossible to turn on Polish television without being exposed to an ad for beer or to drive more than 100 yards without seeing a billboard message. Since 1997, Polish breweries have been creating nonalcoholic brands that have the same bottle type and—except for the small print—the same name and label as their regular beers. Apparently the advertising for nonalcoholic brands is paying off, because sales of "real" beer are rising 10 percent a year in Poland, the highest growth rate in Europe. According to advertising executives, the beer industry annually spends about $100 million marketing nonalcoholic brands. The Polish Consumer Federation estimates that the industry sells about $20 million worth of nonalcoholic beer each year—in other words, $5 in advertising for every $1 in sales. "They are making a mockery of the law," says Krystyna Zazdrosinska, an attorney with the Consumer Federation, which sued the beer industry for violating the law and wants the advertising stopped. "Everyone knows what they are doing" ("Breweries Beat Polish Ad Ban," 1998).

Self-Regulation

Like any industry under attack, the U.S. alcoholic beverages industry has been aggressively outlining codes of ethics related to the marketing of beer, wine, and spirits. For example, the following is a small section drawn from the Wine Institute's Code of Advertising Standards (2002):

> Wine and wine cooler advertising should encourage the proper use of wine. Therefore, subscribers to this code shall not depict or describe in their advertising: (a) the consumption of wine or wine coolers for the effects their alcohol content may product; (b) direct or indirect reference to alcohol content or extra strength, except as otherwise required by law or regulation; (c) excessive drinking or persons who appear to have lost control or to be inappropriately uninhibited; (d) any suggestion that excessive drinking or loss of control is amusing or a proper subject for amusement.

The Beer Institute and the Distilled Spirits Council have similar codes of ethics. Of course, compliance for all codes is voluntary. The code may give the impression that the alcoholic beverage manufacturers are willing to go above and beyond even federal guidelines in order to engage in ethical marketing practices. However, in 1996 the U.S. Distilled Spirits Council announced it would reverse a 50-year voluntary ban on broadcast advertising of hard liquor and begin purchasing commercial time on radio and TV stations willing to air them. As recently as 1993, the president of the Distilled Spirits Council had described the ban to a Senate committee as part of the liquor industry's "responsibility to combat alcohol abuse." The decision to dump the restraint resulted from desperation after two decades of plummeting liquor consumption. In addition, hard liquor companies envied beer marketers' ability to reach mass audiences of young, heavy-drinking consumers and perceived themselves to be their own victims and those of the regulators (Hacker, 1998).

Then President Bill Clinton called the abandonment of the voluntary code "simply irresponsible," while Attorney General Janet Reno and 26 members of Congress asked the Federal

Communications Commission (FCC) to investigate what could be done to protect children, in particular, from broadcast liquor messages. Others have petitioned the FCC to ban such ads outright. Between 2004 and 2007, advertising expenditures by spirits companies topped $1.9 billion, with hundreds of thousands of distilled spirits ads appearing in magazines, on billboards, and on television—though primarily on cable channels. An industry trade group, the Distilled Spirits Council of the United States (DISCUS), boasts that during this period they received a paltry 93 complaints, primarily for alcohol print ads with highly objectionable sexual content. However, in a report reviewing their voluntary self-regulation system, the Marin Institute, an alcohol industry watchdog, found that companies with a representative on the DISCUS board had a three times lower chance of their advertising being found in violation of code guidelines. The report notes that the DISCUS review board consists entirely of industry members, a system inherently biased toward alcohol corporations. "This is the quintessential example of the fox guarding the hen house," notes Michele Simon, research and policy director for the Marin Institute ("Marin Institute," 2008). The report concludes that the oversight process is broken and fails to protect the public from irresponsible marketing practices.

To date, there are only a handful of alcohol advertisers on the Web. Because of the newness of the Web as a marketing tool, and a fear of generating controversy, many alcohol manufacturers and distributors have moved slowly to build Web sites and place ads online. This has led some of them to rely on Internet-savvy third parties, an approach that often results in glitches. For example, in 2000, Brown Forman, makers of Jack Daniels whiskey and Southern Comfort liquor, hired the Internet advertising company DoubleClick Inc. to place banner ads on Web sites that would reach its typical drinker. The Internet sites chosen, like the Food Network and getmusic.com, draw traffic that includes a cross-section of the alcohol makers' consumers. But the ads also ran for several weeks, unbeknown to Brown Forman, on United Media's Comics.com site, the home page for Ziggy and Garfield. They also appeared on Snoopy.com, which features Charles Schultz's characters. These sites expressly prohibit alcohol advertising because of their family appeal. A DoubleClick official stressed it was a mistake, noting a clerical worker checked the wrong box on an ad placement form when typing in the instructions for the liquor ads. With DoubleClick placing more than 1.5 billion ads each day on the Internet, there are bound to be some mistakes in placement. The glitches illustrate the power and pitfalls of the Internet as a new advertising medium (Kranhold, 2000).

MARKETING ALCOHOLIC BEVERAGES TO CHILDREN

Over the years there has been a good deal of research on kids and alcohol. According to one study, 8- to 12-year-olds in the United States could name more alcohol beverage brands than presidents. Another found kids knew the Budweiser frog slogans better than slogans for ads intended for them—such as Tony the Tiger in Frosted Flakes or Smokey the Bear. Indeed, the Budweiser Frogs have been called the Joe Camel of the alcohol industry (Emert, 1998). Since 2001, at least seven peer-reviewed, federally funded long-term studies have found that young people with greater exposure to alcohol marketing—including on television, in magazines, on the radio, on billboards and other outdoor signage, via in-store displays, or ownership of promotional items or branded merchandise—are more likely to start drinking than their peers (Jernigan & Wedekind, 2008). One investigation of over 1,000 6th, 7th, and 8th graders who said they had

never consumed alcohol, found that 29 percent of these children owned or wanted to own an alcohol-related promotional item such as a hat, shirt, or bag. These children were classified as "highly receptive." Twelve percent had a "favorite" brand of alcohol, even though they were non-drinkers and were classified as "moderately receptive." The rest of the kids were classified as "not receptive." The study found that moderately and highly receptive children were 77 percent more likely to consume alcohol in the following 12 months than the not-receptive kids. Twenty-nine percent of the children admitted to drinking alcohol during the follow-up period, and 13 percent reported having a drink at least one or two days in the previous 30 days ("Alcohol Advertising," 2008*)*. Apparently, young people are learning consumption behaviors from advertisements and promotions. Commercial messages intended for adults yet viewed by young people who cannot legally buy, possess, or consume alcoholic beverages, teach the virtues and pleasures associated with beer and wine (Hacker, 1998).

According to the U.S. surgeon general, alcohol is the most widely used drug by youth ages 12–20 in the United States ("Drunk on ads," 2007). In 2007, the U.S. Department of Health and Human Services reported that by age 14, 41 percent of children have had at least one drink. About 16 percent of 8th graders, 33 percent of 10th graders, and 44 percent of 12th graders reported drinking in the previous 30 days, University of Michigan researchers found (Shin, 2008).

The consequences of alcohol consumption by young Americans are particularly frightening. An average of 11 American teens die each day from alcohol-related crashes. Underage drinking leads to an increase in teen pregnancies, violent crimes, and sexual assaults. Among college students, it leads to 1,700 deaths, 500,000 injuries, 600,000 physical assaults, and 70,000 sexual assaults each year (Voas, 2006). The earlier young people start drinking, the worse the consequences. People who begin drinking before age 15 are four times more likely to become dependent on alcohol later in life than those who wait to drink until they are 21. And, despite significant efforts to reduce youth access to alcohol, binge drinking among youth remains stubbornly high. In 2006, 7.2 million youth under age 21 reported binge drinking (consuming five or more drinks at a sitting, usually defined as within two hours) (Jernigan & Wedekind, 2008). It is estimated that four million children are alcoholics or problem drinkers. In a 145-page study, the National Center on Addiction and Substance Abuse claimed that children drink 25 percent of all alcohol consumed in the United States (Branch, 2002).

Unfortunately, the United States does not possess a monopoly with regard to such figures. In Europe, 56 percent of 15- to 16-year-olds admitted in a survey by the European School Survey Project on Alcohol and Other Drugs to having had more than five drinks in a session in the previous month, with 30 percent of this age group admitting this behavior three or more times a month (Branch, 2002). Between 2002 and 2004, the percentage of 14- to 18-year-olds in Spain who said they had been drunk in the previous month jumped from 19 percent to 35 percent; 82 percent said they drink regularly; and 27 percent say they are drunk every 10 days. Spanish Health Minister Elena Salgado reports that the number of hospitalizations from alcohol abuse has doubled in a decade. In Germany, young people are drinking almost 30 percent more alcohol than just four years ago. Emergency room visits caused by "coma-drinking" rose 26 percent between 2000 and 2002—and half the patients were female. And, in Poland, where the number of adolescents who drink jumped 40 percent between 1995 and 2003, 20 percent of 17-year-old boys say they got into a booze-fueled fight in the previous year. Eight percent of Swedish 15- to

16-year-old girls said drink led to unplanned sex, while 12 percent say it made them forget to use a condom (McAllister et al., 2005).

Much like cigarette manufacturers, alcoholic beverage manufacturers prefer to pass the buck. "There isn't a 15-year-old out there who isn't interested in being as adult as they can be. It's up to parents to enforce the rules," notes Francine Katz of Anheuser-Busch "And a Roper Poll showed teens themselves naming parents as the primary influence on their decisions about drinking," adds Katz (Elias, 1998). A study by the U.S. Department of Health and Human Services has found one in four U.S. children (19 million children or 28.6 percent of children up to 17 years of age) is exposed some time before age 18 to family alcohol abuse or alcoholism. "Children of alcoholics may be neglected or abused and frequently face economic hardship and social isola-tion. They also are vulnerable to psychopathology and medical problems, including an increased risk for themselves developing alcohol abuse or alcoholism" (Grant, 2000). Clearly, the frontline against alcoholism must be in the home. Nonetheless, to deflect some of the criticism targeted at the industry, most alcoholic beverage manufacturers have developed self-regulatory guidelines that deal specifically with marketing to minors. (Recall that compliance with the guidelines is voluntary.) Regarding children, the Wine Institute's Code of Advertising Standards (2002) states:

> Any advertisement which has particular appeal to persons below the legal drinking age is unac-ceptable. Therefore, wine and wine cooler advertising by code subscribers shall not: (a) show models and personalities in ads who are under the legal drinking age. Models should appear to be 25 years of age or older; (b) use music, language, gestures or cartoon characters specifically associ-ated with or directed toward those below the legal drinking age; (c) appear in children's or juvenile magazines, newspapers, television programs, radio programs or other media specifically oriented to persons below the legal drinking age; (d) be presented as being related to the attainment of adulthood or associated with "rites of passage" to adulthood; (e) suggest that wine or wine cooler products resemble or are similar to another type of beverage or product (milk, soda or candy) hav-ing particular appeal to persons below the legal drinking age; (f) use current or traditional heroes of the young such as those engaged in pastimes and occupations having particular appeal to persons below the legal drinking age; (g) use amateur or professional sports celebrities, past or present.

Alcoholic beverage companies, however, flagrantly violate their own codes of ethics by designing both products and advertising campaigns that appeal specifically to children. One such product is ShotPak, which its makers call a "party in a pouch" but that critics say is more like an alcoholic candy bar. ShotPak is a line of alcoholic beverages that comes in shot-sized laminated-foil plastic pouches that are reminiscent of the drinks children pack in school lunches. One of the drinks is Purple Hooter. There is also Kamikaze, Lemon Drop, and Sour Apple, as well as a higher alcohol line of pocket-sized drinks called STR8UP of vodka, whiskey, tequila, or rum. ShotPak refers to its drink as "the shot . . . without the glass." Critics call it a blatant play to entice underage drinkers and get alcohol into schools and other public venues where it would not ordinarily be drunk (Hirsch, 2008).

Another product category that has raised eyebrows is caffeinated alcoholic drinks. Sparks, introduced by MillerCoors LLC, is a citrus-flavored malt drink with caffeine and guarana. The full product line includes Sparks Light and Sparks Plus, with alcohol by volume ranging from 6 percent to 7 percent. The company is planning to launch Sparks Red, with 8 percent alcohol. Most popular brands of beer in the United States, such as Miller Lite and Budweiser, typically have an alcohol content of 4 percent to 5 percent. While federal regulators have approved the use of stimulants in such drinks, critics say, "Mix alcohol and stimulants with a young person's sense

of invincibility and you have a recipe for disaster. Sparks is a drink designed to mask feelings of drunkenness and to encourage people to keep drinking past the point at which they otherwise would have stopped" (Daykin, 2008). Indeed, the Center for Science in the Public Interest, a nonprofit health advocacy group, has sued MillerCoors, claiming the line of alcoholic beverages is a health hazard. Even more recently, a group of 25 attorneys general has set out to stop the launch of Sparks Red—the higher alcohol version of the product, setting the state for a potential legal showdown that could have broad ramifications for the future of the category (Mullman, 2008b). MillerCoors is not alone in the marketing of caffeine-infused drinks. Anheuser-Busch makes Bud Extra and Tilt—but has said it intends to remove the caffeine and other stimulants from these two products (Shin, 2008). Federal regulations do not allow ads that imply such drinks have stimulating effects. Nor do they allow marketing that suggests a drink can be consumed without feeling the effects of alcohol.

Regarding advertising campaigns that target kids, for a number of years, Spuds MacKenzie, a cute bull terrier, served as the spokes-dog for Bud Light. In ads that pandered shamelessly to younger consumers, Spuds frolicked with Ninjas in television spots at a time when the Mutant Ninja Turtles were highly popular among youngsters. In response to public criticism, Budweiser retired Spuds MacKenzie. Yet, his replacement, a cartoon character named Bud Man, turned out to be no less popular with children.

Where alcoholic beverage ads are placed is also of concern. In 2000, the trade association for the wine industry adopted, as part of its self-regulatory codes of good marketing practice, a 30 percent maximum for underage audiences of their advertising. Trade associations for beer and distilled spirits companies adopted the standard, under which firms should not advertise on programs with an audience that is more than 30 percent underage, in 2003. A report by the Federal Trade Commission has the alcoholic beverages industry patting itself on the back. Specifically, the FTC found that more than 92 percent of all television, radio, and print advertising placements met the 70 percent 21+ demographic standard, and more than 97 percent of total advertising impressions met the 70 percent standard ("Marin Institute," 2008). However, a comprehensive review of television ad practices by alcohol companies from 2001 to 2007 found an increase in youth exposure to alcohol advertising and relatively few industry-sponsored "responsibility" ads. The new study, released by the Center on Alcohol Marketing and Youth (CAMY) at Georgetown University, found that more than 40 percent of youth exposure to alcohol advertising came from ads placed on programming with a disproportionate youth (ages 12–20) audience—the highest percentage since CAMY began monitoring youth exposure in 2001. The report clearly shows that 30 percent threshold established by the alcohol trade associations has not reduced youth exposure to alcohol advertising on TV, nor has it reduced the youth overexposure that occurs when ads are on programs with disproportionate youth audience. "The sad reality for kids and parents is that the alcohol industry's 30 percent standard is working on broadcast but not on cable television," said CAMY executive director David Jernigan ("The Center on Alcohol Marketing," 2008).

While there has indeed been a decline in placements on TV programming with youth audiences greater than 30 percent, it has been accompanied by increases in the percent of youth exposure coming from overexposing placements—ads on programs with 15 to 30 percent youth viewership. Youth overexposure occurs when advertising is placed on programming or in publications with youth audiences that are out of proportion to their presence in the population. Cable television generated 95 percent of youth overexposure to alcohol advertising on television in

2007. As a result, from 2001 to 2007, youth exposure to alcohol product advertising on TV rose by 38 percent. The average number of television ads seen in a year by youth actually decreased from 216 to 201 (Jernigan & Wedekind, 2008). Some brands do better than others at avoiding youth overexposure. The best performers were Michelob Beer, Santa Margharita Pinot Grigio, Korbel California Champagnes, Arbor Mist Wines, Rolling Rock Beer, and Michelob Ultra Light Beer. The worst performers were Miller Light, Corona Extra Beer, Coors Light, Hennessy Cognacs, Guinness Beers, Samuel Adams Beers, Bud Light, Smirnoff Vodkas, and Disaronno Originale Amaretto.

Some alcohol companies have begun to air "responsibility" advertisements, which seek to deliver messages about underage drinking or about drinking safely (such as drink in moderation, or do not combine drinking with driving). But of the $4.9 billion the alcohol industry spent on television ads from 2001 to 2005, only 2 percent was spent on "responsibility" ads. Another CAMY study revealed that underage youth were 239 times more likely to see an ad selling alcohol than one of the industry's "responsibility" ads, designed to educate about the dangers of underage drinking. Of the 174 alcohol brands that advertised on television in 2005, only 19 sponsored "responsibility" ads—however, that number was higher in 2005 than in any prior year ("Drunk on Ads," 2007).

Various constituencies are arguing for the V-chip to prevent children from being exposed to broadcast ads for alcoholic beverages. For example, the Campaign for Alcohol-Free Kids, along with the National Women's Christian Temperance Union and the American Council on Alcohol Problems, petitioned the Federal Communications Commission to expand the capability of the V-chip to include all alcohol advertising (Fitzgerald, 1998). V-chips, which are now available as stand-alone units, as well as built into some TV sets, allow parents to block programming. The V-chip can be employed along with the TV ratings system to block shows by age and levels of sex, violence, language, and suggestive dialogue. However, the idea of rating or blocking ads is uncharted territory, which has lobbyists in Washington concerned. After all, if viewers can block one type of ad, they could ultimately block all ads. Also, for any kind of advertising V-chip to work, the industry would have to rate itself much like the broadcast industry has done. Once the ads are rated, parents could conceivably block them. To date, the FCC has not officially responded to the petition, and would likely encounter vociferous opposition to any such action. Allen Banks, executive media director for Saatchi & Saatchi in New York, believes that the V-chip is "clearly censorship. It's blacklisting a product irrespective of how responsible any of the ads in the category might be" (Fitzgerald, 1998, p. 27). Further, many do not believe the FCC has authority in this area, since it is the FTC that regulates deceptive and unfair practices in advertising—including harm to children—on a case-by-case basis. Nonetheless, the various constituencies are not without clout, and this issue is expected to receive greater attention in the future.

MARKETING ALCOHOLIC BEVERAGES TO MINORITIES

The alcoholic beverages industry has frequently been criticized for targeting minorities. But alcoholic beverage manufacturers defend their right to target African Americans, Hispanics, and Asian Americans by arguing that these groups should have the right to make their own decisions, including which ads they should see and what they should buy. Indeed, they have even found support for this position from an unlikely source. Manufacturers quote Benjamin L. Hooks,

retired executive director of the National Association for the Advancement of Colored People, who in response to the position that minority groups should be "protected" from advertising for some products, including alcoholic beverages, stated, "Buried in this line of thinking, and never really mentioned by these critics, is the rationale that Blacks are not capable of making their own free choices and need some guardian angels to protect their best interests" (Castellano, 1992).

Research has shown that alcohol availability (measured by the number of bars and stores selling alcohol in a specific geographic area) and alcohol advertising are disproportionately concentrated in ethnic communities (Alaniz, 1998). One study found that West Oakland—an area in Oakland, California, where racial and ethnic minorities and the poor are concentrated—had 1 liquor outlet for every 298 residents. In contrast, Piedmont, the more affluent, predominantly white area of Oakland, had 1 alcohol outlet for every 3,000 residents (Mack, 1997). Merchants use storefronts and interiors of alcohol outlets to advertise beer, wine, and spirits. One study found that a student walking from home to school in a predominantly Latino community in northern California may be exposed to between 10 and 60 storefront alcohol advertisements, and the same study found that there are five times as many alcohol ads in Latino neighborhoods as in predominantly white neighborhoods (Alaniz & Wilkes, 1995).

Studies of alcohol advertising in minority communities have focused primarily on billboards. A San Francisco–based investigation revealed that African American and Latino neighborhoods had proportionately more billboards advertising alcohol than white or Asian neighborhoods (Altman, Schooler, & Basil, 1991). Thirty-one percent of the billboards in Latino neighborhoods advertised alcohol, compared with 23 percent in African American neighborhoods, 13 percent in white neighborhoods, and 12 percent in Asian neighborhoods. Most of the alcohol billboards in Hispanic communities advertised beer and wine, whereas the majority of billboards in the African American neighborhoods promoted malt liquor and distilled spirits. Scores of cities and towns, including New York, Chicago, and Los Angeles, have enacted restrictions on billboard advertising, and in 1997 Baltimore became the first city in the United States to remove all tobacco and alcohol billboards. The ban prompted lawsuits by advertisers and billboard companies, which said limits on billboards violate the advertisers' free speech rights. But in April 1997, the U.S. Supreme Court let the ban stand and the ads came down. However, despite the ruling in the Baltimore case, several other efforts to restrict billboards have been struck down by judges who have found they unfairly singled out tobacco and liquor companies. The Outdoor Advertising Association of America, the industry's trade group, established a voluntary code in 1990 that called for a prohibition on tobacco and alcohol billboards within 500 feet of schools, churches, and playgrounds. Despite some concessions in the 1990s, alcohol ads remain stubbornly entrenched in minority communities (Kwate, 2007).

Minority youth are particularly likely to be targeted by alcoholic beverage manufacturers. And alcohol makers are making great efforts to move their products into the hands of young Latinos. The Latino population is generally younger than the overall U.S. population—with 40 percent of Latinos under age 21—while just 30 percent of the general population is under 21. This translates into market potential in that brand loyalty purchased via advertising today can pay off for years to come. In 2002, alcohol advertisers spent more than $23 million to place ads on 12 of the 15 most popular TV programs among Latino youth, including *Las Vias del Amor, Ver Para Creer, That '70s Show,* and *MadTV.* In 2003, that number jumped to 14 of the top 15 shows. In 2004, Latino youth living in 7 of the top 20 U.S. radio markets heard more alcohol ads

per capita than all other youth in those markets. That year they also saw 20 percent more alcohol ads in English-language magazines than all other racial groups. Beer ads are actually reaching a larger percentage of underage Latinos than adults. By 2004, 85 percent of Latinos aged 12–20 saw beer ads, compared with just 79 percent of those over 21. Ironically, intensified marketing efforts come as alcohol-related problems are hitting Latino communities harder than the U.S. population overall, particularly in relation to drunken driving, alcohol-related vehicle fatalities, and underage drinking. Federal highway statistics from 1999–2004 show that alcohol contributed to 40 percent of all highway deaths in the United States. For the Latino population that number was 47 percent—or almost half. In California, Hispanic drivers made up 45.5 percent of all DUI arrests in 2005. Additionally, recent studies show that Latino youth are more likely to drink and get drunk at an earlier age than whites or African Americans. They are more likely to have been binge drinking in the two weeks prior to the study (Juarez & Rosa-Lugo Jr., 2008).

And while black youth drink far less alcohol than their white counterparts, they are targeted more aggressively. According to a report by CAMY, only 19 percent of black youth used alcohol within 30 days prior to the survey, compared to about 33 percent of whites. Further, young African Americans reported binge drinking at about 10 percent, compared to whites at 23 percent. Nonetheless, alcoholic beverage marketers are hitting them hard. The CAMY report revealed black youth were exposed to the following:

- Twelve- to 20-year-olds saw 15 percent more ads for beer and 10 percent more for distilled spirits per capita than adults age 21 and over; and generally black youth saw more advertising for both products than youth in general.
- In national magazines, black youth saw 34 percent more alcohol advertising than youth in general, 21 percent more for beer and ale, and 42 percent more for distilled spirits.
- Ninety-nine percent of black youth saw an average of 150 alcohol ads in national magazines, while 97 percent of all youth saw 113 alcohol ads.
- Fourteen magazines (including *Sports Illustrated, Vibe, Stuff, Entertainment Weekly, The Source, InStyle,* and *Vogue*) accounted for 75 percent of black youth's exposure in 2004.
- Of a sample of more than 67,000 occurrences of advertising airing in 104 radio markets for the 25 top alcohol brands in 2004, black youth heard 15 percent more advertising per capita than youth in general.
- Colt 45 Malt Liquor accounted for nearly one-third of black youth exposures to radio advertising, along with Hennessy Cognac, which most disproportionately exposed black youth compared to all youth.
- Seventy-two percent of alcohol advertising spending on Black Entertainment Television (BET) targeted 10 programs more likely to be seen by youth (Muhammad, 2008).

Researchers have also revealed a direct relationship between alcohol advertising and alcohol-related problems. For example, a study on alcoholism and Hispanics released by CalPartners Coalition, a group of Hispanic organizations, found that 12 percent of Hispanic homicide victims are killed in bars; the incidence of rape and violence against women is higher in areas where alcohol advertising is most concentrated; and liver disease and cirrhosis of the liver are the sixth and seventh leading causes of death among Hispanics (Herdt, 1998). Heavy drinking is decreasing among whites but increasing among Hispanics. "Regrettably, Latinos tend to be heavier drinkers than other populations," said project director Eduardo Hernandez. "They don't drink as frequently as others, but when they drink, they drink heavily" (Herdt, 1998).

Figure 9.7: Hennessy ad targeting African American consumers

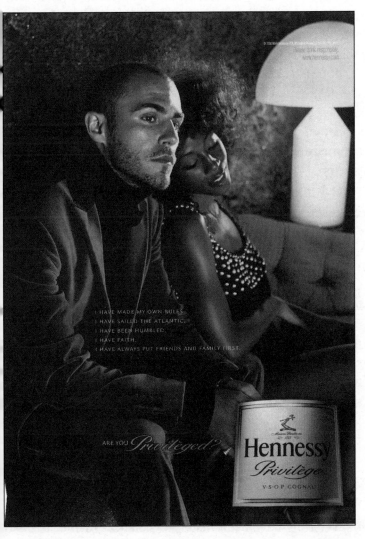

And, according to the National Institute on Alcohol Abuse and Alcoholism, alcohol abuse is the leading health and safety problem in the African American community. Black consumers drink less alcohol per capita than whites, but poverty and poor health care contribute to disproportionately high rates of alcohol-related disease (Hacker, Collins, & Jacobson, 1987). To appeal to this audience, beverages with higher alcoholic content, such as malt liquors, have been developed. For example, Power Master, a beer marketed to blacks by the G. Heileman Brewing Company, contains 7.5 percent alcohol—about 60 percent higher than regular beer. Much like the Wine Institute, the brewing industry's code of ethics contains a guideline that reads, "Advertising should neither state nor carry any implication of alcohol strength." But ads directed at black consumers frequently allude to the product's strength. An advertisement for St. Ides, another high-octane beer, featured black rapper Ice Cube chanting, "I usually drink it when I'm out just clowning, me and the home boys, be like downin' it; Cause it's stronger but the taste is smooth; I grab me a forty [ounce bottle] when I want to act a fool." The "references to 'power' in the ads aimed at minority communities carry a double meaning. These ads borrow the language of the civil rights movement and pretend to offer empowerment to the disenfranchised and alienated. It is a cruel bait and switch" (Jacobson & Mazur, 1995, p. 171).

Many ads also juxtapose alcohol with the penetration of class barriers and the attainment of success. Increasingly, cognac has been heavily marketed to black consumers. "Much of the younger brandy and cognac market skews ethnic-urban African American consumers in particular" (Kwate, 2007, p. 988). Often these spirits are positioned as exclusive products for those with abundant taste and economic resources. Note the Hennessy Cognac ad in Figure 9.7. The copy reads, "I have made my own rules. I have sailed the Atlantic. I have been humbled. I have faith. I have always put friends and family first." The ad concludes with the line, "Are you privileged?"

In addition to developing alcoholic beverages targeted to minorities, and creating hard-hitting and oftentimes exploitive campaigns to sell their products, alcohol companies (much like tobacco firms) insinuate themselves into minority communities by sponsoring ethnic events and organizations, and hiring ethnic employees to work for them. The Hiram Walker Company, which designated 10 percent of its total media advertising to blacks, supported the 100 Black Men of America (an organization that is made up of professionals who are dedicated to helping inner-city youth), the National Caucus of Black Aged (an advocacy group that provides homes for the aged), the United Negro College Fund, and the National Association for the Advancement of Colored People. In addition, the company established the Hiram Walker Foundation, dedi-cated to the support of minority education, particularly in the food service and retail industries (Pomeroy, 1992). Coors has been equally active in supporting events designed to appeal to black consumers. The company sponsored broadcasts of black collegiate football games, tennis tournaments, rock concerts, boxing matches, and more. And while Coors had a reputation for racist hiring policies in the mid-1980s, the company is now recognized for its diversity efforts. Heineken USA has been a longtime supporter of the Congressional Black Caucus Foundation, working with the foundation to "develop a number of innovative programs that serve the local communities where the company's employees live and work and where its products are enjoyed." "Our relationship with the Black Caucus Foundation is founded in common goals and values," says Dan Tearno, senior vice president, Heineken USA ("Heinekin USA Celebrates," 2007). For example, Heineken annually awards scholarships to students pursuing careers in the perform-ing arts, music, and related entertainment fields. Each student recognized is from a district of a Congressional Black Caucus member. Since its inception in 2000, the program has awarded more than $200,000 in scholarships. All too often, however, marketers expect something in return for their sponsorships and diversity efforts. The support of both tobacco and alcoholic beverage firms may buy the silence of minority leaders regarding the dangers of these products in their communities (Jacobson, Taylor, & Baldwin, 1993).

BANS, INCREASED TAXATION, AND COUNTERADVERTISING

Efforts to ban or restrict alcohol advertising have been made in Canada, Finland, Norway, Great Britain, and Brazil, as well as many countries in Asia. However, given the global nature of the mass media, total ad bans are generally difficult to achieve. An additional challenge is that advertising's effects may persist long after a ban has been imposed and thus the effect on sales may be long delayed. An early investigation was conducted in British Columbia in 1971–1972. Local advertising of all alcoholic beverages was banned for a 14-month period; the ban, how-ever, was found to have no effect on beer, wine, or spirits consumption (Smart & Cutler, 1976). Unfortunately, at the time there was no public education program to explain the ban, and it had neither the acceptance of the public nor the media. Norway prohibited all alcohol advertising in 1975 and Finland did so in 1977. At the time, neither country received much foreign televi-sion or other media influences. An examination of per capita consumption figures revealed no obvious post-ban effect. To further study the matter, a comparative approach was employed by Simpson et al. (1985), who examined alcohol consumption in two groups of countries: Hungary, Finland, and Norway, where alcohol advertising was totally banned; and in the Netherlands, Australia, and Japan, where advertising was unrestricted. They found no obvious differences in

consumption between the two groups. These investigations, together with several other related studies undertaken over the years, suggest that advertising bans do not seem to affect overall consumption significantly. This appears consistent with research into tobacco-advertising bans.

Seldom addressed, however, are the effects that such bans might have on the media. The advertising industry, in an attempt to "preserve and enhance the right and freedom to advertise," has argued that if tobacco advertising were banned, nearly 8,000 newspaper jobs would be lost and 165 magazines would be destroyed. An end to beer and wine advertising on television, they claim, would result in a loss of 4,232 jobs, plus an enormous chunk of network sports programming (beer ads account for over 15 percent of all ad spending on network sports—without beer ads, the networks would have far less money to spend on sports programming). And without ads for hard liquor, another 84 magazines would fold, including many for blacks (Lipman, 1990). Ad-ban proponents argue that these statistics do not consider what new forms of advertising might replace lost beer, alcohol, and tobacco ads and point instead to the social good that such bans would accomplish.

According to the World Health Organization (WHO), one way to stem the drinking tide is to raise liquor taxes. When Poland removed its 25 percent tax on spirits in 2003 in advance of joining the European Union, consumption increased 25–28 percent in just one year. When Germany imposed an average euro 0.83 tax on alcopops that nearly doubled their price, sales dropped 75 percent, without a noticeable move to substitute drinks. A WHO report concluded that "the robust finding is that if alcoholic beverage prices go up, consumption goes down. If prices go down, consumption goes up." Increasing liquor taxes in the European Union's countries by 10 percent would prevent 9,000 deaths and raise billions of euros (McAllister et al., 2005).

But increasing taxation would penalize the vast majority who manage to drink without incident say alcohol merchants. Their preferred answer, one shared by many governments, is education. "Experience with counteradvertising in the 'tobacco wars' indicates that a balance of commercials that inform consumers of the risks of excessive drinking, discourage over-consumption, and de-glamorize drinking by underage persons would provide effective relief from the one-sided promotion of drinking" (Hacker, 1998). Over the years, the Ad Council, Mothers Against Drunk Driving (MADD), and various other organizations have sponsored anti-drinking campaigns. Even the alcoholic beverage industry has developed advertising messages promoting responsible drinking, primarily because of concerns that policy makers and the public are being swayed by what it considered exaggerated warnings on the dangers of drinking. The alcoholic beverage industry is pouring millions into anti-alcohol abuse groups. For example, the National Organization for Fetal Alcohol Syndrome received financing from the Licensed Beverage Information Council. Bacchus, which runs programs on 400 college campuses promoting responsible habits and attitudes, in the past has received well over 90 percent of its cash contributions from the liquor industry. And the Alcoholic Beverages Medical Research Foundation in Baltimore receives over 95 percent of its funding from the beer industry. Studies financed by this foundation have found medical benefits in moderate drinking, as has some independent medical research (Abramson, 1991).

The industry has also sponsored a variety of "responsible drinking" messages. Seagram's, for example, notes that it has been running such campaigns since 1934, when it advised those who imbibed to "drink moderately." Miller Brewing has run a "Know Your Limits" campaign for a number of years. And Anheuser-Busch has made an effort to put out a positive drink-in-moderation message by running television ads featuring customers partying in a bar that looks

strikingly similar to regular beer commercials—except at the end they admonish viewers to "know when to say when." Anheuser-Busch ran the "Know When to Say When" campaign from 1985 to 1999. The brewery spent $40 million on a campaign, which saluted those who have made a difference in fighting alcohol abuse instead of preaching about the dangers (Stamborski, 1999). Nonetheless, many critics say industry efforts to combat drunk driving and the other health and social ills of drinking are merely cosmetic and self-serving. They note that the alcohol lobby fought against raising the drinking age to 21 in some states and against tougher blood alcohol standards for defining drunk driving in others. "Would you want the Mafia underwriting anti-crime programs?" asks Andrew McGuire, director of the Trauma Foundation in San Francisco and one of the original directors of MADD (Abramson, 1991).

PHARMACEUTICAL ADVERTISING

The Rules Change

Nonprescription drugs have been directly advertised to consumers via various media for decades. However, commercial messages promoting prescription drugs were typically directed at physicians and at one time appeared only in trade journals. The early 1990s saw a dramatic increase in prescription drug marketing as well as a major shift in the industry's marketing philosophy. In 1990, spending in the prescription drug category was about $46 million. Then in 1992, the American Medical Association (AMA), in collaboration with the U.S. Food and Drug Administration (FDA), lifted its ban on consumer pharmaceutical ads. It issued guidelines for direct-to-consumer advertising that called for accurate information balancing claims of product effectiveness with risk information. According to Leading National Advertisers, spending in the category skyrocketed to $162.5 million in 1993 (Miller, 1994). Experts attribute the bulk of that growth specifically to the explosion of ads aimed directly at consumers who have become more involved in their medical decisions—a trend that experts say will continue. Consumers have become part of the purchasing decision, notes Mike Myers, manager of consumer programs at Pharmaceutical Marketing Services, Inc. "In the early 1980s, before managed care really took hold, the prescriber had 100 percent control, but now the HMO is dictating some of that, and patients are coming in and demanding certain drugs" (Miller, 1994). Faced with a nation obsessed with slashing health care costs, along with an onslaught of lower-priced generic drugs, pharmaceutical marketers have aggressively attempted to build brand awareness.

Prior to 1997, the FDA, which clears ads for prescription drugs, required ads in all media to thoroughly explain the side effects if the message mentions both the product name and the ailment it was meant to treat. Pharmaceutical manufacturers took one of two routes to deal with the guidelines. Upjohn, one of the pioneers in direct-to-consumer marketing, for example, ran a 30-minute infomercial to pitch its Rogaine baldness treatment and employed the same technique to promote its Depo-Provera contraceptive injection, scrolling the fine print from drug labels on the screen like final credits for a movie. The campaign, which included a toll-free number, generated 750,000 consumer responses. But most drug makers using TV simply skirted the rules by mentioning only the product name or an illness but not both. As a result, millions of consumers were left baffled and struggling to understand why the woman on their screen was windsurfing across a wheat field over the word "Allegra," and why a mountain climber in a busi-

ness suit was yelling "Zyrtec." The ads did not mention that the Merck and Pfizer drugs were allergy treatments (Hendren, 1998).

In August 1997 the FDA relaxed the rules of pharmaceutical product promotion. Under the new guidelines, companies need only mention significant side effects in television messages, referring viewers to magazine ads, toll-free phone numbers, Internet sites, or to medical professionals for specific details. The result? The American Medical Association reported that in 1998, $1.3 billion was spent on direct-to-consumer pharmaceutical advertising (Pirisi, 1999). In the first half of 1999 alone, companies spent $905 million, a 43 percent increase over the same time period the previous year, according to the industry research company IMS Health (Neergaard, 1999). Between 2000 and 2004, prescription drug advertising surged 70 percent, to nearly $4.5 billion (Jordan, 2007). Television continues to be the medium of choice, accounting for 59 percent of all direct-to-consumer advertising spending. Indeed, currently, the average American sees about 30 hours of drug commercials a year (McGowan, 2008). Magazines represent about 34 percent of total ad spending on direct-to-consumer medications, while newspapers account for only 3 percent of total spending ("Drug Makers," 2006). However, industry experts predict that pharmaceutical manufacturers may turn to the Web as well as digital and cable alternatives since these options offer better targeted and cost-effective advertising returns.

The United States is on the cutting edge of this trend. New Zealand is the only other country where direct-to-consumer advertising is currently legal, though it is being considered in Australia, Canada, and the United Kingdom. Until quite recently, European consumers were protected from or deprived of (depending on one's point of view) such blandishments. Interestingly, the Internet may ultimately force the issue. The thousands of medical sites worldwide are all accessible from a European desktop, and many of them name branded products. And, many branded prescription drugs have their own Web site, such as the one for Pfizer's best-selling cholesterol drug, Lipitor. The site features an endorsement from Robert Jarvik, who invented the artificial heart and who also appears in Lipitor's TV ads in the United States. Such sites usually have disclaimers saying the product information is intended only for U.S. citizens, but anyone around the world can view them. For some U.S. drug Web sites, up to 30 percent of visitor traffic comes from outside the United States, estimated Mark Bard, president of Manhattan Research LLC, a health market research firm (Loftus, 2007). However, most U.S. product Web sites are in English, limiting their usefulness to non-English speakers. Nonetheless, health chat rooms, virtual pharmacies, and self-diagnosis sites are mushrooming. This flood of information makes a ban on regulated advertising hard to justify. "Consumer pressure is going to become more and more important," says Jean-Pierre Garnier, chief operating officer at SmithKline Beecham. "You can mobilize a group of patients through the internet. That will start to create pressure on what governments can or cannot forbid" (Pilling, 1999). In 2001, the EU proposed to allow direct-to-consumer advertising for three specific conditions—AIDS, respiratory problems such as asthma, and diabetes—allowing pharmaceutical companies to communicate with patients via the Internet ("Side Effects," 2001). If direct-to-consumer advertising were to be legalized, it is predicted to have an even bigger impact on the nationalized health services of Europe than it has already had on the private health services of the United States. Some are concerned that the nationalized health services will not be able to cope with the financial implications of patients' demand for expensive drugs. Soaring drug sales are less of a government concern in the United States, where the bulk of health care is paid by private insurance. In Europe, an advertising-led boom in sales would

have to be met by public expenditure (Thornton, 2000). But because of cultural as well as health system differences between the United States and Europe, most do not expect to see a lifting of the direct-to-consumer ban on the continent anytime soon.

Effects on U.S. Consumers

Consumers have been deluged with broadcast and print messages for a vast range of pharmaceutical products. Most of the marketing has focused on situations in which consumers have a problem they can readily identify themselves, such as birth control, hair growth, or allergy relief. And it appears that campaigns for these kinds of drugs or those with cosmetic aspects are highly successful. Sixty percent of consumers in a recent investigation knew that Claritin, the most advertised drug, treats allergies. Eighty percent recognized the anti-impotence pill, Viagra. "A consumer is not going in and asking his doctor for a particular brand of antibiotic, but they might go in and ask about Rogaine [a baldness cure]," said Joseph Davis, executive vice president/ managing director of Medicus Consumer/DMB&B, which specializes in health care advertising and communication. "Ninety-nine percent of prescription drugs are probably not candidates for direct-to-consumer," he said. "They're too esoteric. Cancer drugs, any life-or-death kind of thing, that's not an area where the consumer has a real role to play" (Miller, 1994). But apparently, the role of the consumer in determining medications is expanding dramatically. Increasingly, consumers are being exposed to campaigns for drugs that treat everything from high cholesterol to depression to prostate problems, and even HIV.

And just how are consumers responding to these advertising messages? A recent survey of over 1,500 consumers on their reactions to direct-to-consumer advertising of prescription drugs found 56 percent of respondents agreeing that drug ads are done responsibly, while 40 percent said government regulations allow only the safest medicines to be advertised. About three-quarters of respondents agreed that "ads tell people about new treatments" (78 percent), "ads alert people to symptoms that are related to a medical condition" (77 percent), and "ads allow people to be more involved in their healthcare" (74 percent). However, nearly half (44 percent) admitted that "ads cause tension between doctors and patients" (Arnold, 2008). Table 9.3 presents the information patients reported recalling from TV ads, according to an FDA survey. These numbers suggest consumers appear to be recalling a good deal from direct-to-consumer ads.

Table 9.3: What Information Was Recalled from TV Ads for Pharmaceutical Products

Benefits	90%
Risks/side effects	90%
Who should not take	89%
How to get more information	86%
Who should take	74%
Questions for doctor	71%
Directions for use	35%
Over-dosage	12%

Source: Rados, 2004.

Figure 9.8: Print version of ad campaign for Bayer's Yaz birth control pill

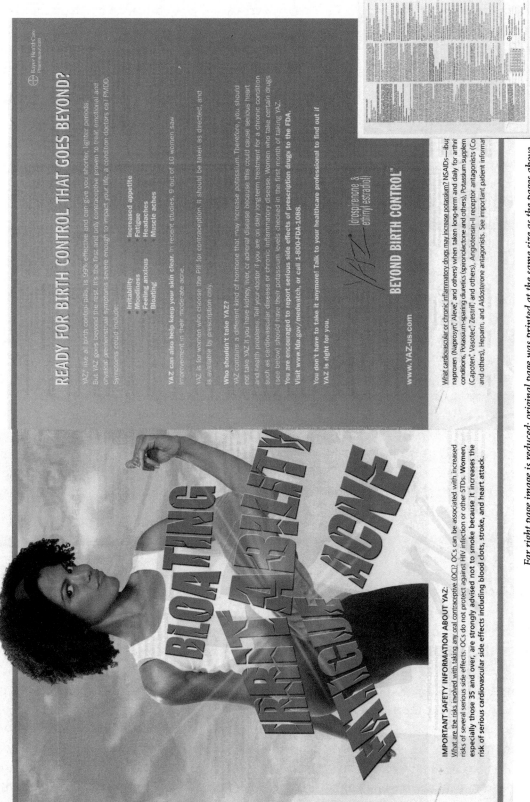

Far right page image is reduced; original page was printed at the same size as the pages above.

The bad news relates to a drug's potential risks and side effects. In order to fulfill FDA requirements, risk information must be presented. However, TV commercials generally deliver that information faster—30 percent faster, on average—than information about a drug's potential benefits, according to an analysis by scholars Kimberly Kaphingst and William DeJong (McGowan, 2008). In TV spots, the rapid-fire voice-overs are often delivered in "medicalese" that can prove bewildering for consumers. And, the typical summary of risks and side effects that accompanies print ads is generally a reprint of all the risk information from the physician labeling. Consumers generally do not read it simply because they are overwhelmed by all the technical information. Of some concern is the fact that while consumers tend to have generally less favorable attitudes toward advertising for pharmaceuticals than toward advertising overall, they also tend to be less skeptical of it—consumers are more likely to believe direct-to-consumer ads, as compared to advertising in general (Diehl, Mueller, & Terlutter, 2007).

On the upside, many patients are being treated with the most up-to-date medications for conditions as a result of their exposure to direct-to-consumer messages. But the trend apparently has a price. Newer drugs are not always better than older ones—but they typically are more expensive. The heartburn medication Nexium, for example, was the most advertised drug in 2005, with more than $224 million spent on consumer ads. It is much like the drug Prilosec with similar rates of efficiency, but because it is newer, it is still protected by patent law, meaning that no other company can sell a generic competitor for 20 years. With no competition, such patent-protected pills are generally more expensive—Nexium costs about $160 for a 30-day supply, compared with just $30 for 42 days for Prilosec (McGowan, 2008). New and better drugs are being brought to market at a record pace, thanks to accelerated development and a fast-track approval system by government regulators. About 395 new medicines have been introduced in the past decade, compared with 231 in the previous 10 years. Now in various stages of development are more than 450 medications just to fight off the big killers: heart disease, cancer, and stroke. And direct-to-consumer advertising will encourage consumers to buy them. The trend is likely to continue as the baby boom generation moves into middle age and beyond, and demand will inevitably mount for drugs dealing with arthritis, osteoporosis, and a host of other chronic problems of the elderly.

The Medical Community's Perspective

Drug manufacturers state that pharmaceutical ads put new patients in doctors' waiting rooms. And, according to an FDA survey, among patients who visited doctors and asked about a prescription drug by brand name because of an ad they saw, 88 percent actually had the condition the drug treats (Rados, 2004). This is important because physician visits that result in earlier detection of a disease, combined with the appropriate treatment, may well mean that more people will live longer, healthier lives. However, physicians have not uniformly embraced pharmaceutical advertising. There is concern over the effect of direct-to-consumer advertising on the dynamics of the patient-doctor relationship. Some complain that patients are demanding brand name drugs, whether their doctor recommends them or not. Physicians not only have to defend what they are going to prescribe but also defend what they are not going to prescribe. One investigation showed that only 9 percent of physicians reported feeling no pressure to prescribe from patients informed by advertising; 38 percent felt very little pressure, 47 percent felt pressure, while 6 percent felt a lot of pressure (Spurgeon, 1999). The study revealed that in 30

to 36 percent of cases in which patients asked doctors about a drug they had seen advertised in the media, doctors gave in to the pressure, even when the drug in question was not their first choice. The doctors surveyed say that television advertisements were the most frequent source of their patients' information (77 percent); print advertisements were next (51 percent), followed by television news stories (49 percent) and print news stories (48 percent) (Spurgeon, 1999).

Table 9.4 presents physician's views on the beneficial effects direct-to-consumer ads had for patients. Clearly, the figures do not represent a resounding endorsement of pharmaceutical advertisements that target consumers. While pockets of physicians and health organizations have been outspoken in their opposition to prescription drug advertising targeting consumers, the industry's key players—such as the American Medical Association, American College of Cardiology, and the *New England Journal of Medicine*—have been surprisingly silent. To date, none of these groups has set policies regarding direct-to-consumer (DTC) drug ads. Robert Mills, spokesman for the AMA, has said, "Frankly, the AMA knows the reality that this is a First Amendment issue and you can't ask for a blanket ban on DTC" (Thomaselli, 2008).

Table 9.4: Physician's Views on Beneficial Effects of DTC Advertising on Consumers

Better discussion with patient	53%
Patient more aware of treatments	42%
Informs/educates	10%
Patient more likely to take prescribed drug	10%
Patient more likely to consider Rx drug	9%
New condition discovered	6%
Patient sought treatment for serious condition	2%

Source: Rados, 2004.

THE PHARMACEUTICAL INDUSTRY ISSUES
DIRECT-TO-CONSUMER (DTC) GUIDELINES

In 2004, Merck & Co. was forced to withdraw its popular painkiller Vioxx when it was found to increase patients' risk of heart attacks and strokes (risks that had not shown up in clinical trials before the drug was approved). Critics claimed the drug maker's splashy campaigns minimized the medication's risks. Publicity about the deaths and thousands of personal injury lawsuits promoted drug manufacturers to ease up on direct-to-consumer advertising, and in 2005, the Pharmaceutical Research Manufacturers of America (PhRMA) released its voluntary code of conduct for the direct-to-consumer advertising industry (see Table 9.5). The trade group's chairman, William Weldon, also the CEO of Johnson & Johnson, noted that the code goes well beyond FDA regulations regarding advertising and promotion (Thomaselli, 2005). In addition to announcing the code of conduct, PhRMA also promised to enforce the guiding principles via a variety of means. For example, each drug firm's intention with regard to the guiding principles would be made public. PhRMA indicated plans to establish an office of accountability that would be responsible for receiving comments from the general public as well as health care professionals regarding DTC advertising conducted by any signatory company to the principles.

Any company that publicly states that it will follow the principles will be considered a signatory company. The PhRMA office of accountability would issue periodic reports to the public regarding the nature of the comments and the companies' responses and would also provide a copy of each report to the FDA.

Table 9.5: PhRMA Guiding Principles on DTC Ads for Prescription Medicines

To express the commitment of PhRMA members to deliver DTC communications that serve as valuable contributors to public health, PhRMA has established the following voluntary guiding principles:

1.	These principles are premised on the recognition that DTC advertising of prescription medicines can benefit the public health by increasing awareness about diseases, educating patients about treatment options, motivating patients to contact their physicians and engage in a dialogue about health concerns, increasing the likelihood that patients will receive appropriate care for conditions that are frequently under-diagnosed and under-treated, and encouraging compliance with prescription drug treatment regimens.
2.	In accordance with FDA regulations, all DTC information should be accurate and not misleading, should make claims only when supported by substantial evidence, should reflect balance between risks and benefits, and should be consistent with FDA approved labeling.
3.	DTC television and print advertising which is designed to market a prescription drug should also be designed to responsibly educate the consumer about that medicine, and, where appropriate, the condition for which it may be prescribed.
4.	DTC television and print advertising of prescription drugs should clearly indicate the medicine is a prescription drug to distinguish such advertising from other advertising for non-prescription drugs.
5.	DTC television and print advertising should foster reasonable communications between patients and health care professionals to help patients achieve better health and a more complete appreciation of both the health benefits and the known risks associated with the medicine being advertised.
6.	In order to foster responsible communication between patients and health care professionals, companies should spend an appropriate amount of time to educate health professionals about a new medicine or a new therapeutic indication before commencing the first DTC campaign. In determining what constitutes an appropriate time, companies should take into account the relative importance of informing patients of the availability of a new medicine, the complexity of the risk-benefit profile of that new medicine and health care professionals' knowledge of the condition being treated. Companies should continue to educate health care professionals as additional valid information about a new medicine is obtained from all reliable sources.
7.	Working with the FDA, companies should continue to responsibly alter or discontinue a DTC advertising campaign should new and reliable information indicate a serious previously unknown safety risk.
8.	Companies should submit all new DTC television advertisements to the FDA before releasing these advertisements for broadcast.
9.	DTC television and print advertising should include information about the availability of other options such as diet and lifestyle changes where appropriate for the advertised condition.
10.	DTC television advertising that identifies a product by name should clearly state the health conditions for which the medicine is approved and the major risks associated with the medicine being advertised.

(Table continued on next page)

11.	DTC television and print advertising should be designed to achieve a balanced presentation of both the benefits and the risks associated with the advertised prescription medicine. Specifically, risks and safety information in DTC television advertising should be presented in clear, understandable language, without distraction from the content, and in a manner that supports the reasonable dialogue between patients and health care professionals.
12.	All DTC advertising should respect the seriousness of the health conditions and the medicine being advertised.
13.	In terms of the content and placement, DTC television and print advertisements should be targeted to avoid audiences that are not age appropriate for the messages involved.
14.	Companies are encouraged to promote health and disease awareness as part of their DTC advertising.
15.	Companies are encouraged to include information in all DTC advertising, where feasible, about help for the uninsured and underinsured.

Source: Thomaselli, 2005.

While a step in the right direction, the PhRMA guiding principles did not implement several measures called for by critics, including a one- or two-year moratorium on ads following a product's approval by the FDA, and a restriction that would limit erectile dysfunction drug ads on TV to between 10 p.m. and 6 a.m. Further, some of the principles have already drawn internal debate. Principle 10 essentially bans reminder ads, which are typically 15-second spots that identify a drug by name but do not have to include risk information. In its defense, PhRMA noted that such reminder ads do not serve the purpose of education. Initially, it appeared that drug companies were indeed following through on their pledge to delay the introduction of new drugs and to conduct more testing before they began advertising new brands. After a brief lull, drug firms' direct-to-consumer advertising surged in 2006. Spending on TV and print advertising grew 14 percent in 2006, to more than $5 billion in the U.S. market and jumped another 6.7 percent in the first quarter of 2007, according to TNS Media Intelligence, a firm that tracks advertising spending (Jordan, 2007).

DRUG ADS FACE INCREASED SCRUTINY

As a result of the Vioxx case (Merck recently reached a $58 million settlement with 30 state attorneys general over the ads for the medication—the largest settlement a consumer-protection multistate group has ever received in a pharmaceutical case—as well as the proliferation of direct-to-consumer advertising, Congress passed new legislation expanding both the FDA's oversight of such advertising and its funding (McGowan, 2008). Previously, if marketers committed serious regulatory violations in their advertising, the FDA could issue a warning letter requesting the offending ad be pulled and might request corrective advertisements to assure that the audience that received the original false or misleading information also received truthful and accurate information. Now, the FDA can also impose fines as high as $250,000 for ads it deems misleading. The FDA had long been so overwhelmed by drug industry advertising materials that only a small portion were reviewed (in 2007, the FDA received 12,616 drug ad materials directed to consumers). Often, the FDA did not declare consumer ads false or misleading until after the ad campaigns had run their course. In 2008, the FDA received $6.1 million (up from $2.2 million

in 2007, and just $1 million the year before) to hire more staffers to review all TV ads for fairness and accuracy before they are aired. But whether this level of funding will be sustained and continue to come from taxpayers—or will be raised from drug makers through new user fees—is likely to be battled out in Congress as it addresses future FDA funding. The 2009 budget sent to Congress for approval called for $14 million from fees for drug ad reviews to fund 27 FDA positions devoted to the consumer ad review program. In exchange, the FDA would agree to review TV drug ads within 45 days of receiving them from drug makers—which is significantly faster than many reviews occur now—and before the ads are seen by millions of viewers. PhRMA supports the user fees, noting that timely FDA review would help drug makers meet marketing goals and lessen the risk of running ads later cited by the FDA for false or misleading content (Schmit, 2008).

Recently, in a surprising development, the FDA—which rarely asks for corrective advertising—along with 27 state attorneys general ordered Bayer to produce a six-month, $20 million corrective advertising campaign for Yaz, the German pharmaceutical company's birth control pill. The FDA ruled that Bayer's marketing and advertising for Yaz (see Figure 9.8) was deceptive and made false claims regarding its efficacy for acne and premenstrual syndrome. Bayer also has to submit all its advertising for Yaz to the FDA for pre-approval for the next six years. Yaz brought more than $600 million in sales to Bayer in 2008 and is the leading nongeneric in the birth control market, with a share of almost 20 percent. The amount Bayer must spend on corrective ads is almost a third of the $66.7 million it spent in measured media in January through November 2008. Notes Michael Guarini, president of the New York–based Flaum Communications, "Corrective advertising punishment could force a philosophical change in DTC advertising. Companies are . . going to be even more careful of how to bring DTC to market." John Kamp, executive director of the Coalition for Healthcare Communications, noted that "corrective advertising is the WMD (weapon of mass destruction) of marketing. Although the FDA always claimed they had it, the FDA never opened fire like this. This could open a new chapter in the history of government attempts to censor pharmaceutical marketing" (Thomaselli, 2009).

The FDA recently launched a new Web site, "Be Smart About Prescription Drug Advertising: A Guide for Consumers" (www.fda.gov/cder/ethicad). The goal of the site is to educate consumers about how to view direct-to-consumer advertisements, prepare them for discussions with health care professionals, and help improve patient understanding and medical care. The site includes the following tips:

- Your health care provider is the best source of information about the right medicines for you.
- Prescription drug advertisements can provide useful information for consumers to work with their health care providers to make wise decisions about treatment.
- If you think a prescription drug ad violates the law, contact FDA's Division of Drug Marketing, Advertising, and Communications (DDMAC).

The online guide also provides the following:

- Interactive example ads: The guide offers example ads for fictitious drugs to illustrate different requirements for different types of ads. This helps users learn in both a visual and written manner.

- A list of questions to ask: Consumers can print out a list of questions they should ask themselves when they see a prescription drug ad. This can help discussions with their health care providers.
- A site-specific survey: Users can answer the survey by clicking on the "Give Us Feedback" tab. This is an opportunity to give the FDA feedback about how well the site addresses users' needs.

CONCLUSION

In this chapter, tobacco, alcoholic beverage, and pharmaceutical advertising has been discussed. Several distinctions need to be made between these product categories. In the case of alcohol and cigarettes, not only is the advertising contested but the products themselves have been recipients of heavy criticism. There is some evidence that when used in moderation, there may be some health benefits to the consumption of alcoholic beverages. In contrast, tobacco is the only legally sold product that when consumed as intended ultimately results in illness or death. In the case of pharmaceuticals, in contrast, it is not the product category that causes consternation but rather the aggressive marketing tactics employed to promote them. Regardless of whether it is the product itself or its promotion that results in controversy, it is the marketers' responsibility to ensure that the consuming public is aware of any and all related hazards. And despite the federal and state laws that regulate the marketing of these goods in most countries, it is up to activists and consumer interest groups to serve as watchdogs over these powerful industries.

REFERENCES

Abramson, Jill. (1991, May 21). Selling moderation: Alcohol industry is at forefront of efforts to curb drunkenness—but critics see it as cynicism. *Wall Street Journal*, p. A1.

Alaniz, Maria Luisa. (1998). Alcohol availability and targeted advertising in racial/ethnic minority communities. *Alcohol Health and Research World, 22*(4), 286–289.

Alaniz, Maria Luisa, & Wilkes, C. (1995). Reinterpreting Latino culture in the commodity form: The case of alcohol advertising in the Mexican American community. *Hispanic Journal of Behavioral Sciences, 17*(4), 430–451.

Alcohol advertising works. (2008, March). *Pediatrics for Parents*, Bangor, *24*(3), 1.

Altman, D. G., Schooler, C., & Basil, M. D. (1991). Alcohol and cigarette advertising on billboards. *Health Education Research: Theory and Practice, 6*(4), 487–490.

Alvarez, Lizette. (2003, August 11). Anti-tobacco trend has reached Europe. Retrieved January 9, 2009 from http://www.nytimes.co,/2003/08/11/international/europe/11TOBA

Anonymous (2008, July 31). One billion lives: A global initiative aims to keep tobacco from ravaging the developing world. *The Washington Post*, Washington, p. A18.

Arnold, Matthew. (2008, August). Survey: Pols don't dent DTC credibility. *Medical Marketing and Media*, New York, *43*(8), 28.

Baltagi, B., & Levin, D. (1986). Estimating dynamic demand for cigarettes using panel data: The effects of bootlegging, taxation and advertising reconsidered. *The Review of Economics and Statistics, 68*, 148–155.

Bannatyne, Duncan. (2008, June 29). The cowards killing Africa's children—one cigarette at a time. *Sunday Times*, London, p. 2.

Barg, Jeffrey. (2007, April 25–May 1). Puff daddies. *Philadelphia Weekly*, pp. 26–30.

Beck, Ernest. (1998, November 10). Tobacco: Big tobacco uses good works to woo Eastern Europe. *Wall Street Journal*, p. B1.

Becker, Jeffrey. (1992, Fall). Advertising and abuse: No link. In "Distilling the truth about alcohol ads." *Business and Society Review, 83*, 15.

Benitez, Mary Ann. (2007, August 7). Tobacco firms exploiting loophole: Cigarette makers skirt law by using brand on other products. *South China Morning Post*, Hong Kong, p. 3.

Bhattarai, Binod. (1999). Nepal clamps down on alcohol and tobacco ads. *Financial Times*, p. 4.

Branch, Shelly. (2002, March 1). Study of underage drinking makes liquor firms defensive. *Wall Street Journal*, Brussels, p. N4.

Breweries beat Polish ad ban by marketing nonalcoholic beer with a wink, nod. (1998, October 9). *Salt Lake Tribune*. p. A18.

Claude Brodesser-Akner (2008, June 23). Hey Buddy, Can I bum a Snus off You? *Advertising Age.* P. 1.

California anti-smoking laws save thousands of lives, new study finds. (2007, March 1). *U.S. Newswire*, p. 1.

Carmona, R., Gfroerer, J., Caraballo, R., & Yee, S. L. (2004, January 30). Prevalence of cigarette use among 14 racial/ethnic populations: United States 1999–2001. *Morbidity and Mortality Weekly Report*, Atlanta, 53(3), 49–52.

Castellano, Joseph P. (1992, Fall). Respecting differences. In Distilling the truth about alcohol ads. *Business and Society Review, 83*, 14.

Center for Substance Abuse Prevention. (1993). Discussion paper on preventing alcohol, tobacco and other drug problems.

Centers for Disease Control and Prevention (CDC). (1998, June 10). Publication of Surgeon General's report on smoking and health. *Journal of the American Medical Association*, p. 1776.

Centers for Disease Control and Prevention (CDC). (2007).

Chelala, Cesar. (1998, March 21). Tobacco corporations step up invasion of developing countries. *The Lancet*, London, p. 889.

Chiesa, Alison. (2007, August 30). Will this shock you into giving up? All tobacco products will soon carry graphic images. *The Herald*, Glasgow, UK, p. 13.

Clark, Cheryl. (1998, February 18). Advertising, teen smoking found related. *The San Diego Union-Tribune*, p. A1.

Commission denies any plans to ban alcohol advertising. (1998, January 17). *European Report*, p. 1.

Connolly, G. N. (2007, February 27). Testimony before the Senate HELP Committee.

Coors brewing company recognized for diversity efforts. (1999, July 28). *PR Newswire*, p. 1.

Cowley, Geoffrey. (1992, June 29). Poison at home and work. *Newsweek*.

Craver, Richard. (2008, October 8). Reynolds moves to be on top when smoke clears: Dissolvable tobacco offered as smoking bans proliferate. *Winston-Salem Journal*, Winston-Salem, NC, p. 6.

Daykin, Tom. (2008, September 9). MillerCoors sued over Sparks: Health groups says beverage shouldn't contain stimulants. *McClatchy-Tribune Business News*, Washington, http://proquest.uni.com.libproxy sdsu.edu/pqdweb?index=32&did

Diehl, Sandra, Mueller, Barbara, & Terlutter, Ralf. (2007). Skepticism toward pharmaceutical advertising in the U.S. and Germany. In Charles R. Taylor and Doo-Hee Lee (Eds.), *Advances in International Marketing, Cross-Cultural Buyer Behavior, 18,* 31–62.

Distilled Spirits Council, FTC report concludes distilled spirits advertising adheres to rigorous adult standards. (2008, July 7). *Business & Finance Week*, Atlanta, p. 129.

Drug makers raise ad spending. (2006, October 6). *Wall Street Journal*, p. B4.

Drunk on ads. (2007, May/June). *Multinational Monitor, 28*(3), 47.

Duffy, M. (1996). Econometric studies of advertising, advertising restrictions and cigarette demand: A survey *International Journal of Advertising, 15*, 1–23.

Elias, Marilyn. (1998, November 3). Under the influence: Children, beer ads don't mix, critics say. *USA Today*, p. 8D.

Elliott, Stuart (2007, February 15). A new Camel brand is dressed to the nines. *New York Times*, New York, p. C9.

Emert, Carol. (1998, May 23). Bud critters criticized: Spokes-animals encourage youth to drink, anti-alcohol activists say. *San Francisco Chronicle*, p. B1.

Ewen, Stuart. (1976). *Captains of consciousness: Advertising and the racial roots of the consumer culture*. New York: McGraw-Hill.

Fairclough, Gordon. (2001, September 24). E-commerce (A special report): Online cigarette sites spark health concerns. *Wall Street Journal*, p. 27.

Farris, Paul, & Albion, Mark. (1980). The impact of advertising on the price of consumer products. *Journal of Marketing, 44*, 17–35.

Fernandez, Elizabeth. (1998, June 28). Multilingual tobacco warning: FTC changes policy for ethnic audiences. *San Francisco Examiner*, p. A1.

Fitzgerald, Nora. (1998). Ad-ulterated. *AdWeek, 39*(15), 27–29.

Flay, B. (1987). *Selling the smokeless society*. Washington, D.C.: American Public Health Association.

Frank, George, & Wilcox, Gary. (1987). Alcoholic beverages advertising and consumption in the United States: 1964–1984. *Journal of Advertising, 16*(3), 22–30.

Galbraith, John K. (1958). *The affluent society*. London: Hamish Hamilton.

Givel, Michael, & Glantz, Stanton. (2004, February). The global settlement with the tobacco industry: 6 years later. *American Journal of Public Health*, Washington, *94*(2), 218–224.

Grant, Bridget. (2000, January 4). US Dept of HHS: One in four children exposed to family alcohol abuse or alcoholism. *M2 Presswire*, p. 1.

Hacker, George. (1998, Spring). Liquor advertisements on television: Just say no. *Journal of Public Policy and Marketing, 17*(1), 139–142.

Hacker, George, Collins, Ronald, & Jacobson, Michael F. (1987). *Marketing booze to blacks*. Washington D.C.: Center for Science in the Public Interest.

Hamilton, J. (1975). The effect of cigarette advertising bans on cigarette consumption. In *Proceedings of the Third World Conference on Smoking and Health*. Washington, D.C.: U.S. Department of Health, Education, and Welfare.

Harwood, H. (2000). *Updating estimates of the economic costs of alcohol abuse in the United States: Estimates, update methods and data*. Report prepared by The Lewin Group for the National Institute on Alcohol Abuse and Alcoholism.

Hatsukami, Dorothy, Stead, Lindsey, & Gupta, Prakash. (2008, June 14–20). Tobacco addiction. *The Lancet*, London, *371*(9629), 2027–2038.

Hays, Jeffrey. (2008). Smoking in China. http://facts and details.com/china.php?itemid+140&catid+11&subcat

Heinekin USA celebrates leadership of Congressional Black Caucus Foundation in creating positive impact on local communities. (2007, September 26). *U.S. Newswire*. http://proquest.umi.com.libproxy.sdsu.edu/pqdweb?index=37&did.

Hendren, John. (1998, January 11). Advertising—drug ads boost sales, enrage doctors. *Dayton Daily News*, p. 6E.

Henke, Lucy. (1995). Young children's perceptions of cigarette brand advertising symbols: Awareness, effect and target market identification. *Journal of Advertising, 24*(4), 13–28.

Herdt, Timm. (1998, March 29). Hispanic groups assail alcohol ads. *Orange County Register*, p. A37.

Hirsch, Jerry. (2008, August 12). Beverages: Critics take shots at alcohol pouches. *Los Angeles Times*, Los Angeles, p. C1.

Hocker, Cliff. (2008, October). United, if not unanimous. *Black Enterprise*, New York, *39*(3), 33.

Ives, Nat, & York, Emily. (2007, December 3). R. J. Reynolds pulls out of print. *Advertising Age*, Chicago, *78*(48), 8.

Jacobson, Michael F., & Mazur, Laurie Ann. (1995). *Marketing madness: A survival guide for a consumer society* Boulder, CO: Westview.

Jacobson, Michael F., Taylor, Patricia, & Baldwin, Deborah. (1993). Advertising alcohol: This brew's for you. *Medical and Health Annual*, p. 154.

Jernigan, David, & Wedekind, Jennifer. (2008, July/August). Intoxicating brands: Alcohol advertising and youth *Multinational Monitor*, Washington, 29(1), 23–27.

Johnson, Bradley. (2007, June 25). Marlboro man rides into the sunset. *Advertising Age*, Chicago, 78(26), 26.

Jordan, George. (2007, July 18). After lull, drug firms' direct-to-consumer ads surge. *Newhouse News Service*, Washington, p. 1. Retrieved October 20, 2008, from http://proquest.umi.com.libproxy.sdsu.edu/ pqdweb?index=37&did

Juarez, Jovita, & Rosa-Lugo Jr., Bernardo. (2008, May 3). Brewers target Latino kids in bid to gain market. *The Sacramento Bee*, Sacramento, California, p. B7.

Kahn, Tamar. (2008, August 15). Report challenges tobacco industry's advertising claims. *Business Day*, Johannesburg, p. 6.

Kranhold, Kathryn. (2000, May 9). Liquor ads pop up on sites for children—glitch shows power, pitfalls of promoting brands online. *Asian Wall Street Journal*, p. 28.

Kwate, Naa Oyo A. (2007, June). Take one down, pass it around, 98 alcohol ads on the wall: Outdoor advertising in New York City's Black neighborhoods. *International Journal of Epidemiology*, 36, 988–990.

Laugesen, M., & Meads, C. (1991). Tobacco advertising restrictions, price, income and tobacco consumption in OECD countries, 1960–1986. *British Journal of Addiction*, 86, 1343–1354.

Lewan, Todd. (1998, February 20). Tobacco firm says it exports high-nicotine blend. *The San Diego Union-Tribune*, p. A7.

Lewit, E., Coate, D., & Grossman, M. (1981). The effects of government regulation on teenage smoking. *Journal of Law and Economics*, 24, 545–569.

Lipman, Joanne. (1990, February 27). Foes claim ad bans are bad business. *Wall Street Journal*, p. B1.

Lo, Alex. (2007, August 9). Some taxing questions over big tobacco. *South China Morning Post*, Hong Kong, p. 12.

Loftus, Peter. (2007, November 7). Drug ads don't tempt Europe. *Wall Street Journal*, New York, p. B5D

Lunau, Kate. (2008, August 4–18). Butts on the line. *McLean's*, Toronto, 121(30/31), 34–36.

Mack, R. (1997). Bringing down the walls of state pre-emption: California cities fight for local control of alcohol outlets. *African American Law and Policy Report*, 3(1), 295–324.

Marin Institute: Big alcohol can't police itself. (2008, October 4). *Business & Finance Week*, Atlanta, p. 324.

Mastering the dark arts. (2004, April 6). *Financial Times*, London, p. 1.

McAllister, J. F., Abend, Lisa, Walker, Jane, Carey, Mairead, & Carsen, Jessica. (2005, December 19). The British disease: Binge drinking used to be a mostly Anglo-Saxon thing. But now it's sweeping Europe from Malmo to Madrid. *Time International*, Atlantic ed., New York, 166(25), 20.

McGowan, Kathleen. (2008, March). There's a pill for that. *Redbook*, New York, 210(3), 158.

McGreal, Chris. (2008, January 15). Smoking: Nigeria takes on big tobacco over campaigns that target the young. *The Guardian*, London, p. 23.

Meller, Paul. (2001, May 31). New effort at curbing tobacco ads in Europe. *New York Times*, p. W1.

Miller, Cyndee. (1994, November 21). Drug firms boost pitch directly to consumers. *Marketing News*, p. 1.

Monroe, Nichole. (1998, September 10). U.S. tobacco warnings not exported. *Austin American Statesman*, p. A8

Morrison, Margaret & Krugman, Dean, & Park, Pumsoon. (2008, March). Under the radar: Smokeless tobacco advertising in magazines with substantial youth readership. *American Journal of Public Health*, Washington, 98(3), 543–548.

Muhammad, Charlene. (2008, May 1–7). Black youths drink less, but they are targeted more. *New York Beacon*, 15(17), 4.

Mullman, Jeremy. (2008a, February 18). Breaking with bottle fires up Absolut sales. *Advertising Age*, p. 4.

Mullman, Jeremy. (2008b, September 17). Attorneys general set out to stop Sparks product launch. *Advertising Age.* Retrieved November 1, 2008, from http://adage.com/print?article_id=131090

Mundy, Alicia. (1994, May 30). Team works. *AdWeek,* p. 8.

Nainggolan, Lisa. (2009, January 7). *Smoking still takes a heavy toll in China.* Retrieved January 9, 2009, from http://www.medscape.com/viewarticle/586426

Neergaard, Lauran. (1999, November 17). Consumers tune out drug ads, expert says. *Arizona Republic,* p. A13.

Nemours Foundation. (2007). *Smokeless tobacco.* Retrieved May 7, 2007, from http://www.kidshealth.org/teen/drug_alcohol/tobacco/smokeless.html

New CDC report demonstrates urgency for all states and cities to become smoke-free. (2008, July 10). *U.S. Newswire,* Washington, p. 1.

New York Times News. (1999, September 23). US files king-size tobacco lawsuit. *San Diego Union-Tribune,* p. A1.

Parker, Betty. (1998). Exploring life themes and myths in alcohol advertisements through a meaning-based model of advertising experiences. *Journal of Advertising, 37*(1), 97–110.

Parker-Pope, Tara. (1996, December 18). Most advertising executives in survey believe tobacco firms target children. *Wall Street Journal,* p. B10.

Passariello, Christina. (2009, January 2). *Europe's smoking culture lingers, despite bans.* Retrieved January 9, 2009, from http://online.wsj.com/article/SB123085631602247715.html

Pilling, David. (1999). Just what the patient ordered: The practice of advertising drugs is spreading. *Financial Times,* London, p. 11.

Pirisi, Angela. (1999, November 27). Patient-directed drug advertising puts pressure on US doctors. *The Lancet,* London, p. 1887.

Pollay, Richard W., Lee, Jung S., & Carter-Whitney, David. (1992, March). Separate but not equal: Racial segmentation in cigarette advertising. *Journal of Advertising, 21*(1), 45–57.

Pomeroy, Henry. (1992, Fall). Proof of commitment in distilling the truth about alcohol ads. *Business and Society Review,* p. 13.

Profitt, Waldo. (1999, July 8). The last stronghold of tobacco ads loses a few troops. *Sarasota Herald Tribune,* p. 12A.

Rados, Carol. (2004, July–August). Truth in advertising: Rx drug ads come of age. *FDA Consumer Magazine.* Retrieved October 20, 2008, from http://www.fda.gov/fdac/features/2004/404_ads.html.

Ramakant, Bobby (2008, June 27). Scaling up tobacco control strategies in India. *News India,* India, *39*(26), 18.

Rice, Dorothy (1999). Economic costs of substance use. *Proceedings of the Association of American Physicians, 111*(2), 119–125.

Rogers, Danny. (1998, November 26). Tobacco spin-offs face new curb. *Marketing,* London, p. 1.

Rosenberg, Neil. (1997, November 18). Lung cancer death rate leaps for state women: Their mortality rises 94% in 15 years; increase tied to cigarette marketing. *Milwaukee Journal Sentinel,* p. 1.

Saffer, Henry. (1998, Summer). Economic issues in cigarette and alcohol advertising. *Journal of Drug Issues,* pp. 781–793.

Saul, Stephanie (2008, July 17). Does big tobacco scheme on menthol? *Desert News,* Salt Lake City, p. 9.

Savage, David. (2007, November 29). High court hears on-line sales dispute: At issue is a law to keep minors from purchasing Internet cigarettes. *Houston Chronicle,* p. 12.

Schleifer, Yigal. (2006, January 9). Turkish leaders push for smoking ban: The bill, which is likely to pass, challenges the stereotype of "smoking like a Turk." *The Christian Science Monitor,* Boston, p. 7.

Schmit, Julie. (2008, February 24). Drug ads to get more FDA scrutiny. *USA Today.* Retrieved October 20, 2008, from http://www.usatoday.com/money/industries/health/drugs/2008-02-24

Schneider, L., Klein B., & Murphy, K. (1981). Government regulation of cigarette health information. *Journal of Law and Economics, XXIV,* 575–612.

Selling death overseas. (1998, April 7). *Washington Post,* p. A22.

Shao, Alan, & Hill, John. (1994). Global television advertising restrictions: The case of socially sensitive product *International Journal of Advertising, 13,* 347–366.

Shapiro, Eben. (1993, January 27). Anti-smoking ads in California prove effective. *Asian Wall Street Journal,* p. 20.

Shin, Annys. (2008, June 27). Anheuser to pull caffeine drinks; States pressed brewer over marketing of Tilt, Bud Extra. *The Washington Post,* Washington, p. D2.

Side effects of an EU drug ads rethink. (2001, July 19). *Marketing Week,* p. 21.

Simpson, H. M., Beirness, D. J., Mayhew, D. R., & Donelson, A. E. (1985). *Alcohol specific controls: Implications for road safety.* Ottawa: Traffic Injury Research Foundation of Canada.

Sivulka, Juliann. (1998). *Soap, sex and cigarettes: A cultural history of American advertising.* Belmont, CA: Wadsworth.

Smart, R. G., & Cutler, R. E. (1976). The alcohol advertising ban in British Columbia: Problems and effects on beverage consumption. *British Journal of Addiction, 71,* 13–21.

Smoking levels in the WHO European region have stabilized (2008). Retrieved January 8, 2009 from http://www.emaxhealth.com/58/9865.html

Spurgeon, David. (1999, November 20). Doctors feel pressurized by direct to consumer advertising. *British Medical Journal,* p. 1321.

Stamborski, Al. (1999, September 10). FTC asks that alcohol ads be kept from minors: A-B begins campaign against drinking abuse. *St. Louis Post-Dispatch,* p. C10.

Steenhuysen, Julie. (2008, August 22). Smoking gun points to ads, movies: Study says depictions of actors lighting up in films and tobacco industry promotions hook smokers early. *Los Angeles Times,* Los Angeles, p. E10.

Stewart, M. (1993). The effect on tobacco consumption of advertising bans in OECD countries. *International Journal of Advertising, 12,* 155–180.

Szynal, Deborah. (2002, February 4). New bill aims to separate kids, cigs online. *Marketing News,* pp. 6–7.

Taylor, Charles, & Raymond, Mary Anne. (2000). An analysis of product category restrictions in advertising in four major East Asian markets. *International Marketing Review, 17*(3), 287–304.

The Center on Alcohol Marketing and Youth: Alcohol advertisements seen by youth on TV on the rise. (2008, July 7). *Entertainment Weekly,* Atlanta, p. 91.

The perverse prosperity of the tobacco industry. (2008, January 26–February 1). *The Lancet,* London, *371*(9609), 276.

Thomaselli, Rich. (2005, August 2). Pharmaceutical industry issues DTC guidelines. *Advertising Age,* p. 1.

Thomaselli, Rich. (2008, February 25). Medical groups mum on DTC ads. *Advertising Age,* p. 4.

Thomaselli, Rich. (2009, February 16). What Bayer campaign means for Pharma ads. *Advertising Age,* p. 3.

Thornton, Jacqui. (2000, May 4). Should drug ads be legal? The ban on DTC pharmaceutical ads looks to be coming to an end. *Marketing.* .

Tkach, Vlada. (1998, August 11). Eastern Europeans fall for appeal of western cigarettes. *Financial Times,* London, p. 2.

Tobacco marketing causes kids to smoke. (2008, August 24). *La Prensa,* San Antonio, *20*(8), 2A.

Todd, Deborah. (2007, August 22–28). Study: Big tobacco targets blacks. *New Pittsburgh Courier, 98*(34), A1–2.

Tribune News Services. (1998, July 31). CDC predicts decrease in smoking from any cost hike biggest cut would be among minorities. *Chicago Tribune,* p. 4.

Voas, Robert. (2006, January 12). There's no benefit to lowering the drinking age. *The Christian Science Monitor,* Boston, p. 9.

Warmbrunn, Susan. (1998, September 19). Tobacco's appeal to minority youth concerns coalition: Residents blame advertising. *Colorado Springs Gazette-Telegraph,* p. 1.

Warner, Kenneth E. (1995). *Selling smoke: Cigarette advertising and public health.* Washington, D.C.: American Public Health Association.

Werner, Erica. (2009, April 3). House votes to give FDA authority over tobacco. *San Diego Union-Tribune,* p. A3

Wine Institute. (2002). Wine Institute Code of Advertising Standards. San Francisco, CA.

World Health Organization (WHO). (2008). *The Nation's Health.*

Zuckerbrod, Nancy. (2002, March 12). Bush seeks tough, new rules on nation's tobacco industry. *The Charleston Gazette,* p. 3A.

Zuckerbrod, Nancy. (2006, July 17–18). Smoking on the rise for women worldwide, report says. *Chicago Defender, 101*(42), 11.

The Commercialization of Societies

INTRODUCTION

The economic meltdown of 2008 had a direct impact on the advertising industry. ZenithOptimedia reported that global advertising spending will decline 6.9 percent in 2009—the greatest drop in nearly three decades. Spending in Western Europe is expected to drop by 6.7 percent, while U.S. outlays will slump 8.7 percent. According to the study, a slight recovery is due in 2010, which will continue in 2011 ("Message to Media," 2009). It is the developing markets that will take over as the main contributors to global growth, compensating for slow growth in developed markets. In most developed nations, advertising can easily be seen as the most intrusive and pervasive form of communication. However, advertising is becoming increasingly pervasive in developing markets as well. In the United States, advertising accounts for approximately 2.2 percent of the country's gross domestic product. The level of advertising expenditures in the rest of the world is not nearly as high. Table 10.1 ranks the top ten global ad markets by ad expenditures for 1998 and 2007. The table reveals a dramatic shift in the rankings over the decade.

Table 10.1: Top 10 Countries by Ad Expenditure (US$ millions)

COUNTRY	1998		2007		98–07 PERCENT CHANGE
	EXPENDITURE	RANK	EXPENDITURE	RANK	
USA	115,878	1	163.260	1	40.9
China	—	—	76,675	2	—
Japan	29,653	2	38,529	3	29.9

Table continued on next page

UK	17,649	4	29,915	4	69.5
Brazil	10,378	5	26,640	5	156.7
Germany	21,342	3	24,306	6	13.9
Mexico	4,071	11	19,036	7	367.7
France	9,967	6	14,595	8	46.4
Italy	6,955	7	12,257	9	76.2
Canada	5.394	8	11,313	10	109.7

Source: World Advertising Research Center. (2008). World Advertising Trends. Retrieved February 5, 2009, from http://www.warc.com/LandingPages/Data/AdspendByCountry.asp

ADVERTISING IS INTRUSIVE

For most consumers, most of the time, advertising is an unwelcome intrusion—unlike any other form of popular communication. For example, we choose which magazines, newspapers, and books to read; we determine which television programs to watch or which radio stations to tune to; and, we decide whether we want to spend an evening at a theater or to rent a video and watch it at home. Or perhaps we'll just surf the Net. When we consume any of the popular media, we are in control of which messages we absorb, where we absorb them, and for how long. The same cannot be said for advertising. Advertising, for the most part, seeks us out, intruding upon our private space. From the moment we open our eyes each morning, advertising is there. The clock-radio alarm rings to awaken us, and we are exposed to the first advertising messages of the day. We head off to the kitchen for a cup of coffee, read the morning paper or turn on the TV, and absorb more advertisements. Going to work or school, we may listen to the radio to check the traffic. The report is interrupted by commercial messages. As we drive down the freeway, the roads are littered with billboards vying for our attention. Advertising pursues us all day long. In the trade journal at work or the campus newspaper at the university, corporations are telling us what to buy. Additional messages pop up on our computer. And the shirts, caps, pants, and shoes of nearly everybody we meet carry brand names on them. At home in the evening, we might anticipate our favorite television program, only to find it interrupted with messages from fast food companies and automobile dealerships. On the weekend, we may head to the gym to get some much-needed exercise. As we climb aboard the exercise bicycle, we are confronted by commercials for health-related products on a television monitor turned to Health Club TV (HCTV). On the way home, we might stop off at K-MART to pick up some shampoo. As we wander the aisles, we listen to KMRT, a point-of-purchase radio signal with 12 minutes of advertising every hour. Later that night, we might head out to a restaurant for an enjoyable meal. The menu pages may well be interspersed with full-page ads for cosmetic surgery, clothing, or real estate. Even in the privacy of the toilet stall, we could be confronted by advertisements for night clubs vying to round out our evening. In the United States, no matter what time of day, day of the week, or where we go, consumers are confronted by a constant stream of inescapable commercial communications.

The proliferation of advertising over the past few decades has been astonishing. J. Walker Smith, president of the market research firm Yankelovich, estimates that the average 1970s city dweller was exposed to 500 to 2,000 ad messages a day. Today, that number is up to 5,000 (Petrecca, 2006). And, Kalle Lasn (1999), founder and editor of *AdBusters*, claims that Americans

are exposed to nearly 16,000 marketing messages every 24 hours. About half of the 4,110 consumers surveyed by Yankelovich said they thought marketing and advertising today were out of control. Advertisers and their agencies, too, find the clutter frustrating. "It is the ultimate challenge," says Jeff Hicks, president and partner of Crispin Porter and Bogusky in Miami. "The greater the number of ads, the less people pay attention to them. One ad is the same as another now. People simply don't believe them anymore" (Pappas, 2000, p. 16). Commercial messages have proliferated in the traditional media (television, radio, newspapers, and magazines) as well as the nontraditional new media.

ADVERTISING IS PERSUASIVE

Traditional Media

In the United States, advertising expenditures in the traditional media—such as TV, radio, and newspapers—have decreased slightly in recent years, but advertising in new media, particularly the Internet, has grown (see Table 10.2). Advertising expenditures inevitably are correlated with advertising clutter.

Table 10.2: U.S. Ad Spending Totals by Medium (Projected in US$ millions)

RANK	MEDIUM	2009	2008	PERCENT CHANGE	PERCENT TOTAL
1.	Direct Mail	$58,430	$59,622	− 2.0	22.6
2.	Broadcast TV (network, spot, syndicated)	40,513	43,734	−7.4	15.7
3.	Newspaper	31,612	35,788	−11.7	12.2
4.	Cable TV Networks	21,654	21,440	1.0	8.4
5.	Radio	16,463	17,535	− 6.1	6.4
6.	Yellow Pages	13,195	13,844	−4.7	5.1
7.	Consumer Magazine	12,053	12,960	−7.0	4.7
8.	Internet	11,940	11,371	5.0	4.6
9.	All Other	52,852	54,473	−3.0	20.4
TOTAL		258,712	270,767	−4.5	100.0

Source: *Advertising Age. (2008, December 29). p. 10.*

Broadcast

Advertisers have long objected to television clutter caused by too many minutes of commercials, along with station promos and other nonprogramming material (such as public service announcements: PSAs)—all of which hampered their ability to break through with their messages. But with branded entertainment—a recent Association of National Advertisers survey found that 66 percent of marketers are engaged in branded entertainment initiatives—the definition of clutter may be broadened to include this growing tactic, which exposes viewers to even more commercialism (Goetzl, 2006). Branded entertainment is quite simply a marketer's attempt to disguise advertising as part of the entertainment, with the hopes of increasing the

chances viewers will pay attention. With branded entertainment—or product placement as it is also known—a brand is included in a media vehicle (such as a television program, a film, or a video game) in exchange for goods, services, and/or money (Lane, King, & Russell, 2008). While product placement in television has been around since the 1950s, when brands were placed in soap operas, it did not really take off until the turn of the twenty-first century; and today it is nearly impossible to watch a TV program without being exposed to one or more placements. One report (Goetzl, 2006) shows that after product placement is factored into the equation, marketing messages account for 21 minutes or 35 percent of every hour in prime time. In reality or unscripted programs, that figure increases to more than 40 percent in an average hour. Not surprisingly, reality shows on average had more than triple the product integration time of dramas and comedies (Goetzl, 2006). See Table 10.3 for a breakdown of advertising and brand appearances per network TV hour.

Table 10.3: Advertising & Brand Appearances Per Network TV Hour (Minutes : Seconds Per Hour)

AD/ MESSAGES	BRAND/ APPEARANCES	AD/BRAND	TOTAL
Network Prime Time Average	17:38	3:22	21:00
Unscripted/Reality Programs	18:06	7:39	25:45
Scripted Programs	17:31	2:08	19:39
Network Late Night Average	22:46	8:41	31:27

NOTE: Ad messages include network and local commercial time, promos, and PSAs.

Source: TNS Media Intelligence. (2006, First Quarter).

Bond and Kirshenbaum (1998) note that these types of subtle ads allow sponsors to get past the radar and penetrate beyond the audience's barrier of cynicism. Product placement works precisely because it does not seem like advertising. Evidence that program audiences pay better attention to and more often remember brands placed within media programs is mounting (Babin & Carder, 1996; Brennan et al., 1999; Gupta & Lord, 1998; Karrh, 1994). It appears they also have an impact on the bottom line. Crest's Vanilla Mint toothpaste, AT&T's text-messaging phones, and Illuminations' candle sconce all saw boosts in sales after being featured on *The Apprentice*, *American Idol*, and *Queer Eye for the Straight Guy*, respectively. Pontiac received 1,000 orders for its Solstice roadster in just 41 minutes the day after the car played a prominent role in an episode of *The Apprentice* (Lovell, 2005). These seamless commercial messages woven into the program's plot can occur in the following forms:

- A passing or background visual: The brand is displayed in the background. For example, a scene might be shot on a city street and a Federal Express truck bearing the bright orange and purple logo might be seen passing behind the actors.
- Verbal mention: The product is explicitly mentioned in the script.
- Handling the product: The actor handles or uses the product.
- Combination of uses: A combination of verbal and visual placements.

Given the proliferation of product placement, critics have called for increased regulation, arguing that product placement blurs the lines between advertisement and content, and is thus a form of deception. "Programs like 'The Apprentice' and 'American Idol' deal in dishonest or

stealth advertising that sneaks by our critical faculties and plants its message when we're not paying attention," said Gary Ruskin, executive director of Commercial Alert. "What is 'American Idol' but an infomercial for Coca-Cola?" (Lovell, 2005). Indeed, in 2005, Commercial Alert petitioned the Federal Trade Commission and the Federal Communications Commission to regulate reality TV the way they regulate infomercials for exercise equipment and diet supplements. Both the FTC and the FCC ruled against requiring placement disclosures for television programs. Proponents of product placement suggest that it is unnecessary to regulate the practice because the public can choose to tune out.

Brand placement in television production is much more common and overt in some countries than others. In Brazil, popular soap operas are so full of brands "that some multinationals, like Coca-Cola, sign annual contracts with TV Globo to keep their wares incessantly written into the show's ongoing stories" (Miller, 1990, p. 196). Product placement also plays a dominant role in South African programming. South African broadcasters are very aware of the concept as an alternative to traditional advertisements, and the past 10 years have seen a move away from scripted to natural and organic, seamless integration of brands. South African soap operas, in particular, have become the vehicle of choice—with programs like *Generations, Isidingo, Muvhangol,* and *7 de Laan* being used for such campaigns. Fast-moving consumer goods, such as shampoo and household cleaning products, are the most commonly used products for placement as they are not difficult to reconcile with viewer demographics. In this market, product placement can be good for TV networks struggling to produce quality content with tight budgets (Tlaleane, 2009). In contrast, the United Kingdom's culture secretary recently decided to block product placement in UK television—allowing it only in video-on-demand programs and in films produced outside the country (Darby, 2009).

Because radio listeners tend to switch stations when commercials come on, Clear Channel communication developed the concept of the two-second spot. The two-second format—Clear Channel calls them "blinks"—offers two immediate benefits for advertisers. First, because they pop up within programs, they do not compete for consumer's attention with longer ads packed into minutes-long commercial breaks. The second advantage is the ads' brevity: listeners would have to be awfully fast on the draw to zap such a brief commercial message. For example, on an oldies station, just as one song on the radio fades away, the audience might hear "Iced coffee at McDonald's." Just four words and the commercial is over. The National Association of Broadcasters has commissioned a study to determine the effectiveness of "blink" ads compared to 30- and 60-second spots (Farhi, 2007).

Print

Most newspapers have a 60/40 ratio of advertising to editorial content. To combat clutter, advertisements have been making their way to the front page. American newspapers ran front-page ads in bygone days, but in modern times, most have not opted to do so. Some papers, such as the *New York Times, Boston Globe,* and Minneapolis's *Star Tribune,* have experimented with ads on section fronts, but have kept page one off-limits. But in 1999, *USA Today,* owned by Gannett, began running a strip ad along the bottom of its front page, and now most Gannett papers also run front-page ads. Then, in 2006, even the venerable *Wall Street Journal* opened its front page to advertisers. The move was a sign of the relentless financial pressures that have forced newspapers to consider new ways of raising money—like giving prominence to advertisers in areas of the paper once considered sacred. The *Wall Street Journal's* front-page ads are designed to bring

Figure 10.1: Increasingly, ad stickers are plastered across newspaper front pages

in tens of millions of dollars a year in revenue (Bosman & Seelye, 2006). In Britain, front-page ads appear in both *The Daily Telegraph* and *The Financial Times.*

Another approach to front-page advertising has been to plaster a sticker across the newspaper's front page (see Figure 10.1 for an ad stuck to the front page of *The San Diego Union-Tribune*). *USA Today* has taken ad stickers one better—they have scented them. Guests at Omni luxury hotels found small scented stickers on the front pages of their complimentary copies of the newspaper. A blackberry aroma suggested that guests start off their day at the hotel with a cup of Starbucks coffee paired with a fresh muffin. The stickers are the "peel and sniff" variety in that the berry scents are not released until the top layers are lifted. This is intended to minimize complaints from allergic hotel guests. "Omni is one of the brands getting aggressive about sensory marketing," said Michael Davidson, vice president for national circulation sales at *USA Today* in McLean, Virginia, "which made Omni executives excited to try this." The scented stickers are gaining favor because they help brands stand out in crowded, competitive categories (Elliott 2007). Whatever the shape, size, or hue, the long-unfashionable page-one advertisement is gaining grudging acceptance from many editors, page designers, and even reporters (Shaw, 2007).

Many consumer magazines are 50 percent advertising. Indeed, in some instances, these figures are conservative. While fall fashion issues of women's magazines are notoriously fat, a recent September U.S. edition of *Vogue* magazine weighed over 4 pounds, and contained more than 600 pages of ads—over 75 percent of the entire content. Readers looking for editorial content in fashion magazines might turn past over 100 pages of ads to get to the first article. Advertisers try hard to break through all that clutter with a constant stream of innovations. While tear-off strips that allow readers to sniff a new fragrance or even try out a new nail polish color have been around for a while, "Peel 'n Taste" strips may catch the consumer's attention. First Flavor, creators of the strips, hope they will drive sales for food, beverage, and oral care brands by turning one-dimensional ad messages into what they say will be an interactive and entertaining taste experience. Peel 'n Taste is presented to consumers in a compact, easy-to-open, tamper-evident sachet distributed via print ads, direct mail, in-store point of sale, and even on the product itself. Welch's Grape Juice teamed up with First Flavor on a two-page insert in *People* magazine. A study conducted by Starch Communications (Zmuda, 2008) found the strips are indeed rais

Figure 10.2: Ad showcasing an upcoming film on a 4-story building in L.A.

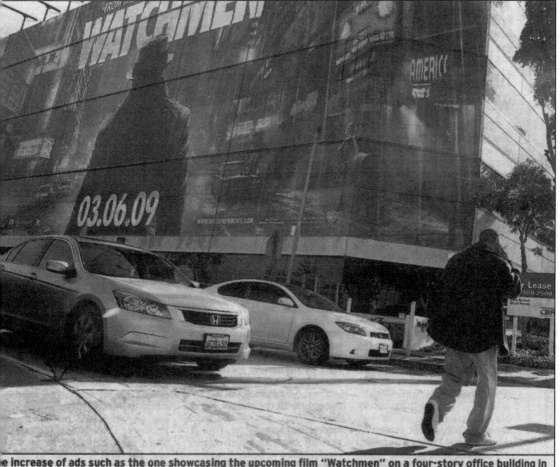

e increase of ads such as the one showcasing the upcoming film "Watchmen" on a four-story office building in st Los Angeles is being condemned as "billboard blight." *Matt Sayles / Associated Press*

ng awareness and increasing purchase consideration with consumers—at least, those who try hem. Of the 328 consumers interviewed, just 29 percent had tried them, but of those who did, 9 percent said they were more likely to purchase Welch's Grape Juice. A full 70 percent of those nterviewed remembered seeing the ad, and of that group, 62 percent took some action, from nentioning the ad to others to actually purchasing the juice—demonstrating the strip's ability o cut through the clutter. Skyy Vodka, Sunny Delight, Campbell's Soup, and Kellogg have all igned on as First Flavor clients, so consumers will undoubtedly be seeing and tasting more of the trips (Zmuda, 2008). Despite these innovations, though, advertising clutter increasingly reduces he effectiveness of individual ads. Ha (1996) found when consumers perceive that there is too nuch advertising, they develop negative attitudes toward the ads. These results are consistent vith learning theory. In a U.S. survey of nearly 1,000 consumers, television and direct mail were ated highest in perceived clutter (Elliott & Speck, 1998).

Nontraditional Media

In the past, advertisers relied on the traditional media to convey their advertising messages. Media planners asked the question, "broadcast or print?" Or, they used direct mail or outdoor billboards to complete the media plan. However, the costs of advertising in the traditional

media have been climbing steadily. For example, prime-time commercials can cost upwards o US$500,000 for 30 seconds—even though cable networks, videos, and the Internet have been drawing viewers away from the broadcast networks. At the same time, both the print and broad cast media have to contend with the increasing clutter discussed above. As a result, companie are steering their advertising spending to "new media." Today, virtually every square inch of the landscape is perceived as fair game in terms of getting the marketer's message across (see the building draped with an ad in Figure 10.2). More often than not, these unconventional ads ar inescapable—which often makes them more annoying.

Place-Based Advertising

A place-based medium is defined as "one where the demographics of the reader, viewer o listener are controlled by the location in which the message is delivered" (McAllister, 1996). And the places where advertising can pop up appear to be endless: places of entertainment, travel health, work, retail, education, and just about anywhere.

Places of Entertainment: Theater advertising is a nontraditional form of advertising that i used worldwide. In the United States, it allows American marketers to get their message to nearly 90 million movie-going patrons annually. While on-screen advertisements preceding movi trailers have been common in Britain, the Commonwealth, and many other countries around the world for decades, the United States has taken theater advertising to a new level. In addition to pre-feature slide programs, plus 30- and 60-second commercials, marketers can now employ "in-theater radio" complete with piped-in ads that follow patrons into the restroom and out into the parking lot, as well as messages on movie tickets, popcorn bags and soda cups, box offic coupons, sampling, interactive lobby kiosks (offering touch screens, e-commerce, and register to-win and other sweepstakes promotions), counter cards, banners, product displays, and even ads on theater chain Web sites to promote their goods. Of the nation's 37,000 movie screens, som form of advertising is shown on about 24,000 of them, according to industry estimates. And exit polls have found that as many as 80 percent of the theatergoers can recall the subject of an ad they have seen in a cinema—four to six times the number who can typically recall television commercials (Bannan, 2001). Theater advertising in the United States is a $200 million a yea industry, growing at an annual rate of 20 percent (Paul, 2001).

Water Closet Media, based in Portland, Oregon, has put ads in the restrooms of restaurants bars, nightclubs, concert arenas, and sports facilities for more than a decade. Ads are placed in women's stalls and above men's urinals. The company has offices in Spokane, Washington, and Phoenix, Arizona, and has affiliates in most major U.S. markets. President John Koenig report that revenues have been jumping through the roof. In fact, business is so good that the more than 30 companies involved nationwide have formed, as Koenig says, an "indoor-billboard associa tion," which is the polite name for the restroom-advertising industry. Today, however, restroom advertising is not limited to mini-billboards. NextMedia, the nation's largest provider of indoo advertising, collaborated with the digital sign company AlivePromo to install networked digita advertising boards in Minneapolis/St. Paul-area restrooms. The digital boards, displaying high resolution, animated advertising, will be managed using AlivePulse, a process that allows for the content to be changed from anywhere with access to the Internet. With AlivePulse, NextMedi has the ability to change, customize, and day-part client ads at each location, allowing advertis ers to pick and choose where and when they want to advertise and change their ads overnigh in response to market events and conditions ("NextMedia and AlivePromo," 2004).

Another new technology that has intruded into men's restrooms is Wizmark, an interactive urinal communicator. Wizmark looks like a hockey puck with mesh wings, and is sensitive to changes in light and movement, prompting flashing lights, guitar chords, and commercial announcements. Some are skeptical. "I can't see someone wanting their brand name urinated on," said Tony Jacobson, president of AllOver Media, another company behind LCD screens above urinals (Miller, 2004). But clearly others disagree. Clients include Viacom (which deployed the devices in bars to promote Country Music Television) and Molson, the Canadian brewer, which used them in several cities in Quebec (Miller, 2004). Plans are in the works to install Wizmarks in women's restrooms as well.

Advertising in the sand at beaches is now a marketing reality. Adman Patrick Dori designed a rubber mat attached to a roller to leave multiple impressions in the sand behind the tractor that rakes the beach in the morning. On an average, about 5,000 mini-billboards measuring 12 by 4 feet can be sculpted into the sand before the first beachgoers arrive. The ads also incorporate a "please do not litter message." Dori calls them environmentally safe billboards because they disappear without a trace as the day wears on. His company, Beach'n Billboards of East Rutherford, New Jersey, charges US$25,000 a month per beach for the ads. It also pays a fee to the various towns, allowing them to rake the beaches more regularly. Participating municipalities have reported a 20 percent reduction in beach litter. Skippy Peanut Butter, Volvo, and ABC Television are brands that have employed this new medium. Beach'n Billboards claims to bring in seven-digit annual revenue. Aside from its U.S. locations, Dori notes, "We just sold six machines last season to Portugal and already have the Netherlands and Puerto Rico onboard. We're entertaining five more international licensees" (*Brand Strategy*, 2006, p. 14). Six Flags Entertainment, owned by Time-Warner, has 150 television monitors placed along waiting lines for rides in each of its amusement parks—all plugging Time-Warner merchandise. A Six Flags executive boasts about the company's TV monitors: "This is the ultimate zap-proof TV; No one can change the volume, no one can change the channel and they can't go to the bathroom because they'd lose their place in line." Channel M (for Minotaur Promotions) is a successful television advertising medium placed in video arcades, positioning music videos and video game tips around ads. Resort Network Sport has established SKI TV nationwide, featuring ads from such marketers as Chrysler and Anheuser Busch. Advertisers such as Lubriderm lotion can also buy outdoor billboards along the chair lifts at these resorts.

In France, bistro tables have become hot spaces for companies to promote themselves while cafe clients sip espresso and Perrier (Ellison, 2000). While it has long been common for beer distributors and other vendors to provide logo-bearing furniture to cafe owners in Paris and other European cities, this is the first time an independent company has put tables in bistros as advertising space to sell to third parties. United Airlines, Virgin Cola, and Swatch were among the companies to take advantage of this new medium.

Places of Travel: Ads have long appeared on both the outsides and insides of buses, taxis, and subways. But now they have gone high tech. For example, TV monitors with commercials blaring communicate with commuters riding in city buses and taxis in many parts of the world. However, airports and airlines have seen the real proliferation of advertising over the past few years. At the airport, travelers will increasingly find ads on their boarding passes—undoubtedly a high-engagement medium as they tend to be closely scrutinized. American, Continental, Delta,

Northwest, United, and US Airways have all partnered with a new ad company, Sojern, to put ads, coupons, and promotional announcements on boarding passes.

In 2006, a company called SecurityPoint Media, based in St. Petersburg, Florida, began testing ads on carts, tables, and bins for personal belongings at security points at LAX in Los Angeles. The airport received $5,500 a month and fresh new trays every quarter. The Transportation Security Administration agreed in early 2007 to allow firms such as SecurityPoint Media to begin selling ads in exchange for the trays and other hardware, seeing it as a win-win situation. The program provides new equipment and saves taxpayers money because the trays come from the private sector. Subsequently, SecurityPoint Media scaled up the program through partnerships with airports around the country. Television monitors showing Turner Broadcasting's Airport Channel are played at the gates and luggage claim areas of many airports. These programs feature material from Turner's own CNN as well as advertising messages.

And, of course, once the traveler is in the air, there are a slew of additional advertising opportunities. Besides the in-flight magazines that carry ads, SKY Radio, run by Gannett, and other in-flight programs carry news, sports, weather, and ads. SKY Radio plays eight commercials per hour, with the ninth reserved for the host airline. On longer flights, passengers may see commercials or other promotional videos on cabin or personal screens. Back in 2003, advertising on airplane tray tables was considered an outrageous news item. By 2006, US Airways announced it would be selling ad space on its barf bags. "Little things like that work," notes Michael Boyd (2006), president of the Boyd Group, an aviation-consulting group in Evergreen, Colorado. "Barf bags have a lot of shelf life—people aren't barfing as much in planes as they used to." Indeed, the barf bag itself is a holdover from the days when air travel was stuffy, bumpy, and full of severe turbulence—a major cause of air sickness during earlier days of aviation. "Having an ad on a barf bag, especially if it's for something like Dramamine, now that is brilliant," notes Boyd. US Airways is not the only carrier to use this particular medium. British carrier Virgin Atlantic even held a barf bag design competition. Some budget carriers have gone even further. Low-cost European carrier Ryanair plasters ads not just on closed tray tables but also on the overhead luggage bins. Bulkheads are also available for advertising plugs. And Thailand's Nok Air even uses cabin crews as "advertising space," with flight attendants sporting sponsored caps or aprons. "As long as it does not jeopardize safety, we are open to new ideas," notes Nok Air vice president for marketing, Pinyot Pibulsonggram. This openness has seen three of Nok Air's planes wrapped by Thai telecom giant TOT and Muang Thai Life Assurance, as well as a variety of innovative in-flight activities, such as on-board quizzes where souvenirs are awarded for correct answers. Of course, the souvenirs carry the sponsor's logo (Mulchand, 2008, p. 22).

Airline marketers attempt to target customers at times when they are unoccupied. Take-offs and landings, when in-flight entertainment and electronic devices are switched off, and passengers have little to do but look out the window, are an ideal opportunity. London-based Ad-Air Group PLC places ads flat on the ground over an area as large as five acres alongside flight paths in and out of the world's busiest airports. Depending on their take-off or landing approach, passengers are provided with an unrestricted view of an ad for more than 10 seconds (Balasubramanian & Bhardwaj, 2008).

As airlines continue to search for every opportunity to offset rising fuel costs and other operating expenses, more and more are considering onboard ads. Such ancillary ads can prove quite lucrative for airlines. For example, for US Airways, the ads are worth about $20 million

a year (Higgins, 2008). Marketers note that these advertising platforms allow them to better reach a well-heeled, mobile demographic that is increasingly difficult to capture via traditional print and TV. Indeed, there are now so many platforms at airports and in planes that companies are popping up to aggregate them—giving media buyers a single point of purchase. One such firm, InterAir Media, offers platforms including plane exteriors or "wraps," cocktail napkins, "sponsored seats," carpets, in-flight handouts, beverage carts, ticket jackets (to complement the boarding passes), beverage cups, meal trays, and gift bags (Sass, 2008).

Health Places: Media entrepreneur Christopher Whittle was a pioneer of place-based advertising. Beginning in 1988, his *Special Reports* magazine was placed in U.S. doctors' waiting rooms. Filled with health-related news, these magazines were jammed with advertising messages. Later, posters, pamphlets, and eventually TV monitors were added. By 1992, over 32,000 doctors' offices carried at least one of the Special Reports media. Whittle's Newborn Channel, placed in hospital maternity wards, is aimed at new mothers. And, the Good Health Channel is targeted at pediatric offices. According to Supply Marketing, a company that gives doctors free samples to encourage use of products, Walt Disney advertised its *Little Einsteins* DVDs for preschoolers on the paper liners of examination tables in 2,000 pediatricians' offices. Health Club Television is placed in Ballys' Health Clubs around the country. The program, which includes 12 minutes of advertising per hour for diet and exercise products, reaches 11 million health club members—members whose household income is over $47,000—making them particularly appealing to advertisers.

Work Places: One of the newest and fastest-growing media is known as "digital out of home." Promoters of the new medium report that the video screens, playing a two- to three-minute loop of news and commercials, are going up in workplaces in the United States at a rate of nearly 100 a day. "We're looking for all those moments when people have nothing better to do than stare at the tops of their shoes," notes Tom Pugliese, CEO of Minneapolis-based Next Generation Network, which has installed about 6,000 "ebillboards" across the country (Wilmsen, 2000). Elevators in office towers, for example, are prime spots for restaurant ads aimed at corporate lunchers. And Internet sites have found almost instant response in elevators. When people get to their desks, they log on to their computer and check out the site they just saw advertised on the elevator. Focus groups conducted by Next Generation Network, which is reaching some 40 million consumers weekly, found viewer attention riveted on the screens for 2 and ½ minutes of the average elevator ride. At 150 Federal Street in Boston, where screens—flashing news, trivia, weather reports, traffic conditions, and, of course, commercials—are installed in elevators, office workers say they hone in on the 12-inch panel. "Sometimes I forget to get off at my stop," one worker said, nearly missing her floor. "The fact is, there's nothing else to do but watch," Pugliese noted (Wilmsen, 2000).

Retail Places: Selling to consumers at the point of purchase is really nothing new. Retailers have been enticing customers with free samples within their stores for generations. And point-of-purchase displays have graced store aisles for decades. But ads today are popping up in unexpected places—the shopping cart, for example. Videocart is a small electronic screen attached directly to the grocery cart that provides the customer with recipe ideas, information on where products are located within the store, and—most important—15-second advertisements that literally reach the consumer at the moment of decision making.

FloorGraphics of Princeton, New Jersey, creates "billboards for the floor," positioned directly in front of the product in over 15,000 supermarkets, drugstores, and mass-merchandise retailers

nationwide. Advertisers get 6 square feet (0.6 square meters) of laminated material that can be divided any way they wish. Campbell's Soup had a trail of O's that led customers to the shelf for its Spaghetti-O's. Then there was the "Got Milk" floor ad that looked like a puddle of spilt milk flanked by an actual milk carton lying by its side. Some shoppers went to find supermarket personnel to point out the hazard. It costs about $250,000 per month to advertise in 8,000 grocery stores with FloorGraphics. The next generation of floor ads will likely allow for animated messages, thanks to built-in floor lights (Van Bakel, 1999).

Another such place is the checkout line. NBC has funded a TV system at the checkout. The project, featuring silent TV monitors placed strategically in retail outlets, is currently being tested in eight states. There appears to be no end in sight, with commercial messages on grocery store checkout conveyer belts, as well as on the backs of the cash-register receipts. Advertising messages have even appeared on automated teller machines (ATMs) at 7-Eleven stores. The program was tested in San Diego, Los Angeles, Chicago, and New York City. EDS, the company that developed the ATM video advertising system, sells the ads and rents the space for the machines at 7-Eleven stores. Notes Don Jarecki, an executive with the company, "They've done well for us. We just finished a big campaign with Compaq and we've had a great response with the 'dot-coms.' Our exit-interview polling showed us that three-quarters of the consumers liked the ads. I don't think it will be too long before this type of ATM advertising is commonplace" (Clark, 2000). And, many gas stations now allow consumers to watch television on a small gas-pump screen while they fill their tanks. Gas station managers have access to nearly 100 channels—everything from CNN to cartoons. Small ads are commonly found on gas pump handles, as well.

Advertising messages have come to parking stripes at malls, courtesy of advertising executive Greg Gorman, who used to work for Anheuser Busch and is credited with coming up with the Budweiser frogs. In a meeting one day, Gorman was apparently needling people to come up with new places to put ads in an increasingly cluttered landscape. "I pointed out the window, and then said 'like why not on those parking stripes?' Then I said 'Oh my God, why not on those parking stripes? Meeting over,'" (Mann, 2007). And that is how it came to pass that in parking lots across America, ads are being plastered on those once plain stripes. For example, outside the Macy's at Oak Park Mall in Overland Park, Kansas City, Nationwide Mutual Insurance is paying what it views as an affordable $34.99 a stripe per 30 days to entice new customers as it competes against insurance giants such as Geico and State Farm, which outspend the No. 5–ranked Nationwide by millions of dollars each year. Jeff Myer, Nationwide's director of advertising, said it was the novelty that caught his attention. "We're doing it mostly because it is new and it is unique," Myer said. "It definitely cuts through the clutter" (Mann, 2007). For Oak Park Mall, it is a no-lose proposition. Someone else takes care of the parking stripes. The ads generate revenue to cover costs on the expense side of the balance sheet, and tenants like the idea because the ads are in the parking lot and not at intrusive points inside the mall.

And while consumers may be watching ads in retail locations, ads may be watching them in turn. Small cameras are embedded in the video screens at the mall or grocery store, tracking who looks at the screen and for how long. Manufacturers of the tracking systems note that the software can determine the viewer's gender, approximate age range, and even ethnicity—and change ads accordingly. Razor ads could target men messages about cosmetics could appeal to women, and ads for video games could pop up when teenagers wander by. The new technology's ability to determine the viewers' demographics is a gold mine for advertisers, who want

to know how effectively they are reaching their target audience. The makers note that their systems can accurately determine gender 85 percent to 90 percent of the time, while accuracy for the other measures continues to be refined. Concerned that consumers might perceive this as rather Orwellian, manufacturers are racing to offer reassurances. They note that when the systems capture an image of who is watching the screen, a computer instantly analyzes it—but nothing is ever stored and no identifying information is ever associated with the images. This makes the system less intrusive than, say, a surveillance camera that records what it sees, the developers argue. Because the tracking industry is in its infancy, there is no consensus yet on how to refer to the technology—though some call it face reading, face counting, gaze tracking, or, more generally, face-based audience measurement (Ramde, 2009).

Education Places: Although place-based advertising can be found in a variety of settings, one of the most controversial and prevalent has been the emerging trend to use schools to deliver promotional messages aimed at children. The efforts of corporate America to distribute their advertising messages to youngsters through the school system are discussed in detail in Chapter 8.

Everyplace: Ads are sprouting up in lots of unexpected places. Ask Jeeves, an Internet search engine, recently bought space on 100 million bananas and apples in the form of those little stickers that normally say "Chiquita" or "Dole." A new U.S. company, Fruit Label Co., works with clients to put ad stickers on produce sold in grocery stores nationwide. And, to hype its fall TV season, CBS laser-coated its eye logo on more than 35 million eggs.

Another new and unexpected venue for advertising is the personal automobile. Dozens of companies are popping up nationwide offering to turn consumers' cars into moving billboards. For example, Myfreecar.com offers motorists US$350 a month to transform their vehicles into rolling 3-D commercials. Cars are draped with removable vinyl sheets that do not harm the car's exterior. In addition, global positioning trackers are installed in the cars so advertisers can monitor the exposure they are getting. Drivers are required to travel at least 800 miles per month. "For companies seeking to stand out from the crowd, billboard cars offer one of the forms of advertising that cannot be switched off, tuned out or lost in a quicksand of other advertisements," declares Autowraps.com, a competitor. Advertisers seem pleased. Dryer's Ice Cream, based in Oakland, California, hired nine VW Beetles through Autowraps.com and received so many calls from consumers that they decided to add another 11 cars to their "Sweet Fleet" (Rivenberg, 2000). See Figure 10.3 for an example of an Autowraps campaign.

Figure 10.3: Autowraps on a car

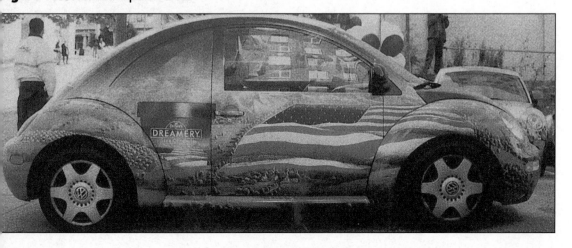

Even police departments are adopting the sponsorship concept. Captain Leon White of the Moorsville, North Carolina, police department hatched the idea after then President Bush called for suggestions on how to improve homeland security in the aftermath of September 11. White believed adding more squad cars to a department's fleet could mean a significant improvement in security. But new police cruisers are expensive—running upwards of US$25,000 (Siuru, 2003). Today, departments can acquire free police cars if they are willing to have cars with ads painted on the sides. The program works as follows: Commercial sponsors contract with Government Acquisitions to have their advertising placed on police cars or emergency vehicles. Government Acquisitions then donates these vehicles to a police department to use for free for three years. It keeps the money paid by the advertiser. The agency does not contract with (and does not receive any money from) sponsors directly. This setup eliminates the appearance of a conflict of interest between the agency and sponsors. Government Acquisitions will not accept advertising from alcohol, tobacco, or firearms companies or any firm that may provide an unfavorable image for the police. The program has received tremendous response from government agencies, potential sponsors, and the media. According to Government Acquisitions, almost 100 police departments in 20 states have signed contracts (Siuru, 2003).

In another take on the auto as ad, a Florida-based graphics firm has devised a way to put ads on automobile wheels (Ave, 2000). They call their wheel covers "ad caps," and the names and logos of products, companies, and organizations are placed on the hubcaps. The firm prints the ads on stickable vinyl and places them on the wheel covers, which remain motionless as the car moves because of a weighted centerpiece that remains stationary at speeds up to 70 mph. As the car moves, the centerpiece stays horizontal so passers-by can read it. Automobile dealership service vehicles, as well as Yellow Cab Co. of Tampa, Florida, have already taken to the roads, sporting the portable billboards.

It appears that every blank space, no matter how public or how private, now ranks as a prime target for marketers. This trend has been dubbed "ad creep," which refers to the way advertisements relentlessly cover more and more formerly empty spaces, like a fungus or kudzu vines (Pappas, 2000). Indeed, even humans themselves are being turned into advertisements. New technologies assist advertisers to creep ads into these virgin spaces. Wearable video is under development. Experimental clothing, such as leather jackets, include a 6-inch ultrathin screen with wireless Web access (see Figure 10.4). Microsoft Corp's MSN Network displayed the clothing at an @dtech conference and plans to use it at trade shows. "It's a combination of art and commerce," says Stephan Fitch, president of

Figure 10.4: Video ads on fashions

Hardwear International, developer of the video. "Within two years," he predicted, his computer couture will be mass-produced" (Pappas, 2000). And, Ireland-based Adwalker offers an upgraded, interactive version of the sandwich board. Brand representatives wear a compact body pack incorporating an LCD screen, Internet-linked computer, and handheld touch screen and printer. The technology enables credit card transactions, tickets, coupons and other printouts, games, competitions, and real-time data capture. Simon Crish, chief executive of Adwalker, argues that it answers a requirement that has come to the fore over the past couple of years. He explains, "We're finding that consumers are looking for engagement, interaction and experience. Marketers really do need to wrap the brand around the consumer" (*Brand Strategy*, 2006). In some cases, brands are even tattooed right on consumers. In 2006, Robert Reames III, a father of three girls who was looking for money to replace the family car, sold rights to a permanent tattoo on his neck to Web-hosting company Globat. Globat also bought a temporary tattoo ad on the pregnant belly of Asia Franci of St. Louis. The company would not disclose what it paid for the "body art" (Petrecca, 2006). London-based WWP Group, one of the world's largest advertising and marketing groups in terms of revenue, estimates that nontraditional media and marketing efforts, such as those described above, have already overtaken traditional advertising in terms of global spending, and are showing higher growth rates as advertisers look for alternatives to the saturated conventional media (Tomkins, 2000).

Virtual Reality

As the technology improves, it provides an increasing number of ways for movie and TV producers to modify their films according to the wishes of a placement sponsor. In the film *Demolition Man*, for example, scenes depicting a fast-food outlet of the future were set in either a Taco Bell or Pizza Hut, according to the markets where the film would be distributed (Karrh, 1998). In a more recent deal, Turner Broadcasting System has agreed to allow advertisers to place virtual product images in reruns of *Law & Order* when the hit show moves to TNT in syndication. According to *Ad Age*, "that means an advertiser can put its product on a desk, in a character's hands, or even brand the precinct's soda machine" (Goetzl, 2001, p. 8).

Princeton Video Image (PVI) is the technology company most often credited with developing virtual product placement technology. PVI is being widely used by advertisers to insert ad messages as part of sports broadcasts. The ethics of this type of reality adjustment were raised during the New Year's Eve celebration at Times Square in 2000. CBS, using virtual technology supplied by PVI, blotted out some Times Square billboards for companies like Budweiser and Panasonic to virtually substitute its own corporate CBS logo in their place. The owner of the Times Square billboard company sued CBS for unfair competition, deceptive trade practices, and trespassing, contending that the network took away the value of the advertising for which its clients had paid, and misappropriated the value of the ads for which the network *did not* pay. The issue was that the price of the billboards during that time of year was raised to reflect the additional exposure given to Times Square in television broadcasts. Diminishing the value of a billboard by digitally replacing the signs was considered a form of unfair competition (Rigoboff, 2000). The network eventually settled for an undisclosed sum. More recently, Sherwood 48 Associates, another billboard company that owns several signs in Times Square, sued Sony/Columbia for digitally replacing the ads seen in a Times Square scene in the *Spider-Man* movie.

Ironically, critics have long contended that advertising distorts reality by presenting us with a distorted mirror (Pollay, 1986), but the latest technology of virtual reality certainly makes the advertiser's ability to distort reality much, much easier.

The Internet

In the past few decades the Internet has made its debut and has quickly generated a profound impact on communications and, of course, advertising. On the Internet, the line between advertising and editorial content has become blurred. Anybody and everybody can now provide "information" to Internet users. This has raised a whole new set of ethical questions as to exactly what an "Internet ad" is. Some of these issues arise out of the fuzziness of the definition of a legitimate content provider. While traditional journalistic concepts like editorial integrity, balance, accuracy, respect for others, and fairness are the mainstays of print newspapers, they are fading fast with the pervasiveness of the Internet. The absence of gatekeepers on the Web raises questions about whether the information we are receiving in cyberspace is real news, real chat, or real advertising.

The inherent nature of the Internet, with its high degree of interactivity, provides a fertile ground for advertisers. On the Web, advertisements appear in many different forms: advertorials, paid links, ads or promotions that appear in navigational sidebars, pop-up windows, sponsored pages, advertising sections, and banner ads. The reader constantly interacts with these new advertising modes—knowingly or unknowingly. For example, many search engines sell keywords and phrases to advertisers. A user might key in "New Hampshire" on a search engine like Google. Seconds later a banner ad might pop up on the screen from Amazon.com offering "books on New Hampshire." Or, while reading an article online, users might click on an underlined word or phrase in search of further information only to find themselves instantly transported to an advertiser's Web site.

The questions proving to be critical in the cyber world are related to the lack of an ethical firewall between the editorial and the advertisement, and the intrinsic nature of the Web does not lend itself to any single organization conscientiously creating one. The ease of using Internet links can also set up ethical dilemmas. Take, for example, the weekly e-zine *Salon,* which has become one of the few successful online magazines. This e-zine draws a huge following. To attain its success, top management was very clear about its goals of mixing editorial content with business (Goth, 1997). *Salon's* management has no qualms over the primacy of the profit motive. E-commerce links between Salon.com's book review section and Amazon.com, for example, are essential for its survival. Ultimately, when Salon.com gets a commission for steering readers of its book reviews to the Amazon site, it breaks a cardinal rule in the ethics of old media journalism. The ease of interactivity sets the stage for "transaction journalism," as it is being referred to by some traditional writers (Lasica, 1997).

A few attempts have been made to develop guidelines for adoption by online publishers. For example, rules formulated by the Internet Content Coalition (ICC) include some of the basic ethical concepts of the old media, such as the need to label advertorials, disclose paid links, and to draw a definite line between promotional and editorial material. But so far, neither these rules nor any others that could be binding to all Web publishers are in place. Meanwhile, the ethical dilemmas are getting murkier by the day.

In addition to paid links embedded in editorial text, other questionable advertising practices on the Internet concern *bots* and *cookies.* For example, imagine someone chatting with another

user in an online chat room, and one of them mentions that they had a "bad hair day." Some advertisers employ Internet robots, known as "bots," to monitor chat rooms. When the word "hair" is used, a bot could break into the chat (appearing just like any other Internet user) and suggest that the person having a bad hair day should try using the advertiser's shampoo.

Cookies are text files inserted on users' hard drives when they access many Web pages. Most of the time users are completely unaware that they are receiving cookies from Web sites. Once placed in the home computer, cookies gather information that allows the Web site operator to build a profile of users without their knowledge. Let us say, for example, that a user visits the auto section of a certain Web site three times requesting information on the features of a specific car. The automobile company can track these requests and, using the information gathered by the cookie, create a profile of the consumer and the consumer's interests. The next time the user logs onto the Web site, the company can present ads or messages created on the fly and targeted to that particular user's individual interests.

Web sites can also create databases of users of their sites and track which individual users see which advertisements. This information can ensure that the same ad will not be delivered more than once to the same person. For advertisers, the possibilities presented by the Internet are endless because the medium allows for very specific targeting of individual consumers. Some authors, Rust and Oliver (1994), for example, predict that traditional advertising—mass media ads targeting mass audiences—is on its deathbed and that, in the future, interactive media which allow for greater individualization of messages and higher levels of interactivity (as well as stealth) will predominate.

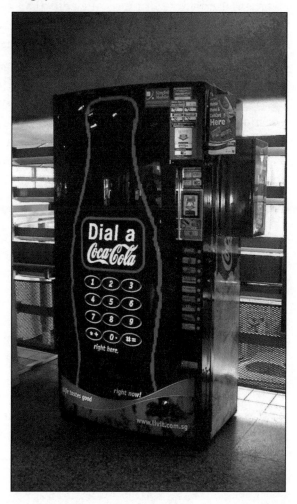

Figure 10.5: Dial-a-Coke vending machine in Singapore

Mobile Phones and M-Commerce

Mobile phone networks are emerging as yet another new way for advertisers to "reach out and touch someone." This medium, which adds a textual dimension to what was originally a voice communications technology, not only provides a medium for the exchange of messages between users but also provides for a high degree of interactivity.

Text transmission first became a practicality in 1844 in the United States when Samuel Morse established telegraphy between Baltimore and Washington, D.C. In 1901, Guglielmo Marconi used Morse's code to send radio messages across the Atlantic. Soon, digital text messaging by wireless spread rapidly beyond the reach of the global network of telegraph wires. However, the development of digital communication as we know it today

was to some extent sidetracked by Alexander Graham Bell's 1876 invention of the telephone and later the radio and television media.

Yet Morse-based digital communication did not die out, but neither did it immediately evolve into the binary form that now underpins the Internet, digital broadcasting, and mobile wireless telephony. Almost a century elapsed between the invention of the telephone and the advent of computer-to-computer communications. Digital text transmission is what drives the Internet. The new communication uses the binary code of high-speed data processing and replaced Morse's dits and dahs with longer strings of zeros and ones.

In the past two decades, mobile phone technology has moved from voice-only (first generation) to incorporating limited text-handling capabilities. Mobile phone service providers first introduced *SMS* (short message service) in the 1990s. Using the phone pad, mobile subscribers can compose messages and send them to each other. This has become wildly popular in places where a critical mass of mobile subscribers is connected by a common text messaging technology. In Europe, Asia, and many other parts of the world, text messaging has become a truly mass medium. Text messaging is cheaper, faster, and less intrusive than conversational calls. But the most important difference is that it brings asynchronous communication to the mobile subscriber. Like e-mail, text messages can be read and replied to at the convenience of the receiver, while they are on the go. Despite text messaging being cheaper than voice telephony—typically only a few cents each—mobile service providers are finding it highly profitable. This is because text messages use airtime far more efficiently than voice.

Today billions of text messages are sent around the world each day and advertisers are beginning to use this medium for marketing. Coca-Cola has expanded the use of mobile phones beyond personal communication into the realm of *m-commerce* (mobile commerce). They introduced the first "Dial-a-Coke" vending machines in Australia and Singapore in 2001. To purchase a beverage through Dial a Coke, customers simply use their mobile phone to dial a phone number indicated on the vending machine. The drink pops out automatically and the purchase is confirmed through an SMS to the customer's mobile phone. The cost of the drink is the same as if the customer were to put coins in the vending machine, and customers are not charged for the cost of the call, just for the cost of the drink, which appears on the customer's next mobile phone bill. The Dial-a-Coke concept works with all brands of mobile phones in these markets (see Figure 10.5).

This latest application of wireless payment technology is a way to introduce mobile phone users to the concept of wireless transactions and is a precursor to people being able to use their mobile handsets for functions such as micropayments for parking, ticketing, and even movie and theater bookings.

Several other possible areas for mobile payments include:

- Automated point of sale—for vending machines, parking meters, and ticket kiosks—which is being tested in Japan and Scandinavia;
- Attended point of sale—using phones for purchases at shops or in taxis;
- Mobile-assisted Internet sales—where payments by phone replace credit cards;
- Peer to peer—picking up a friend's dinner tab or putting the cost of movie tickets on one's mobile phone bill—which McDonald's is experimenting with.

McDonald's in Japan has a joint venture that will allow its consumers to make purchases electronically through mobile phones with Internet access. Under the plan, EveryDMc (which

reads like a text message for "everyday Mac") consumers will attach small bar-code readers to their cell phones. These readers will be able to scan bar codes that correspond to products in special catalogues distributed at McDonald's restaurants. Not only will consumers be able to buy McDonald's products, but they will also be able to access Web sites that will allow them to book hotel rooms, reserve restaurant seats, and make other purchases. EveryDMc started experimenting with the system in 2002.

Viral Marketing

As soon as e-mail and text messaging came into use, innovative marketers recognized its potential for viral marketing. Viral marketing is any strategy that encourages subscribers to pass on marketing messages, thus creating the potential for exponential growth in the message's exposure and influence. It is a form of "word-of-mouth" or "refer-to-friend" marketing strategy that often uses the new electronic media such as Internet, e-mail, and mobile telephony as the means for "viral infection." The effect of this form of marketing is like a virus—one person does it, then another and another until the word has spread across entire communities. Ultimately, the aim of viral marketing is to encourage customers to talk about a product, pass on recommendations or samples, or use the product overtly, so that other people notice it. Viral marketing often combines visually attractive logos, brands, interesting text messages, and music—all downloadable onto e-mail or to cell phones or i-mode enabled phones.

One of the criteria for a successful viral marketing campaign is to make the product and the message creative or attractive enough for users to bother spreading it around. Incentives such as free products, free information, interesting games, attractive prizes and discounts, and other innovative freebies may get the campaign snowballing.

An important economic factor that makes viral marketing a popular strategy in today's marketing arena is that it is cheap while it can yield high returns. It is almost "costless" to type out a message and send it through an e-mail or SMS to a large population of people. It also costs nothing for a company when their message is redistributed to an ever-larger population, many times over.

In March 2001, Coca-Cola brought viral marketing on mobile phones to new heights by using an interactive game played on i-mode phones to promote one of its juice drink brands in Japan, which was a first for the company. Mobile phone subscribers using i-mode could now play an interactive game with Qoo—a cute cartoon character that was also the brand image for a new fruit drink (see Figure 10.6).

Figure 10.6: Cartoon character Qoo

Players could interact with Qoo on their handset displays by entering messages on the phone keypad. After scoring successfully in the game, users were rewarded with an appealing Qoo picture that could be downloaded to their phone. This image could then be re-transmitted to friends. This process helped to spread brand awareness of the new drink. According to Coca-Cola, they adopted this strategy to win over young opinion leaders who would then convince their friends to buy the product. This marketing exercise was relatively low profile, and yet Qoo has now become a very popular soft drink not only in Japan but also in other Asian countries (Francis, 2001).

Consumers have at their disposal an increasing number of means to escape advertising—TIVO is but one example. Ad-zapping devices, along with a decrease in consumer attention

spans, have created doubts about the effectiveness of traditional media. In response, advertisers have become increasingly invasive. "I've never seen things changing as much as they are now," said Rance Crain, editor-in-chief of the leading trade magazine *Advertising Age* and a 40-plus-year observer of marketing. "Advertisers will not be satisfied until they put their mark on every blade of grass." And Mike Donahue, executive vice-president of the American Association of Advertising Agencies, notes that message clutter is not going to go away. If anything, it's going to proliferate (Petrecca, 2006). The game has become one of finding the next black space that has not yet been covered.

THE EFFECTS OF COMMERCIAL OVEREXPOSURE

The 24-Hour Economy

Dr. Jelly Helm, an associate professor at the VCU AdCenter, an advertising school in Richmond Virginia, notes, "Hiding cleverly disguised ads in unexpected nooks and crannies might make people even more irritated. Not just because the messages are intrusive, but because the relentless, almost militaristic assault dehumanizes you—your worth is no longer as a person, but a a consumer" (Van Bakel, 1999, p. 47). Bob Garfield, a columnist for *Advertising Age*, concurs. Garfield alleges that advertisers are "fouling the receptors of the increasingly skeptical, increasingly annoyed, increasingly disaffected consumer" (Van Bakel, 1999, p. 49).

Indeed, one *Advertising Age* survey found that across the board most respondents (91 percent) expect to see an increase in the tendency for everything to be advertised and commercialized and the majority felt that this was a negative trend. Eighty-five percent of respondents expected to be "overexposed" to advertising. Such data suggest that an unwelcome consumer backlash is on the horizon. The biggest worry for agencies is that individuals are so dazed and cynical about ads that they automatically ignore them or turn off, and in the new century, consumer disinterest may turn into frustration, distrust and hostility" (Voight, 2000, p. 50).

Clearly, this problem results not just from the amount of advertising, but the messages it carries. Commercial communication's insistent message is really quite simple: buy, buy, and buy some more. Indeed, consumers are encouraged to shop around the clock. Although American consumers have long been served by some 24-hour supermarkets and gas stations, what is happening now is of a different magnitude. Can't wait for a new set of dishes? Not a problem with a 24-hour Wal-Mart Supercenter nearby. Need an airline ticket? Just log onto a Web site. Want to buy a stock? The National Association of Securities Dealers can accommodate that urge during an extended day (Uhlman, 1999). Thus we are seeing the emergence of a 24-hour economy.

Many suggest that this urging by marketers for consumers to shop nonstop encourages materialism. Marketers might argue that materialism increases a society's economic health and that the accumulation of material possessions leads to a higher standard of living. But, an increasing number of studies have suggested that growing materialism has negative effects on individuals, families, society, and the environment. Belk (1984) defines materialism as: "The consumer orientation commonly known as materialism, reflects the importance a consumer attaches to worldly possessions. At the highest levels of materialism, such possessions assume

a central place in a person's life and are believed to provide the greatest source of satisfaction and dissatisfaction in life" (p. 292). Most empirical data reveal that dissatisfaction with life is the result of a materialistic orientation. Belk (1985) found that that those who score higher on the materialism scale reported to be less happy in life. Richins and Dawson (1992) found that those who score higher on the materialism scale were less willing to share their money and possessions. This unwillingness went beyond contributions to charitable and ecological organizations and extended to less willingness to help family and friends. In 1995, the Merck Family Fund commissioned a public opinion survey by the Harwood Group as part of an examination of the patterns of consumption in the United States and the consequences of those patterns. "The resulting report, *Yearning for Balance,* provided a statistical portrait of how Americans think about issues connected to consumption, the environment, and the values and priorities of their society. Many survey participants felt that excessive materialism was at the root of many of our social problems, such as crime and drugs. Eighty-two percent agreed that most of us buy and consume far more than we need. Ninety-one percent agreed that the "buy-now, pay-later" attitude contributes to overconsumption. When asked what was driving so many of our society's troubles, their responses revealed a shared belief that "our values are out of whack—that we value things too much and people too little." The report said, "Americans intuitively believe that our current ethic of 'more, more, more' is unsustainable in human and environmental terms" (Blakley, 1999).

And for many consumers, this ethic has become unsustainable in very real terms. In 2008, 1.4 million Americans declared bankruptcy—more than graduated from college. U.S. household debt averaged a record 133.7 percent of disposable income in the fourth quarter of 2007. Also in the fourth quarter of 2007, families spent 14.3 percent of their disposable income to service their debt, up from 13.0 percent in the first quarter of 2006. One-third of Americans describe themselves as heavily or moderately in debt (Goodman, 1998). The typical middle-class American is, in the words of economist Schor (2005), "the overspent American." Schor says that one of the major reasons middle-class Americans are living in debt, or barely making it from paycheck to paycheck, is that what we want grows into what we need—at a sometimes dizzying rate. More than a quarter of the households earning $100,000 a year said that they could no longer afford to buy everything they need. According to Schor, the main engine of a troubling cycle of "see-want-borrow-buy" is competitive consuming. We are still trying to keep up with the Joneses, but today the Joneses are not our neighbors or even friends. They are the "Friends" we see on television, the lifestyles of the rich and famous, upscale and advertised. These Joneses are way up there compared to our old neighbors. The average employed American now works more than 47 hours a week in the struggle to keep up with mounting bills. This causes tremendous levels of stress on individuals and their families.

Regarding materialism's impact on the environment, a few startling facts offer some perspective:

- Twenty percent of the earth's population uses 80 percent of its natural resources.
- The average North American consumes 5 times more than a Mexican, 10 times more than a Chinese, and 30 times more than a person in India.
- Americans consume 40 percent of the world's gasoline.
- The U.S. population consumes more paper, steel, aluminum, energy, water, and meat per capita than any other society on the planet.
- The average American produces twice as much garbage as the average European.

- Recent scientific estimates are that at least four additional planets would be needed i
 each of the earth's six billion inhabitants consumed at the level of the average American.

Table 10.4 further highlights the imbalance in the distribution of consumer goods across the
globe. In the West we suffer the impact of excessive consumer behavior in many ways. The ques
for ever- increasing consumer goods has resulted in the dramatic loss of forests for paper and
packaging as well as the conversion of farmlands and wetlands to large suburban developments
We have generated huge quantities of atmospheric and solid waste while degrading the water.
soil, and air necessary for healthy living—all in the name of consumption.

Table 10.4 : How Families Compare

UNITED STATES	JAPAN	CUBA
(Family of 4)	**(Family of 4)**	**(Family of 9)**
5 telephones	1 telephone	
4 bicycles	3 bicycles	4 bicycles
3 motor vehicles	1 motor vehicle	
3 televisions	1 television	3 televisions
3 stereos	2 stereos	
3 radios	3 radios	3 radios
1 computer	1 computer	
1 VCR	1 VCR	1 VCR
1 microwave oven	1 microwave oven	
ALBANIA	**MONGOLIA**	**MALI**
(Family of 6)	**(Family of 6)**	**(Family of 11)**
1 bicycle	1 bicycle	
1 television	1 television	
1 radio	1 radio	
6 goats	1 sheep	
1 donkey	1 Buddha statue	5 ceramic pots
2 butter churns	2 water kettles	2 sieves for grain

Source: Carlozo, L. (1999, April 11). Enough already: A case of Affluenza. Orange County Register, p. J8.

"Affluenza" has developed into a worldwide phenomenon (Droge & MacKoy, 1995). According
to a study conducted in Britain, despite being wealthier than ever, more than 70 percent of
respondents rejected the suggestion that most people were content with their lives, and almost
90 percent believed Britons increasingly expected to "have it all and have it now" (Millar, 2000)
The same survey reported that while more than 80 percent of respondents agreed that people
were under too much pressure to spend unnecessarily, a similar number admitted that however
much they earned, it was never enough.

Evidence of the desire to become a member of the consumption culture can be found in
developed and developing societies alike. For example, Malaysia's Consumer Association of
Penang (1986) described the situation as follows: "A worrying trend is the growing influence

of negative aspects of Western fashion and culture on the people of the Third World countries, including Malaysia. The advertising industry has created the consumer culture which has in fact become our national culture. Within this cultural system people measure their worth by the size of their house, the make of their car and the possession of the latest household equipment, clothes and gadgets" (p. 4).

Although significant economic differences still exist between Mexico and the United States, middle-class Mexican consumers have much in common with American consumers. Both attempt to signal their comparative degree of social power through consumption. One negative outcome of the consumer culture is compulsive buying, which has been described as "chronic, repetitive purchasing that becomes a primary response to negative events or feelings" (O'Guinn & Faber, 1989, p. 148). Researchers in the United States have found that as much as 10 percent of the population can be classified as compulsive buyers (Trachtenberg, 1988). Surprisingly, nearly 7 percent of Mexican young adults can also be classified as compulsive buyers (Roberts & Martinez, 1997).

Another negative effect associated with growing materialism is that it may well lead to a decline in morals. Researchers have associated certain types of unethical behavior with greater amounts of materialism. Muncy and Eastman (1998) found that higher levels of materialism were directly associated with lower ethical standards. Indeed, many of the problems with crime experienced in the former Eastern Bloc countries have been attributed to materialistic influences of the West (Barrett, 1992).

For many, curbing their addiction to consumption—even for just a day—would be as difficult as smokers giving up cigarettes for 24 hours. But, much as it is up to smokers to "kick the habit," it is up to all individuals to examine their lives, their priorities, and their purchases and find some room for moderation. Assessing that difference between what we need and what we want is at the heart of this examination. Blakley (1999) suggests we subject every purchase to five simple questions: Do I need it? How much will I use it? How long will it last? Can I do without it? And how will I dispose of it when I am through using it? The result of just a few decisions not to buy, not to pursue "more, more, more," could have a significant and positive impact on our lives.

The Spread of Global Consumer Culture

We began this book with a discussion of advertising and the history of globalization, and we end with a discussion of the spread of consumer culture worldwide. The speed with which ideas, products, and services now move around the globe is increasing exponentially as each day goes by. While in the past, companies like Ford Motors and General Electric had to rely on the postal services to inform their overseas growth, today's companies like Starbucks and The Body Shop have the fax, the Internet, and mobile phones to help them expand worldwide. With the introduction of new media technologies and the growing number of people exposed to these new media, a company can establish itself as a global brand in *virtually* no time.

Amazon.com established a global sales network on the Web without the expense of building a single "outlet." While auctioneers Spink's and Christie's took decades to establish their brand names globally, eBay took only months to set up regional auction sites in 20 countries worldwide, and to host regional auctions at the global level. According to Friedman (1999), there is no longer any escape from globalization. He contends that, "What is new today is the degree and intensity with which the world is being tied together into a single globalized marketplace.

What is also new is the sheer number of people and countries able to partake of this process and be affected by it" (p. xv).

Global advertising is a double-edged sword. On the one hand, it has been credited with creating new markets, improving economies, and connecting people worldwide through trade in consumer goods. On the other hand, it has been criticized for spreading consumer culture to every corner of the globe. During the closing decades of the twentieth century, helped in no small way by emerging digital communication technologies, international markets began to be opened up by multinational corporations and their advertising agencies, which have spread around the globe the concept of branding (Klein, 2000). Modern media allow Western advertisers to spread unified branding campaigns and advertising messages around the world at a phenomenal rate through the global media.

In a 2009 study of the world's top 100 Global Brands by Interbrand, over 50 percent were U.S. corporations and 40 percent were based in Europe (www.interbrand.com/best_global_brands. aspx). Less than 10 percent of the top global brands were headquartered in Asia and none in Africa. The top 10 Global Brands as identified by Interbrand include mainly U.S. and European-based firms (see Table 10.5).

Table 10.5: The World's Top Global Brands in 2008

RANK	ORGANIZATION	HEADQUARTERS
1	Coca-Cola	USA
2	IBM	USA
3	Microsoft	USA
4	GE	USA
5	Nokia	Finland
6	Toyota	Japan
7	Intel	USA
8	McDonald's	USA
9	Disney	USA
10	Google	USA

Source: www.interbrand.com/best_global_brands.aspx

While the expansion of Western brands throughout the world proceeded quite successfully during the twentieth century, bringing massive wealth to the West, at the beginning of the twenty-first century there are signs that the spread of global capitalism may have some unintended side effects. During the next 50 years, 97 percent of the world's population growth is expected to take place in the developing countries (e.g., India, China, Indonesia, and Brazil). The United Nations Population Estimates and Projections also predict that the populations of Europe and North America will shrink to only 11 percent of the total world population by 2050. Africa will grow to account for over 20 percent and Asia will make up 60 percent of the world's total population (see Table 10.6).

Table 10.6: World Population by Continent, 1998–2050 (population in millions)

CONTINENT	1998	PERCENT	2050	PERCENT
Asia and Oceania	3,615	61 percent	5,314	60 percent
Africa	749	13 percent	1,766	20 percent
Europe	729	12 percent	628	7 percent
North America	305	5 percent	392	4 percent
Latin America and Caribbean	504	8 percent	809	9 percent
TOTAL	5,902		8,909	

Source: http://www.popin.org/

These substantial shifts in the centers of gravity of global markets represent an interesting set of problems as the rise of global consumer culture fuelled by global advertising and branding means that millions, even billions, of global consumers will soon be driving new cars, consuming fossil fuels, and wearing Calvin Klein jeans at an unprecedented rate.

The irony, of course, is that Western branding and marketing have created the global desire for branded goods. Thus, in countries where consumers cannot yet afford the "real" thing, "fake" markets continue to grow exponentially. China, which already has one-fifth of the world's consumers, has a rapidly growing middle class hungry for consumer goods. Economists forecast that in 10 years, China's middle class will be 400 million strong. While this economic growth has created unprecedented opportunities for Western multinationals—nearly 30 percent of all new McDonald's opened this year will be in China, and Starbucks, the huge U.S. coffee company, expects China to become their second largest market in the world—this rampant consumerism has also brought with it another phenomenon: piracy. At the Shijingshan amusement park, which recently opened in the suburbs of Beijing, children are greeted by costumed figures like a large duck and a happily waving lady mouse. Is this Daffy Duck and Minnie Mouse? "No," say the management of the park, "the characters in our park just look a bit similar" to those in Disneyland.

Figure 10.7: Label from men's underwear sold in China

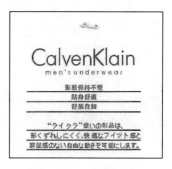

Huge markets have sprung up in all the large cities across Asia, selling fake branded items like Gucci bags, Calven Klain underwear (see Figure 10.7), as well as pirated CDs and DVDs. In China, for example, the rise of consumerism and the Chinese ability to copy branded icons have strained ties between the wealthy countries in the West and China. Thus, global advertising's success in creating new markets for branded Western consumer goods has created eager new consumers in the developing world, as well as opportunities for local entrepreneurs to capitalize on the rising tide of capitalism by producing an endless array of fake global brands for local consumption.

CONCLUSION

As consumers we are all moving into the global marketplace with ever-increasing speed, and more and more of our lives are being taken up with commercialism. The lines have become blurred as to what is an ad, what is news, what is entertainment, and even what is real and what is fake. Our children learn to add and subtract with worksheets from M&Ms; they play with toy cash registers brought to us by McDonald's. Robots call us on the phones and try to sell us credit cards, and cookies and bots hide in our computers and pop up with cheery messages about weight loss plans when we go online.

The phone rings and we find out that our friend has sent us a viral coupon for a free McDonald's burger. Or worse: that the person we thought of as our friend was really a paid shill. *The New York Times* reports that companies are hiring good-looking young people to go to bars and talk to as many people as possible about certain drinks and cigarettes (Rutenberg, 2001). These "aspirational marketers" can reach up to 25 people in one night with word-of-mouth advertising. Companies hire young people who have the qualities of "key influencers" to buy people drinks, smoke certain brands of cigarettes, wear certain brands of clothes; and all this is done without any of these "influencers" disclosing that they have received financial remuneration for promoting the products.

The ability of marketers and advertisers to constantly devise new and improved ways of reaching people appears to be endless and ever expanding. And as quickly as new media emerge to help connect members of the human race, marketers and advertisers are ready to step in and quickly commercialize our relationships and interactions. Thus, our concept of what is real, what is commercial, and what is really of value promises to be profoundly challenged in the twenty-first century.

REFERENCES

Ave, Melanie. (2000). Hubcaps put new spin on outdoor advertising. *St. Petersburg Times,* p. 6.

Babin, L. A. and Carder, S.T. (1996). Viewers' recognition of brands placed within a film. *International Journal of Advertising,* 15, 140–151.

Balasubramanian, Sridhar & Bhardwaj, Pradeep. (2008). Notice me: Cutting through marketing clutter. *The Wall Street Journal Asia,* Hong Kong, October 20, p. R-8.

Bannan, Karen. (2001). Catch them when they're attentive, settled in their seats and eating popcorn—at the movies," *The New York Times,* October 8, p. C-10.

Barrett, A. (1992). Crime waves spread very democratically in Czechoslovakia; even toilet paper is locked away as new breed of thief hails western materialism, *The Wall Street Journal,* November 6, p. B7B.

Belk, Russell W. (1984). Three scales to measure constructs related to materialism: Reliability, validity and relationships to measures of happiness. In T. Kinear (Ed.), *Advances in consumer research,* vol. 11 (pp 291–297). Provo, UT: Association for Consumer Research.

Belk, Russell W. (1985). Materialism: Trait aspects of living in the material world. *Journal of Consumer Research,* 12(3), 265–280.

Blakley, Melissa Hope. (1999, November 26). It's tme to just say no to over-consumption. *Kansas City Star,* p. B10.

Bond, Jonathan and Kirshenbaum, Richard. (1998). *Under the radar: Talking to today's cynical consumer.* New York: John Wiley and Sons.

Bosman, Julie and Seelye, Katherine. (2006). Front page of *Journal* to get ads. *New York Times,* Late Edition, East Coast, New York, NY, July 19, p. C-1.

Boyd, M. (2006). Retrieved April 17, 2009 from http://antiadvertisingagency.com/news/ads-on-barf-bags

Brand Strategy (2006). Global trends watch—Innovative advertising: New ways to sell. London, April 10, p. 14.

Brennan, I., K. M. Dubas, and L.A. Babin (1999). The influence of product-placement type and exposure time on product-placement recognition. *International Journal of Advertising,* 18, 323–337.

Carlozo, Lou. (1999). Enough already: A case of Affluenza, *Orange County Register,* April 11, p. J-8.

Clark, Brian E. (2000, January 28). A is for ad in ATM. *San Diego Union Tribune,* p. C-1.

Consumer Association of Penang, (1986). *Selling dreams: How advertising misleads us,* Penang, Malaysia, as quoted in Katherine Toland Frith and Michael Frith, "The Stranger at the Gate: Western Advertising and Eastern Cultural Communications Values," paper presented at the International Communication Association Conference, San Francisco, 1989, p. 4.

Darby, Ian. (2009). Television is shaken and stirred by odd government ruling. *Campaign,* Teddington, March 20, p. 12.

Droge, C. and R.D. MacKoy (1995). The consumption culture vs. environmentalism: Bridging value systems with environmental advertising," Marketing and Public Policy Conference, pp. 227–237.

Elliott, Stuart (2007). Scenting the news on advertising. *International Herald Tribune,* Paris, April 2, p. 9.

Elliott, Michael T. and Paul Surgi Speck (1998). Consumer perceptions of adverting clutter and its impact across various media, *Journal of Advertising Research,* Jan–Feb, pp. 29–41.

Ellison, Sarah. (2000). Ad nauseam! Cafe commercialism hits Paris, *Asian Wall Street Journal,* May 30, p. 12.

Farhi, Paul (2007). And now for a syllable from pur sponsor: The new radio spots, shrinking into freckles. *The Washington Post,* Washington, D.C., June 17, p. D-1.

Friedman, Thomas L. (1999). *The Lexus and the olive branch: Understanding globalization.* London: HarperCollins.

Goetzl, David. (2006, June 1). Product placement fueling TV clutter, brands now present more than half the time. MediaPostNews. http://mediapost.com/publications/index.cfm?fuseaction=Artic . . . Retrieved April 20, 2009.

Goodman, Ellen. (1998). Consumer culture keeps Americans in debt," *Greensboro News Record,* Greensboro, NC, June 16, p. A-7.

Goth, Nikki C. (1997). Juggling idealism and business: *Salon.* Red Herring, winter supplement.

Gupta, P. B. and K. Lord (1998). Produce placement in movies: The effect of prominence and mode on audience recall. *Journal of Current Issues and Research in Advertising,* 20(1), 47–59.

Ha, Louisa. (1996). Advertising clutter in consumer magazines: Dimensions and effects. *Journal of Advertising Research,* 36(4), 76–84.

Higgins, Michelle. (2008). Advertisers are flying high with a captive audience, *The Gazette,* Montreal, Que., July 12, p. H-2.J.

Karrh, J. A. (1994). Effects of brand placements in motion pictures. In K. W. King (ed.), *Proceedings of the 1994 Conference of the American Academy of Advertising.* Athens, GA: American Academy of Advertising, pp. 90–96.

Klein, N. (2000) *No logo: Taking aim at the brand bullies,* New York: Picador.

Lane, W. Ronald, Karen Whitehill King, & J. Thomas Russell (2008). *Kleppner's Advertising Procedure,* Upper Saddle River, New Jersey: Pearson-Prentice Hall.

Lasica, J. D. (1997, December). Preserving old ethics in a new medium. *American Journalism Review.*

Lasn, Kalle. (1999). *Culture jam: The uncooling of America,* New York: Eagle Books.

Lovell, Glenn. (2005). Ads creep into programs as TV counters commercial-skipping. *Knight-Ridder Tribune News Service,* Washington, May 25, p. 1.

Mann, Jennifer. (2007). Businesses find a new place to park their ads. *The Kansas City Star,* September 20. Retrieved April 3, 2009 from http://www.parkingstripe.com/news.php?itemid=24.

McAllister, M. P. (1996). *The commercialization of American culture: New advertising, control and democracy* Thousand Oaks, CA: Sage, p. 64.

Message to media: Ad scenario remains bleak. (2009, April 15). Retrieved August 22, 2009, from http://www domain-b.com/brand_dossier/media/20090415.

Millar, Stuart. (2000). Britons get 'stress and spend' blues, *The Guardian,* February 25, p. 1.11.

Miller, M. C. (1990). End of story. In M. C. Miller (Ed.) *Seeing through movies,* pp. 186–246. New York: Pantheon Books, p. 196.

Miller, Jonathan. (2004, October 1). Flushed with commercials. New 'interactive' device in urinals offers ads in a whiz. *Houston Chronicle,* Houston, Texas, P. 2.

Mulchand, Sangeeta. (2008). Why the sky is no longer the limit. *Media,* Hong Kong, February 21, p. 22.

Muncy, James and Jacqueline Eastman (1998). Materialism and consumer ethics, *Journal of Business Ethics* January, p. 137–145.

NextMedia and AlivePromo collaborate for networked restroom marketing. (2004, September 13). *PR Newswire* New York, p. 1.

O'Guinn, Thomas C., & Faber, Ronald. (1989). Compulsive buying: A phenomenological exploration," *Journal of Consumer Research,* Vol. 16, September, p. 147–157.

Pappas, Charles. (2000). "Ad nauseam," *Advertising Age,* July 10, p. 16–18.

Paul, Pamela. (2001) "Coming soon: More ads tailored to your tastes, *American Demographics,* August, pp. 28–31

Petrecca, Laura. (2006). Product placement—you can't escape it. *USA Today,* October 10. Retrieved April 3 2009 from http://usatoday.printthis.clickability.com/pt/cpt?action=cpt&title

Pollay, Richard. (1986). The distorted mirror: Reflections on the unintended consequences of advertising *Journal of Marketing.* 50(2) 18–36.

Ramde, Dinesh. (2009, February 4). As you watch ads, they may watch you. *San Diego Union Tribune,* p. 1.

Richins, M. L., & Dawson, S. (1992). Consumer values orientation for materialsim and its measurement: Scale development and validation. *Journal of Consumer Research, 19*(3), 303–316.

Rigoboff, Dan (2000). Virtual ad, real suit. *Broadcasting and Cable,* 130(42), p. 40.

Rivenburg, Roy. (2000). Advertisers have got us covered, *The Los Angeles Times,* July 7, p. E-2.

Roberts, James A., & Martinez, Carlos. (1997). The emerging consumer culture in Mexico: An exploratory investigation of compulsive buying in Mexican young adults. *Journal of International Consumer Marketing 10,* 7–31.

Rust, Roland and Richard Oliver. (1994). Notes and comments: The death of advertising. *Journal of Advertising,* 23(4), 71–77

Rutenberg, Jim. (2001). The way we live now. *New York Times,* section 6, p. 21.

Sass, Erik. (2008). Air travel means endless ads for captive audience. *Media Daily News,* July 17. Retrieved April 3, 2009 from http://www.mediapost.com/publications/?fa=Articles.printFriendly

Schor, Juliet. (2005). Interview with Juliet Schor (by Douglas Holt), *Journal of Consumer Culture,* 5(1):5–21, 2005

Shaw, Donna. (2007). A fading taboo. *American Journalism Review,* June/July. Retrieved March 20, 2009 from http://www.ajr.org/articles.asp?id=4342

Siuru, Bill. (2003). Funding patrol cars with advertising. *Police and Security News.* Retrieved April 17, 2009 from http://ww.policeand securitynews.com/marapr03/Advertising.htm

Tlaleane, Viwi. (2009). Pushing brands on TV. *Business Day,* Johannesburg, April 18. Retrieved April 2, 2009 from http://proquest.uni.com.lobproxy.sdsu.edu/pqdweb?index=1&did

Tomkins, Richard. (2000). It's an ad, ad, ad world: As companies spend ever-greater sums to bring their products and services to the attention of consumers. *Financial Times* (London), July 21, p. 20.

Trachtenberg, J. (1988). Shop until you drop, *Forbes,* January 11, p. 40.

Uhlman, Marian. (1999). The consumer culture never sleeps more and more, ours is an open-all-night world which is convenient but may have troubling repercussions," *Greensboro News Record,* Greensboro, NC July 18, p. D1.

Van Bakel, Rogier. (1999). "Your ad here, there, everywhere," *Christian Science Monitor*, September 20.

Voight, Joan (2000). The consumer rebellion, *Adweek* (Eastern Edition) V. 41, no. 2, January 10, pp. 46–50.

Wilmsen, Steven. (2000). Advertisers try to tap captive audience: Coming soon to an elevator near you: Ads. *Star Tribune*, Minneapolis, Minn., April 3, p. 1-D.

Zmuda, Natalie. (2008). Taste strips give ads a new flavor. *Advertising Age*, June 2, p. 4.

Index